D062156?

TRANSITION

CINEMA

ILLUMINATIONS: CULTURAL FORMATIONS OF THE AMERICAS

John Beverley and Sara Castro-Klarén, Editors

TRANSITION CINEMA

Political Filmmaking and
the Argentine Left since 1968

JESSICA STITES MOR

UNIVERSITY OF PITTSBURGH PRESS

Published by the University of Pittsburgh Press, Pittsburgh, Pa., 15260

Copyright © 2012, University of Pittsburgh Press

Manufactured in the United States of America

Printed on acid-free paper

10 9 8 7 6 5 4 3 2 1

Library of Congress Cataloging-in-Publication Data

Stites Mor, Jessica.
 Transition cinema : political filmmaking and the Argentine left since 1968 / Jessica Stites Mor.
 p. cm. — (Illuminations: cultural formations of the Americas)
 Includes bibliographical references and index.
 ISBN 978-0-8229-6191-8 (pbk. : alk. paper)
 1. Motion pictures—Political aspects—Argentina. 2. Motion picture industry—Political aspects—Argentina—History—20th century. 3. Politics in motion pictures.
I. Title.
 PN1995.9.P6S75 2012
 791.430982—dc23 2012001784

CONTENTS

ACKNOWLEDGMENTS

PUTTING TOGETHER this book has been a much more collective process than I would have hitherto imagined. Nothing that I've accomplished in these past few years would have been possible without the strong and consistent support of a community of people committed to my scholarship as friends, mentors, and critics. As a graduate student working on the dissertation that led to this book, I received a remarkable amount of support at Yale University from dedicated and accessible faculty, vigorous intellectual exchanges in a variety of settings, singularly capable peers, and generous funding opportunities. Listed in order of appearance, those most responsible for assisting me in the early, conceptual stages of this research include Anton Rosenthal, Gilbert Joseph, James Scott, Arun Agrawal, María Victoria Murillo, Stuart Schwartz, David K. Jackson, Benjamin Kiernan, Seth Fein, and last but by no means least, Dudley Andrew. Once in the field, I benefited tremendously from correspondence and visits with several of my colleagues who generously allowed me to talk shop, especially Jana Lipman, Martin Nesvig, Raphael Folsom, Saeed Ahmed, Daniel Gutiérrez, Alison Bruey, Amy Chazkel, Tori Langland, and April Cohen. I owe special thanks to Jana Lipman for hearing me out through various major evolutions of the dissertation project, a close reading of earlier incarnations of several chapters, and constant *compañerismo* despite great continental and technological divides.

I owe a special debt of gratitude to the handful of scholars who read various drafts of chapters and commented on presentations of portions of the material. Mark Healey, Sandra McGee-Deutsch, Alberto Spektorowski, and Rosalie Sitman all trudged through and helped clarify my early ideas and drafts, some of which didn't make it into the final manuscript. Many of my thoughts were developed further through incisive conversations with participants in a graduate seminar on twentieth-century Argentine intellectual history that I led at the Instituto de Desarrollo Económico y Social in Buenos Aires. These include Mireille Abelin, Louise Belfrage, Kerry Bystrom, Karen Faulk, Katherine French-Fuller, Daniel Grech, Sarah Muir, Alison Post, Daniel Richter, Noa Vaisman, and David Woken. Of these, Noa Vaisman and Kerry Bystrom each made important contributions to the fifth chapter of this work. I also owe special thanks to Ismail Xavier, Raanan Rein, Mario Sznadjer, and Luis Roniger for their candid comments on various ideas and directions. Portions of chapter 4 were published by Editorial Paidós in Buenos Aires in

a book I coedited with Claudia Feld entitled *El pasado que miramos: memoria e imagen ante la historia reciente* (2009). This chapter benefited tremendously from Claudia's insights and suggestions, in addition to the careful readings of Valeria Manzano and Laura Wittner.

Organizations that supplied financial support enabling me to embark on what eventually became a five-year period of fieldwork in Argentina and, later, to travel to conferences and archives include the Social Science Research Council–International Dissertation Research Fund program, the Andrew W. Mellon Foundation, and the University of British Columbia Faculty Research Grant program. I am extremely grateful for the many opportunities these funds provided. In addition, I would like to thank the Instituto de Historia Argentina y Americana "Dr. Emilio Ravignani," of the University of Buenos Aires, for providing me with an institutional home during my stay in Argentina and also the Universidad Torcuato Di Tella, which gave me access to its library collection and graciously allowed me to attend valuable lectures and seminars on a regular basis. Many Argentine academicians were critical in helping me to formulate thoughts and locate sources for this book. I offer my sincere thanks to Noemi Goldman, Graciela Silvestri, Adrián Gorelik, José Burucua, Sebastián Elionzado, Victor Heredia, Marco Novarro, Jorge Oubiña, Elizabeth Jelin, Mariano Plotkin, Carmen Guarini, Ricardo Salvatore, Torcuato Di Tella, David Oubiña, Tomás Abraham, Sylvia Saitta, Sylvia Sigal, Manuel Antín, Claudio España, and Andrés Di Tella. I also owe an enormous debt of thanks to Marcella Cassellini and Guillermo Fernández Jurado, of the Fundación Cinemateca Argentina; Adrián Muoyo and Silvia Barales, of the Escuela Nacional de Realización y Experimentación Cinematográfica; and Fabián Sanchez, Daniel Paraná Sendros, Andrés Insaurralde, and Silvia Presedo, at the archives of the Museo de Cine Pablo C. Durcós Hicken.

As the book was finally coming together, I also benefited from the support of an intellectual community at large and within my institutional home at UBC Okanagan that cheered me on in the final stages. I am extremely grateful to Luke Rogers, Francisco Peña, Alwyn Spies, Peter Urmetzer, Ann McKinnon, Christopher Schneider, Daniel Keyes, Hugo De Burgos, David Jefferess, Patricia Tomic, Ricardo Trumper, James Rochlin, Ariane Hanemaayer, Margo Tamez, Jan Gatrell, and my colleagues in the history and LAIS program for their moral support and good company. I am also thankful to my UBCO students and in particular to Stephanie Tissot and the indefatigable Ashley Black for their help and many wonderful questions. It would not be the same work had it not also been for the comments of audiences that heard various chapters presented at LASA and the AHA, specifically

those of Jeffrey Gould, Steve Stern, Florencia Mallon, James Green, and Eric Zolov. Brenda Elsey also provided key emotional support throughout the process of finishing up the manuscript for publication. I am grateful for the comments of the anonymous reviewers of the work and to Joshua Shanholtzer at University of Pittsburgh Press, whose wonderful suggestions and corrections have added much to the final draft.

I also want to thank Ian Bricke and Leandro Burrafato for their friendship and the many ways they helped me see film production from the inside out. I owe a very heartfelt thanks to my dearest friend, Rodrigo Cañete, without whom I unquestionably would not have come to appreciate Argentine film and culture in the same way. I must also thank my parents for their support and patience with my extended time far from home. However, of all the people who helped me throughout this project, the hardiest thanks are reserved for my advisor, Gil Joseph, whose encouragement and insightful critiques guided my way, and to my husband, Uri, whose constant support and patience made this adventure possible.

ABBREVIATIONS

AAA • Artistas Argentinos Asociados (Associated Argentine Artists)

ADOC/Argentina • Asociación de Cortometrajaistas y Documentalistas Argentinos (Association of Argentine Producers of Short Films and Documentaries)

AGICA • Asociación Gremial de la Industria Cinematográfica Argentina (Union Association of the Argentine Cinematographic Industry)

APPA • Asociación de Productores de Películas Argentinas (Association of Producers of Argentine Films)

ARGENTORES • Sociedad General de Autores de la Argentina (General Society of Authors of Argentina)

BAFICI • Buenos Aires Festival Internacional de Cine Independiente (Buenos Aires International Festival of Independent Cinema)

CELS • Centro de Estudios Legales y Sociales (Center for Legal and Social Studies)

CERC • Centro de Experimentación y de Realización Cinematográfica (Center for Cinematographic Experimentation and Production)

CGT • Confederación General del Trabajo (General Confederation of Labor)

CNC • Comisión Nacional de Cultura (National Commission of Culture)

CONADEP • Comisión Nacional sobre la Desaparición de Personas (National Commission on Disappeared Persons)

DAC • Directores Argentinos Cinematograficos (Argentine Cinematographic Directors association)

ENERC • Escuela Nacional de Experimentación y Realización Cinematográfica (National School for Cinematographic Experimentation and Production)

ESMA • Escuela Superior de Mecánica de la Armada (Superior School of Naval Mechanics)

FAR • Fuerzas Armadas Revolucionarias (Revolutionary Armed Forces)

FAS • Frente Antiimperialista y por el Socialismo (Anti-Imperialist Front for Socialism)

FREPASO • Frente País Solidario (Front for a Country in Solidarity)

FUC • Fundación Universidad del Cine (Foundation University of Cinema)

HIJOS • Hijas e Hijos por la Identidad y la Justicia contra el Olvido y el Silencio (Children for Identity and Justice against Forgetting and Silence)

ICAIC • Instituto Cubano de Arte e Industria Cinematográficos (Cuban Institute for Cinematographic Arts and Industry)

INC · Instituto Nacional de Cinematográfia (National Institute of Cinematography)

INCAA · Instituto Nacional de Cinematográfia y Artes Audiovisuales (National Institute of Cinematography and Audiovisual Arts)

INDEC · Instituto Nacional de Estadistica y Censos de la Republica de Argentina (National Institute of Statistics and Census of Argentina)

MALBA · Museo de Arte Latinoamericana de Buenos Aires (Buenos Aires Museum of Latin American Art)

MAMBA · Museo de Arte Moderna de Buenos Aires (Buenos Aires Museum of Modern Art)

MD · Movimiento de Documentalistas (Documentalists' Movement)

MIFED · Mercato Internazionale del Cinema e del Multimediale (International Market of Cinema and Multimedia)

MTD · Movimiento de Trabajadores Desocupados (Movement of Unemployed Workers)

OXFAM · Originally Oxford Committee for Famine Relief, now Oxfam International

PC · Partido Comunista (Communist Party)

PJ · Partido Justicialista (Justicialist Party)

PO · Polo Obrero (Workers' Pole)

PRT · Partido Revolucionario de Trabajadores (Revolutionary Workers Party)

PRT-ERP · Partido Revolucionario de Trabajadores-Ejército Revolucionario del Pueblo (Revolutionary Workers Party-Revolutionary Army of the People)

SICA · Sindicato de la Industria Cinematográfica Argentina (Union of the Argentine Cinematographic Industry)

SIDE · Secretaría de Inteligencia del Estado (Secretariat of State Intelligence)

Triple A · Alianza Anticomunista Argentina (Argentine Anticommunist Alliance)

UNESCO · United Nations Educational, Scientific, and Cultural Organization

UNIARGENTINA · Sociedad Mixta de Comercio de Cine Argentino (Mixed Society for the Commerce of Argentine Cinema)

UNICEF · United Nations Children's Fund

TRANSITION

CINEMA

INTRODUCTION

ON MAY 27, 2003, police barricades caged the four blocks bordering the
zone that surrounds the Brukman textile and garment factory, while armed
guards anxiously stood watch over a large group of demonstrators who had
gathered just outside the riot fences. Situated on Avenida Jujuy, the central
artery leading from the central commercial district of Buenos Aires to distri-
bution hubs across the country, Brukman was the scene of one of the most
dramatic factory takeovers in recent Argentine history. On this particular eve-
ning, it was also the scene of a film intervention. The directors Ernesto Ardito
and Virna Molina brought *Raymundo,* their first feature-length film, to share
with the assembled group of demonstrators as a means of expressing solidar-
ity with the unemployed workers' movement and the cause of occupied fac-
tories. This moment demonstrates a key shift in Argentine politics of the
audiovisual in which activist filmmakers framed a significant national debate
and its relationship to the evolution of leftist political action in a significant
space of civil society, where social movements and emerging political identities
were coming together in common struggle. In the following pages, I examine
how the political filmmaker became an important feature of mobilization and
activism in the transforming landscape of oppositional politics in Argentina

and how the act of filmmaking came to assert an unprecedented authority to intervene in critical debates about the nation's political past and future.

The events leading up to the Brukman factory occupation were set in motion in December 2001, as Argentina faced a dramatic crisis of its financial system. While the Argentine government undertook highly controversial policies to limit the macroeconomic impact of the banking system's impending insolvency, individual citizens faced first restricted access to their own savings and then a dramatic devaluation of the Argentine currency. Pensioners watched their life savings disappear just weeks after investment bankers had successfully sent their own assets overseas. Vast portions of the middle class began to struggle to meet daily needs, and many quickly fell beneath the poverty level. Protesters filled the streets banging on pots and pans, some even vandalizing and setting fire to buildings housing banks and foreign companies, such as the Bank of Boston and McDonald's.

That same month the owners of the Brukman clothing company had decided to cut their losses by closing the factory and filing for bankruptcy. On December 18 the company's displaced employees, already owed considerable back pay, decided to take matters into their own hands. While the company's owners prepared to leave the country, a group of the newly unemployed workers broke into the compound's central building and locked themselves inside, prohibiting entry by the factory's owners and former managers. The workers then restarted the factory's normal production schedule, arguing that Brukman's bankruptcy was no reason for its workers to lose their source of livelihood. Government officials and the factory's proprietors made a number of forceful attempts to remove the workers that eventually resulted in a series of increasingly violent standoffs. By the time Brukman's owners finally succeeded in expelling the workers from the factory, a section of Avenida Jujuy had been turned into a militarized zone in the heart of the city.

Outside the riot fences and just meters away from federal tanks and tactical security squads, the former employees of the Brukman factory refused to retreat. At first they gathered to protest, shouting slogans and waving banners, but soon the workers set up tents to maintain a constant presence in the street. As news of their protest spread, the demonstrators were joined by members of a number of sympathetic organizations, including student associations, the Movement of Unemployed Workers, the Partido Obrero (Workers Party), representatives of neighborhood assemblies, and at least two young documentary filmmakers. The standoff continued for seventeen months, but in May 2003 the former factory workers and their supporters decided it was time to recover their occupation of Brukman. The filmmakers Ardito and Molina,

supporters of the Brukman workers, offered to use their film work to help communicate the ideological aims of the takeover. In the middle of the rally, the directors presented a film to the audience, a documentary that recounted the well-known struggle of an Argentine filmmaker and militant leftist who had been the victim of military violence. The directors used this film to signal a common cause between the workers and themselves as activist documentary filmmakers, a line of connection and political affinity between two sets of victims of state repression.

After the screening, Ardito and Molina announced plans to make a new film about the successful takeover of the occupied Cerámica Zanon factory in northwestern Patagonia, documenting the workers' fight to reclaim livelihoods and personal dignity in the wake of neoliberal reforms and antilabor violence.[1] Using testimony from the workers themselves, the film would document the stories of two ceramists' wives who had been kidnapped in the midst of a series of attacks on the factory by paramilitary groups. The directors explained their hope that the screenplay would create a bridge of understanding between the politics of the military dictatorship and the incomplete process of ridding the country of the regime's legacy of structural and economic violence. Their film *Corazón de fábrica* (*Heart of the Factory*), they announced, would communicate the workers' efforts to audiences around the globe and generate transnational support for the occupied factory movement.

Ardito and Molina's involvement in this most recent wave of factory takeovers in Argentina[2] reflects a shift in thinking about the politics of film that began in the late 1960s and culminated in the first decade of the new millennium.[3] This book is an attempt to describe how that ideological shift took place, drawing attention to what happened not only on screens but also in the moments of social interaction before, during, and after film screening events. I argue that contemporary political cinema in Argentina, particularly *documentalismo,* or activist documentary filmmaking, has become an alternative mode of political communication and engagement, one increasingly tied to social movements and institutions of the political left. Leftist intellectual communities, political organizations, and social movements alike have recognized the critical impact these films have made on national memory and identity debates, and the impact of the political film has been felt across all three realms.

This work explores the means by which filmmakers demarcated a new terrain of cultural politics, making the most of intervention in politicized public spaces, such as the one created in front of the Brukman factory. It follows the Cuban cinema scholar Michael Chanan's challenge to move beyond textual

analysis of film content to interrogate how films situate or position the viewer, recognizing the extraordinary role that these films have played in Argentina's recent political life, interacting with audiences in nontraditional settings and through exceptional means. To understand these films in their historical context is to understand how they began to engage in a thoughtful dialogue with an emerging political left and a growing public of politically committed groups, acknowledging "the space between the screen and the viewer's eyes" that makes these films truly distinct as a political phenomenon.[4]

Revising official historical narratives and retextualizing events of the past, filmmakers in Argentina began to reshape the nation's historical imaginary and to influence understandings of dictatorship and democracy, coding a new set of historical sensibilities onto the post–cold war political landscape. Ardito and Molina's alliance with the Brukman and Zanon workers illustrates how film became a key site of politics in Argentina, providing a frame for gauging the progress of civil society under democracy and for mounting a broad-based critique of neoliberalism and state violence. As filmmakers in Argentina have verified, film has the power to subvert state authority, offering alternative sources of historical knowledge and structuring alternative historical narratives. Film can function as a counterforce to hegemonic state discourses about the national past, suggesting critical viewpoints and attitudes toward events and ideas.

This book thus examines the role political filmmakers played in constructing a postmodern historical engagement with Argentina's recent past in dialogue with the post–cold war intellectual and political left. In the case of *Corazón de fábrica*, the collaborative work undertaken in producing the documentary not only unearthed the Zanon workers' lived experiences of exploitation and abuse at the hands of their employers but also provided a powerful corrective to the official story of the province and the state, whose authorities had previously cited truancy and irresponsibility when explaining the disappearance of workers. Ardito and Molina, by transporting repressed popular memories into public consciousness, took an active part in the construction of collective memory. They not only documented the repressed experiences of factory workers to a larger public but also communicated and interpreted information to the workers themselves, both during the process of making their film and afterward in exhibition spaces.[5]

To understand the genesis of political filmmakers' roles in generating a viable and *present* past, it is necessary to examine the interstices of practice and representation of film culture during Argentina's period of "transition to democracy." In the long process of seeking social justice and a return to

representative politics, transition culture faced a reckoning with history and a revisiting of traumatic and often incomplete collective memories of past events. A political and intellectual left, fragmented and largely dismantled by successive military regimes during the cold war,[6] also looked to film as a medium through which dissident and previously excluded voices could be meaningfully reintegrated into public debate. While many claim that a return to sustained democratic elections and civilian rule in 1983 marked a transformational change in Argentine political life, the left still struggled with important questions not only about the reinstatement of political process and constitutional protections but also about the extent of participation, the enforcement of human rights protections, and the political disempowerment determined by material inequality.[7] The left sought to demonstrate that the transition hardly ended socioeconomic injustice and certainly did not open the political playing field to all participants.

Understanding the context of political filmmaking and its relationship to the left requires challenging the standard framing of the transition, expanding the notion of transition along an extended timeline that begins with challenges to military rule of the late 1960s, when filmmakers became more directly involved in political activism, and reaches into the Néstor Kirchner administration, when the legacies of some of the most profound violence of the military regime's policies continued to be felt across the political and economic spectrum. The narrative thus begins in 1968 and moves through the dictatorship of 1976 and then into the postdictatorship period of 1983 to 1989 and beyond, tracing how cinematic politics evolved over this time to contextualize the flourishing of political cinema that began in 1983 and continues to the present. In discussing this history, I examine how political film practice transformed alongside critical moments for the left, as film activists using increasingly portable technologies began to adopt "camera as gun" revolutionary film techniques. Film simultaneously began to act as testimony to the present and as a means of facilitating political communication for organization. In many ways, the repression of filmmakers that followed in the 1970s and early 1980s mirrored the experience of many groups of leftists, though it was not until the early 1980s and the start of the return to civilian rule that filmmakers came to take on a more prominent role in mainstream political culture. Following my discussion of those issues, I examine the emergence of an independent film culture during the mid-1980s to the 1990s, culminating in the documentary film boom of the post-2001 financial crisis. Throughout these events, the relationship between filmmaking and political activism provided crucial momentum to political film culture, revealing much about the challenges

put to the redemocratizing state from a "new left" closely tied to emerging social movements. The book ends in 2004, when cinema legislation redrafted under Néstor Kirchner cemented the gains of political filmmakers for independent filmmaking, and in particular, for the independent political documentary film.

TRANSITION CINEMA AND DEMOCRACY

The year 1968 was critical for Argentine political cinema culture, a time when political filmmaking transcended any neat and dismissive interpretation as either the political genre film or "cinema with a social conscience." Although earlier filmmaking had been an important venue for the expression of political critique, Argentine political and activist cinema traces its roots to the labor movement and the militant left as they intersected with the tumultuous events of 1968. Its principal assumptions, developed by an intellectual and cultural vanguard deeply engaged with political tensions between democracy and authoritarianism and wary of neocolonialism under the guise of the cold war, illuminate the left's cultural response to a shifting national and international political economy. Activist filmmaking in this period was clearly influenced by the transnational flow of ideas about film and politics, art and revolution, associated with the cultural politics of the Cuban Revolution and earlier revolutionary cinema projects. Unlike later comparable cinema movements in other parts of the Latin America, however, political filmmaking in Argentina was remarkable in the scope and militant heights of its expression, its relative autonomy from the state, and its continuity between periods of dictatorship and democracy. Argentine film bore a distinctive relationship not only to the nation's leftists but also to the legacy of Peronism, which set it apart as a vanguard of political filmmaking, one that would later be lauded as the intellectual wellspring of "Third Cinema."

While events occurring in Argentina during the 1960s and 1970s mirrored changes happening in many other places, social and political transformations during this period were heavily influenced by the legacy of the populist president Juan Domingo Perón. Under Perón, Argentina had enjoyed a degree of economic expansion, fueled by industrial and urban growth, that by the late 1950s had resulted in the solidification of a working class eager to mobilize its political and material gains. The labor movement, the courting of which had powered Perón's success, cast a tremendous shadow over the political landscape, even after Perón's second presidency ended in 1955 in a

military-led rebuke. Throughout the decades that followed, tensions between the left, Peronists, and the military frequently came to a head, but in the fragile moments of a democratic opening for civilian rule, oppositional elements such as the labor movement, the Peronist resistance, and the student movement all asserted themselves. In the late 1960s, however, with the return of the military and increasing repression, factions within many of these social movements and dissident groups moved toward radicalism. Militant politics and attacks on the state, such as bombings, assassination attempts, kidnappings, and other violent acts, escalated rapidly beginning in 1969, from fewer than 200 in 1968 to a peak of nearly 1,400 such acts per year by 1972.[8] While these more radical expressions of discontent did not always reflect a more profound tidal shift, the most poignant moment of synchronicity between Argentina's historical experience of the 1960s and its Peronist past was the outbreak of strikes, work stoppages in industrial centers across the nation that paralleled France's general strikes of May 1968.

The nation's political left of the late 1960s was a product of the revolutionary spirit of the times, of Argentina's unique political past, and of conservative reactions to these challenges. Far from being a unified front, however, the left was riven by divisions and internal hostilities. Different groups formed factions that tended to identify themselves in terms of resistance to the state, with some favoring reform and others seeing a future only in armed revolutionary insurrection. Importantly, parties of the traditional left in Argentina and even Peronists faced extreme factionalism. Both fractured along divisions between factions firmly entrenched within the labor movement and its key bargaining tool of the general strike and those oriented toward militancy, such as armed struggle and the factory takeover. Anti-Peronism had long been a feature of some leftist circles, particularly those that viewed Peronism, and specifically the legacy of Perón, as authoritarian and patriarchal, a view espoused by the Communist and Socialist parties and many leftist intellectuals who had been repressed under Perón. Despite sharing common cause against military dictatorship, the place of Peronism within the left complicated the landscape of political activity around filmmaking. Individuals in the film industry had suffered at the hands of Perón, and many had been persecuted under his rule, but this period also marked significant advances for state subsidization of film,[9] and eventually, the most important filmmakers union came to be dominated by left-leaning Peronists. These complicated relationships among film, the left, and Peronism propelled film activism in the 1960s and 1970s as part of a set of central narratives of film activism and intervention in national politics.

The radicalization of politics during the late 1960s and early 1970s provided conservative sectors with a crisis of security that the military used to justify deposing the civilian government. Although incidences of violence declined sharply in the period of democratic opening beginning in 1973, the military invoked these events to court international support for taking power again in 1976. The successful coup orchestrated that year began a period of military rule marked by the most violent state repression in Argentina's history, all with the approval of the U.S. secretary of state Henry Kissinger and other world leaders. Kissinger counseled that the coup's leaders should act with all due haste to counter the "terrorist acts" of revolutionary groups. The military regime, which remained in office until 1983, took the cold war mantra of national security seriously, stamping out supposed enemies of the state and rationalizing the national economy to stabilize and better integrate Argentina into hemispheric trade relations, all in the name of democracy, a political utopia that the far right would embrace only once order and progress could be effectively reestablished.

The city of Buenos Aires provided a key setting for filmmakers to respond to these decades of political upheaval. At a time when politically active filmmakers faced censorship, blacklisting, forced exile, and even kidnapping if they were suspected of involvement in leftist politics, the city provided them a nexus of exchange and collaboration, even when they were on the run. In the period after 1983, urban spaces associated with groups such as nongovernmental organizations, cultural centers, universities, film schools, and the municipal government came to play an increasingly critical role in the making and viewing of politically oriented films. During the democratic transition, the city witnessed the film sector mobilize, with film activists displaying renewed energies to deal with the complicated legacy of the dictatorship.[10]

Examining political filmmaking along a time horizon that connects the works from the 1960s to those of the next century's first decade breaks from traditional periodizations of Argentine film scholarship, which tend to divide the subject into decades and compare across expanses of time without examining continuities. Instead of taking this tack, I identify three distinct generations of "transition filmmaking" to emphasize the specific contributions of three sets of filmmakers vital to the transformation of film culture's role in political life during the long transition period. I use the term *generation* to refer to sets of filmmakers who became active politically during roughly the same period. This choice of terminology is meant to suggest, as it does in describing population demographics, that the start of activist filmmaking careers is really just a beginning and that although there is significance in the

collective experience of time, this feature is not sufficient to determine any given individual filmmaker's intersection with his or her time. I also use the term to argue that the repercussions of political film work were not tightly confined within decades, historical moments, film groups active at a given time, or film genres; rather, political filmmaking was constantly adapting and evolving over time, even in periods of official silence.

The periodization of this work also departs from the standard model of political history of Argentina, which treats "transition culture" as overlapping with the civilian administration of Raúl Alfonsín, from 1983 to 1989. Starting from the premise that the circulation of films relevant to the political opening was not bounded by the political markers of this time period, I push the temporal endpoints in both directions in the hope of illuminating the continuities of film activism in reaction to the neoliberalism, social inequality, human rights violations, and repression that characterized the cold war era in Argentina and the rest of Latin America. The political economy of transition culture after 1983 included the rediscovery and circulation of critical films from the late 1960s and early 1970s. It also included cinematic revisitings of Argentina's history of labor struggles that antedated 1968, an important feature of which included the dramatic reenactment and revisioning of the place of filmmakers in that history. These "present pasts" formed an important part of the landscape of ideas about filmmaking that informed political cinema produced in the 1980s and afterward. If we think about political transitions as broader democratic openings involving greater profundity than just a return to free elections, we can see that the cultural transformations of political filmmaking in Argentine cold war history followed a distinct ideological progression, from the militant cinema that emerged in 1968 to well beyond the final days of the Alfonsín administration, culminating in 2004, when political cinema was officially recognized as a critical feature of political and intellectual life in Argentina, worthy of institutional support.

In categorizing individual examples of Argentine political cinema as "transition film,"[11] I mean to assign a specific political valence to the cinematic encounter of these films and to political film culture within the political economy of transition culture. I have identified three generations of transition filmmakers belonging to this overarching and eventually quite broad-based cultural phenomenon. The first generation produced films prior to 1976, both during the dictatorship of 1966–1973 and during the somewhat more open period beginning in 1973. These films were frequently censored and generally formed part of an underground grassroots activism, screening either clandestinely or in spaces of exile. Many of these films circulated only after

the democratic opening in 1983. The second generation made their first films after the reintroduction of democracy in 1983. Their works began to stake out new territory for film's entry into national political and historical debates and entered the national film scene as filmmakers in the first generation were becoming more widely known, and at least a few were continuing in more advanced careers. Finally, the most recent generation of filmmakers, those who began working after 1989, past the endpoint of Alfonsín's formal transition government, made films that not only underscored the accomplishment of filmmaking's strategic positioning as a result of the cultural politics of the transition but also called into question the notion of the transition as a fait accompli. This generation came of age as the institutions of cinema were being radically stripped down and reinvented in the name of free trade. Reperiodizing political filmmaking in this way highlights the continuities and contrasts between the cultural institutions and markets of the dictatorship and those of the civil governments that followed in their wake, specifically in terms of the everyday regulation of film work. It also proposes an analytical bridge between generations of filmmakers and their political habits that have traditionally been studied only in isolation or in very general comparative terms.

Transition cinema began to shape a new political subjectivity that was highly accessible to other kinds of intellectual projects, particularly to those of the Argentine intellectual left. Film projects traded in iconic moments in the history of the left, reinvigorating successful narratives and framing more troubled aspects of this history within a critical and reflective consciousness. Filmmakers relied on the ability of audiences to quickly read and identify historical news footage and important figures of the left as representations of ideas that transcended the scripted narrative. In this regard, transition film as an event wielded a tremendous mimetic capacity for representing competing narratives of the cold war era. Filmmakers of the transition reproduced coded encounters among images, testimonies, narratives, and sound that could simultaneously resonate with and challenge subjective experiences of the past. In a general sense, these films situated the individual viewer within a past only partially accessible but from which new collective memories could be cobbled together. As a result, viewing films in Buenos Aires during this period was a highly self-conscious experience. The individual film viewer, typically well aware of the constructed nature of a film's representation of a particular past, actively negotiated categories of understanding through which the film could operate both on its subject and its spectator.

Viewers of political films during the long transition actively elected to participate in this process of imagining and reimagining the past, willfully allowing their own political identities to be called into question. In this way, film also became a vehicle for and common referent within emerging debates in other politicized spaces. Argentine film moved into a controversial realm that, instead of using history as background, made history the revealed content of the film. As a register of politicized representations of the past, these films also began to suggest possible new or newly refined political subjectivities. Providing filters of intelligibility for connecting to meaningful pasts within the present, political filmmaking by 2001 had become deeply embedded in the political projects of social movements and in the framing of left-oriented activist resistance to neoliberalism and social inequality. Some transition films, particularly those of the third generation, even went so far as to suggest specific revised categories of posttransition political subjecthood that would better jibe with the challenges of realizing meaningful citizenship. They suggested multiple ways Argentines simultaneously positioned themselves within and were positioned by historical narratives of dictatorship and resistance, neoliberalism, and state violence. Transition film became a key instrument in setting the tone of left-leaning activism for intellectuals in search of a more authentic encounter with historical silences and, later, for a digital media generation with new demands for a wider political community.

BEYOND FILM AS TEXT

The chief obstacle to the historian trying to map the political ecology of film in Argentina during this period is the task of teasing out the social and political history of film practice and culture from the myriad responses any given film provokes. Although the role of culture in transitions has recently come into sharper focus in the theoretical literature on democratic political life and civil society, studies of Argentine cinema have tended to approach the subject predominantly from the study of film as a cultural text.[12] Cultural studies and film scholars have made tremendous progress in identifying subjectivities crafted on-screen, and this book is heavily indebted to their fine work.[13] One leading theory of this literature argues that the transition in Argentina and its cultural by products were a highly sophisticated performance that concealed the persistence of political and economic inequalities.[14] According to this hypothesis, film was the commercial consequence of a

market for social memory, and cultural production during the transition merely served as a means for the transition administration to establish control over the symbolic field. Critics of this hypothesis argue that Argentina's postdictatorship period reveals art's power to speak truth to silences and ruptures in the official historical record. They assert that the visual and literary arts brought about new collective understandings, primarily emerging from an organic ethical humanitarianism, that, together with a determined human rights movement, challenged both the new political order and the left's entanglement in the violence of the past. While each of these positions adds depth to the multiplicity of meanings and interpretations of the period, neither conclusion adequately describes the political economies within which transition films actively took part.

I thus initiate this study by examining relationships among filmmakers, their collective organizations, political activism, and the state. I emphasize the complex processes of cultural production and reproduction within this context and focus on the political alliances and directives of filmmakers that formed part of political cinema culture. In doing so, I turn the investigative and thematic gaze away from the films per se and toward the political landscape of filmmaking itself. I take this more expansive view of political filmmaking and activist cinema principally because most directors and state institutions regulating cinema rarely saw themselves or their work as separated from historical situations or political contexts. I study film practice and other by-products of cinema culture not only for their on-screen politics but also as "important events in their own right."[15] This is not to say that the films somehow should not speak for themselves, for certainly they do, but my aim here is to fill in a significant gap that has been overlooked by studies that focus primarily on film content.

In part, this approach is a response to the way that the linguistic turn in contemporary scholarly writing on Argentine film has decentered the filmmaker and the political economy of filmmaking, replacing individual agency with representational analyses of film as text. The tendency of this critical approach has been to "desocialize" culture, such as cinema, stripping a degree of political agency from filmmakers and from audiences alike in the process of reifying a general narrative of culture as politics. But the everyday political and social habits that surround cultural objects are just as important as (if not more important) than the politics they may exemplify and inscribe. Political filmmaking in Argentina has a material and social life in which producers, filmmakers, activist groups, critics and intellectuals, and audiences actively participate, each making an important contribution

to the varied landscape of political concerns expressed and transported into public consciousness through film.[16] Within this heterogeneous political economy, production decisions are also governed by system-level operations, such as the laws governing cinema production and regulating viewing experiences, underlining the decisive magnitude of power relationships between cultural producers and the state. In my research and analysis, I constantly sought to forge a more integrated methodology and conceptualization of cultural politics by combining an analysis of social structures and political economy with cultural theory. I reintroduce the political film in Argentina to an older tradition of history of ideas that connects practice to representation.[17]

The nature of the questions that drove this project led me along an unusual and somewhat complicated journey. I examined documents related to individual filmmakers, people and organizations connected to the industry, and the regulatory apparatus of the state in setting the parameters for film production and film politics. In doing so, I was most interested in finding out how the institutional settings of film, which often changed with each new government or as a result of broader economic shifts, influenced the way filmmakers went about their work. In addition to reviewing legislation and records of regulation, I looked at previously unexamined industry archives, film union records, obscure trade magazines, film school curricula, directors' requests to the national film institute for funding, "organizational memories" of film institutions, and production data. I also sought to assess the role of state power in a changing cinema culture by analyzing film policy, legal conflicts, political campaign rhetoric, senate proposals, executive decrees, and cultural ministry initiatives. I read directors' initial proposals and *post facto* narratives of filmmaking aims against their official submissions to the national registry of films, which contain detailed records of the justifications filmmakers used to convince the state of the merits of their projects, in order to piece together the complex negotiation of ideological projects behind the scenes. I went to hear makers of both films and film policy speak about their careers in retrospective events at museums and film festivals across the continent. I examined debates between filmmakers and the organizations and political entities that negotiated their relationships to the viewing public or markets in concert with the accounts of filmmakers and films themselves. Along the way, I often found myself checking my intuition in conversations, observations, and informal interviews. Together, this variety of sources helped form my interpretation of the many internal mechanisms that drove production before and throughout the long transition.

I decided to approach the more complicated question of reception by examining the relationships between groups of viewers brought together by acts of film exhibition. For instance, I open a window onto the interested parties in film circulation and film culture by examining the financing and sponsorship of film production, promotion of film products, and cycles of film exhibition in university faculties, international organizations, nongovernmental organizations, film clubs, and cultural centers, among other venues. I was particularly interested in the physical spaces of these exhibition events, the way space determined relationships of film viewing to the politics of the social encounter and to the referentiality of film content, and where possible, I tried to determine who came to see these films, who advertised them, how they were publicized, and in what material context they were screened. Were there tables of propagandist party literature outside the theater doors? Was the theater part of an educational space? Were screenings designed to attract the average passerby, or were they better suited to a more exclusive and informed public? I also was compelled to examine the way filmmakers, film critics, and public figures reframed the history of the film industry, particularly in the literature and the pamphlets that introduced or critiqued film exhibitions, and specifically how they treated censorship, blacklisting, and disappearances of filmmakers during the dictatorship. This helped indicate the variety of narratives about earlier generations of political filmmakers presented to and received by those who would form opinions about filmmaking's political relevance during the later transition. Finally, I examined the field of film study in intellectual journals, scholarly works, critical sources, and the popular press to gauge the reception of films and filmmakers within well-defined intellectual communities.

PART ONE

The Spectacle of the Past

"It's the hour of the furnaces and only the light should be seen."
Che Guevara, quoting José Martí's "Letter to José Dolores Poyo,"
December 5, 1891, in his last public address,
"Message to the Tricontinental," 1967

La ideología la hemos hecho
sangre
saliva
esperma
muertos
exilio
resistencia.
Violenta, serena
liberación
del hambre
de la conciencia.
El problema ahora
es el lenguaje
una revolución
que no revoluciona
(permanentemente)
sus lenguajes
alfabetos
gestos
miradas
involuciona o muere.

Fernando Birri, from "Para seguir resistiendo," delivered in Havana,
Cuba, 1985, at the Seventh New Latin American Film Festival,
acceptance speech on receipt of the Felix Varela Medal

1

CAMERAS IN THE HANDS OF
"ANGRY YOUNG MEN"

Filmmaking and the Cordobazo

The future was no longer theirs, though nobody knew whose it
was. More than ever, they knew themselves to be on the margin.

Eric Hobsbawm, *The Age of Extremes*

THE BIRTH OF radical political filmmaking in Argentina was intimately
tied to the struggles for social justice that marked the political scene of the
late 1960s. Revolutionary politics both at home and abroad brought into ques-
tion the relationship between filmmakers and the political use-value of their
work, and a handful of filmmakers just beginning their careers turned their
attention to the social and political margins in an attempt to transform
their medium and to reinvent the production and exhibition of their work as
sites of political activism. The creative vanguard of Argentine cinema of the
early 1960s that had pioneered innovation in filmic art and cinematic narrative
structure responded to political turmoil by adopting a new self-reflective con-
sciousness, but those emerging later in the decade wanted their works to inter-
vene directly in politics. In their hands, the camera and microphone took on
revolutionary purpose. Raymundo Gleyzer, a film student in the mid-1960s
who began making documentaries during this period, exemplifies the shift of
political filmmaking away from the avant-garde and toward political action.

Gleyzer was born in 1941 to middle-class Ukrainian and Polish Jews, and
many of his immediate family members participated actively in dissident poli-
tics.[1] His mother worked as an actress, performing in a downtown theater in
Buenos Aires frequented by well-known Communists and politically engaged

Jewish intellectuals. In the Idisher Folks Theater, politics were openly discussed and often integrated into the cultural fare.[2] Since both his parents and most of their associates in the Jewish community were involved with the Communist Party, friends of the family often joked that Gleyzer belonged to the Communists by right of birth. In fact, his mother claimed that he was named after a famous French guerrilla, Raymundo Guyot, who was killed by Nazis in World War II. Gleyzer's early life was shaped by his family's political experience, particularly his hours spent in the theater, at political rallies, and in heated discussion over the dinner table.

Like many Argentines who grew up during this period, Gleyzer was exposed to the frequently fatal consequences of opposing the Argentine state apparatus, both under Perón and during the dictatorship that followed his deposition in 1955. As Communists and staunch anti-Peronists, Gleyzer's family feared repression under both Perón and the military. Like most first-generation transition filmmakers, Gleyzer also grew up in a tumultuous economic moment in Argentina's history, suffering through boom-and-bust cycles that culminated in a major economic crisis during the early 1950s.[3] Most months, his family just scraped by, working hard to pay the rent on their small apartment. Although his mother did not approve, Gleyzer worked from an early age to help support the family, picking up odd jobs from family friends.

After he finished high school, Gleyzer enrolled in film school in La Plata; each day he and a group of friends would commute from their Buenos Aires homes to attend classes there. As a university student, he developed his own formal ties to the Communist Party, to which many of his film school companions also belonged. Already a capable photographer, Gleyzer distinguished himself early among his classmates. While many of his colleagues were more interested in philosophical and aesthetic discussions of films, Gleyzer established a reputation with his instructors as someone who knew how to see a project through, from the conceptual and planning stage to the final cut. He also stood out among his peers for his ability to find financial backing for his projects. Between semesters, Gleyzer hitchhiked to northeastern Brazil to shoot a short documentary. He wanted to record the travails of the region's destitute peasantry, a cause with which he identified strongly. According to his own account, he took just the clothes he was wearing and some basic film equipment. Gleyzer and his traveling companion, Jorge Gianonni, stayed in unused student dormitories and reportedly ate and slept little. Gianonni abandoned him midway through the trip, but Gleyzer completed the journey and managed to return to Buenos Aires with sufficient exposed reels to complete the short film *La tierra quema* (The burning earth [1964]).

La tierra quema received a warm critical reception, and subsequently Gleyzer was invited to work with the veteran director Humberto Ríos, a professor under whom he had studied, on a documentary project about working-class politics in the industrial city of Córdoba, to the north of Buenos Aires. Together they filmed two documentaries produced by the University of Córdoba, one of them dealing with the experiences of workers in a local ceramics plant as they confronted an increasingly hostile developmentalist state, factory layoffs, and growing violence in labor disputes. The films argued that as Argentina's political elite became more committed to capitalist economic progress as a weather vane for political legitimacy, wealth was being redistributed from the labor sector to industrialist capital and foreign investors. In 1967 Gleyzer was hired by a news service, Telenoche, where he was given the task of traveling across the country to film stories of local interest for a national audience. In this capacity, he came into contact with other correspondents and documentary filmmakers, many of whom had adopted a revolutionary model inspired by the experience of Castro's ambitious film projects during and following the Cuban Revolution.

From his youth Gleyzer had exhibited a fascination with communist Cuba, "the first free territory of Latin America," as he called it, and so he was excited to become the first Argentine reporter to photograph Fidel Castro for the Argentine news media, going to Cuba to do so in 1969. Once there, Gleyzer was influenced by Castro's strident position on the role of the arts in revolution and was drawn to the Cuban leader's support for the arts: building a national art academy, sponsoring documentary film, inviting influential filmmakers to Cuba, sending Cuban filmmakers abroad, and improving education in the arts as part of a broader ideological project to cement the goals of his revolution into the national imagination of the Cuban people. Documentary filmmakers participating in Castro's July 26 Movement had captured the overthrow of the Batista regime and the revolutionaries' rise to power. The rebel army had even had its own film unit, in which the future luminaries of Cuban cinema Tomás Gutiérrez Alea and Julio García Espinosa both served. Only three months after Castro came to power, the Instituto Cubano de Arte e Industria Cinematográficos (ICAIC) was created, and Alfredo Guevara, a close friend of Castro's who was often credited with introducing the revolutionary leader to Marx, was appointed director. The ICAIC would be charged with producing documentaries and newsreels and eventually would also subsidize the production of art films, all in the name of revolutionary advance. Important political filmmakers from abroad, notably the Dutch filmmaker Joris Ivens and later the Argentine social realist filmmaker Fernando Birri,

served as consultants or were employed by the ICAIC for extended periods of time. The institute produced and coproduced films in collaboration with other revolutionary projects across Latin America and in Africa. The ICAIC also sponsored the Cuban director Santiago Alvarez's highly experimental documentary work on the civil rights movement and political corruption in the United States. In the 1960s, Havana became something of a second home to leftist filmmakers throughout the Americas.[4] And it was within this transnational experiment in film community that filmmakers began to heed Ernesto "Che" Guevara's call to internationalism and solidarity.

Gleyzer continued to be active in the Communist Party in Buenos Aires throughout the late 1960s and early 1970s, despite mounting tension between the party's leadership and the state. After his return from Cuba, student members of the local party split between two factions over the issue of armed resistance and guerrilla warfare. Gleyzer initially sided with the pacifists, but as state violence increased, he became convinced of the necessity of armed resistance and joined the Revolutionary Army of the People (ERP), a militant faction of the communist Revolutionary Workers Party (PRT). This moment reflects a critical juncture in filmmaking and political activism within Argentine history, a clear beginning of film production tied to social movements and radical political action. Filmmakers had already begun to use film as a tool for communicating increasingly radical political ideas, but developments in Gleyzer's professional cohort marked an important milestone in Argentine political film history. Filmmakers had finally transgressed the boundaries between political critique and direct political action.

Just as the breakout of strikes and demonstrations in Rosario, Tucumán, Buenos Aires, and Córdoba from 1968 to 1969 marked a turning point in the radicalization of political life in Argentina, the creation of a new film collective called Cine de la Base, which Gleyzer founded in 1971, evidenced a significant shift in political filmmaking there. This latter turning point effectively cemented the role of activist film media in leftist political endeavors. These two decisive moments occurred just as the military issued new legislation that set limits on film activity and expression, charting a course for the important stations along which politically conscious filmmakers would be transformed in the historical imaginary from vanguard cineastes into radicalized film activists.

Gleyzer and others spearheaded an emergent culture of radical and militant filmmaking in Argentina, a phenomenon that included the development of increasingly independent film organizations, the birth of new left-leaning film publications, and the early politics of underground film culture. The rise

of militant cinema would bring about major shifts in political cinema practice and thinking and would set the parameters for filmmaking and its involvement with intellectuals and political organizations on the left. Without analyzing these critical moments, it is difficult to situate an understanding of the political filmmaking that would follow. Forged in the turbulent politics of the late 1960s, the beginning of militant revolutionary filmmaking and the state's attempts to control it were counterpoints in exposing the conflicts and concerns of political cinema that would evolve over the course of the next three decades.

TRANSNATIONALISM AND THE ARGENTINE LEFT

By the time Raymundo Gleyzer had aligned himself with the ERP, the Argentine left had begun to map itself over a fairly complicated new political terrain. During this period, the left in Argentina, already "extensive, prolific, [with] countless complexities and contradictions,"[5] gradually transformed itself into a "new left," confounding the situation of the traditional left by introducing a wide range of new ideological influences. The left of this period revealed a tremendously powerful tendency to splinter and divide into ever more conflicted factions. Participants in the *nueva izquierda* included intellectuals, university students, defectors from traditional labor parties, Peronists, Trotskyites, Leninists, guerrillas, social action Catholics, and a variety of ideologically left-leaning social sectors, many of which had broken away from traditional party structures to form the beginnings of social movements. Leftist political parties, for their part, had become a hodgepodge of acronyms and divided loyalties by the time strikers and demonstrators took to the streets in Córdoba in May 1969.

In general, however, the new left-leaning political consciousness that echoed across Latin America looked to socialist and communist utopias to articulate visions of a postcapitalist future. The working classes in the swelling cities of Latin America were exposed to the vagaries of an increasingly liberalized economy matched with the political tensions of the cold war, which pitted communist ideology against free-market capitalism and democracy.[6] Authors and intellectuals presented their ideas and work in open forums, speeches, letters, and manifestos. In this way, a new canon of left-leaning cultural expression was made available by the popular press, busy urban cultural spaces, and the expansion of mass media. Televised news coverage of Castro's Cuba, the Vietnam War, Algerian independence, and Mao Tse-tung's China,

along with student uprisings, such as the one that led to the 1968 Plaza de Tlatelolco massacre in Mexico City, continually prompted critical reflection and debate.[7] Leftist intellectuals participated in what Diana Sorensen calls a "transnational republic of letters," sharing the work of political theorists, including Frantz Fanon and Hannah Arendt; existentialists and feminists; and postcolonial Latin American novelists and poets, such as Julio Cortázar, Lezama Lima, Carlos Fuentes, Pablo Neruda, Mario Vargas Llosa, and Gabriel García Márquez. Through this transnational social network of intellectuals, news of the literary and cultural production of Latin American leftists circulated rapidly among the literati of several continents.[8]

In Argentina, increasing political radicalization underlined long-standing tensions within the left and labor sectors. An important instance of such tensions occurred within the General Confederation of Workers (CGT), the national umbrella union created in 1930 when the two largest national trade unions united and revitalized under Perón as minister of labor in 1943 after a period of division and suppression of labor organizing.[9] In the later 1960s and the 1970s, the CGT, which had become a stronghold of Peronism from 1944 to the 1960s, splintered into two main blocs, one of which took a decidedly combative stance toward the state, while the other opted for reform.[10] The Peronist hardliners of the CGT were seen as suspect by many members of other labor-based, communist, and socialist parties, creating additional lines of fissure within these two major blocs.

Armed struggle had been a divisive question for Argentina's left as early as the turn of the century, but the issue became increasingly more visible in public debate, first when the Peronist resistance (those who supported Perón after his ouster in 1955) considered militarization and then again when guerrilla insurrectionists in a Cuban-inspired rural movement called the Uturuncos attacked a police office in Santiago del Estero and launched aggressive attacks in Buenos Aires and Córdoba beginning in 1959.[11] In 1963 a rural-based uprising carried out by a group calling itself the Guerrilla Army of the People made waves in leftist circles, despite its lack of success. The Revolutionary Army of the People, which Gleyzer eventually joined, had been formed in 1963 when two Argentine labor-based communist parties, the Trotskyist Worker's Word Party and the Indo-American Popular Revolutionary Front, fused to form the Revolutionary Workers Party (PRT). Although militancy was certainly not new to the Argentine left—or to the right, for that matter—by the late 1960s it was clear that this matter would become the focal point of contention between oppositional political organizations and the state.

Competing factions and perspectives from the left came into contact with one another throughout this period through leftist publications, various news media, and dramatic public events. A key space for leftist intellectual debate, the Gramscian communist publication *Pasado y Presente,* published out of Córdoba, claimed to be the expression of a historical process characterized by a strong leaning toward a revolutionary break. Even when it was forced underground in 1968, it circulated over ninety-eight issues under the title *Cuadernos de Pasado y Presente.* Espousing a revamping of Marxism to address contemporary problems of the left, it quickly became required reading for left-leaning intellectuals. For example, when the Montoneros, a guerrilla faction with ties to Catholic Social Action and the student movement, emerged from the Peronist left, the publication produced debates about ways in which the prime beneficiaries of the militant labor movement of the earlier decades would respond to a Peronist entry into militant politics. Writers for the magazine established reputations based on their contributions but also sometimes on active support and participation in political organizing, including militancy.[12]

One of the most dramatic public events that put different leftist organizations into conversation with one another occurred when General Juan Carlos Onganía came to power in 1966 in a military coup. Onganía's regime premised itself on the state's need to establish order over the chaos of the radicalizing left. His administration declared its mission, which it called the "Argentine Revolution," to be steering the nation on a course toward renewed economic prosperity, eliminating what it perceived as structural obstacles to capitalist development.[13] This economic restructuring situated the labor sector in a precarious position, giving the traditional left reason to create alliances with more radical sectors. In anticipation of a strong rejoinder from the working class, almost immediately after assuming office, Onganía suspended all forms of popular participation, creating a common cause that united leftists of a variety of stripes. The president dismissed the Congress and made clear that political party organization would not be tolerated, leading leftists to seek alternative modes of communication and organizing that often brought them together outside party structures.

Onganía's economic policies announced in March 1967 were seen as a frontal assault on the labor movement in Córdoba and other working-class cities. His economic stabilization approach consisted of making the labor force more "flexible" for international capital, which he accomplished by eliminating the right to strike, freezing worker's wages, and launching a series

of rationalization programs that resulted in the closing of a number of "unproductive" industries. Adding insult to injury, Onganía's strict developmentalist economic plan followed with a 40 percent devaluation of the Argentine peso, sending shockwaves through the working and middle classes. The military regime was determined to wrest power away from labor to attract foreign investment.[14] After only two years of military rule, wages had fallen in real terms by nearly 10 percent, while nonwage economic indicators had temporarily stabilized, presenting a picture of profitable growth within the industrial sector.[15] The Labor Ministry reported a 4.5 percent national unemployment rate in 1969, the lowest level Argentina would see between 1966 and 1973, despite real losses in workers' earnings and collective bargaining power.[16]

Facing strong currents of radicalism across multiple sectors, Onganía's administration called for careful monitoring of the emerging "Communist threat." Bolstered by the anticommunist cold war crusade of the United States, Onganía created a special police force to investigate and monitor suspect political activity. Onganía also cracked down on the intellectual and student sectors of the left by reversing the University Reforms of 1918, which had granted faculties and student bodies significant authority in university policy and intellectual autonomy. In July 1966 he authorized the federal police, under the auspices of the new office of the director general of urban order, to occupy five of the main buildings of the University of Buenos Aires, expelling university students and professors in what would come to be known as "la noche de los bastones largos," or the night of the long bats.[17] The police detained around four hundred students and faculty members during the course of the occupation, many of whom later fled the country anticipating increasing state violence in the days ahead.

Argentina's cultural and artistic vanguard under Onganía consolidated around a set of political strategies that used experimental art to confront the rising level of military repression. On the left, established artists and newcomers often joined forces in displays of outrage against the military's cruelty. For instance, a group of artists came together at the Di Tella Institute in Buenos Aires to participate in a show entitled "Experiences of '68," which was designed to expose and condemn the violence of the Onganía regime. The show provoked such a hostile reaction from conservative art critics that it was decried in the popular press as obscenity. The military censored one work in the show, "El Baño" (The bathroom), an installation by the visual artist Roberto Plate composed of full-size replicas of public restrooms; attendees were invited to write on the insides of stall walls. The resulting com-

ments included criticisms of military officials and repression, after which the artist was asked to remove the installation. In protest, all but two of the invited artists removed their works from the show and burned them in front of the institute in the middle of Calle Florida.[18] Political manifestos and protests of artists were published in left-leaning weeklies, such as *Primera Plana* and *Confirmado,* and events such as these became symbols of resistance that could powerfully connect leftist intellectuals and artists to more traditional political organizing.[19]

Another key example of this phenomenon is the collective project Tucumán Arde, which brought together a number of important leftist artists from the cities of Rosario and Buenos Aires to act in solidarity with workers and peasants in Tucumán who had been politically silenced by the military. The artists Roberto Jacoby, Eduardo Costa, and Raúl Escari traveled to Tucumán to document social and economic conditions and to discover the fates of union leaders and other outspoken members of the community who had been the targets of military violence. Using photographs, film, and interviews to show how the Onganía regime's economic policies were harming the local population, the artists then returned to Rosario, where they mounted a protest exhibition with the help of local labor movements. The show then traveled to Santa Fe and Buenos Aires, but attention from the military led to its closure after only a few days in the nation's capital city.[20] On May 13, 1969, when factory workers at a Tucumán sugar mill took the plant and its manager hostage, demanding the payment of back wages, the Tucumán Arde project paid its political dividends, as leftists across the country were primed to support the workers. The following day autoworkers in the city of Córdoba took to the streets to protest the elimination of the Saturday work holiday. The very next day, in Corrientes, a student demonstration over the price of meal tickets in the cafeteria broke out in violence, leading to the death of Juan José Cabral, a student leader, as a result of police brutality. On May 16 university students in the city of Rosario took to the streets, leading the rector to temporarily suspend university activities. Rosario students subsequently declared a national strike and were soon joined by the CGT, which came out in protest of the rector's actions. Over 4,000 people flocked to the streets of Rosario to demonstrate, and in short order the city was put under martial law and declared to be in a state of emergency. By the end of May similar student and labor strikes had broken out in a number of cities, culminating in Córdoba, where a major civil uprising, the Cordobazo, would soon become a defining moment of the decade.[21]

EL CORDOBAZO

The Cordobazo and the popular rebellion that followed it commenced what the historian Oscar Terán has described as an epidemic of "angry young men."[22] Sparked, at least ostensibly, by the military's repeal of the 1932 Ley del Sábado Inglés, the Saturday holiday, and a freeze on collective bargaining, the initial popular mobilization in Córdoba started via clandestine cooperation among a large number of allied unions calling themselves the "62 Organizations" and a handful of politically sympathetic groups, which included student organizations and Catholic groups influenced by the Priests of the Third World movement, among others. Outspoken labor leaders, including Elipdio Torres, Atilio López, Jorge Canelles, and Augustín Tosca, would later characterize their participation in the events of May 1969 as nothing less than an attempt to overthrow the dictatorship of Onganía, just as Castro's revolution overthrew Batista, also comparing themselves to the likes of the revolutionary leader Patricio Lumumba, who fought for the decolonization of Angola; Cassius Clay, who was stripped of his heavyweight world championship boxing title when he refused to fight in Vietnam; and Salvador Allende, whose popular election had led to a socialist revolution in Chile.[23]

On May 29, gathered workers marched toward the center of Córdoba, some armed with Molotov cocktails, lead pipes, stones, and other simple weapons, largely for self-defense. Along the march, demonstrators vandalized businesses that were viewed as complicit with the regime, such as two foreign companies with offices downtown, Xerox and Citroën, which to the workers symbolized the dictatorship's alliance with foreign capital and collaboration with neocolonialism.[24] Mounted police forces confronted the demonstrators as they advanced on the downtown area, leading to a general mêlée. Participants threw stones, destroyed stoplights, smashed store windows, and set several storefronts on fire. The demonstrators removed wooden planks from road construction sites so that police horses and cars would not be able to safely maneuver.[25] By the middle of the afternoon, the workers and their allies had taken the city.

Images of the Cordobazo were quick to circulate in the televised media. Snapshots of police officers awaiting the order to repress an uprising and video footage of columns of workers marching from auto-manufacturing plants and of students waving banners in the barricaded and burning streets of the city flooded the national press. Photographs of middle-class residents of Córdoba's downtown core bringing mattresses and furniture down to the

street to start bonfires announced cross-class solidarity.[26] Descriptions of violent confrontations between the police and the demonstrators filled the airwaves on national and underground radio. Then came chaos: images of overturned automobiles in flames in the streets, of makeshift sheet-metal and wooden barricades guarding protestors as they tossed Molotov cocktails at the advancing police, of smoke barreling out of hollowed-out shop fronts, and of men hurling stones at the windows of auto-manufacturers' offices. Finally, the photographs and news footage captured the rebellion's success, showing mounted police fleeing from the triumphant mob of angry workers.

For several days the city was turned on its head. A column of students occupied the courthouse, demonstrators looted local stores, five police officers were taken hostage, police headquarters were sacked, and police weapons were confiscated. According to some estimates, almost 150 city blocks served as a battleground of revolutionary and counterrevolutionary activity. By the time the army was eventually able to put the rebellion down, dozens on both sides were injured, sixteen rioters had been killed, and many of the leaders of the uprising had been captured. Of these, several of the most prominent leaders were sent to a federal high security prison in Rawson, a city in the Patagonian province of Chubut, where they would be held as political prisoners, some with maximum sentences of ten years.[27]

If, as Maurice Halbwachs suggests, the past is filtered through frameworks of social memory,[28] then it is clear that the journalists, photographers, and news media that documented the Cordobazo and participated in its unfolding meant to invoke the social memory of heroics from a past moment of solidarity and glory among the laboring classes. The journalist Roberto di Chiara's televised images of the assault on the city center and the subsequent military repression were a significant point of inflection in this struggle, unique in Argentina's history because of the way that the conflict was captured by and broadcast over the national media, almost in real time. His footage captured a specific narrative of the conflict that celebrated the worker and emphasized the repressive nature of the state's intervention, a triumphalist vision that suggested an opportunity for radical action to make real change.

The Cordobazo documented the beginning of a sustained period of armed conflict for the Argentine left, and its highly televised nature exposed the weaknesses and excesses of Onganía's dictatorship. For the labor movement, it was a great victory of collaboration among unionists, students, social activists, and intellectuals, proof of cross-class support for a combative stance toward the military regime. But for others, the Córdoba rebellion was the first stirrings of a coming revolution, the inaugural celebration of an epoch of popular

mobilization and armed militancy that had been brewing for decades.[29] A year later, in May 1970, the Montoneros would kidnap a prominent general and former president in broad daylight on the streets of the capital city. From 1969 to 1974, the number of guerrillas actively engaged in destabilizing the Argentine political establishment would number over 5,000.[30]

The Latin American political left of the late 1960s emerged from a variety of ongoing social and political efforts that were influenced by communication through mass media, and militant political film partially resulted from the mass media's technological progress in documenting momentous political events such as the Cordobazo. Not until the consolidation of continuous broadcasting in the mid-1960s was television in Argentina able to play a significant role in documenting and publicizing events of national significance.[31] Mass media images of the Cordobazo, in many regards Argentina's "May '68," circulated a utopian political vision of popular rebellion that was easily recycled as stock footage for documentary and political filmmakers who had previously had to rely more heavily on propagandist newsreels for historical images. The television and print media manufactured an expansive collection of audiovisual material that filmmakers could use to reflect on and then represent the lived experiences of the period. This synergetic relationship would feed a hungry audience of leftist intellectuals, university students, labor activists, and their allies eager to participate in the encoding and decoding of their ideological messages to a larger public.

TESTIMONIAL FILM AND DENUNCIALISMO

After the media boom of the 1960s, Argentine activist filmmakers began to reexamine models of national cinema concerning social and political issues. Revisiting political film from a new vantage point, many looked to the genre of *cine social* of the mid-1930s, which dealt with issues of class and the rights of laborers in predominantly dramatic fiction films. The film that brought the genre into national prominence was Mario Soffici's *Kilómetro 111*, produced in 1938 by the studio house Argentina Sono Film, one of the largest production venues in Buenos Aires at the time, when the cinema industry was starting to unionize.[32] This film took on big agricultural exporters and railway companies, critiquing the way their exploitative policies affected the daily lives of farmworkers. Critics labeled the film a "testimonial" in the popular press, a term they used for the first time to describe political filmmaking, and Soffici was lauded on many fronts for his representation of the injustices in rural

working-class conditions. The script was written by three well-established literary figures, Enrique Amorim, Sixto Pondal Ríos, and Carlos Olivari, and served as an entry point for the literati to intervene in the politics of the industry. Pondal Ríos himself went on to become a vocal spokesperson of the newly created film worker's union, the SICA (Sindicato de la Industria Cinematográfica Argentina), which would later, under Perón, become the central force of the industry's labor.

Kilómetro 111 and subsequent works by Soffici and this screenwriting trio were tremendously influential. Even Mexican and Hollywood film studios adapted several of their works.[33] Soffici followed this success with *Prisioneros de la tierra* (Prisoners of the land), a 1939 film based on the lives of yerba growers in the northern province of Misiones. One of the first "low-budget" films of Argentine cinema, *Prisioneros de la tierra* met a critical reception that inaugurated the notion of film as social document, with an intrinsic value that extended beyond the commercial market. By the 1960s Soffici was regarded internationally as a filmmaker of the same caliber and relevance as Sergei Eisenstein, Dziga Vertoz, John Grierson, and others who were at the time in Argentina labeled "social realists."[34] His early films centered on social issues and were made with few resources, a method and genre that became known during the 1940s as the "Soffici school" of filmmaking, occasionally referred to as "social-folkloric" cinema in critical texts. In 1941 Soffici was elected president of the newly founded Argentine film academy, the Academia de Artes y Ciencias Cinematográficas de la Argentina, and recognized for his influence on the industry by other filmmakers and key advocates from the arts sector. Soffici's work continued to enjoy critical and popular acclaim after Juan Perón began his first presidency.

During the late 1940s and early 1950s, as Peronism became increasingly authoritarian, cine social became an instrument of sociopolitical critique within cultural circles in Buenos Aires. In 1952 one of Soffici's students, Hugo del Carril, released *Las aguas bajan turbias* (*Rivers of Blood*, also known as *Dark River*). A historical fiction film based on agricultural workers in the yerba industry during the 1920s, it contains scenes of violence between workers, sexual abuse, exploitation, and even the murder of laborers who try to escape the brutal working conditions of the plantation. When the film was shown in France, critics called it an apology for Perón's regime, while in Argentina, Perón's undersecretary of culture accused it of being communist and thoroughly anti-Peronist.[35] Despite del Carril's political affiliation with Peronism, many political foes within the Peronist state denounced his work as threatening to the regime. Del Carril nevertheless followed the critical

success of *Las aguas bajan turbias* with *Barrio gris* (Gray barrio) in 1954. This film, based on a novel by Gómez Bas, is set in the outskirts of the city of Buenos Aires and deals with questions of poverty, alcoholism, prostitution, and other social ills in the gray wasteland of the city's suburbs. It blames a vaguely defined status quo for the plight of the urban poor, and many critics considered it to be a pamphlet for socialism.[36] The aristocracy of culture bestowed its graces on del Carril's film, awarding it prizes, such as that for "Best Film" from the private cinema club Gente de Cine and directors' awards from the prestigious Argentine Film Academy.[37] But del Carril was rapidly losing the good graces of the Perón administration.

Political filmmaking evolved rapidly to express more radical leftist ideologies after Perón was forced to flee the country in 1955. Perhaps the most outspoken and influential of directors producing cine social by the mid-1950s was Fernando Birri. Having studied at the Centro Sperimentale in Rome, like many Argentine filmmakers of the late 1960s and early 1970s, Birri was considered a vanguardist, introducing the style of Italian *neorrealismo* to Argentina.[38] His 1956 film *Tire dié* (*Toss Me a Dime*), made with the assistance of a number of his students, dealt with the situation of the marginalized inhabitants of the river banks alongside the railway in the province of Santa Fe. This film was perhaps one of the most important precursors of later developments in the intellectual recognition of filmmaking outside the industry and the academy, being one of the first films to become "required viewing" for the historically and socially informed by the 1960s. When it was first released, *Tire dié* was shown in universities, public institutions, centers of the CGT, and even jails and was hailed by film critics as "denunciaist" cinema, borrowing the term from the idea of the *denuncia*, the affidavit or statement given to the police after a crime is committed.[39] In 1958 Birri founded the Documentary School of Santa Fe under the auspices of the Universidad Nacional del Litoral to promote filmmakers pursuing nonfiction cinema outside the capital city of Buenos Aires.

Tire dié and Birri's next film, *Los inundados* (*Flooded Out*), released in 1962, established Birri's reputation and launched his international career as a maker of social documentaries. Young filmmakers of the 1960s considered these two films to be flagships of "cinema with a social conscience," which they studied and imitated as they began their own film projects. Birri, who was closely tied to the transnational community of filmmakers across the Americas, called for films to be directed primarily to peasant and working-class audiences. In fact, he was among the first directors to begin using the term "*nuevo cine*," articulating some of the primary tenets of this cinema

movement. He argued that nuevo cine should break with the primarily bour-geois audience of independent cinema prior to the 1960s and address plots and narratives to the working classes. The producers of these films designed them to be participatory and didactic, to exhibit both a critique and a redefini-tion of nationalism and politics from below, and to assist in the process of developing a radical political consciousness and collective identity among the masses.[40]

In his excellent article on the politics of the Argentine documentary film in the 1960s, Emilio Bernini offers a cultural-historical reading of the genre known as the "political avant-garde" during this period. Analyzing the gen-eral practices of filmmakers, such as Birri, who were involved in the politici-zation of filmmaking, he argues that these avant-gardists "broke away from the studios and abandoned a tradition that they deemed irredeemable, re-defining a moral responsibility toward the image and toward those they were addressing."[41] The almost artisanal work of the early directors of this period were an "expression of the situation," in the words of the director Simón Feldman, a filmic reality made in the image of shantytowns and workhouses, infused with the elements of journalistic narrative that positioned the realist and critical director as witness and bearer of testimony.

The notion of the ethical filmmaker, creating cinema by means of in-stinct and vocation, that emerged from this vanguard would provide an intel-lectual point of departure for the increasingly radical political filmmaking of the late 1960s and early 1970s. Building on cine social, both the vanguard of the 1960s cinema and the political documentary filmmakers who followed treated the camera as an active participant in documenting historical realities and social injustices. By denouncing the manufactured techniques and spe-cial effects of big studio cinema, filmmakers turned to the camera as a faithful means for registering and preserving the past. The films they produced sug-gested a symbolic construction of filmmakers as objective and critical re-producers of reality, given a presupposed legitimacy of the representational apparatus itself and of reality, one that had to be captured and mediated through the lens of the camera to be believed.

CINEMA OF HUNGER

On the eve of the Cordobazo, as nuevo cine began to take root in Argentina, leading filmmakers of the movement turned their attention more broadly toward an internationalist critique of power. Critics and practitioners alike

soon began to describe political filmmaking in Argentina as part of the "Tercer Cine" (Third Cinema) movement emerging simultaneously across Latin America, Africa, and Asia. Critics and vocal directors made connections between Tercer Cine as a critique of the high-budget but apolitical cinema of Hollywood and Europe, denouncing U.S. and European imperialism and its political encroachment via cultural exports throughout the cold war, and the local activities of Argentine filmmakers working in political cinema. Building on a transnational anticolonialism, nuevo cine as part of Third Cinema adopted the language of liberation campaigns in Algeria, Vietnam, and elsewhere to "decolonize minds and culture" and thus bring about radical social change.[42] Filmmakers used what they described as an aesthetic of hunger to create "imperfect cinema," an extremely low-budget mode of producing films that were designed to have the feel of a documentary, their images accurately conveying the conditions of poverty in which many Third World people lived.[43]

Filmmakers from Brazil, Cuba, Colombia, Argentina, Bolivia, and other parts of Latin America theorized about the need for a cinema that would be neither derived from the big studio production houses nor tied to the elitist vanguards of cinema as fine art, and this conversation led to new ways of thinking about making films.[44] Directors began experimenting with what they called guerrilla film, with making film as collectives, with producing anonymously, and with using highly experimental fiction film techniques. The modes of *nuevo cine latinoamericano* can be generally characterized by aesthetic experimentation in the service of anticolonialist, anticapitalist political ideals. At the New Latin American Cinema festival in Merida, Venezuela, in 1968, the continent-wide defining event of the movement, directors adhering to the principles of a broad social realist agenda gave speeches and penned manifestos regarding the work of cinema to bring "testimony, profound analysis, or agitation tools" to audiences.[45] Several Argentine directors played prominent roles in this move toward a new Latin American cinema and the Third Cinema movement, particularly Fernando Birri, Octavio Getino, and Fernando Solanas. These three would pen important manifestos that helped concretize the cinematic objectives of the transnational film movement and its political underpinnings. In Argentina, the earliest films of the movement were screened clandestinely through a network of trade unions and activist groups, for most would not have made it past the military's censors to commercial exhibition.[46] Despite the relative lack of domestic engagement with these films, their ties to the ambitions of nuevo cine latinoamericano and the roles that prominent Argentine directors played in this movement led many

contemporaries and later scholars to consider Argentina the crucible of the Third Cinema movement.

When Onganía's regime declared a wage freeze amid soaring inflation, suspended collective labor contracts, and promoted the privatization of banks and industry, filmmakers made short responsive "denuncialist" films, mini-documentaries and journalistic pieces attacking the social impact of Onganía's policies.[47] As a response, Onganía turned the problem of filmmakers over to the industry, creating official blacklists that studios were cautioned to respect. Shortly thereafter his secret police were charged with kidnapping filmmakers who were unresponsive to the regime's policies. As a result, a good number of leftists who were in the industry and producing political film at the time chose to leave the country. Some sought refuge within communities of other exiled or fugitive filmmakers in Madrid, Paris, Havana, and so on. Factions within the union and affiliated associations organized campaigns to raise public awareness about the fate of their comrades. Building on the momentum of social and intellectual support garnered by the nuevo cine movement, political cinema lived by way of its reputation. The signal film of Argentina's nuevo cine, the one that has received the most attention from film scholars, was a three-part film called *The Hour of the Furnaces* (*La hora de los hornos* [1968]), directed by Octavio Getino and Fernando Solanas with assistance from the Cuban experimental documentary filmmaker Santiago Alvarez. The film's progress enjoyed a tremendous following in underground political organizations, despite the fact that few were able to see any of the final footage until well over fifteen years after the film's completion. Filmmakers and their allies organized support to challenge the military regime and used their films much like an underground press to suggest political positions and to denounce injustice and repression.

The rise and spread of the "cine club" further marked filmmaking's entry into political activism. Starting as specialized theaters catering to a highly educated public interested in cinematic culture, by the mid-1960s private cinema clubs served as popular hangouts for artists, intellectuals, and their entourages. In Buenos Aires the most notable of these were Cine Club Núcleo, Enfoques, Gente de Cine, and the Pablo Ducrós Hicken Film Museum.[48] Several clubs had their own publications, such as *Tiempo de Cine*, printed by the Núcleo. These intellectualized spaces would begin to reflect the left-leaning politicized nature of film culture in which nuevo cine argentino participated. Film intellectualism, also on the rise in Europe and the United States,[49] resulted in the launching of new cinema periodicals that responded to the spirit of radicalism among readers and echoed the artistic aspirations of the rising

trend of Marxist ideas influencing activist cinema. Magazines such as *Cine '64* and *Cinema Nuovo* tackled issues including the working conditions of large studio productions, free expression, and Marxist cultural theory.

The filmmakers of the "Generation of the '60s" enjoyed a period of intense experimentation and creativity, facilitated by the move toward independence and auteurism, but this also resulted in an active dialogue with film critique, which was reflected in the political economy of film culture in print and in alternative film spaces. By the late 1960s, partially because of the introduction of formal film schools and the expansion of independent venues for film spectatorship, directors had access to a variety of film journalism that constantly made demands on independent filmmakers and reinforced positions on matters of vital interest regarding aesthetics, techniques, ideology, and film practice. The proliferation of film magazines such as *Cinedrama, Cine de Hoy, Cine '64, Panorama, Tiempo de Cine,* and *Cineclub Quilmes,* some published by universities and others by independent associations or clubs, reflected a budding critical erudition within independent cinema.[50] These magazines interpreted other cinemas for an Argentine audience, staking out territories of critical dialogue between national film and avantgardes of Paris, Rome, Havana, New York, and Mexico City. In opinion pieces and interviews, they also provided directors a way to add narrative flourish to their films and interpret the politics of their choices. These periodicals heralded the arrival of a truly vibrant intellectual life for political cinema culture in Argentina, replete with discursive and social spaces, where ideas about radical filmmaking could interact with conversations about film technique and calls to political participation.

Filmmakers of the nuevo cine movement found in this social life of film a venue to promote their perspectives on political cinema, the practice of their art, and transnational politics in general. In interviews, editorials, and commissioned pieces of writing, filmmakers championed ideas on the connection of film to national liberation, frequently framed as a "Third Worldism" that sought alliances with the anticolonialism campaigns of Africa and Asia, with the platform of agrarian reform and class struggle championed by Guevarism, and with the Non-Aligned Movement. Filmmakers publicly endorsed the Non-Aligned Movement, an independent organization of states created in 1955 opposed to any major power bloc, such as those associated with the United States or the Soviet Union, and spearheaded by the former Egyptian president Gamal Abdul Nasser, the Indian prime minister Jawaharlal Nehru, and the Yugoslav president Josip Broz Tito. The African decolonization process figured heavily into the political activism of this film movement,

both as an interpretive space in which U.S. imperialism in Latin America could be critiqued and as a transcendent "emancipation horizon" for which left-wing politics the world over could be harnessed.[51] To this end, filmmakers from Argentina participated in the 1973 meetings of the Non-Aligned Movement, held in Algiers, out of which blossomed the Third World Cinema Committee, part of an attempt by Algerian filmmakers to broaden the Pan-African Cinema movement.

The first meeting of the Third World Cinema Committee, held in Algiers in December 1973, invited African, Asian, and Latin American participants to set out a formal structure for the organization. Following the political mandate of the 1966 Tri-Continental Conference, a meeting organized by Castro in Havana to build a bridge between solidarity organizations in Africa and Asia and those of Latin America, this meeting was meant to include participants from all the regions of the Third World. Timing and the high cost of travel ruled out Asian participation, however, and the hastily planned event attracted only forty-five participants, who came from Egypt, Guinea-Bissau, Congo, Mali, Morocco, Mauritania, Senegal, Tunisia, Argentina, Brazil, Cuba, Bolivia, Chile, Colombia, Uruguay, and Palestine. Jorge Giannoni, Argentina's representative to the conference, participated in sketching out "coproduction" plans that would transfer funds from Asia and Latin America to Africa, making possible a transnational market that could effectively bypass European or U.S. funding and could break away from dependence on imperialists' technology. The committee issued a number of manifestos expressing solidarity with the oppressed and artistic confrontation with Western capitalism, statements denouncing Western cultural imperialism and advocating the salubrious nature of technical and ideological exchange between countries of the Third World. Many of these manifestos advocated nationalizing cinema production and distribution, a process that had already been undertaken in a number of newly independent former French colonies in Africa.

The Algiers meeting formally issued recommendations regarding the status of national cinemas that directly challenged the politics of cinema in Argentina. Recommending not only the nationalization and dispossession of foreign-owned commercial cinema companies, the committee's general assembly also counseled the promotion of transnational coproductions, which might effectively free national cinema from the bounds of national legislation. The assembly also denounced fascist coups, such as the one that had recently established Pinochet's military regime in Chile, and even denounced "authoritarian populism" in Argentina, calling for the freedom of imprisoned filmmakers. Finally, the committee endorsed the search for new forms and

models of creating anticapitalist cinema to "decolonize Third World screens."[52] This cinema would be dedicated to an aesthetic and political identity directly opposed to the imperialist Hollywood model.

Jorge Giannoni, Raymundo Gleyzer's close friend and the man who had initially traveled with Gleyzer to northeastern Brazil, returned from the meeting in Algiers and cofounded the "Manuel Ugarte" Third World Cinématèque in the archives of the University of Buenos Aires. This official vessel of the Third World Cinema movement in Argentina situated the struggle of filmmakers against the forces of imperialism within a frame of solidarity with the universal underclass's revolutionary impulses. It held regular film series, presenting films from the Third World to the largely university audience, and eventually invited the Third World Cinema Committee to have a second meeting under its auspices in Buenos Aires in 1974. By this point, however, the only countries with the means to send delegates were those in Latin America, Libya, and Palestine. Giannoni's work is representative of the sentiments of this movement; his film *Palestina, otro Vietnam* (Palestine, another Vietnam [1971]) illustrates the anticolonialist rallying point around which veiled critiques of national political disfranchisement and the heavy hand of authoritarianism could be made.

This is the best documented period of Argentine filmmaking history, in part because luminaries of the nuevo cine movement wrote extensively about their work and their politics as a function of their radical project. In addition, internationalist film periodicals, such as *Cine Cubano,* the Latin American answer to the French *Cahiers du Cinéma,* recorded important events and critical reflections on the progress of the movement. The two best documented collectives of nuevo cine argentino filmmakers of the late 1960s and early 1970s were Gleyzer's Cine de la Base and Solanas and Getino's Cine Liberación. Cine de la Base embodied the turn toward radical militancy among filmmakers in the early 1970s. Gleyzer himself participated in actions by the Revolutionary Workers Party, a Marxist-Leninist revolutionary strand of Peronism that actively pursued armed struggle.[53] Gleyzer was primarily recognized for his work on documentary films but advocated what the collective itself termed "radical cinema," or filmmaking used directly in the service of militant action as a weapon of propaganda. His Argentine documentaries were received by like-minded groups of leftists as testaments to their political and social causes. For instance, his 1974 film *Me matan si no trabajo, y si trabajo me matan* (They kill me if I don't work, and if I work they kill me [1974]) deals with the corrupting influence of capital interests on union leaders and the attendant exploitation of workers and echoes the

earlier film politics of the Soffici school and the aesthetics of Fernando Birri's *Tire dié*.

Gleyzer's radical documentary films espoused a militancy that openly threatened powerful sectors of Argentine society, including more conservative factions of Peronism. Cine de la Base's 1971 short film *Swift* documented the kidnappings of an industrialist and a diplomat by an anonymous revolutionary army of the people. It used many images and propaganda pieces of the Revolutionary Workers Party in its montages. The kidnapped industrialist headed a meat refrigeration plant and represented an influential segment of the conservative elite, those tied to the powerful cattle ranching sector. Another film made by Cine de la Base, completed in 1972, recounts the imprisonment and escape of militants from a prison in the Patagonian city of Trelew. This film, *Ni olvido ni perdón: 1972, la masacre de Trelew* (Neither forgetting nor forgiveness: 1972, the Trelew Massacre [1972]), like its predecessors, was circulated and screened only clandestinely. Even after Perón's return to Argentina, the group, along with the Revolutionary Workers Party, maintained a distrust of Peronism and a deep suspicion of its multisectoral pacts.[54]

Cine Liberación evolved directly out of the leftist labor politics set in practice by vocal exponents of industry interests but had strong ties to militant Peronism. It was led by Octavio Getino and Fernando "Pino" Solanas, two experienced directors active in the film workers union who both had ties to the Peronist resistance and supported Perón following the coup that deposed him. The work of the Cine Liberación collective became a cultural, ideological, and aesthetic model for a generation, as well as an emblem of radical cinema. The group's political rhetoric drew on the theories of postcolonialism and on the anti-imperialism of the Non-Aligned Movement, but Cine Liberación also spoke to the labor movement and articulated concerns about labor conditions for filmmakers. The group issued manifestos regarding the role of politics in filmmaking. It combined demands for improved working conditions with a call for an end to state censorship, reclassification of prohibited films, and increased autonomy for the film industry.[55]

Octavio Getino and Fernando Solanas produced the epic three-part film *Hour of the Furnaces*, deriving the title from Che Guevara's last public speech. This symbolic reference to pan-Americanist solidarity, particularly the clear reference to anti–Vietnam War activism, underlined the film's relationship to internationalist cultural politics. The three parts, entitled *Neocolonialism and Violence, Act for Liberation*, and *Violence and Liberation*, were designed to foment public debate. The style of the film was similar to that of black-and-white publicity or propaganda films. Several images, particularly those

shot in the meatpacking industry showing workers slitting the throats of cattle, were intended to shock audiences, much as Sergei Eisenstein's *Battleship Potemkin* had aimed to do. Filmed clandestinely and exhibited only in the underground circuit in Argentina, the film was prohibited by various regimes from being exhibited commercially because of its argument for armed resistance.[56] This film would be the bellwether of the first generation of transition films.

Hour of the Furnaces and the group's next film, *Perón: actualización política y doctrinaria para la toma del poder* (Perón: political and doctrinal actualization for the assumption of power), became key propaganda tools for several Peronist militant groups.[57] Cine Liberación advocated an outspoken activist approach to continuing the unionist politics of Perón, even under repression by the military and its big business supporters. As early as 1963, Getino and Solanas maintained close contact with Perón, then living in Spain, a connection that grew stronger as the military regime increased its repression of Peronism and the labor movement. They did this by conducting short interviews with Perón in Madrid and undertaking a correspondence that the group made public in Buenos Aires. In one of the letters, written on March 10, 1971, Perón openly expressed his support of "a third position" for Latin American cinema, generously endorsing the language and ideology of Getino and Solanas's film activism.[58] Cine Liberación's films articulated the political ideology of Peronism for a postcoup generation. The group made films that privileged Peronist interpretations of historical events, such as *Argentina, mayo de 1969: los caminos de la liberación* (Argentina, May 1969: the paths of liberation [1969]), a "clandestine" project that combined ten unsigned short films on the subject of the Cordobazo emphasizing the heroics of Peronist unionists in the uprising.[59] The group also published its own periodical, *Cine y Liberación,* and a 200-page book about the experience of making political cinema in the struggle for liberation.[60]

HISTORICAL SPECTACLE IN TRANSLATION

The historical narrative about their collective identity that vanguard political and Third Cinema filmmakers presented in the late 1960s and early 1970s can partially be understood by examining their symbolic appropriation of the struggle of the political left, the labor movement, and the Cordobazo as an iconic force field. Although filmmakers had no interest in presenting iden-

tical narratives, or in presenting the same ideological treatment of a given subject, they did invoke a consistent mode in assembling data and representing the past to the present. Despite the heterogeneity of meanings that filmmakers attributed to the events of the late 1960s and early 1970s, the preeminence of the historical narrative *form* of representing events was clear. In particular, they chose to enlist a set of symbol objects in their narration of the recent past, repeating and concomitantly indexing a specific interpretation of the ideological politics of the left in that period.

Perhaps the most profound of these symbol objects was the idea of the people, as a class-based identity, understood as a collectivity of the exploited. Film projects such as *Argentina 1969* and *Ya es tiempo de violencia* (Now is the time for violence [1969]) presented militancy as the last recourse of the people, the worker as hero, and class solidarity, especially the student-labor alliance of Cordobazo, as the only mechanism by which the political collectivity of the marginalized could seek justice. These films foregrounded the populist nationalism that had inspired radical and working-class politics as early as the 1940s and the Peronist resistance in the 1950s and presented it as having given way to a general sense of disillusionment by the late 1960s; as a result, the films advocated that the working-class solidarities of the past find a new expression. Instead of espousing a nationalism confined by a disappointing state apparatus, they called for a new postnational form of radicalism, embracing ideas of liberation from postcolonial Africa and Asia, a utopia of a collective identification carved from common resistance to oppression.

When popular mobilization picked up speed toward the end of the 1960s, filmmakers were among the first to use their medium to participate in the struggle. In 1969 Enrique Juárez anonymously produced *Ya es tiempo de violencia,* which used images from televised sources to construct a narrative of the events that took place in Córdoba, with a focus on the June 30 assassination of the steelworkers union leader Augusto Vandor. A contentious figure within the labor movement, Vandor had been vocally opposed to Peronist factions of the movement and had taken a more conciliatory stance toward the Onganía government. The film was composed primarily of images recorded directly from televised news broadcasts, using voice-over to narrate and give meaning to the events on the screen.[61] Vandor represented an argument, via inversion, for the solidarity that had the potential to bridge the intellectual gap between party loyalties and a general identification with class. This vision of factionalism as oddity or as complicit with the state spoke directly to a labor movement riven by political fragmentation.

Under the sign of the Cordobazo, filmmakers of this generation in Argentina also employed the *mode* of history as spectacle, using the historical moment of the late 1960s and early 1970s, and its energetic embrace of media as politics, as a means of connecting to other leftist intellectual and creative production in Argentina and abroad. Filmmakers used stills and footage from Gillo Pontecorvo's film *La battaglia di Algeri* (*The Battle of Algiers* [1966]), inspired by the memoirs of a commander in the Algerian liberation movement against the French, which began in 1954 and concluded with independence in 1960, making Algeria the first African country to liberate itself from a major Western imperial power. Associating the political meanings of resistance across the Third World, Argentine filmmakers marked symbolic valences between the struggles of the left in Argentina and independence struggles of the colonized, equating liberation struggles abroad to the labor movement at home. As Eric Hobsbawm did in his collection of photographs *1968: Magnum throughout the World,* which assembles images of the Prague Spring in Czechoslovakia, American bombings in Vietnam, and the assassination of Martin Luther King Jr. and argues for their interconnectedness, filmmakers created a montage of iconic images, both still and moving, that connected Argentina's left to the plight of the Third World and to the spirit of the radical 1960s around the world. Likewise, the manner in which the military under Onganía viewed leftist cultural production mirrored Charles de Gaulle's description of a war against "internal subversives."

Stuart Hall writes that commonly held cultural beliefs and representations hold together communities via a production of collective distinctiveness.[62] Close observation, however, of the everyday habits of the Argentine left in the late 1960s reveals that individual participants identifed themselves and operated within cultural structures that were constantly shifting, transforming, and multiplying. During the late 1960s and early 1970s, as the Argentine left was forced to adapt to a changing and increasingly hostile social and political landscape under the military regime, it became all the more imperative that these collective identities be constructed according to more universal and pluralist visions of struggle. This notion put a premium on the representation of historical experience as a fountain from which to draw historical understandings of the present, particularly for leftists trying to reconcile shifting positions. Filmmakers of a variety of political identifications relied on a flourishing political culture of cinema to constitute alliances outside traditional film circles, outside Argentina, and within other politicized spaces. Political filmmaking of this period also constructed as a symbol object an image of the state's antisubversive campaign as class war. This con-

struction does not neatly map onto the constellation of issues that concerned the left of the day; rather, it avoided critical ideological distinctions between factions that threatened to divide the left. The filmic interpretation of state violence as symbol object also fit well into a compelling narrative of class war, collapsing the complexity of the military's economic and social policy and military repression into a more manageable operating concept.

State political violence, the symbolic other on which visions of resistance and collective action could be premised, eventually also created the conditions for the radicalization of the practice of film viewership. By the early 1970s the spectacle of violence had become a common occurrence, an everyday affair, and though it was seldom carried out in public, it did not go unwitnessed. Political violence certainly did not necessitate a clandestine theater in which to make itself known, but the act of making political films and exhibiting them in illegal venues, particularly when the audience bore the mark of political subversion, made filmmakers a target for state repression. As a result, making and viewing movies became expressions, in and of themselves, of active resistance. To understand how this moment in film culture eventually gave way to a much more subversive and underground militant one in the early 1970s, the next chapter follows Cine de la Base and Cine Liberación more closely in the years following the Cordobazo, teasing out peculiarities of the increasingly hostile relationship between the state and the left that shaped the direction of the radical filmmaking community.

2

FILMMAKERS INTO
FILM WORKERS

Peronism, Dictatorship, and
the Film Industry

GUERRILLA ACTIVITIES, factory takeovers, strikes, and acts of civil dis-
obedience, on the rise since the Cordobazo, expanded to include high-profile
kidnappings, political assassinations, bombings, intelligence breaches, thefts,
and money laundering in the early 1970s. The militant cause had swept thou-
sands of Argentines into armed political action, and the level of ideological
conflict on the left reached an absolute peak. Revolutionary groups were held
responsible for the deaths of nearly 700 entrepreneurs, unionists, police offi-
cers, and other "allies of the state."[1] Onganía's regime was followed by three
subsequent military governments that pushed many leftist artists and intellec-
tuals further in their sympathies toward political radicalization. Raymundo
Gleyzer set off his own bomb in 1972, an incendiary film called *Los traidores*
(The traitors), described by Cine de la Base as a "detonator" film. The film was
meant to be an insurgent act, announcing the immediacy of the militant cause
and striking a serious blow to the military regime. The flip of a light projector
switch, the group hoped, would ignite a spark that would soon set political
filmmaking "volando para el cielo," flying toward the heavens. This move
toward film activism could easily have been either folded back into the shad-
ows of the time's largely underground political film scene or disappeared from
collective memory, like many other moments of protest purposely obscured

by the military, had its experience not been captured and preserved within radicalizing sectors of the film industry and a vibrant political economy of leftist film culture.

In the 1970s many filmmakers working on the outskirts of the national film industry began to confront the authoritarian rule of successive military regimes with a growing awareness of the necessity to respond. Although most directors were far from revolutionary in their modes of production or style of filmmaking, many began to espouse more radical ideas as individuals and to ask the industry community to redraft operating principles and make alliances that reflected their shift in thinking. Political filmmakers worked together to document and expose the nuances of the state's repressive measures and began to reinvigorate industry-related associations as spaces of exchange and mobilization. To mainstream filmmakers, it was significant that underground film work, such as Gleyzer's "assault" film, was undertaken within their ranks, even if they were not directly involved in such work themselves. Gleyzer and other filmmakers doing guerrilla cinema were "marked men," blacklisted filmmakers whose lives were openly threatened by paramilitary organizations operating on behalf of the state. As such, they represented the vulnerability of the community as a whole and to an extent were idealized as the "covert operations" of their newly established set of oppositional political identities.[2] With a number of political filmmakers reporting death threats, fleeing the country, or simply vanishing, it became clear that the freedom of all members of the filmmaking community was in danger.

Films such as *Los traidores* provided the military the justification it needed to launch an assault on film as a form of subversive propaganda. Alongside the state, paramilitary organizations, such as the Alianza Anticomunista Argentina (Argentine Anticommunist Alliance, or Triple A), conducted counterrevolutionary operations that included threatening, detaining, and kidnapping suspected "terrorist" filmmakers.[3] Human rights commissions accused the military of being responsible for the disappearances of between 15,000 and 24,000 left-wing activists, university and high-school students, intellectuals, Catholics, members of ethnic minorities, unionists, artists, teachers, journalists, and others between 1970 and 1977, despite an interlude of civilian rule from 1973 to 1976. Many of these victims were taken from their homes in the middle of the night by secret police and brought to detention centers, where they most often suffered torture, sexual abuse, starvation, and even death.[4] Although the Argentine police and military had used torture to extort information since at least the 1930s, this was by far the most extensive and systematic use of state violence in the nation's history.[5] At least 340 known detention

centers used by the military have been discovered across the Argentine republic, with the highest density in the greater Buenos Aires area. The majority of the disappearances were carried out between 1974 and 1979, tailing off eventually in the early 1980s. Numerous atrocities were committed in several of these centers; for example, babies born to interned women were forcefully taken away from their mothers and given to the families of guards, interrogators, military officers, and outside collaborators, creating a generation of children separated from their biological families, most without any knowledge of their birth parents' fates.[6]

PERONISM AND THE COLD WAR

Gleyzer's film *Los traidores,* the only work of partial fiction that the director would produce, centers on the true story of a corrupt syndicalist who staged his own kidnapping to manipulate union politics. Using a common technique of analytical filmmaking, the narrative collapses a series of leftist struggles into the central storyline, layering meanings of a variety of salient political events into the representation of the case at hand. The film incorporates news footage of the Cordobazo, the Peronist labor movement, the 62 Organizations, and the group of Montonero militants who in 1970 kidnapped, "tried," and assassinated the retired general Pedro Eugenio Aramburu, an important figure behind the 1955 coup against Perón. The film combines documentary elements of eyewitness testimony, interviews, and newsreel clips with a stylized chronicling of the events surrounding the corrupt unionist's undoing. Rather than document state violence or socioeconomic injustice, *Los traidores* explored fissures within the left and projected a call to radicalism that some viewers in the clandestine spaces where the film circulated read as a how-to guide.[7] It was an overt critique of the corruption of the state and of the labor movement, but it also gave audiovisual presence to otherwise invisible political acts that happened off the national news media grid, specifically the state's practice of politically motivated kidnapping, torture, and clandestine detention.

During the late 1960s and early 1970s, a pandemic of military coups broke out across South America; as a result, few public institutions remained untouched by the politics of state violence. Inserting themselves with full force into a variety of offices of public life, military leaders tended to formalize what Guillermo O'Donnell has identified as "bureaucratic authoritarianism." O'Donnell describes this phenomenon as arising from the political manipu-

lations of a power elite whose privilege stems from their relationship to transnational commerce. The power elite turns to the military to protect their interests against pressure from the popular sector.[8] Military regimes tend to curtail popular dissent by foreclosing avenues to democratic expression. This model describes the military regime of 1966, which brought Onganía and his successors to power, and later the military coup of 1976, but it can also be seen in dramatic flashes during the democratic opening running from 1973 to 1976.[9] This form of government became a continent-wide trend partly because of the specific transnational economic interests at stake and the way in which the power elite, which transcended national borders, found the means to fix local political games.

After Fidel Castro's regime pushed many foreign investors out of Cuba, industrialists across the Americas increasingly reacted to any left-wing political movement in Latin America with suspicion and hostility. The United States launched programs such as John F. Kennedy's Alliance for Progress, which pledged $20 billion to support public policy initiatives in noncommunist countries, and began to pursue transregional cooperation of military services. Various U.S. administrations supported the fighting of what eventually were termed "dirty" wars against the encroachment of Soviet imperialism and organic strands of communism. In targeting subversives as potential allies of the Soviet Union, the United States gave Latin American military regimes a powerful idiom through which to legitimize their claims to power.[10]

In Argentina the cold war contest for power revolved around the military as a purveyor of conservative interests and its efforts to rein in the political volition of the working class. As the cold war started brewing, the military monopoly on state power extended itself to almost every Argentine political institution, and of these, the ministries of labor and commerce were among the most coveted. Even Juan Perón, a general in the armed forces, began his political career in 1943 as secretary of labor within a military regime. In that position, Perón gained the confidence of several labor and union leaders while he pursued his official mandate to foreclose the spread of extreme leftist currents within organized labor.[11] Although decades would pass before the military attained the level of sophistication and complexity required to sustain its 1976–1983 stranglehold on power, some of the most important elements of institutionalized military rule would begin to emerge during this early period in which Perón was directly involved. By the 1966 coup, and increasingly on the eve of the 1976 coup, the military had begun to act as if for all practical purposes it were a political party, and the various branches of the military, each with its own set of divisions and factions, struggled over control within their

discrete spheres of influence.[12] Part of the military's regular strategy involved the suspension of political activities to reorient parties away from sectorial interests, such as labor, and toward "national interests," meaning the interests of industrial capital.[13]

To make matters more complicated, Peronism under Perón in his first presidency began to compete directly with the military as guarantor of national interests, building strength by appealing to the working classes and organized labor. This contest for power between the military and Peronism was quite entrenched by the 1970s. Perón had risen to the office of presidency in popular elections as a charismatic leader whose ability to consolidate popular sectors had shifted the balance of power away from the conservative elite parties that had ruled Argentina since its independence. Perón successfully constructed a broad, multiclass alliance that elected him to the presidential office from 1946 to 1952 and again from 1952 to 1955. Broadcasting slogans such as "neither Nazis nor Fascists, *Peronists*" and "neither Yankees nor Marxists, *Peronists,*" Perón configured an inclusive constituency and an "open field of identification and affiliation" that marked outside agitators and neocolonialist powers as the symbolic Other to the Argentine people.[14] The Peronist movement would eventually pit the working classes against the military, pointing to its alliances to a capitalist class in league with foreign interests.

The military that had ousted Perón in 1955 sought to contain the Peronist resistance after the deposed leader had fled the country. This government, which lasted from 1966 to 1973, not only confronted strands of the Peronist resistance that remained active but also saw militant Peronism creating new alliances with non-Peronist radicalism. In 1955 the military was already attempting to "de-Peronize" the masses by dismantling union leadership; denouncing Perón's excesses and corruption; and even, at one point, making it illegal to mention the name of either General Perón or his deceased wife and former first lady, Eva Duarte Perón, known popularly as Evita.[15] The military junta that brought General Onganía and subsequent generals to power had the effect of pushing Peronists and anti-Peronists of various stripes out of their hostile camps and into a temporary alliance against the military. A handful of leftist groups, some tracing their origins to the mid-1950s and others newly formed, touted images of Evita and Perón as a mode of symbolic resistance, while others revisited Peronist thought in search of its applications to a more authentic form of class struggle. During outbreaks of strikes and demonstrations, popular chants evoked the symbolic image and leadership of Perón. A Peronist youth organization began actively recruiting and conducting political and social activism in the name of Perón's legacy,

and elements of the labor movement and its political representation maintained contacts with Perón while he lived abroad, following his guidance via correspondence.[16]

As the military regime progressed, divisions internal to it multiplied. General Roberto Levingston usurped power from Onganía and ruled from 1970 to 1971, and he was replaced in another intramilitary coup during which Alejandro Lanusse came to power, ostensibly to bring about a return to constitutional rule. Lanusse's de facto presidency, lasting from 1971 to 1973, entailed a general softening toward Peronism. Lanusse even went so far as to invite Perón to return to Argentina, encouraging many Peronists to come out of hiding.[17] During the cold war, however, the military's de-Peronization agenda took on heightened significance. Professional military training had expanded to include education in economics and social affairs, and Peronism was reread as a form of nationalist populism hostile to democracy and capitalism. Officers participated in transregional and academic programs, many sponsored by the United States, such as the School of the Americas, now called the Western Hemisphere Institute for Security Coordination, which between 1946 and 1984 operated in Fort Amador, Panama. At the School of the Americas, veterans of wars in Algeria, Cuba, and Vietnam taught courses in counterinsurgency, their principles based on the notion that military might is the only social force sufficient to prevent social dissolution and defeat the unconventional "enemy from within." Under the banner of the cold war, the nations of Latin America were encouraged to embrace what the United States termed the "doctrine of national security," which endorsed the criminalization of political parties that reject the ideological precepts of capitalist "freedom and democracy." Even after the military allowed for civilian elections again, in March 1973, the apparatus of the state was firmly entrenched in cold war politics and rhetoric, and Peronists were not allowed to compete in the elections.

THE EZEIZA MASSACRE AND ISABEL PERÓN

Like his political allies, Perón himself was banned from participating in the elections of 1973, although his influence from abroad was still apparent. During the elections, various political groups made multiple and competing claims to represent the true legacy of Peronism. A movement calling itself the Justicialist Nationalist Movement campaigned in favor of economic nationalism and social justice, courting a strong constituency of Perón's supporters,

and managed to sweep the elections. The election of the Justicialist candidate Héctor José Campora, popularly considered to have been Perón's local representative while the former president lived in Spain, resulted in a brief term in office, beginning on May 25, 1973. Campora immediately moved to decriminalize Peronism, making way for the Justicialist Nationalist Movement to transform itself into the Justicialist Party, and granted amnesty to political prisoners, including Perón himself.

On June 20, 1973, Perón returned to Argentina. Throngs of his supporters waited to receive him at Ezeiza International Airport. Tensions among militant and conservative Peronist factions were high, particularly among groups that had evolved from the Peronist Resistance, which had developed several armed splinter groups including the Peronist Armed Forces, Peronismo de Base, and the Montoneros guerilla organization. Feverish divides within those assembled led to an outbreak of violence, exacerbated by paramilitary snipers who left over a dozen people dead.[18] Whereas events in 1968–1969 produced a wave of sympathy between the labor sector and leftists of various stripes, Perón's return and what later became known as the Ezeiza Massacre signaled a divisive crossroads for labor, the new left, and militancy. Shortly afterward, on July 12, Campora resigned from office, facing a wave of factory takeovers, rising militancy, and mounting social conflict. Campora's resignation made way for Perón to participate in a popular election in September of that same year, days after the fall of Salvador Allende's socialist government in Chile. The timing of this succession has been read as evidence of the political relationship between Campora and Perón.[19] In this election, Perón was elected with 60 percent of the vote; his third wife, María Estela Martínez de Perón, known more commonly as Isabel Perón, stood as his vice president.

Juan Perón's return to office was brief, as this presidency was cut short by his untimely death, but also disappointing to many, for the returning leader was quick to disown as "mercenaries" the militant groups that claimed him as their ideological and political leader.[20] On his demise, Isabel Perón assumed the presidential office, and her husband's skepticism about the radicalizing left was transformed into deep fear and intolerance after Isabel solemnized her duties as executive. Adding further insult to those who had hoped for a return to democratic politics, the new administration was overshadowed by the constant vigilance and intervention of an anxious leadership in the ranks of the military. In the fall of 1974, José López Rega, Isabel Perón's close confidant and minister of social welfare, convinced Perón to declare a state

of siege under which over 3,000 individuals suspected of involvement in subversive activities were placed in "preventive detention." López Rega was later revealed to have been one of the founders of the paramilitary terror organization the Argentine Anticommunist Alliance.

The regime targeted left-wing activists, outspoken students, and trade unionists, accusing them of disloyalty tantamount to treason. On September 30, 1974, the administration passed into law Security Act 20.840, which imposed severe prison terms on persons found guilty of subversion or other "antisocial" acts, defined as any action that might upset the peace of the nation. This measure allowed the police to arrest even nonviolent demonstrators. General strikes in June and July 1975, a moment of brief optimism among syndicalists and a handful of parties of the traditional communist left, were quickly suppressed by Isabel Perón's government.[21] Although a high percentage of more extreme revolutionary acts were carried out by a handful of especially militant groups, such as the Montoneros and the Revolutionary Army of the People, which Gleyzer eventually would join, all oppositional political organizations were targeted by the state as potentially suspect. Human rights watch organizations estimated that in 1975–1976 almost fifteen disappearances and political murders per day were carried out in complicity with or in resistance to Isabel Perón's regime.

In March 1976 the office of the presidency issued Executive Decree 21.264, which allowed any breach of peace to be considered a major criminal offence, with a penalty of up to eight years' imprisonment. The decree also authorized the police to use firearms against suspected offenders and declared any attack on public transportation, commerce, or services to be punishable by imprisonment or death. The criminal age of responsibility was lowered to sixteen years, and the scope of activities that carried the death penalty was extended to include acts of civil disobedience. In April 1976 the government issued a law that made it illegal for the media to report on subversive activity, and that June a total of forty-eight political organizations were declared illegal. On June 19 a high-school student, Ana María González, placed a bomb underneath the bed of the chief of the Federal Police, General Cesáreo Cardozo, whose daughter had been González's school friend, raising the conflict to new levels of social and political anxiety.[22]

The tenor of crisis struck the military as an exact fit to the situation for which the national security doctrine was designed. During the generals' coup, headed by Jorge Rafael Videla, Emilio Massera, and Orlando Agosti, when officers marched into the presidential offices to arrest Isabel Perón on charges

of corruption, the military leaders seemed to be following a cold war template. The Brazilian military had undertaken a similar application and formalization of the security doctrine in the form of a coup in 1964, as had the Chilean and Uruguayan governments in 1973. After assuming power, the Argentine armed forces almost immediately dissolved the two cameras of national government and the Supreme Court and shortly afterward suspended political activity and civil liberties. Despite the dramatic nature of these events, national politics had already been overshadowed by bureaucratic authoritarianism for a decade, and both labor and industrialist sectors were already polarized as increasing economic instability threatened to plunge the national economy into a crisis. By the time the military took power, Argentina faced spiraling consumer prices and flat industrial growth, and the public extended a degree of good faith to the military's promise to end hyperinflation. The generals also vowed to eliminate the corruption of the previous government and to end the torrent of political violence terrorizing the nation. As the first appointed president of the military government, General Jorge Rafael Videla pledged himself to the task of restoring economic prosperity, social order, and respect for human rights in his inaugural speech.[23]

Only three months after the coup, Amnesty International, an international human rights watchdog organization, received letters claiming that the number of politically motivated murders, arrests, disappearances, and allegations of torture and death in custody had doubled since the generals had assumed power. The organization quickly set up an investigative delegation, sending it to Argentina to gather information and interview informants, detainees, and families of the missing. Once they had arrived, the delegation reported that plainclothes police officers driving unmarked Ford Falcons were following them everywhere they went, intimidating potential informants and recording their movements. They claimed that several of their informants had subsequently been taken into custody for weeks at a time and that the police had not informed families of their whereabouts while they were detained.[24] Thus began what the military called the "Process of National Reorganization," or *el proceso*, a period of repression that would result in an estimated 30,000 disappearances and deaths over the following years. The military concentrated the legislative powers of government, in all its capacities, into the executive authority and named military personnel to all formal offices of government. As the international community was becoming aware, the military government institutionalized the elimination of political opposition through systematic violence.

PERONISM AND THE FILM INDUSTRY:
FILMMAKERS INTO FILM WORKERS

One of the "subversive groups" that the military dictatorship targeted with striking intensity was the film community. Although the *golpe de estado* of 1976 had brought most radical film activities to an almost immediate end, filmmakers were still considered serious threats to the state, not simply because of the opposition to which they gave voice, but also because of the industry's evolving political identity. Although filmmakers had begun to take part in a variety of leftist politics, the military associated the film industry with revolutionary dissident politics partly based on the long-standing relationship between Peronism and national cinema. During the 1970s the film community had begun to reshape its image to reflect new currents of political identification within its ranks, and part of this move involved revisiting the political history of the national film union and of political filmmaking itself. Two of the most striking narratives of this historical revisioning trend were celebrations of past moments of political activism from within the labor union and critical examinations of the industry's ties to Peronism. As president, Juan Perón had influenced the shape of film media, his cultural policy and economic nationalism molding film production in profound ways. Under his rule, national cinema and the film industry took on new functions for the state, which translated into new opportunities for filmmakers, and despite the complicated nature of the relationship between the state and Perón's administration, this legacy was by the mid-1970s an important connection for nuevo cine filmmakers, some of the more prominent of whom would become identified with the Peronist arm of the labor movement or allies of its cause.

Early on, then, the Perón administration gave birth to a complicated relationship among the state, the industry, leftism, and labor. On one hand, Perón's administration marks the beginnings of censorship, the ratings system, and centralized state control over film activity. During this same period, however, the industry began to rely increasingly on state subsidization and eventually the state's political support of its labor force. Perón oversaw the creation and organization of a film workers union that served as an important fixture of the film community's activism. The activity of this union and its relationship to the state under different authoritarian regimes after 1955 was used during the 1970s to construct an internal discourse about the function of film in politics. The symbolic relationship that developed in the mid-1970s

between the film community, on the one side, and the heroics of Peronist resistance and the labor movement, on the other, was then employed to articulate a role for filmmaking in a broader field of oppositional politics that was colored by the military-industrial forces' cold war contest with labor and Peronism. The situation produced a dialogue between repression and resistance that eventually proved helpful when the left sought to use film in building a representational apparatus—one that would later be invoked by subsequent generations of political filmmakers.

Between 1946 and 1955, Juan Perón's government targeted the film industry as a vehicle to diffuse ideology and conduct political campaigns. From the start, Perón's government recognized the need to protect the industry in order to use its informative capacity to publicize political objectives. To head the Ministry of Propaganda, Perón chose Raúl Alejandro Apold, whose background as a former film producer served the administration and its relationship to the industry well. With Apold installed, Perón commissioned a number of films to publicize new norms and statutes and to boast of state accomplishments, sometimes even before they were achieved.[25] But Perón's economic interest in the industry did not come without a cost. The administration decided to dispossess studio houses that did not comply with the regime's political agenda, shutting out and blacklisting filmmakers who struck a dissenting chord against the regime. Occasionally the state patronized the production of dispossessed studios' pending films, sometimes overhauling production entirely, turning the Peronist state into an occasional producer of orphaned films. Most often, however, it simply shut down studios, giving the remaining compliant commercial studios a larger market share. Under Perón, the Argentine Industrial Bank was designated as the main guarantor and lender for production, centralizing the business of state subsidy of cinema. This intervention cemented the state's role in overseeing national film production and secured the financial means for the Peronist state to become a major sponsor of the majority of national film production activities.[26]

Perón's cultural politics were often extremely authoritarian, particularly in the film sector. Making Raúl Alejandro Apold also his undersecretary of culture, Perón gave him a far-reaching mandate to intervene in media industries. Perón used public outcry directed against former cultural ministers to allow Apold to introduce sweeping reforms of film regulation. During this phase of Perón's first presidency, the policy of state film censorship was inaugurated. Ostensibly motivated by political concerns, in a handful of cases the censorship came in response to humiliations suffered by the first lady, Eva Duarte, during her brief acting career.[27] The state often justified blacklisting,

censorship, and studio closings as means to settle worker-patron disputes that threatened the health of national film production, a strategic industry. During Perón's first presidency, twelve studios were closed, in several cases with the state citing unresolved or outstanding claims that the studio had abused its workers.[28] In this way, these two obvious forms of repression were married to the industrial protectionism and labor politics of Perón's administration.

Perón's cultural policy became a secondary concern, however, as filmmaking revenues began to spiral downward in the mid- to late 1940s. A slump in the film economy shifted film entrepreneurs' criticism away from censorship and toward a call for increased state sponsorship. Before his appointment by Perón, Apold had been the head of publicity at the major studio Argentina Sono Film. During that time, he had his hand in a number of film projects and served in many industry-related offices. His knowledge of the internal workings of the industry gave him insight into restructuring the film market, and in February 1948, when Apold was named the director of spectacles, he instituted a tax on ticket sales at the rate of 10 percent of each ticket sold, with the funds raised thereby going to a development fund for national cinema. At the same time, Apold also initiated the obligatory exhibition of national films in the cinema houses of the many barrios across greater Buenos Aires.[29] These measures were received by a struggling industry as lifelines, and many saw the new policies as heralding a shift in Perón's position on film, from unyielding regulator to munificent sponsor.

Despite increased protection, filmmakers continued to see their profits decline. As a response, Apold began to assert that the industrial losses were a result of poor production quality, evening out his loyalties while justifying increased state intervention. In 1951, in an interview with the magazine *El Hogar*, Apold declared: "It seemed that official production stimulated a rise only in the number of films but not in quality. . . . The financial losses [our producers] have suffered or that some companies are suffering are due to poor organization, extravagant administrative budgets, bad publicity of films, and poor quality of the same. . . . Exterior markets are conquered and maintained on the basis of competition, in the quality of films, in commercial spirit, and in propaganda, and our producers have lately left all of these factors unattended."[30] Far from addressing the impact of authoritarian cultural policy on national cinema, Apold used declining production and profits to justify an extensive project of rationalization of the film market.

Under Apold's direction, state-run enterprises managed the industry through a surfeit of new decrees and layers of bureaucracy. Alongside ever more burdensome production costs and scarcities of raw materials during

and after World War II, these policies led to the eventual dismantling of the economies of scale that had previously bolstered film revenues.[31] As a consequence, many of even the biggest studios were falling into bankruptcy by the early 1950s, the victims including industrial powerhouse studios such as Lumiton, Emelco, San Miguel, EFA, Mapol, and Interamericana.[32] Simply allowing some companies to fall by the wayside increased both the industry's centralization and the state's ability to control production. With this control in place, Perón's government increased support for the industry through a swell of official productions.

The official documentary film and the *noticiario,* or newsreel, became two of the main state-sponsored cinematic undertakings under Apold in his role as Perón's minister of propaganda. During Perón's tenure in office, Apold encouraged the production of official documentaries and newsreels through various units under his charge. These films highlighted Perón's ambitious social policies and were meant to project a positive image of Peronism during domestic campaigns and while courting support from abroad. One such film, for example, depicts Perón's urban reform and housing projects. *La ciudad frente al río* (The city on the river), made in 1949 by the Study for the Plan of Buenos Aires, was designed by an organization within the Buenos Aires municipal government to educate citizens and publicize Perón's public housing campaigns. Hundreds of films were made under the auspices of the Subsecretariat of Information to illustrate Peron's national reforms and social welfare projects.[33] The undersecretary of information and the press would determine the programming of the noticiarios and fix the price of their rental by the theaters. The propagandistic style of these Peronist noticiarios would later be copied by Solanas, Gleyzer, and other filmmakers who sought to appropriate the symbolic vehicle of state propaganda for the purpose of resistance filmmaking. The films themselves would also be mined for stock footage to represent Peronism and its relationship to social justice and class struggle.

When Perón became president for the first time, Sono Film, San Miguel, Mapol, and Lumiton were among the largest of about fifteen grand studios that together employed nearly 4,000 workers.[34] In September 1944 a large group of these workers decided to form a union to demand better working conditions, overtime pay, and regulated hours from the large studio production companies. This union, the Union Association of the Argentine Cinematographic Industry (AGICA), fought for increased benefits, protection of workers' rights, and mediation of conflicts between exhibitors and producers. Juan

and Eva Perón encouraged the organization, despite its independence from the state, as a part of their sweeping initial support of unionism.[35] Perón's favor allowed AGICA to assert an important presence in negotiating the national film industry's interests, mediating to some extent Perón's aggressive efforts to control production. The first treaties on international film trade were signed by AGICA as the official representative agent of the Argentine industry's interests, and the number of Argentine films produced during the organization's early existence steadily increased.[36] On July 4, 1945, a group of AGICA workers took to the street en masse for the first time in a demonstration in favor of increased protection for the industry, parroting Perón's anti-imperialist rhetoric and pushing for increased economic nationalism as a reproach to nefarious foreign interests. The United States had placed an embargo on the sale of raw celluloid to Argentina because of the country's neutral stance toward Germany during World War II. The AGICA protestors marched on the U.S. embassy to ask Ambassador Spruille Braden to view a petition on the unavailability of celluloid, the prime material then used for film, and its impact on Argentina's film industry. The first of many notable public demonstrations by film industry workers, this anti-imperialist event set a precedent that would soon be used to promote broader political objectives.

Only a few years after Perón assumed the presidency, the political climate within the union shifted from that of pluralism to loyal Peronism. In 1948 ACIGA gave way to a new state-sponsored union, and the Union of the Argentine Cinematography Industry (SICA) was born, with *la compañera* Evita as its symbolic leader.[37] The union was incorporated into the central national union, the General Confederation of Labor, or CGT, which would become one of the strongest arms of Peronist support by the 1950s.[38] The CGT became the only union officially recognized by Perón's government, cementing the relationship between the national union and all its feeder organizations. Clientelism between the CGT and SICA was not seen as a threat by the Peronist majority within the film industry's union, and SICA often benefited from such odd perks as the Fiat 1400 that the administration presented to its general staff.[39] In 1953 SICA opened its new headquarters at Juncal 2029, a *hôtel particulier* in the heart of the upscale Barrio Norte in Buenos Aires. The mansion was a gift from Evita Perón herself, most likely a property confiscated from a wealthy anti-Peronist family.[40] Through its alliance with Peronism, the union made many gains during this period and became a powerful force as its members were integrated into the state's regulatory apparatus and offices of the Ministry of Culture.

Outside these material and political gains, perhaps the most significant film-related achievement of the first Peronist period consisted in the refashioning of filmmakers as "film workers," or *obreros de cine,* within both spaces of cultural production and larger conglomerations of workers across the city. Prior to this period, most people working on films were referred to as "independent," meaning they were contracted only for the weeks of a production's filming, resulting in an unstable and rapidly fluctuating labor market. Displaying its typical organizational genius, SICA lumped all kinds of employees, from technicians to directors, into the unified category of "film workers" participating in the same union. In this way, prominent public cinema figures, such as actors and celebrated directors, allied themselves with skilled laborers and tradespeople under the banner of workers' rights and could tout a variety of industry concerns without the accusation of elitism, an image of solidarity that held broad appeal to leftist intellectuals and cultural producers of later periods.

During the legislative electoral campaigns of April 1954, Perón faced discontent among many of the unions he had helped to engineer. Promoting his successes in raising the quality of life for workers,[41] Perón kicked off his campaigning in Mar del Plata by publicly designating the city, long considered a beach resort for the wealthy, to be the new capital of workers' leisure.[42] In the course of the same speech, Perón also announced that the city would host the annual International Festival of Cinema.[43] The festivities would be held in the same hotel and casino that, as a vacation spot, had long been an icon of the country's elite. The reverberations among the film community were mixed. Some saw the refashioning of the resort town into a worker's paradise as a facile tool of propaganda. Others, however, saw this as a strategic move that would allow the film industry to attract a wide international audience to its most splendid shores, where producers and film executives from Hollywood, Paris, and Rome could be directed to the talents and enterprising excellence of the Argentine film industry.[44]

The creation and promotion of vacation opportunities for the working class responded to the matter of workers' rights—specifically, the right to leisure and recreation. As such, it created a mirror of a democratic and egalitarian society while dealing with the concrete issues of workers' standards of living. The Peronist government incorporated state-financed worker vacation opportunities near the top of its political agenda. This act of promoting social tourism transformed the city of Mar del Plata, but it also added strength to the CGT by reassuring the union's many constituencies of its usefulness. In turn, moving the film festival to the symbolic center of this project was a

strategic technique through which the regime could showcase its project in an international forum. The festival ensured a quantity of notable guests and a flurry of global press every year as the festival commenced, all of which would draw attention to Peronism's success in transforming the city into a working-class utopia.

The strength of syndicalism under Perón empowered filmmakers, for they were successfully incorporated in national-scale labor mobilizations. The nuance of this distinction was certainly not lost on leaders within the film community, for whom Peronism became a means by which the industry could professionalize. From the late 1940s to the early 1950s, professional associations, which played a significant role in projecting the image of filmmakers as part of the workers' struggle, began to proliferate. Several associations were formed to negotiate film industry conditions via collective action. Often, a handful of these associations would band together to protest specific national and international policy directions. The modes of action they most commonly employed included issuing *solicitadas,* statements published in newspapers soliciting readers' support, and making *denuncias,* public denunciations often aired at press conferences, media releases, or in formal letters to the offices of the government. During the mid-1950s, alongside SICA, the other collective-bargaining organizations in the film industry became instrumental in developing a new identity among film workers through these forms of action. Collectively they took on a broad array of issues, from local social concerns to cold war politics.[45] These organizations were vital in the effort to pressure national lawmakers and the executive branch to push through legislation, to expedite the delivery of credit from the national bank, and to add political weight to various projects of the film union.[46]

The legacy of Perón's first two administrations had special significance for the military regimes that would follow. First, Peronist cultural policies gave the military a centralized apparatus through which the film industry could be controlled and monitored. Although future generations of political filmmakers would use this apparatus as a litmus test of respect for civil liberties, from 1955 to the early 1980s, it would most often serve as a means of screening film for subversive content and for locating filmmakers who opposed military objectives. The second legacy was the consolidation of the film industry's labor force under a powerful, predominantly Peronist union. Not only did this enable the film community to display its political might, but it also brought filmmakers deeper into both Peronist resistance and the labor movement, which would later, in the 1960s, become a crucible of revolutionary politics. Finally, the multiple links between Perón and the film industry would

be recognized among anti-Peronists, such as the military, and by the general public as an important feature of national cinema. This connection gave the industry a public reputation as a stronghold of Peronist sympathy, a legacy that would have important ramifications after Perón's ouster.

PREVIEW/REWIND

In September 1955 the military junta calling itself the Revolución Libertadora deposed Perón's government in a violent coup, forcing Perón to flee the country and turning a suspicious eye on his many mainstays of support, including film industrialists and unionists. Shortly after the military coup, the new government initiated an inquiry into the state of affairs in the cinema industry under Perón. In the subsequent climate of increasing mistrust, shifting political pressures and alliances left film workers and many of their counterparts in the CGT without much official influence. Nonetheless, many film workers and organizations continued to form an important part of the new political mapping of national politics as a part of the loyal Peronist opposition to the new military government. A group of these film associations hosted an assembly at the Teatro Presidente Alvear, and during this public conference, filmmakers as *workers* became the principal subject of press coverage. Journalists who covered the event focused on reprinting speeches given in the name of *"el obrero de cine,"* reprinting dozens of times for the national news services language that depicted the film industry as comprising film workers, not merely wealthy actresses and investors.[47] These writers also integrated the language of the labor movement into their narratives of the event, concentrating on workers' rights and working conditions in the attempts to protect national film interests, an image that would endure for the next several decades.[48]

This new political identity had been reinforced by the film union itself, which began regular public demonstrations after the march on the U.S. embassy. Associations within the industry, particularly SICA, became increasingly vocal about their political and economic interests in public affairs. The discontent of film workers within the sphere of institutional cultural politics became increasingly evident on July 11, 1957, when three truckloads of men pulled up before the steps of the National Institute of Cinematography (INC), in the heart of the cinema district in downtown Buenos Aires. The protests, which had been organized just the previous night, expressed support for two national films facing censorship; posters had been taken down and their screenings had been canceled by theater exhibitors earlier in the week.[49] After hav-

ing spent the earlier part of the day traveling from cinema house to cinema house protesting, at least eighty members of the national film union stood menacingly outside the institute's main entrance. According to eye-witness accounts, these film unionists had already forced their way into exhibition spaces, breaking windows, threatening the management, and even hitting one cinema owner on the head with a can of paste. The group had heard news that a similar battle had been won in Mexico when a truck drove through the wall of a theater.

Arguing with passers-by and exhibitors who claimed that no one would go to see the films anyway, the demonstrators yelled, "Guys, you are laborers like us, why are you doing this to us?"[50] By the afternoon, the protestors had forced their way into the film institute and officially begun an occupation of the building. Alongside workers in other communications media and powerful members of the Association of Argentine Film Producers (APPA), SICA and a handful of allied participants, estimated to number 300, occupied the institute's headquarters. This highly visible takeover presaged similar actions to follow, beginning with the 1959 takeover of the Lisandro de la Torre factory and increasing in scale and number by the 1960s.[51] This event epitomized the contentious relationship between filmmakers and the state that would continue to develop over the next two decades. It also signaled the beginning of a new kind of public sensibility toward national cinema and its industry. This group of cultural producers asserted a presence in the politics of urban space that the public would begin to associate with leftist ideology, militancy, and radical politics over the next few decades. These intimations of what would later follow, however, serve as only a starting point for the revolutionary film interventions that would become the target of military repression by the 1970s.

By the time figures such as Raymundo Gleyzer began their careers, the film industry's ties to the labor movement and resistant strains of Peronism were firmly in place. Mirroring other spheres in the political arena, divisions between hard-line labor advocates and more radical elements within film associations and the union had begun to transform the film community into a heterogeneous field on which the variety of national political camps could easily be drawn. Peronists were no longer a heavy majority within the union, as they had been in the 1940s, but they did maintain a strong presence in union affairs and offices. Filmmakers were highly conscious of the political environment of production and exhibition—in particular, the means by which cinema could intervene and deliberately influence that environment.[52] Although certainly not every filmmaker of the 1960s and early 1970s had an interest in consciousness raising or activism, political radicalism was commonplace

within the industry, particularly in the film schools, which produced a current of films attached to political projects of the university student movement. Most significantly, emerging filmmakers made films that effectively staged political conflicts, mapping their own narratives of trade unionism, the working class, and activist opposition to the status quo. These films also framed and represented the objectives of the political organizations to which their directors belonged.

The high-profile nature of the film industry's negotiation of labor rights, the 1957 invasion of the INC offices, and the success of the film union as an organization of workers in making its demands on the state made military governments from the 1950s onward highly suspicious of industry activity. When the industry stepped beyond the scope of film, as it often did in, say, protesting imperialism and cold war politics abroad, the public took notice. This public profile made the film industry a potential force for widespread insurrection. When filmmakers in the early 1970s began making propaganda films for the militant left, such as Gleyzer's film *Los traidores,* these outspoken detonator pieces were used to justify cracking down on the entire industry.

THE FILM INDUSTRY UNDER THE MILITARY

Under Argentina's military regimes, film unions, producers, and exhibitors justifiably feared that the military government would shut down studios and blacklist filmmakers based on ideological grounds. Despite the climate of limited liberty of expression, however, a handful of major studios and directors continued to produce regularly throughout periods of the military's rule. Critics characterized the cinema of big studios under military rule as escapist, irrelevant, and politically sterile, and the public often followed their lead, resulting in increasingly low box-office returns.[53] The military under Onganía revoked the majority of Perón's protectionist policies, and filmmakers faced the dual problem of reduced subsidies and less favorable market regulation alongside an onslaught of foreign-made films that were allowed to compete for exhibition revenues. Under Onganía, the film institute was finally granted full authority over all aspects of film production, distribution, and exhibition, a measure that the military regime had hoped would usurp power from Peronist unions. The military realized that the institute could be used to check the influence of SICA and other film associations by regulating all aspects of film production and commercialization.[54] Without adequate protection, many

studios, accused of being full of Peronist-sympathizing and leftist workers, soon went out of business.[55]

The imposition of state authority became an immediate source of discontent within all sectors of the film industry. The INC announced a wave of new policies designed to direct distribution and exhibition and thus ensure the public access to "quality national cinema." But many film industry workers and industrialists accurately viewed this centralizing move as the beginnings of repression.[56] In fact, the institute had been created by the military regime of Pedro Eugenio Aramburu, which came to power in 1955 and ruled until 1958, and the military had designed the agency primarily to centralize the exportation of films. The Mixed Society for the Commerce of Argentine Cinema, known as UNIARGENTINA, was given full legal authority to represent all the major studios and any independent films in negotiating their access to markets abroad. The organization foreclosed filmmakers' entrepreneurial activities abroad and thus allowed an "iron curtain" of sorts to fall on the already crippled industry.[57] The precarious authority of the INC continued as political instability produced a rapid series of regime changes.

In 1967, under the declaration of a state of emergency, a new cinema law was imposed, Ley 17.741. This would prove to be Argentina's most significant and lasting pieces of national film legislation to date. It was part of a broader project of rationalization of the radio, television, cinema, and tourism industries meant to ensure a greater degree of top-down management.[58] The legal program was intended to streamline the state's intervention in these industries as a precursor to privatization.[59] The Mar del Plata Festival Commission would formally be dissolved and the festival canceled, depriving the national industry of one of its most important international forums.[60] Ley 18.019 was passed the following year, in December 1968; this law stated that all domestically produced scripts had to pass through the Ente de Calificación, or Rating Entity. Films that did not pass this board's careful content examination would not be produced:[61] the penalty for exhibiting unrated films was set at one million pesos, a cost high enough that it would likely have shut down all but the very largest production studio, and the material itself was liable to be sequestered by the national government.[62]

The oligarchs of the studio system, such as Atilio Mentasti, mogul of Argentina Sono Film, saw these measures as a harbinger of the industry's death.[63] Many industry representatives, principally SICA and its predominantly Peronist political allies, made their frustrations public via international solicitations conveyed via telegram and newspaper. Addressing both their international

colleagues and domestic allies, they expressed despair in facing the compli-
cated new legal project and what they conceived to be dictatorial powers being
executed by the top functionaries of the INC.[64] They were, however, struck
with the difficulty of assigning blame, for the film institute underwent a suc-
cession of appointed directors.[65]

Increasing political tumult brought further tribulations to the film industry.
By the early 1970s, studio financial insolvency was rampant and unemploy-
ment had reached a peak. It was estimated that only 600 to 700 film workers
made a living as affiliates of SICA, the majority of whom were employed by
the three large studios still in stable operation. The public viewed these studios
as at best noncontroversial and at worst compliant with the military's repres-
sion.[66] Under Isabel Perón, producers lacked independent access to foreign
markets and faced the Rating Entity, which was a serious impediment to free-
dom of expression. In the first years of Juan Perón's 1973 government, there
was some hope for greater democracy. Films that had previously been cen-
sored for ideological content were released. Some films made clandestinely
or outside the country were permitted screening as well. Nonetheless, films
that were viewed as threatening to the democratic administration of Peronism
were deprived of ratings, and directors were kept under close scrutiny. Argen-
tina produced thirty-nine films in 1973 and forty-eight in 1974, reflecting a
small surge that might have promised a revitalization of the industry. In 1976,
however, representatives of the armed forces announced that Argentina's civil
government would cease until economic and social chaos could be controlled,
cutting all production budgets financed through the national bank to zero
until further notice. The climate of optimism that had surrounded Perón's
assumption of office in 1973 had already shifted to one of skepticism, but after
the coup, the industry knew it faced an uphill battle to recuperate itself eco-
nomically. Meanwhile, many filmmakers chose to work underground, avoiding
official regulation and disappointing markets.

The intellectual left from the first period of Perón's rule demonstrated a
strong tendency toward anti-Peronist sentiment. By 1973, however, the radi-
calization of certain factions of Peronism and the left, together with the in-
creasing participation of artists and intellectuals in the emerging ideological
politics of a revised and militant left wing, shifted many alliances. In certain
intellectual spaces, revisiting Peronist authoritarianism became a means of
allegorically critiquing the military state, but others saw new hope in a revi-
talized labor movement and thought of the Peronist legacy as a strong sym-
bolic base for their renewed energies. Both moves resulted in literature, art,
and film that overtly and covertly critiqued the state and its participation in

the cold war from the perspective of class struggle. "El cine que quema" (literally, the cinema that burns) would be an important mode of expression for the intellectual left and a means by which the military would identify potential intellectuals as subversive. The films made in this period, from 1968 to 1976, form the first generation of transition filmmaking and would serve as a model for the second and third generations.

Censorship and blacklisting were widely practiced under Onganía, Levinston, and Lanusse, as they had been under Juan Perón and were later under Isabel Perón. After the dictatorship of 1976, however, these practices were formalized when the INC was placed under the authority of the air force.[67] The air force administrators of the INC had no trouble reining in the work of small-scale film producers, but they had more difficulty policing the bigger studios, whose large labor forces were often strongholds of loyalist Peronism. According to a rumor circulating in Buenos Aires during 1981, the government planned to shut down the Baires studio and to stop projects underway at Aries, the production company run by the Peronist SICA members Héctor Olivera and Fernando Ayala, largely considered the last bastions of the film industry and its union.[68]

THE ROLE OF CENSORSHIP, EXILE, AND BLACKLISTING

Jorge Cedrón, Gleyzer's colleague, became an almost mythological hero of political cinema's alliance with the militant politics of the new revolutionary left during this period. Cedrón is best known for his 1973 film adaptation of the novel *Operación masacre* (Operation massacre), by Rodolfo Walsh. The novel is based on the clandestine assassinations of several workers that took place in 1956. Cedrón decided to undertake this project as a means of bettering his understanding of Peronism and class struggle, working alongside survivors of the massacre, Peronist and otherwise, to gain a fuller understanding of the event. During the filming, Cedrón realized that he was taking a huge political risk, so he began filming in secret. No one working on *Operación masacre* was paid for labor as a member of either the cast or the crew, and when not being used for filming, costumes and props were buried so as not to be discovered by the police. The work circulated in clandestine film clubs and other illegal meetings organized by militant groups, a tactic that, Cedrón boasted in an interview in 1980, allowed an estimated 250,000 spectators to see the film. After 1973, when these groups were forced even further underground

after the Ezeiza disaster following the return of Perón, the film was projected in factories and churches, often housing as many as 1,000 spectators at a time. Walsh, the novel's author, was eventually murdered in 1976 by the armed forces.

Cedrón wanted to raise public consciousness through cinema by delivering a nondistorted vision of social reality. He was actively militant in his politics, moving from party-line Peronism to sympathy for the armed resistance of militant Peronist groups, such as the Montoneros, the Revolutionary Armed Forces (FAR), and the Revolutionary Workers Party together with its Revolutionary Army of the People (PRT-ERP).[69] Cedrón actively participated in the FAR alongside many other filmmakers and later shifted his support and participation to the Montoneros. He fled the country in 1976, living in Cuba and Europe. After returning in 1980 to see his eleven-year-old son, who was living in Buenos Aires, Cedrón was finally kidnapped and disappeared.[70] Cedrón was memorialized by his surviving colleagues, and eventually his story became a common referent among leftist intellectuals, political activists, and cultural producers encoding the meaning of radical film of the 1970s.

Multiple periods of military rule in Argentina, each with its own brand of repression of the film sector, served to strengthen the credibility of cinema as a force of resistance. During every military installation from the 1940s onward, a noticeable number of union members, actors, directors, technicians, and film critics were persecuted. Confronting censorship—from Perón's studio takeovers to the caprices of the Rating Entity—was a common experience for generations of filmmakers. Suppression of politically charged film was a norm long before the dictatorship of 1976 began. Under these conditions, filmmaking communities became somewhat fragmented. The union maintained a degree of common cause, linking a traditional narrative of film workers' concerns to calls for protection of civil liberties. At the vanguard, however, radical filmmakers continued to make films that directly challenged the source of persecution. As such, despite great differences in political ideology and status, militant cinema became the industry's banner of resistance. This cinema, its films and its directors, came to signify a sense of unity in the struggle against repression in the film sector.

The film industry reacted to military repression by revisiting some of the strategies that had unified it in the past. By 1973 the film workers' union was beginning to democratize, with SICA's Council of Delegates sending mandates to the Directing Commission, particularly regarding issues related to workers' benefits and management of the union itself. During the early 1970s, despite this democratizing impulse, union activities of film workers were still

discouraged.[71] By early 1974 a dynamic conversation about these issues was again taking place, increasing the active participation of members of all stripes. Even the theme of the decadence of Argentine cinema, long a divisive point within the industry, became a defensive rallying point in the wake of censorship. With the sexual revolution's arrival in the Southern Cone, mature content as a component of many late 1960s and early 1970s films was undeniably on the rise. In periods of democratic opening, prominent popular newspapers published opinion pieces written by filmmakers arguing for a more dignified national cinema, but by the mid-1970s, the union was vocal in calling for the protection of mature content as an issue of civil liberty and critical to the liberation of women.

Filmmakers of every political persuasion were affected by the waves of political radicalization and the violence that surrounded them. A close friend of Gleyzer's, the Uruguayan-born director Walter Tournier, was kidnapped in 1974 by an Uruguayan guerrilla group calling itself the Tupamaros, or the National Liberation Movement, which kept him detained for three months until a ransom was paid. Víctor Proncet, whose role in *Los traidores* had made his likeness and identity known to the military government, was taken prisoner and questioned about his involvement with Cine de la Base. When the military came to examine the contents of the film archives at the university that Gleyzer had attended, they spent over a year reviewing and confiscating material, after which several producers and technicians named in the archived material were disappeared or killed, including Mario Hernández, a lawyer who worked on behalf of the university. The actors' union created a branch of the Anti-Imperialist Front for Socialism (FAS), which was aligned with the Revolutionary Workers Party. The filmmakers union also saw the creation of its own branches of revolutionary parties, causing a major rift between those who identified more closely with Peronist militancy and those who did not.[72]

In 1975 Miguel Paulino Tato was named head of the Rating Entity, and he remained in office from Isabel Perón's presidency until almost the end of the military regime, in 1983. By the beginning of his second year in office, this self-declared "religious fanatic" had already achieved world-record status by banning over 160 films.[73] Tato was known for such scandalous public pronouncements as "¡Hitler tenía razón!" (Hitler was right!). On one occasion, Tato even telephoned one of Cine de la Base's members, Luis Angel Bellaba, inquiring if he had a copy of *Los traidores* on hand, making it clear that the state would consider this an obvious proof of involvement in the Revolutionary Army of the People. A number of individuals identified as having helped make any of the revolutionary films that fell into the hands of

the military received anonymous threats on their lives in 1974 and 1975 (now thought to have come from the Triple A), leading a number of them, including Gleyzer, to leave the country for brief or extended periods.

Like many political filmmakers, Gleyzer endured some of the most trying and difficult times of his life during the final months of Isabel Perón's government and the first months of the military's regime. This period saw a massacre of leftist intellectuals and prominent cultural figures; the military targeted any visible leftists or public figures identified with the left. The high level of visibility of filmmakers, whose work was often on display in film houses around the country and whose faces were reproduced in countless interviews in any number of popular magazines and newspapers, made them ideal targets. Even before taking power, the military knew that marking prominent figures would resonate strongly with the public at large and saw this as an ideal opportunity to send a clear message about its aims.[74] Gleyzer became active in the ERP, one of the most powerful groups of the early 1970s, as a leader of the group's official cultural arm and had begun to make films that were propaganda pieces for the revolutionary organization. By 1976 he had become something of a ghost in his former film circles, frequently traveling around the country and abroad, speaking little about his political involvement, and occasionally denying his affiliations even to life-long friends. Because the employment situation in Argentina was precarious, he accepted a well-paid position working on a production in New York in the spring of 1976, leaving behind his former companion, Juana Sapire, and their young son, Diego.

Despite the professional nature of his visit and his promises for a prompt return, his family was concerned that Gleyzer might not be back in Argentina any time soon. Since many of his companions had chosen to flee, Gleyzer's family considered a prolonged absence a real possibility. Communicating through postcards from New York, Gleyzer reassured his family of his safety. After a few months, he decided to return to Buenos Aires to visit his son, arranging to travel through several countries, including Venezuela, perhaps hoping to keep his travel under the radar by making a handful of stops. By the time he had reached Caracas, however, friends tried to communicate to him that a return to Buenos Aires would be dangerous, but Gleyzer ignored their warnings, for he was desperate to see his son again. He returned to the city and moved among the homes of his friends, happy to spend time with his son.

On May 4 his friend Haroldo Conti disappeared, and Gleyzer took precautions to conceal his whereabouts, even from his son's mother. On the last weekend of May, he was expected to pick up his son for a visit on a Friday

evening but never arrived. Two days later the boy's mother became concerned and began frantically calling Gelyzer's friends, none of whom knew where the director could be found. After days of unsuccessful searching, the filmmaker's mother, Greta Gleyzer, was able to contact the woman who cleaned the apartment where he had been staying with a friend, Germán Salgado. The woman told her that on June 2, a group of men had broken down the door to the apartment and taken Gleyzer, after which they turned the apartment inside out, seizing cameras, photographs, books, valuables, and phonograph records and slashing the furniture, mattress, and pillowcases. What the kidnappers had left behind, however, was perhaps more telling. They had stolen the living room rug, kitchen utensils, clothing, and a film projector, but they left behind all Gleyzer's films and the file folders of information on each production. In overlooking these reels, the abductors evidenced that they were not aware that these items were probably the chief motivation for their assignment.

The films rescued from the apartment were divided among Gleyzer's friends and family and hidden. Salgado entrusted his father-in-law with some of the reels before fleeing the country to Mexico and, later, Peru. But his father-in-law, fearful of the possible repercussions if they were found, put them in bleach to erase their contents. Luis Angel Bellaba also kept some of the material, and when he later fled the country, Greta Gleyzer took the film and stored it in the garage of her building. In the weeks that followed Gleyzer's disappearance, Juana Sapire was followed by plainclothes police officers wherever she went. Discovering a Ford Falcon parked outside her home, she decided not to return and remained on the run for weeks. The Gleyzer family queried the police commissariat about the filmmaker's disappearance but received no assistance. Eventually, Sapire forged papers to allow herself and Diego to leave the country; they traveled first to Peru and then to the United States.

In a testimony to the CONADEP human rights commission in 1984, Horacio Ramiro Vivas, a lawyer, reported that on June 2, 1976, five men dressed as civilians entered the apartment of Raymundo Gleyzer, breaking down the door and carrying arms. The report goes on to say that Gleyzer was blindfolded and forced into a car that transported him to a house located somewhere in the vicinity of the Ezeiza airport, where Vivas claimed he was detained until July 15. Gleyzer spent most of this period of apprehension handcuffed and blindfolded in the basement of the house, with periodical sessions of torture and interrogation and infrequent bathroom visits. The handcuffs used on Gleyzer were marked with the symbols of the penitentiary

service, and the men who guarded the prisoners in the house were penitentiary workers, mostly from outside the city of Buenos Aires. The torture methods used, according to Vivas, included strapping the prisoner to a metal bed, where he was electrocuted and burned with electric prods. Amnesty International was able to gain information on the Gleyzer case, which it provided to his family, detailing that the ligaments in Gleyzer's feet had been cut and that he had been badly beaten and electrocuted, leaving him in a state of incontinence and illness. Acceding to pleas from his friends in the United States, the Organization of American States opened a case file on the director, case OAS 625, which later confirmed these details through the testimony of other detainees.

One of the other prisoners of the house where Gleyzer was alleged to have been held hostage claimed that on June 20 both he and Haroldo Conti were transferred from that site. This date is not insignificant, for it was the day after an exploding bomb killed a police officer named Cesario Cardozo, an act that was initially blamed on the ERP-PRT, though the Montoneros later claimed responsibility. On June 20 the journalist Juan Gasparini reported that a number of prisoners arrested by the state on charges of affiliation with the ERP-PRT were indicated as "retired" from their detainment in clandestine detention centers. This report was confirmed by the Anthropological Forensic Institute, which worked closely with CONADEP on its fact-finding mission at the end of the dictatorship.[15]

MARTYRS, ACTIVISTS, AND INTELLECTUALS

Gleyzer's story reveals a great deal about the experience of filmmakers under the repression of Argentina's cold war–era politics during the 1970s. Although Gleyzer was not among the more prominent militant fighters of the radical left, he became a victim of the loose association of all leftism with guerrilla terrorism. This narrative clearly indicates that mere political identification was considered a sufficient motive for state violence and that the blurring of the lines between activism and militancy was just one of the losses suffered under the military repression. The impact of Gleyzer's death on the lives of his family also illustrates the more universal effects of the state terror and rampant suspicion that engulfed Argentina in 1976. Gleyzer's disappearance was a commonplace occurrence for this period, one of many such events that created permanent ruptures in the lives of families and made an entire generation of children such as Diego into victims of the dictatorship. The ac-

claim that Gleyzer had received as a filmmaker and the wide community of colleagues and friends that he had established made him a prime target of the repression; later, these same elements would make his legacy emblematic of this community's efforts to bring justice to the perpetrators of human rights abuses.

In early 1978 SICA's offices were invaded by a counterrevolutionary regiment of the army, with the union secretary, Iris Pumares, injured during the incident. She later testified publicly to the military's search for information about suspected militants within the organization. In response to this internal and external threat, SICA, along with other affiliated organizations, organized the first annual week of national cinema, with posters announcing "Argentine cinema is still possible." This meeting triggered a high-risk public debate about censorship and the abuses of the regime within the industry, discursively located around the disappearance of Gleyzer. At this 1978 meeting these organizations created the Permanent Committee for the Defense and Promotion of Argentine Cinema. Under the banner of this new organization, the film industry began to make public demands for the abolition of censorship, freedom of labor, and the protection of national film exhibition.[76] The group presented its demands in a petition to the acting military president, General Videla. They also issued a series of solicitadas denouncing the disappearance of the documentary filmmaker Raymundo Gleyzer. In July 1979 the committee sent an open letter regarding the Rating Entity to the Office of the President, calling for more thematic liberty and an opening for "responsible" filmmaking. In September 1979 General Antonio Llamas, the secretary of information, granted an audience to representatives of film workers' groups, who used the opportunity to speak of the marginalization of certain actors and filmmakers, alluding to blacklisting and the disappearance of various compatriots.[77] The general responded that their needs could be addressed only once the industry had become "compatibilized" with the appropriate mandates and ministries.[78]

From 1976 to 1983, official military film production policies had dire consequences for national production, virtually silencing the film industry and its workers.[79] The INC ceased to function as an autonomous institution and was incorporated as a dependent body of the Ministry of the Treasury. By 1980 the 10 percent of box-office revenues collected to manage the institute was redirected to the ministry, ending the INC's financial independence. In September 1980 legislation was passed to levy a 20 percent value added tax on all film exhibitions, and this charge was applied to all national films, however much revenue they generated.[80] Film industry representatives decried

this measure as a means of impeding the financial agility necessary to manage the industry. By converting the INC into a fiscal dependent of the military state, the institution's radius of action and operation was curtailed to the point of mere survivalism.[81]

In 1980 the Permanent Committee for the Defense and Promotion of Argentine Cinema hosted a public debate in the Teatro Nacional, asking, "Does Argentine cinema have a future?" This meeting was attended by representatives of various sectors of the industry, students of cinema, important creative and intellectual figures, and members of cinema clubs. The writer Beatriz Guido gave a speech in which she declared that the government's regulations were inflicting greater censorship on cinema than that imposed on theater or literature.[82] At the meeting, the committee decided that in the following year it would convoke a project called Cine Abierta, or Open Cinema, with its parallel Teatro Abierto, a movement that attempted to encourage artistic production independent of military policy.[83] This forum provided all manner of cultural producers with a site where they could converge under the flag of anticensorship. Shortly afterward, in May 1981, the cultural supplement of *Redacción* published a series of interviews with several prominent artists and authors, including Ernesto Sabato, Jorge Luis Borges, Alfredo Alcón, Roberto Cossa, and Fernando Ayala, many of whom had been present at the Teatro Nacional meeting. The pieces openly addressed the state of censorship and its impact on the arts. Under this pretext, the various interviewees expressed their views on the regime's impact on Argentine intellectual and cultural life, citing important cases of disappearances of filmmakers, Gleyzer among them, and the decline of productivity within the film industry itself.[84]

All sorts of intellectuals found in cinema a universal cause through which to express their common frustrations and desires for change. When two students were expelled from the national film school, the Center for Cinematographic Experimentation and Production (CERC), their case became a highly public battle against censorship. These two students were expelled because of subject matter in the short films they made as second-year finishing projects. The military director of the film institute, Commodore Francisco Roberto Pítaro, came to the classroom of Víctor Alejandro González and Rolando Enrique Santos to withdraw them from the program personally.[85] Pítaro charged the students with having directed short films containing "characteristics that invalidated the continuation of the works as part of the learning process" and made specific note of the aspects of the films that the administration considered denigrating, sexually immoral, and truculent. The two

films were shot in a *villa de emergencia,* or a shantytown, and this choice was noted as one of the students' principal offenses. The case was particularly notable for its timing, with the students' removal occurring before the works were even completed, suggesting an ongoing surveillance.

The questionable film content resonated with a number of frustrations important to intellectuals and cultural producers at the time. Santos's film, *Revelación* (Revelation), tells the story of a man, a prostitute, and a boy living in a shantytown. The offending scenes recount the relationship of the man and the boy, specifically the former's attempt to befriend the latter. He begins by giving the boy a rabbit and eventually brings him to see a prostitute, an event that terrorizes the boy, resulting in the rabbit's violent death. González's film, *Siluetas* (Silhouettes), involves a thief, an old man, and a young woman, with the offending scene depicting the thief's attempt to violate the woman. Immediately following the expulsion of the two students, the school set a code to regulate the thematic material of future student works, prohibiting them from including violence, sex, or any otherwise "depraved" scenes.[86] The Argentine Cinematographic Directors organization released a declaration condemning the activities of the INC, underlining the fact that filming poverty and underdevelopment in the country was not expressly prohibited under cinema legislation. Many intellectuals made public statements in support of the students. Several argued that the films were censored for presenting not violence but rather social ills, which intellectuals claimed had resulted from the dictatorship's disastrous economic policies.[87]

Within this context, then, left-leaning political and intellectual leaders in Argentina began to use film politics as a stage to promote various causes, ranging from antiwar protest to labor politics. The struggles of a handful of high-profile dissidents would emblemize the new political life film was to play, strongly identified with leftism and cultural resistance. Within the profound transformation of the left during the early 1970s, when traditional forms of popular engagement were foreclosed and a variety of new proposals for action were put on the table, this was one of the first moments during which an artistic vanguard emerged as part of the popular struggle, not as the fringe sector of a cultural elite, but as *obreros de cine.* This period added new layers of sensibility to the construction of cinema in the Argentine cultural imaginary. Peronism, in its various manifestations from the 1940s, was partially responsible for the evolution of strong currents of leftist political filmmaking both within and on the outskirts of the industry. Subsequent military interventions saw the emergence of a certain dialogue between repression and

resistance that proved useful for building a symbolic vocabulary that later generations of transition filmmakers would put to use. Peronism also facilitated the formalization of union activities within this sector and the careful articulation of relationships between state sponsorship and film workers' causes, which would later manifest themselves in terms of individual filmmakers' careers and professional formation, as the next chapters will address. In addition, this was the period when the makers of cinema began to be recast in popular media as *workers* rather than as merely industrial entrepreneurs or artists. This novel image gave filmmakers a place in state-level politics, facilitating a conversation about the workers' struggle both on and off the screen that would later become a vital source of credibility when the industry needed to invoke its left-leaning past to promote new interests in the aftermath of repression.

At the conclusion of Argentina's "dirty war," Raymundo Gleyzer became the martyr par excellence of the film community under dictatorship. The nature of the film industry's pursuit of justice and the denunciation of his disappearance was at the forefront of this community's public identity during the return to democracy. All this came together to create a stronger association between the revolutionary left and national cinema, raising the profile of otherwise underground and vanguard films with limited audiences and making the contributions of these filmmakers the message about the national film industry and its role in recuperating democratic cultural politics. The films of Cine Liberación and Cine de la Base were some of the first to be censored in 1976. They were also, however, the first to be brought to light again when the transition to democracy began. As such, they are the most well known of the first generation of transition films, which gave inspiration to filmmakers of the second and third generations in the democratic opening after 1983.

Peronism's relationship to the film sector found its way into the works of many radical directors during the 1960s and 1970s. The conflicts among different factions within Peronism and the complicated relationship of Peronism and the Argentine political left was symbolically bridged in film union activity vis-à-vis larger national political struggles. This vexed relationship is absolutely critical to the history of the film industry in Argentina, and it is also key to the question of the way filmmakers came to identify themselves collectively as a sector of the working class left rather than as an artistic community removed from the political fray or as a purely capital-driven industrial sector.

Reimagining the Left

Until recently, film had been synonymous with spectacle or
entertainment: in a word, it was one more consumer good.
At best, films succeeded in bearing witness to the decay of
bourgeois values and in testifying to social injustice. As a rule,
films only dealt with effect, never with cause; it was cinema of
mystification or anti-historicism. It was surplus value cinema.
Caught up in these conditions, films, the most valuable tool
of communication of our times, were destined to satisfy only
the ideological and economic interests of the owners of the
film industry. . . . The intellectual must find through his action
the field in which he can rationally perform the most efficient
work. . . . If we choose films as the center of our propositions of
debate, it is because that is our work front and because the birth
of a third cinema means, at least for us, the most important
revolutionary artistic event of our times.

> Fernando "Pino" Solanas and Octavio Getino,
> *Towards a Third Cinema*

We need to modify the current situation, but that will require
the firm political will of those who govern us, those not in
fear of confronting monopoly structures and directed toward
destroying those which have been until now centers of power.
Obviously, a profound revolutionary action should occur and
that activity should keep in mind that cinema should be, and
in fact is, not just an industry but an informative element, as
testimony, and a formative element, as a transmitter of ideas.

> Federación de Cine Independiente, 1983

3

THE SCENE AND THE CITY

Coded Landscapes and
Collective Memory in Transition

AT THE END of 1982, it might have seemed unlikely that even a peaceful transition to democracy in Argentina would bring about a substantial change in daily life. Army tanks still lined important public plazas, and uniformed officers maintained a watchful eye over commercial centers and plazas. Civilians continued to tread uneasily in streets where armed gunmen only months before might have arrested a neighbor or relative. Even if the details of quotidian existence in Buenos Aires had not altered, however, the city was already preparing itself for the change lying just on the horizon. For two years the military dictatorship had shown signs of relinquishing power. As General Leopoldo Galtieri took the reins in November 1981, the economy posted an 11 percent decline in GNP for the final quarter of the year, and the following years saw a negative rate of growth, rising unemployment, and the return of hyperinflation.[1] Journalists and activists had begun to test the tender opening for free expression without significant reproach. Even the generals in power were beginning to sound more like their critics in discussions of internal affairs. Nonetheless, although a political change was clearly in the works, the urban spaces of Buenos Aires still concealed a landscape of hidden terror.

By late 1983 it had become clear that Argentina's military government would indeed allow a democratic presidential election, and a cultural gridlock

of repression and fear began to warily unsnarl. The city of Buenos Aires cautiously began to turn out its demons. Emboldened by the possibility of a democratic election, many of the individuals and institutions that had been working clandestinely to uncover the truth about the fate of the disappeared under the military dictatorship began to report their findings publicly. Eyewitness reports and the testimonies of survivors began to surface at a steadily increasing pace. Eventually, residents of the city, *porteños,* would awake each morning to find their newspapers filled with the details of incomplete histories. Each day brought the promise and fear of new revelations concerning the whereabouts or fates of those who had fallen victim to the military's repression. Detailed accounts of torture methods, abduction, and systematic slaughter were interspersed with identifications of clandestine detention centers and reports of body drop sites. The city became a living museum of the dictatorship's excess, slowly unearthing fragments of a vast system of human rights abuse. In the first few years of the democratic opening, the city of Buenos Aires became a hotbed of political activity, much of it centered on making sense of the complex and vast array of information about the military regime's tyranny then coming to light.[2]

Argentina's return to civilian rule was observed as closely by outsiders as by insiders. International political organizations, foreign governments, and financial investors monitored every stage of the transition. Coming at a high point during the Reagan administration's fight against communism and the Soviet Union, which was steeped in the language of a transcendent and international "fight for democracy," Argentina's democratic transition to civilian government was full of promise. Cold war rhetoric during the 1980s underlined the themes of human rights, empowerment and representation, and individual liberty. Outside observers framed the end of Argentina's military rule in 1983 in precisely those terms.[3] The manner in which the transition government of Raúl Alfonsín handled the return to civil liberty became an item of intense scrutiny among skeptical critics and would-be lionizers alike. The new civilian president's handling of the dictatorship's human rights violations supplied the world with an object lesson in the precariousness of transition from authoritarianism to representative rule. Left-leaning parties in militarized countries across Latin America examined Argentina's transition in the hopes of finding a model of institutional reform, while remaining military juntas worried about the writing on the wall. This heightened international attention lent additional momentum, and at sometimes financial support, to the many local projects the transition undertook to uncover and analyze the dictatorship's silences.

Harnessing the synergy of international and local enthusiasm became a priority for Alfonsín's transition government. Establishing the legitimacy of Argentina's return to democracy was critical for attracting much-needed foreign investment and international support for the new president's political agenda. Knowing he had to assert the strength of Argentina's political and financial institutions, Alfonsín recognized the need to rehabilitate state enterprises and bureaucracies. Many of these had been co-opted, corrupted, and debilitated over years of military management. Since censorship had become a banner for the evils of military rule, its end was a point easily agreed on, even among rival camps in the Congress.[4] Alfonsín recognized cinema as a high-visibility medium that could quickly communicate the transition's legitimacy to a wide audience. Accordingly, he pushed reform of the film institute, the INC, to the top of his cultural agenda early in his first year in office. Alfonsín decided to use the popularity of ending film censorship, and a new investment in filmmaking, to help market the transition.

Using film as a flagship for a tenuous transition meant courting filmmakers. The success of Alfonsín's project hinged on whether the film sector could be convinced that revamping the INC would make it useful. Filmmakers, strongly identified with militancy and resistance in the public's eye as a consequence of their collective action and identification with the denunciation of the dictatorship's human rights abuses, were thus symbolically allied with Alfonsín's most challenging political opponents, those who sought more radical changes in the new democratic aperture. If Alfonsín could convince this highly visible and vociferous sector, symbolically identified with the radical left and Peronism, he might be able to strengthen his own more moderate party's left-friendly credentials and keep at least some critical opponents at bay. Argentina's transition to democracy was a moment of delicate political transformation, and Alfonsín's cultural agenda recognized the position of filmmakers in shaping the national political scene. Alfonsín acknowledged that film had the power to symbolize his administration's progress in matters of free expression and artistic liberty and as such could serve as a strategic tool to capture and direct international attention.

The transition required a technology, a system of techniques and means, to bring forth the pluralist society that had survived military repression. The very procedures used to frame progress in the transition were transformed to take on the role of making meaning in cultural politics of the reestablished democracy. As Martin Heidegger suggests in his 1954 *Vorträge und Aufsätze* (Lectures and essays), a technology of place has the power to convert the techniques used to generate change into the expression of that change itself.[5] As

Argentina moved toward a new democracy, the mechanics of the transition took on a new purposefulness that often superseded the initial design of democratization outlined by Alfonsín's administration. During the transition, film industry associations, alongside a number of important industry figures, capitalized on the strategic political framing of their enterprise to confirm the legitimacy of their stakes in the politics of culture. In a way that Heidegger perhaps would not have foreseen, they did this without having to rely on the consumptive practices of the body politic to bear out their new authority.[6] Instead, this credibility came from skillful representational maneuvering within the political scene of Buenos Aires at the moment of the transition. During a short space of time, mainstream film in Argentina was transformed from a rather escapist variety of entertainment to a means of furthering social reflection and intellectual critique, taking on many aspects that bore a portentous similitude to the avant-garde and militant cinema of the late 1960s and early 1970s. Filmmakers utilized the transition to establish their credibility in speaking truth to the past and in defining the terms of the new postdictatorship symbolic order.

TECHNĒ OF THE TRANSITION

The architecture of the transition created a highly unstable political environment. The institutional maneuverings that would turn vague promises of democracy into reality had to allow for a pluralist vision of Argentina's future, and many competing political claims were launched from a variety of sectors. The departing military leadership had left a power vacuum at the federal level that gave alternative sources of authority, such as the municipality and state ministries, greater influence on the direction of national politics. When the military's appointees ceased directing these state institutions, an assortment of politically minded figures began jockeying for influence. The moment of the transition in Buenos Aires, as a "technology of place," favored the advance of filmmakers in this uncertain political landscape.

For Argentine society, the promised return of representative rule in 1983 was more a statement of intention than a fait accompli. Collaborating sectors would need an array of means to absorb the public's deep suspicion and broader uncertainty about the emerging political economy. The state needed to create room for a shift to a more active civil society. The political map was deeply divided, despite a concurrence on the issue of redemocratization. The armed forces still feared a resurgence of popular mobilization, Peronism, or

the radical left of the 1960s. Significantly, the military government had been able to transfer power to a non-Peronist government.[7] Many intellectuals on the left read this to mean that the historical fissures in Argentine political life between traditional conservative and working-class sectors had come to a stalemate.[8] In terms of institutional politics, the new government faced the challenge of decolonizing state bureaucracies abandoned by military personnel and agendas. By no means was there a clear-cut agenda for dealing with the almost eight years of authoritarian initiatives prior to the Process of National Reorganization. Thus, the initial *techne* of the transition, the means and techniques used to advance toward democracy, was consensus building.

Public outcry for justice and the release of information about the years of violence and social repression experienced under the military's reign created a climate of long-suffering social unrest. The streets and central plazas witnessed a constant flow of demonstrators from almost every social sector. Raúl Alfonsín had been elected on a noncontroversial platform of stimulating education and reestablishing democratic institutions. Most political analysts considered him to have been merely a default candidate. To establish the transition as a political reality, then, his Radical Party's agenda had to bridge the gap between soft campaign goals and the sweeping actions that the public was demanding. With such a rocky foundation, the party needed to buttress its more ambitious goals, which included ensuring its own political longevity in office, with visible accomplishments in the human rights arena. The period immediately following the power transfer saw soaring public suspicion regarding complicity of institutions on the right, such as the Catholic Church, the landed elite, and other traditional sectors. Likewise, as information was released, public sympathy for the leftist politics of resistance movements of the past steadily rose.

Alfonsín's press agents appealed to public sensibilities by coloring the president's background to emphasize his compatibility with potential opposition on the left. Born an affluent Roman Catholic in the province of Buenos Aires, Alfonsín had attended the prestigious General San Martín military school, graduating as a second lieutenant. Early in his adult life, he joined the Radical Party and quickly became active in internal party affairs. As a law student at the University of Buenos Aires, he was a leader in the Juventud Radical, the youth wing of the party. These credentials smacked of an elite upbringing, but party rhetoric and press agents attempted to neutralize these details.[9] Early during the transition, the Radical Party press emphasized Alfonsín's participation in an internal party movement that sought to reform the elitism of the party by formally addressing the needs of the working and lower classes.[10]

The party was also quick to praise his confrontation with earlier incarnations of authoritarianism, beginning with his 1953 arrest under Perón.[11] Despite these details, the public still harbored serious misgivings about Alfonsín's handling of human rights abuses by the military. Many intellectuals and activists suspected a tacit pact or an early promise of amnesty.[12]

Alfonsín marketed his credibility within the emergent human rights movement to assuage public doubt. He used his human rights credentials to move forward the process of building consensus. In 1974 he had cofounded the Permanent Assembly on Human Rights, which targeted abuses of the Isabel Perón government. Shortly afterward, in his law practice, he had pursued a series of investigations soliciting habeas corpus writs for individuals detained without charge in order to find persons disappeared under the subsequent military regime. He made a series of international trips to draw attention to the atrocities of the armed forces during this time, visiting the Soviet Union, the United States, and several Asian, Latin American, and Western European countries. During the Malvinas War, in 1982, Alfonsín took advantage of a large-scale public outcry over the military regime's ineptitude in confronting Great Britain for control over the Falkland Islands to question its neglect of human rights more publicly. This brought his party much needed support from university students and disgruntled factions within mainstream Peronism, represented by the Justicialist Party.[13] These precedents in Alfonsín's career lent legitimacy to his status as a defender of human rights in the political spaces opened by the transition.

Alfonsín entered office with the promise of continuing his commitment to human rights through a sweeping set of initiatives that would set the tone for national politics throughout the decade. Reinstating a democratic order was a process to be undertaken by all branches of government. By the end of 1983, several provinces had ratified new constitutions, six of which included clauses regarding the protection of human rights and eight of which included the defense of constitutional order, meant to prohibit military intervention. Alfonsín also initiated the process of reforming the national constitution. In 1984 the national government finally approved the stipulations of the 1969 inter-American convention on human rights, or the Pact of San José, and a United Nations convention on torture.[14] Alfonsín's administration designed laws to modify the penal and military justice codes (Leyes 23.049 and 23.077, respectively), which would alter the manner in which courts could process and punish the offenses of military personnel. These laws were complemented by additional legislative reforms, Leyes 23.042 and 22.942, that included allowing the review of civilian detentions and military convictions and a law that

revoked the automatic amnesty declared by the military government. In a gesture of evenhandedness, Alfonsín also issued a presidential decree (Decreto 157/83) mandating that the national procurator investigate and publicly announce the crimes committed by seven leaders of guerrilla groups prior to the military coup.

Alfonsín's most successful project, however, was the National Commission on Disappeared Persons (CONADEP), which went a long way in the process of normalizing discourses of the human rights movement in the restless cultural scene of the transition. This commission was created to centralize the investigation of cases of disappeared persons under the regime. A council of ten members chosen by the executive branch, CONADEP included a former Supreme Court justice, a Catholic bishop, a Methodist minister, a rabbi, a human rights lawyer, an engineer, a surgeon, a journalist, and a philosopher, all presided over by Ernesto Sábato, who was a well-established writer with ties both to the Communist Party and to anti-Peronist intellectual politics of the 1950s.[15] The commission collected evidence on the intimidation, kidnapping, detention, and disappearance of individuals and families under the military regime. It sought to determine the whereabouts of missing persons and their remains whenever possible and compiled a database of forensic evidence that could be used later in judicial proceedings. The members of the commission listened to the voluntary testimony of hundreds of families of the disappeared and paid special attention to the testimony of survivors or persons who had been released from clandestine detention centers. In total, the commission received information about the forced disappearance of 8,961 individuals and about the fate of over 2,000 more, including Raymundo Gleyzer.[16]

The commission released a report in 1984 entitled *Nunca más* (never again), which detailed the manner in which the military regime had conducted its systematic repression, kidnapping, and disappearance of an estimated 30,000 individuals. Full of illustrations and photographs, the report also documented the existence of at least 380 detention centers.[17] Widely accepted as the most accurate account of the military's atrocities, the CONADEP report quickly became the most often cited reference regarding this missing history of the dictatorship. It became an instant bestseller in Argentina, and the report was eventually translated into a number of languages and circulated all over the world. This document would serve as the knowledge base for innumerable subsequent intellectual and cultural forays into the history of the military regime. Between 1995 and 1996, the leftist Buenos Aires newspaper *Página/12* serially reprinted the entire report, selling over 75,000 copies each.[18]

Human rights discussions that began as a confrontation of the systematic violence of the dictatorship transformed into an all-encompassing shorthand for dealing with contemporary politics during the transition. Polemical debates by leading leftist public intellectuals, such as Mario Bendetti, David Viñas, Marcos Aguinis, Ernesto Sábato, and Horacio Verbitsky, began to revolve around themes of human rights violations and protection, as a lens through which both to measure the new political regime and to understand the dictatorship's repression. Leading social scientists, many of whom had by the end of the dictatorship been absorbed into small centers of investigation, began to examine the underlying causes of violence and its ramifications on the generation of survivors. The labor sector and many leftist political parties, some almost completely dismantled by the end of the dictatorship, saw a glimmer of hope in participating in the human rights movement. In general, the more militant sectors of the political left faced a collective crisis of identity and a tendency toward deradicalization as the military ceded power to a democratic transition government.[19] The national labor union, the CGT, which was still a stronghold of hard-line Peronism, had made strides in public demonstrations as early as 1982, decrying the military's excess. Many, however, saw the move toward the human rights movement as a strange devil's deal with the military to curb a resurgence of more radical leftism in the democratic opening.[20]

CULTURAL POLITICS OF HUMAN RIGHTS

The ascendance of the human rights movement in the political scene of the 1980s was further reinforced by events that threatened the stability of the transition. In an executive decree (Decreto 158/83), Alfonsín mandated judicial proceedings, popularly called the *juicio a las juntas,* or "the trial against the juntas," against the nine generals who had led the military regime, charging them with human rights abuses. These trials were attended by approximately 350 reporters, invited guests, and others, but information was not released to the public immediately. Because the 830 statements from both victims and perpetrators of the military's abuses were highly sensitive, the government permitted the media to broadcast only three minutes of video footage each day—and that without sound. Nonetheless, details from the trial filtered through the city. Individual stories of horror, alongside the shocking reactions of defensive military personnel, personalized the dictatorship's repression, replacing statistics and isolated facts with lived experiences. Images from these

trials were made exclusively from behind the backs of the victims and surviving family and friends. This measure, taken to protect victims' identities, heightened the public sensation of urgency in cementing gains in human rights protection for fear of renewed conflict. As locations of clandestine centers were made public, new mappings of the urban environment began to reflect knowledge of rights abuses. Photographs of the disappeared prior to their capture circulated in newspapers, on television, and in demonstration banners, posters, and leaflets. Each accusation launched against the military heightened tensions between the deposed regime and the new democratic administration. The perceived threat of reproach kept the human rights question in the center of national security debate; fearing that the videotapes of the trial might be destroyed, the federal judges sent a copy to Oslo for safekeeping.[21]

In April 1987, shortly after this trial began to issue convictions, the Fourteenth Regiment of the Aero-Transport Infantry in Córdoba threatened to undo all progress by staging a new military uprising during Semana Santa, the week running from Palm Sunday to Easter, once again demonstrating the fragility of civilian rule. Although the crisis was forestalled, this uprising resulted in the passing of the law of *obedencia debida,* or due obedience (Ley 23.521), meant to avoid another disastrous confrontation between the civil government and the military. This law gave impunity to military personnel found to have acted in accordance with orders from superiors during the regime, virtually nullifying the progress made by CONADEP in bringing justice to human rights offenses under the regime. Despite the frustration of the social justice and reconciliation process, the trials themselves served as an important step in creating an archive of collective memory and a potential source of historical documentation of the dictatorship period.

The *Nunca más* report and the juicio a las juntas became sites not only of public historical reflection but also of a new variety of cultural politics. The statistics, the images, and the testimonies released to the public quickly found their way into theater productions, literature, paintings, sculptures, photographs, popular music, comics, and cultural magazines.[22] In addition, cultural productions created under the dictatorship were revisited and reintroduced during this dynamic period of the city's cultural and intellectual history. For example, new interest surged in the mocking depictions of the military and its violence produced by the left-leaning magazine *Humor,* which had somehow managed to continue its political satire during the regime. The work of the social realist painter Carlos Alonso, who found safe haven in Italy and Spain during the dictatorship and even lost a daughter to the repression, found a new following. His paintings, which depicted acts of torture in visceral

detail, played on imagery of the conservative elite establishment, such as the Catholic Church, cattle interests, and of course, the military. Several authors, including Luisa Valenzuela, Alicia Portnoy, Mario Benedetti, Ricardo Piglia, and Manuel Puig, achieved widespread renown with what the literary scholar Amy Kaminski describes as "dirty war stories."[23] Manuel Puig's *Kiss of the Spider Woman*,[24] a novel about prisoners of a military regime, was made into both a play and eventually an international large-studio film. Ricardo Piglia's 1981 allegorical novel *Artificial Respiration* became an emblematic work of the transition, as did Jacobo Timerman's prison memoir *Prisoner without a Name, Cell without a Number*.[25] The decade saw almost weekly releases of cultural productions based on or related to the graphic details made public by the fact-finding commissions and the military trials.[26]

Human rights organizations also became prominent in the press and the international community for shaping the transitional cultural politics scene in the city of Buenos Aires. Some of these organizations were dedicated to public protest and symbolic resistance, often using images or likenesses of victims of the repression in public spaces to draw attention to the cause. In September 1983, for instance, on Students' Day, three visual artists with support from the activist group the Mothers of the Plaza de Mayo used paper cutout silhouettes of victims strategically placed in the plaza where the mothers marched in front of the presidential palace to demand justice for their disappeared children.[27] Still others were occupied with the legal work and documentation of the military regime's abuses. Among these, the most prominent was the Center for Legal and Social Studies, though many international organizations also played a role, such as the Ecumenical Movement for Human Rights, led by members of the Catholic Church; the Peace and Justice Service; and the United Nations' Permanent Assembly for Human Rights. Adding an important component to the public pursuit of justice and information, the Argentine Forensic Anthropology Team was formed in order to exhume and identify the bodies of disappeared and executed victims of the oppression. Each of these organizations had its headquarters in Buenos Aires and targeted the city's major periodicals for press releases, television and radio stations for interviews, and public spaces for conducting demonstrations and campaigns.

Together these groups led the public debate in Buenos Aires surrounding these issues. Adolfo Pérez Esquivel, the founder of the Peace and Justice Service, won the Nobel Peace Prize, for which Estela de Carlotto, then president of the Grandmothers of the Plaza de Mayo, was also nominated, both nominations in recognition of their efforts to bring about social justice. As more

graves were discovered and new clandestine detention centers found, and with an increasing number of families offering testimony, these human rights groups organized and analyzed the information, often before the press entered it into public consciousness. In their continuing efforts, these organizations made the language of the human rights movement commonplace in the press and in daily parlance. Human rights became a sweeping, multisector social movement that changed the lexicon of public discourse about the recent past.[28]

Many films, books, and other cultural products that had previously been censored by the military, or had been completed but not yet made public, were released to a hungry public after 1983. Cultural and intellectual producers capitalized on the spirit of the period by identifying themselves with the human rights movement. Some intellectuals articulated solidarity with these causes as a means to balance their objections to other key issues of transition politics, such as a handful of well-known Peronist intellectuals concerned with allegations of a labor-military pact. This kind of cultural politicking became common in the atmosphere of mutual suspicion that followed the dictatorship. Frequently, charges of tacit consent with military policies were launched at individuals and social groups to discredit their positions or their productions.[29] Thus, forming alliances often entailed disproving any complicity with the wrongdoers of the past, which created a market for cultural ties to "heroes" of resistance, a term that in this case was often synonymous with "victims."

Within the left-leaning media, the turn toward identification with the victims of the dictatorship and, more generally, with the human rights movement was also observable. Two new newspapers, the leftist daily *Página/12* and the politically focused weekly *El Periodista,* both included regularly running columns dedicated to the subject of human rights. The Peronist monthly magazine *Unidos* regularly published interviews with political prisoners who had survived or been released. Jacobo Timerman even began hosting his own television program on the state-sponsored channel.[30] Intellectual magazines, such as the left-leaning *Punto de Vista,* which had remained in clandestine circulation from 1978, became increasingly popular, advancing a more scholarly approach to questions of human rights, collective memory, and the reconstruction of a missing chapter of national history.[31] The cultural and intellectual scene in Buenos Aires during the transition provided a rich landscape within which filmmakers would have to stake out their own territory.

The discursive framing of human rights in Buenos Aires came to color evaluations of the transition's progress and created a new field of symbolic politics, one that would be particularly auspicious for dealers in audiovisual

media. The graphic images that created a new visual "ideascape" of the city and its past were widely circulated and available for reuse. Oral testimony as a narrative mode was well suited both to documentary film and to fiction film screenplays. In a climate of hostile suspicion, it was no small matter that the public relied on the testimonies of survivors and families of victims as accurate representations of a hidden past. The collaboration of voluminous photographs, forensic records, official reports, and testimonies also meant that generalizations could be made from individual accounts. These elements of political discourse could be easily incorporated into the format of audiovisual media, which commonly employ montage and a collapsing of historical complexity into representative characters and storylines. What better way to re-present these histories to a ravenous audience than to assemble oral accounts, photographs, drawings, and video footage into an audiovisual argument? Thus, the very techniques that Alfonsín had used to establish his own credibility in the transition served as a platform for the authentication of an audiovisual information and knowledge base.

URBAN SYNERGIES AND SENSIBILITIES

Alfonsín further paved the way for the ascension of audiovisual media through his ambitious set of cultural policy initiatives. To publicly reinforce the genuineness of his party's return to democracy, he created a more flexible institutional apparatus and production infrastructure for cultural activities. For instance, he authorized the transfer of several radio stations from state to private hands. Alfonsín also opened new radio channels in the provinces to decentralize the dissemination of information and gave several national universities the right to broadcast a radio signal.[32] These gestures went a long way toward reinforcing the image of restored civil liberties and advancing the notion that the public could count on the communications media for reliable information. Alfonsín was conscientious about pursuing cultural projects that also promoted autonomy within state cultural industries.[33] As part of the first cultural restructuring initiatives taken in 1984, the administration decentralized the film institute and made it once again an autonomous organization.[34]

Similar measures were taken for state bureaucracies in other mass communication media. Alfonsín also encouraged these institutions to become more participatory, sponsoring public initiatives that would make the media more transparent. For example, he created opportunities for community participation in cultural workshops on journalism, television production, script-

writing, and radio broadcasting. These programs were lauded across the political spectrum as indicative of a new climate that encouraged freedom of expression—a litmus test for the place of human rights within the new value matrix of Alfonsín's democracy.[35] All these measures made audiovisual means more accessible to the average citizen and expanded the image of participatory and democratic national communications media.

The city of Buenos Aires was the showpiece of Alfonsín's cultural initiatives. In 1986 the cultural workshops program was initiated in ten popular libraries across the city. Over the course of Alfonsín's administration, it expanded to 100 locations, mostly in the capital district. By the time Alfonsín was leaving office, this program had sponsored 295 functions. From 1984 to 1988 the government raised the total number of prizes, subsidies, and scholarships awarded through the National Art Fund to 3,246, with the vast majority awarded to artists working in the city of Buenos Aires. The art fund organized "national salons" in the port city for painting, sculpture, ceramic arts, printmaking, drawing, and photography.[36] In addition, the Alfonsín administration prompted the Ministry of Culture to sponsor a national congress on theater studies, to be held in Buenos Aires every year starting in 1984. The congress was conceived as a site of intensive exploration of cultural problems during the transition. For instance, in 1989 artists attending the congress chose the theme of national identity, with congress roundtables confronting shifts in national identity brought about by the cultural politics of the democratic opening. By directing considerable resources and opportunities to the city's burgeoning talent base, Alfonsín's cultural policies turned the city and its municipal government into a machine of cultural production in the service of his transition agenda.

Alfonsín also sought to revitalize the democratic nature of cultural life in the city. In 1983, with the appointment of Mario "Pacho" O'Donnell as the new secretary of culture of the Buenos Aires municipal government, he pushed forward an agenda that he hoped would expand cultural programs to promote democratic ideals across the city. In 1984 the municipal government created the Cultural Program in the Barrios with the objective of expanding the reach of cultural education. This program decentralized the mode of public sponsorship of cultural events, stimulating cultural life in the city's different neighborhoods. The municipal government also worked through the Historical Institute of the City of Buenos Aires, initiating a program called Workshops in Collective Oral History. This program was intended to recover collective memories and archive the lived experiences of the inhabitants of the city. The workshops were designed to develop nuclei of social solidarity

and assist communities in reestablishing bonds broken during the dictator-ship.[37] In another city initiative, O'Donnell's office began to host events to raise awareness about the dictatorship and the process of redemocratization. In 1985 the municipality hosted an exposition in the barrio of San Telmo on the transition to democracy, attracting large crowds to view open-air exhibi-tions of photographs and informational displays. These projects stimulated public debate about the nation's recent past. They also served as the begin-ning of an important cultural movement for making the city a living site of memory production and preservation, one in which filmmakers and other groups of cultural producers would energetically participate.

Alfonsín's cultural opening indirectly favored Buenos Aires as the site of emerging and reemerging intellectual communities. The Alfonsín adminis-tration normalized the functioning of universities, beginning with the insti-tutions of higher learning in the capital city. The primary beneficiary of this reform was the University of Buenos Aires, which from 1983 onward stood as the leading institution of higher learning in Argentina, if not throughout South America. Beginning in 1983, Alfonsín also encouraged the reconstitu-tion of previously repressed academic communities. Many of these commu-nities had gone underground or abroad during the dictatorship. When they finally found support within state-funded institutions and assurance of intel-lectual freedom, they tended to converge on the capital city.[38] Intellectuals and academicians were invited, on occasion personally, back into public life, and the transition scene in Buenos Aires quickly became one of renewed in-tellectual dynamism. The vitality of urban intellectual space created a credible arena for cultural expression and critique, particularly for media that relied on intellectual and critical communities to provide an audience.

The foreign politics of the transition also played a role in reinforcing achievements of audiovisual media in the new political culture. As Alfonsín was acutely aware, he needed to cultivate international support to strengthen both his domestic image and the economy. The image the transition projected abroad would condition foreign investment and thus his party's longevity in office. Logistical support from abroad, the United States in particular, was critical to the consolidation of democracy.[39] This particular balance of inter-national relations meshed well with the Radical Party's focus on human rights issues. First, party leaders considered investment flows to Argentina to be directly linked to the reintroduction of democratic elections, civil liberties, and human rights protection.[40] This tended to elevate the discourses of human rights protection to a matter of national economic significance, giving greater weight to the social agenda of the Radical Party. Second, such ties fostered

the party's security, for international hostility toward the Argentine armed forces limited the scope of claims that could be made by the many conservative detractors who still had close ties to the military.[41] Most important, international support demonstrated that the strategic ideological capital of the human rights movement could be utilized to promote a number of distinct political projects. The currency of human rights ties used by the Alfonsín government was immediately recognizable in posttransition politics, and the capacity to direct social change by making such ties was not lost on the Argentine public. Alfonsín recognized the strategic usefulness of this particular kind of cultural production in furthering his party's agenda and maintaining support from powerful allies. For this reason, he took special interest in the film industry.

PARTICIPATORY TECHNOLOGIES

Alfonsín saw the film industry as a tool to fashion a new national image. He hoped that Argentine films could help publicize a redemocratized Argentina and thus convince the international community that the country was once again open for business. With Congress and his political opponents universally accepting an end to censorship, Alfonsín sought a way to use this measure as a means to appeal to filmmakers.[42] His first gesture to the industry was to formally dissolve the board of the military's Rating Entity, which had been the military's censorship engine, asserting that the common penal code, which criminalized public obscenity, was adequate protection against any "concrete dangers" arising from lewd cinema.[43] There was a hefty profit to be made by the industry once films that had been previously excluded from the market were allowed to be imported and screened. This change was well received by a national film industry starved for revenues and also by international distributors who would be more likely to pay attention to Argentine films under reciprocal arrangements. Breathing new life into the film market, however, would not be enough to convince directors to make films favorable to the Radical Party's transition agenda.

Evidence of renewed state support was critical in confirming Alfonsín's commitment to the industry. Alfonsín appointed the established filmmaker Manuel Antín as the new head of the National Institute of Cinematography, or INC. Antín would be responsible for enacting the broad policy mandates outlined by the administration. He was also charged with resuscitating the state's financial sponsorship of cinema. In an institution with a dubious

history concerning financial solvency and bureaucratic stability, the director-ship would need to be the driving force behind real institutional change.[44] Alfonsín privately offered Antín $200 million to accept the appointment.[45] One of a handful of established directors of the Generation of the '60s and the director of important vanguardist films of the period, such as *La cifra impar* (*Odd Number* [1962]) and *Los venerables todos* (*The Venerable Ones* [1962]), Antín had chosen to remain in Argentina throughout the dictatorship, despite the military's censorship and blacklisting.[46] Antín had a solid reputation in the industry as a longtime member of several important industry organizations, including the writer's guild ARGENTORES, the film industry union, and sev-eral professional associations of producers and directors. By appointing a well-established director with strong leadership credentials within these orga-nizations, Alfonsín signaled his willingness to invest in the industry's future.

Alfonsín was also interested in courting Antín as a means of adding cred-ibility to the Radical Party's cultural agenda as a whole. Antín was a member of the party and had participated in outlining its cultural platform for the early transition.[47] Antín accepted the directorship, vowing to do his part to further the new government's agenda and expressing his belief that film should be used as a means to establish faith in the new Argentine democracy.[48] In 1985, once Antín was in office, Alfonsín sent him on a "democracy tour" of the Soviet Union, where he showed Argentine films "made under condi-tions of freedom of expression" and spoke about the use of film to promote representative politics.[49] As a result, the Soviet Ministry of Culture hosted a week of Argentine films in Moscow, a highly symbolic gesture given the height-ened tension of the cold war at the time.[50] In addition to supporting these outward-looking measures, Antín emphasized bettering the education given at the INC's film school by improving its course offerings and adding advanced degrees.[51] Antín and his subdirector also made ambitious plans to democra-tize national cinema by extending film exhibitions to the interior provinces, reopening film schools closed by the military, and decentralizing the mar-ket.[52] By February 1985 Antín had negotiated a settlement in Congress to reinstate the 10 percent exhibition tax (enacted by Ley 23.170). This tax au-tomatically went toward the film development fund, allowing the institute to revive its former status as a producer of national cinema.[53]

Antín further strengthened the government's commitment to the industry by using the film institute to open access to external markets. By sponsoring and sending Argentine films to international festival competitions, he im-proved their international visibility. During the first year of his directorship, Antín participated in the Berlin Festival, supporting the two-part documen-tary *La república perdida* (*The Lost Republic* [1983 and 1985]) and the fiction

film *No habrá más penas ni olvido* (*Funny Dirty Little War* [1983]). The latter won three important prizes and brought international attention not only to its producers but also to the administration's attempts at social justice and reconciliation. Antín also traveled to Paris to conduct negotiations with the French Ministry of Culture. There, he reached an accord to send films to Paris for a retrospective of Argentine cinema and negotiated with the French periodical *Liberation* to sponsor an exclusive screening for contemporary Argentine films. He arranged for coproductions by Argentine film producers and French television companies, paving the way for increased broadcasting of Argentine films on French television. The French government agreed to raise the budget of its allotted development subsidies to F 3 million toward coproductions with Argentina. In Madrid, Antín met with Spain's director general of cinematography to sign a treaty that enabled coproductions and expanded the distribution of Argentine films to Spanish audiences. In addition, he worked with the authorities of the Spanish news magazine *Cambio 16* to organize a week of Argentine cinema in Madrid.[54] Finally, he was able to rehabilitate the class A status of the Mar del Plata International Film Festival with the International Association of Film Producers, alongside such major festivals as those in Berlin, Cannes, and Venice.

The regulatory changes to film policy enacted under Alfonsín's Radical government reinforced the idea of the democratization of cultural institutions to the Argentine public. The first new cinema law passed was Ley 23.052, ratified on February 22, 1984. This law ended previous regulations regarding film rating, preserving only the protection of minors and notices of film content.[55] Article 2 of this law articulated the state's mandate to protect pluralism, ensuring adequate respect for diversity in culture, ideology, and religion. It even added a representative of the Grandmothers of the Plaza de Mayo to the new Rating Entity board as the new national representative of "family values." Soon thereafter came reform to film rating, with the creation of a commission composed of members selected by what was considered a set of organizations and institutions representative of Argentine society and values.[56] These popular regulatory moves, along with the adept management of the film institute, became motors of change for Alfonsín's pursuit of collaboration between the film industry and the state.[57]

Cinema in Buenos Aires, like its cultural industry counterparts, experienced a phase of incredible vitality during the transition. Independent cinema began to reemerge after a long silence. The Argentine Association of Independent Cinematographers (Asociación Argentina de Productores Cinematográficos Independientes) was created in 1983 to represent producers of independent cinema, with Oscar Barney Finn and a handful of renowned

directors, including Luis Puenzo and Antonio Ottone, at the helm of the new organization.[58] This group's stated goals included promoting artistic cinema, mobilizing international distribution as a means to create dialogue with other national cinemas, and promoting changes proposed by Alfonsín's new legislation for the film industry. In addition, it voiced support for new forms of production, opening the market to grassroots and nonstudio productions.[59] This call to pluralism intentionally reflected the urban cultural politics of the democratic transition.[60]

The film industry continued transforming as independent producers began to shake up the traditional industrial relationships between the film institute and filmmakers. In 1987 eight cinema cooperatives came together to form the Argentine Federation of Cinema Labor Cooperatives, electing Antonio Ottone to serve as president.[61] This federation created a capitalization scheme by which cooperatives could acquire equipment and labor without relying on traditional market structures.[62] Ottone voiced his organization's official accord with the principles of the film workers' union, SICA, but argued that cooperative members should not be beholden to its dictates. He claimed that industry compliance with its system of contractual obligation was at best applied only partially and that the entire industry ought not be obliged to a set of rules that were not consistently enforced. He pointed to 1982–1983 as the period when the cooperatives began working, a moment when film legislation was viewed at best skeptically, since its sponsor had been the discredited and illegitimate military regime. Because the cooperatives considered legitimate by the federation were nonprofit organizations, their productions remained outside the scope of the union's mandate and the legislation governing the commercial industry.[63] The federation used this justification to make a case for operating beyond the bounds of industry regulation, allowing grassroots and noncommercial cinema a legitimate means by which it could be produced and exhibited.[64] The Alfonsín government regarded this move by independent filmmakers as a blessing, reducing the power of the still predominantly Peronist SICA.

A second source of independent cinema, grassroots film cooperatives proliferated steadily throughout the transition. Many students graduating from various film schools at the time were active in cooperatives. They argued that such spaces were necessary to produce artistic rather than simply commercial films. Students fought for this mode of production as an alternative to the industrial mode that, they argued, excluded many workers and potential filmmakers. In the year it was created, 1985, the cooperative Centro de Producción Avellaneda, presided over by Raúl Tosso, released the film *Gerónima*, which

was based on the true story of a Mapuche mother who faced violence at the hands of the state in the 1970s and eventually lost custody of her children. The film went on to win many international prizes that same year, and its success helped foster increased acceptance of cooperatives as a legitimate mode of film production. By 1987, 25 percent of nationally produced films were made by cooperatives.[65] These mutual labor associations claimed to be the most democratic forms of solidarity among directors working with scarce resources. In this way, films made by cooperative labor, particularly those of the late years of the military regime, were hailed as being the vanguard of transition culture.

As early as the final years of the military regime, filmmakers had already become one of the most active and publicly recognized groups to organize for democratic change. After the transition, a smaller set of SICA members, more closely aligned with the aims of leftist Peronism, organized as the Seventeenth of October Group to promote their political interests through the union. Flyers made by this group reprinted quotations from Fidel Castro's 1973 speeches on nonalignment and from Juan Perón's speeches about the workers' plight.[66] They demanded the dismantling of economic policies that favored neoliberalism and foreign interests, if not the actual homes of "capitalist pigs" as well. This vocal group increased the union's public presence and raised the flag of militancy, which had been cast aside during the epoch of repression. In 1985, when Alfonsín initiated economic reforms, it protested the lack of industrial solvency, this time incorporating antidevelopmentalist rhetoric into its calls to safeguard democracy against another military usurpation.[67] This group considered Alfonsín's administration to be falling into the same trap of external economic dependency and neocolonialism that had already sabotaged other national industrial pursuits. Thus, it allied itself with other vocal communities of intellectuals on the left, such as the Communist Party and the new Workers Party, to promote increased industry protection. The activity of this subgroup of film workers was complemented by the activism of the union itself.

At this time SICA began a broad-based campaign to claim political space in the public arena by organizing demonstrations with other groups of cultural producers. A large group of film workers took to the streets on September 7, 1983, accompanied by members of the writers' guild ARGENTORES, the actors' association Artistas Argentinos Asociados (AAA), the national labor union CGT, and the Argentine Cinematographic Directors association (DAC). Their presence was perhaps one of the most organized and recognized of the many demonstrations taking place in the Plaza de Mayo during

the transition's early months. Their calls for justice for disappeared colleagues, an end to censorship and blacklisting, and new cinema legislation became emblematic of the popular demands prevalent in the transition. The protests, which proceeded from the Ministry of Culture to the Casa Rosada, were front-page news in all the leading national newspapers, including *Clarín, La Nación,* and *La Voz.* The easy identification of various actors and directors in photos and on television increased the marches' public visibility.[68] Thus began the significant public presence of filmmakers, which would continue throughout the Alfonsín presidency, from 1983 to 1989, and even afterward. Their activism marks a unique moment during which workers within a particular industry were able to capitalize on the opening created by democracy to refashion their image and to augment their collective political currency.

Filmmakers, however, had established themselves in the emerging ideological political architecture of the transition even prior to the democratic opening. One of the modes filmmakers reused to make their collective voices heard during the transition was the solicitada. In 1982, on the verge of the military's softening, a group that included several prominent women filmmakers printed a solicitada in the popular magazine *Humor.* This piece, signed by the director María Luisa Bemberg and the screenwriter Aída Bortnik, argued for the protection of human rights and for the duties of citizenship.[69] In 1983, in solidarity with the Movement for the Recuperation of Disappeared Children, organized by the Grandmothers of the Plaza de Mayo, the prominent directors Adolfo Aristarain, Aída Bortnik, and Luis Brandoni, as well as several other important cultural and political figures, signed a solicitada that was printed under the title "Disappeared-Kidnapped Children since 1976." This brought early attention to the cases of kidnapped children and began to form a link between the public image of the grandmothers' group and filmmakers.[70] In 1984 filmmakers aligned with other important figures of Argentine cultural and political life to commemorate the ten-year anniversary of the assassination of Father Múgica, a Catholic priest who had spoken out against the military regime.[71] Many of these solicitadas addressed the theme of culture in democracy. In response to rumors and open threats of a return to military rule, filmmakers, alongside many other representatives of the arts, signed several solicitadas calling for the maintenance of democracy and liberty of expression in the arts.[72]

In fact, the early activism of the film industry helped it establish credibility in the urban cultural environment of the transition before other communities did so. In 1982 SICA and its many allies vocally protested the military's repression. It issued some of the most direct statements coming from such organiza-

tions at the time, accusing the military government of unconstitutionality and clamoring for the reestablishment of moral order and justice.[73] The four film organizations involved—the Unions of Employees of Cinematographic Distributors, the Cinematographic Operators, the Union of Public Spectacle Workers, and SICA—came together to petition the military's undersecretary of culture, Julio Gancedo, to rectify the situation.[74] A commission for the study of human rights was founded within SICA and worked in conjunction with groups from affiliated unions as an interunion organization centered in the CGT. Documenting how the regime had intervened in a variety of unions, the report recounted cases of imprisonment, assassination, and torture of various union leaders. It noted the disappearances of important film workers, including Armando Imas, Julio Carboni, Raymundo Gleyzer, and Enrique Juárez, whose names, carried on banners in many public marches, became emblematic of SICA's quest for justice. Taking part in the first mass political demonstrations against the regime in the Plaza de Mayo, SICA would become one of the most visible presences during these events.

Along with engaging in political activism, filmmakers were beginning to reclaim a place within cultural and intellectual life in Buenos Aires by renewing the publication of film "*revistas,*" or magazines. The number of these periodicals began to increase following the democratic opening, as many filmmakers began to return from abroad. The reemerging magazines included several that had begun underground during the late stages of the military regime. For instance, *Cine Boletín,* founded in 1981, was dedicated to the production of politicized noncommercial cinema. It published issues featuring themes such as the decolonization of culture, political cinema, and pioneers of the nuevo cine movement. *Cine Libre,* begun in 1982, counted on the collaboration of several important figures in both political and industrial settings. With long editorial appeals to public conscience for the recognition of all that had been experienced under the military regime, both in sociocultural terms and in terms of film censorship, this publication was perhaps one of the most outward-looking and reflective of the genre. It commented on scholarly themes, such as ethics in art; the status of independent production; and the political potential of militant cinema. Many of these new cinema magazines aimed to cultivate an audience among intellectual circles, particularly those returning from abroad or reentering newly reopened spaces. Intellectual audiences soon picked up the other end of the dialogue. Some publications targeting those audiences, including *Punto de Vista,* the magazine of an intellectual group that emerged from underground resistance during the transition, even advertised in several of these film magazines.[75]

The first generation of transition films, previously banned by the military, finally had public screenings in Argentina during this wave of activity. Films by Cine Liberación and Cine de la Base were screened across the city at cultural centers, universities, and museums, as well as at political party meetings. In 1983 the municipal government of Buenos Aires even sponsored a special tribute to Cine Liberación, hosting a series of films in the San Martín Cultural Center. The Senate contributed funds to the project and was billed as a cosponsor of the film series.[76] As the first generation of transition films began to enjoy a prominence in even official national film history, contemporary filmmakers were encouraged to take on similarly politicized themes. The film industry's favorable reputation as part of the resistance, which it had established through outright activism prior to the transition, was complemented by a surge in public demand for film products, particularly those that had been censored under the military regime. Together, these factors enabled filmmakers to participate in the technology of place emerging in transition cultural politics.

RAISING CONSCIOUSNESS, CRAFTING SUBJECTIVITIES

The second generation of transition films evolved in the restless climate of cultural politics following Alfonsín's election. From 1983 to 1988, several Argentine filmmakers returned to the ideological mantras of the nuevo cine movement. Some followed Fernando Birri's call to create a revolutionary public consciousness about the recent past. Applying the principles of the nuevo cine movement to larger-budget commercial films, this generation aimed to strengthen a critical social awareness by using more popularly accessible modes.[77] Under Alfonsín, all filmmakers could apply for state coproduction, regardless of political affiliation,[78] and many filmmakers accepted this assistance to fund projects that would participate in the process of crafting a new collective subjectivity.[79] The common elements of this new subjectivity included incorporation of the values outlined within human rights discourses, acknowledgment of the nation's history of politically motivated violence, and acceptance of accountability and a civic duty to act against such injustice. Although different directors chose to make films with competing arguments about the past, their projection of a common sensibility toward these themes was virtually universal.

Among those who rose to the challenge were several directors who wanted to bring a nationalist, realist, and autocritical cinema to the foreground of

Argentina's popular film culture. María Luisa Bemberg, for example, through her allegorical films *Camila* (1984) and *De eso no se habla* (*I Don't Want to Talk about It* [1993]), dealt with issues of gender relations during and after the dictatorship and with the silencing of dissonant viewpoints and memories. Her films attracted international praise for their allegorical references to the dictatorship and to the women's rights movement, allowing Bemberg to become a prominent spokesperson for feminist issues, articulating gender issues and the body as reclaimed territory in the postmilitary era. From the veteran ranks of social cinema, Fernando Ayala, Leopoldo Torre Nilsson, Fernando Birri, and others contributed work that addressed the use of cinema in collective memory, the creation of a visual symbolic vocabulary, and the spectator as active participant in dialogue with the filmmaker.[80]

Working in a film community already geared toward international audiences and radical politics, many of these filmmakers sought to raise consciousness and spur social activism across a variety of continents. To do so, they had to tackle the dictatorship in an intelligent and thoughtful manner. The approach they took can be seen, at least in broad strokes, in two sets of issues the directors addressed. In general, earlier films tended to deal with issues of acknowledgment, familiarization, recognition, causality, and consequences of the military repression. Later films leaned more toward issues of social reintegration and the recognition of complicity, healing, and recovery. The most internationally recognized of the second generation of transition films was *La historia oficial* (*The Official Story* [1985]), which won an Oscar for best foreign-language film in 1986. Made by Luis Puenzo and based on a script by Aída Bortnik, this film typifies the manner in which this set of filmmakers hoped to craft a new subjectivity.

The film narrates the story of one high school history teacher's attempt to make amends for her unwitting complicity with the military regime. Her personal story, with its parallels to that of the nation, reveals in semidocumentary style the horrors of the military's repression. The protagonist "interviews" several representative characters, is confronted by newspaper clippings and news footage of the release of information by the fact-finding commission and the military trials, scrambles through photographs of the disappeared released by the Grandmothers of the Plaza de Mayo, and visits locations of freshly revealed clandestine detention centers. The film culminates when she discovers that her adopted daughter is actually the stolen child of a disappeared woman and that her husband participated in the repression, his complicity arising through his position within a multinational corporation. The film moves from consciousness raising to an acknowledgment of complicity

and, finally, restitution. The main character is transformed from an unsuspecting accomplice into a responsible citizen. The politicized subjectivity the film was meant to create is visible in the protagonist's acknowledgment of her former neglect in failing to teach her students about the abuses of the military regime and her search for her daughter's biological grandmother.[81] A border-crossing cultural document, the film was among the most successful manifestations of global interest in the redemocratization of the Southern Cone. In addition, Bortnik's account was considered critical in presenting the experience of the middle class, an angle of the story that had been somewhat overlooked in official narratives.[82]

Puenzo and Bortnik's international experience epitomized the successful collaboration of Alfonsín's transition government, human rights organizations, and filmmakers. The official press book of the film, printed and circulated by Hollywood's Academy of Motion Picture Arts and Sciences for the Oscars, presented the film's argument alongside a number of journalists' and critics' analyses of its relationship to the events of the dictatorship. It included testimonies that confirmed the accuracy of the film's portrayal of historical events. Addressing an international audience, the press book described the military regime, kidnappings, torture, and disappearances, as well as the relevant social context. This introduction was followed by a piece written by Puenzo, who describes his reasons for making the film, ones derived from his own "awakening from the nightmare." The film evolved, he states, from his desire to communicate to average spectators, appealing to their senses of seclusion and budding awareness about the events of the recent past. Puenzo clearly indicates that the film was not directed toward militants, though many of his cast and crew had been forced to flee the country, and several continued to be harassed by the armed forces.[83]

A piece written by a Grandmother of the Plaza de Mayo compares the film to her personal desire to return stolen memories and identities to her own granddaughter, whose parents were among the disappeared. Following her moving commentary, a journalist recounts the political activism of the Grandmothers and Mothers of the Plaza de Mayo and calls for solidarity with their cause. The back cover of the press book carries the Argentine cinematographic institute's slogan, "Argentine movies enjoy freedom and democracy," and lists several films with political content alongside the festivals in which they participated and the awards each received.[84] In a press conference following the Oscars, the actor Luis Brandoni, in the self-appointed role of international film diplomat, made clear that the film was made possible by the process of the transition and the generous credits of the film institute.[85]

Second-generation transition films often took allegorical approaches, as can be seen in the seasoned director Héctor Olivera's *No habrá más penas ni olvido* (There will be no more suffering or forgetting; the film was released abroad as *Funny Dirty Little War*). Olivera made his mark on the world of radical Argentine cinema in 1974 with the film that forced him to flee the country, *La Patagonia rebelde* (*Rebellion in Patagonia*). As one of the first directors to return and take on the second-generation challenge of postmilitary cinema, however, Olivera created new work that was much more controlled in its critique. Based on an eponymous book by Osvaldo Soriano, the later film is a farcical comedy about factionalism. The action begins when a local Peronist functionary decides to defend his job by occupying town hall with the assistance of the town drunk, two half-wit police officers, and a couple of his buddies from work. A comic play on the political behavior of stock types quickly transforms into a sweeping social critique, as "Bolshevik" student activists, labor unionists, the army, the state governor, and the town crop duster all join in the standoff.

According to the film's national registration, this mise-en-scène of the military takeover uses narrative comedy to illuminate the possible motives and misunderstandings behind certain disastrous decisions made by the power elite. Olivera uses black humor to explain the rationality of responses from various politically charged sectors of the population. For instance, the crop duster, who uses his plane to dump manure on the attacking military police, was meant to signify the dangerous combination of nationalist zeal and inadequate channels for expression that characterized the activities of several left-wing militant groups. The entire violence of the film is staged at night, hinting at the obscurity and hidden nature of the events represented.[86] By caricaturing Peronism on the eve of the military coup, Olivera created an anthology of political and psychological behavior meant to be applied beyond the scope of the film's critique as part of a new political subjectivity.[87]

Various other filmmakers further articulated the new political subjectivity of the second generation of transition films. Miguel Pérez's two-part documentary *La república perdida* was the most acclaimed nonfiction film by an Argentine director to be released either nationally or abroad in the 1980s. The first of these two films, which took sharp aim at Peronist politics, gave a strong impetus to the new radical regime under Alfonsín and contributed to the future president's campaign. Oscar Barney Finn's film *Contar hasta diez* (*Count to Ten* [1985]) tells the story of a man who, together with his father, looks for a disappeared family member. Throughout the film, the father reads letters that interweave individual events with national events during the dictatorship.

The film ends with the family's attempt to deal with the eventual discovery of their relative's murder. A representative sampling of these films would also include José Santiso's *Malayunta* (*Bad Communication*), released in 1986, a film about the manner in which an authoritarian regime gradually transforms normal citizens into monsters; Eliseo Subiela's *Hombre mirando al sudeste* (*Man Facing Southeast* [1987]), which narrates the mysterious appearance of a man in the neuropsychiatric ward of a hospital searching for a lost identity; and Simón Feldman's *Memorias y olvidos* (*Memories and Forgetting* [1987]), which relates in semidocumentary fashion the story of two journalists attempting to reconstruct the events of the military dictatorship.[88] Of the 173 films released during Alfonsín's presidency, 54 related directly to dictatorship.[89] At one point, Manuel Antín claimed that the experience of going to the cinema had become "psychoanalytic sessions on film," with audiences using the movie house as a sort of collective confessional.[90]

Audiences were particularly fascinated by the first films of the second generation, but interest waned in the later years of the transition, and production companies could no longer bank on box-office revenue for films addressing the dictatorship. The high point for these films came in 1985 and 1986, which corresponded to Oscar nominations for Puenzo and Bemberg's films. During these years, the two directors' films topped the charts for several months with record audiences. Both before and after Alfonsín's term in office, however, American productions with similar themes began to compete for market space, often successfully. These included Constantinos Gavras's 1982 film *Missing*, which deals with the disappearance of an American in Chile, and Roman Polanski's 1994 film *Death and the Maiden*, adapted from Ariel Dorfman's Argentine-Chilean theater piece about the aftermath of Pinochet's regime. Over the course of these years, however, even the most popular national films and films about dictatorship lost out in the box offices to standard Hollywood fare, such as *Ghostbusters, The Purple Rose of Cairo, The Killing Fields, Last Tango in Paris,* and *The Karate Kid*.[91]

FILM CRITICISM AND THE END OF THE TRANSITION

The variety of critical discourses that emerged around the success of *The Official Story* illustrates the manner in which films crafted subjectivities in relating the recent past. Despite the fact that these consciousness-raising films did not single-handedly recover the market shares lost to foreign films, they did go a long way toward demonstrating that national cinema could

speak to its audience about the particular experience and collective past of Argentine society. Specifically, the flurry of activity generated by the success of *The Official Story* proved that film could spark political debates and bring awareness to a public otherwise more difficult to engage. This was a revelation not to be lost by filmmakers or their viewing public. Reactions to *The Official Story* ranged from affirmation to disgust, from seeing it as validation of democratic impulses to taking it as proof that no real justice would prevail. Conservative periodicals, such as *Familia Cristiana,* called the film "a call to conscience" and reflected on the importance of its proposition and the freshness of its handling of contemporary affairs.[92] Industry periodicals used the film to measure gains in human rights by tracking its exhibition in various countries where oppressive regimes delayed its release. For instance, *Heraldo* celebrated its 1987 release in Chile, a country that had censored even the television broadcast of the Oscars when the film was nominated.[93] Some critical reviews drew attention to the activism of the Grandmothers and the Mothers of the Plaza de Mayo, using the forum generated by the film to address the social questions raised by these groups.[94]

Several mainstream newspapers reported on reactions to the film abroad as a means to gain an "objective viewpoint."[95] For instance, *Ambito Financiero* interviewed the Spanish filmmaker Pedro Almodóvar regarding his impressions of *The Official Story* and *Camila.* Almodóvar compared these films to his own ideas about character development in filmmaking and expressed his disappointment in their failure to make a more serious political argument.[96] This and other reviews and observations helped frame the subjective experience of watching these films, situating the viewing public as critics of the way the past would be handled by its narrators. Public discussions centered on such issues as the manner in which spectators should use specific films as a means to evaluate the various projects of human rights groups and other sectors of civil society.

In turn, the second-generation transition films made film critics of various people involved in cultural politics, creating conversations that used film to talk about additional political matters. By the time the 1986 Academy Awards were televised in Argentina, many critics were ready to voice their objections to a film they saw as principally opportunistic and commercial and used *The Official Story*'s shortcomings to criticize the lightness and failures of Alfonsín's democracy.[97] Vocal critics, such as César Magrini of the popular news magazine *Gente,* openly maintained that the Oscar was a politicized award, reflecting the geopolitical interests of the United States at large, rather than an award strictly for talent in filmmaking.[98] Some human

rights organizations, particularly writers for the in-house publication of the Mothers of the Plaza de Mayo, complained that the film had not gone far enough in its ideological treatment of the subject matter, while others, such as the Grandmothers, were quite complimentary of the film, collaborating with the director and even sending a congratulatory card to celebrate his success.[99] By contrast, in the House of Representatives, homage was given to *The Official Story*, and its projection in the congressional chamber was followed by praise from senators and Secretary of Culture Marcos Aguinis.[100] When Alfonsín's term in office came to an end, the landscape of political filmmaking in Argentina had permanently changed.

Filmmakers found ample support to assert their presence within the dynamic cultural scene of Buenos Aires by appealing to the state and the film institute. Antín considered the position of cinema during the transition as one that transcended mere industrial politics or artistic endeavors. He saw film as a mirror that could reflect the democratic dialogue taking place, and he was able to convince the Alfonsín government to increase funding on that principle.[101] By December 1987, he was able to announce at a press conference that never before had so many Argentine films been made under conditions of liberty, to such international and critical acclaim, and with the guarantee of national exhibition. The distribution of national films abroad had been incredibly successful, with thirty-six films sold internationally and deals cut with television channels in various countries.

By 1988 Argentine films had been awarded over 150 prizes in international competitions. An important share of films produced in Argentina involved coproductions with Italy, Spain, or France.[102] This meant that Antín had succeeded in courting international capital to advance national industry and production and in bringing jobs and recognition to the Argentine filmmaking industry. Most Argentine coproductions with European countries were set and filmed nationally, with almost all native casts, directors, musicians, and technicians. By 1989 the number of prizes won by Argentine films at international festivals reached upward of 200. And on October 30, 1988, the National Day of Cinema was inaugurated, celebrating the day of the opening of democracy five years earlier.[103] Filmmaking was thus given a boost by the state in competing for space within the cultural politics of the city.

The cultural context of the transition period produced a unique moment for the assertion of filmmakers as participants in mainstream national politics. Alfonsín's appointment of Manuel Antín as head of the film institute was a critical public image move made by the administration. Antín's vision deftly connected industry needs with cultural policy objectives at the domestic and

foreign levels. The film community strategically accepted Alfonsín's cultural politics agenda, which allowed it to take advantage of the architecture of transition cultural politics. During this moment in Argentina's history, the national government was particularly weak, a fact that elevated alternative sources of authority, such as the municipality of Buenos Aires and the INC. The city's cultural dynamism during this period contributed to a technology of place that gave film a natural audience among like-minded cultural and intellectual communities and created space for dynamic, left-leaning film activism.

The opening of film content near the end of the military dictatorship also allowed filmmakers to address themes that would court public interest and engage people in critical issues of the politics of the transition. The human rights movement and its discourses created an intersection where film projects could begin to participate in critical public debates. With the transition as a catalyst, national cinema in Argentina went from being an object of mass entertainment to a means by which political sensibilities could be crafted. By the end of the period of transition, however, the discourses of human rights had become normalized as a discourse and were invoked by all parties to further divergent political ambitions. Thus, national debate shifted from rights to social and economic issues.

By 1987, however, the support that Alfonsín's party had maintained in subnational elections in 1985 was withering away, largely from the public perception that his financial projects favored external interests and that his efforts at economic recuperation had failed. On July 8, 1989, President Alfonsín officially resigned his office. It was clear that his administration's economic troubles had caught up with him, leading to an increasing number of unfavorable mass demonstrations. Between May and July of 1989, inflation had soared to over 200 percent, resulting in an outbreak of riots and the pillaging of grocery stores, principally in the large metropolitan areas. Congress declared a state of social emergency, and rumors of renewed military action circulated. The Peronist candidate in the 1989 elections, Carlos Menem, was elected as Alfonsín's successor and took the reins of government a few months prior to his term's official beginning. Despite this, Alfonsín's final presidential message concluded that the transition itself was a continuing success.[104]

4

EXPERIENCE, REPRESENTATION, AND REPRODUCTION

Displacement and *el sur de Solanas*

MEASURING THE DISTANCE between the origins of structural violence and the reopening of democracy following the dictatorship, the notion of displacement became a central theme of transition cultural politics. Realities of forced migration, disappearance, and what Marina Franco has identified as the military's program of "recasting" Argentine society[1] undermined any sense of collective agency within the Argentine social imaginary. This social imaginary—the social institutions, representations, ideas, and symbolic practices that order and comprehend the social realm—provides a bridge between subjective and collective experience, allowing individuals to situate their actions within a constructed and shared reality. A heightened cultural sensibility of remoteness or dislodgment from the collective identity and memory constructs prior to the dictatorship presented transition-era cultural producers the task of redefining and giving shape to this sense of displacement and dispossession. Silvina Jensen describes this phenomenon as having created a subjectivity of exile, "a suspension or expulsion of an individual or group from its history."[2]

The political utopias of the intellectual and political left of 1968, which had made significant gestures toward Argentina's popular sectors, had given way to much more cautious engagements and ideological positionings. The

cultural critic Béatriz Sarlo describes the reopening of democracy as a crisis of both Marxism and of the intellectual critiques of socialism, communism, and various social movements.[3] Having spent almost a decade under conditions of censorship, repression, and ideological warfare, the left now faced a crisis: what should it do with its renewed liberty? Many important figures of the left, both intellectual and political, had been active in political organizing and cultural production from abroad, much of which had centered on drawing international attention to the state's terrorism and publicizing information about human rights violations. Marina Franco argues that such organizations worked to construct a public image and cultural discourse that was politically "neutral," distanced from the partisanship and ideological differences that had divided the left so fiercely in the early 1970s.[4]

When those who had fled returned to Argentina and leftists returned to active public life, both experienced the period of removal from public space as a major part of their transforming political identities. The process of returning from exile became an important preoccupation of many leftists, for they were finally able to address a larger national audience.[5] The filmmaker Fernando "Pino" Solanas had spent most of his years outside Argentina in France. Although his important role in Cine Liberación marks Solanas as part of the first generation, his work in the 1980s was tremendously influential for the second generation of transition political filmmaking. When he returned to Argentina, he released two films during the early democratic opening, *El exilio de Gardel: tangos* (*Tangos, the Exile of Gardel* [1985]) and *Sur* (*South* [1988]), both of which draw on ideas and images of a distant and forgotten "South," using its rich symbolic connotations in Argentine literary and cultural history to represent this sense of emotive and political exile from the past. Solanas posed *el sur* as an organizing image construct able to, on the one hand, represent the traumatic displacements suffered in forced flight, disappearance, and political displacement and, on the other, recast or resurrect the idea of an oppositional politics of the left that seemed to have been buried with the disappeared generation. In part, the success of Solanas's use of this device resulted from the way it was able to structure debates surrounding the recovery of agency, both collective and individual. In unpacking the image economy's modes of operation during the transition, Solanas's vision of el sur and its relationship to the topography of transition cultural politics of the reemerging left sheds light on the means by which meaning and political identity were crafted within a much more profound and heterogeneous field of cultural imaginary construction during the transition.

While a number of extremely important images and image constructs—such as the body, the silhouette, the handkerchief, the detention center, and the identification photograph—emerged during this early period of the transition within the highly volatile reopening of democratic cultural politics, Solanas's use of el sur is a critical example of the way in which the political left, in this case the Peronist left, reordered cultural memory to reconstruct its identity and rebuild its constituencies. Peronists who identified with more radical or prolabor positions prior to 1983 found themselves at a crossroads, in search of a credible yet rehabilitated political and historical identity. The Unión Cívica Radical's successful presidential bid in 1983 brought Raúl Alfonsín to power as champion of human rights and defender against what his party decried as the "labor-military pact."[6] In the wake of this public image crisis, left-leaning parties sought a new political language that would simultaneously deliver their political reemergence and transcend the negative image attacks of their opposition.[7] Solanas's career, as a case in point, allows a line to be drawn between the cultural politics of the radical Peronist left immediately preceding the regime and the "new left" emerging after 1983. Solanas produced key films during this period that performed the highly charged political narratives of loss, accountability, and remembering visible in the early transition. In this sense, his work came to mark the stakes of the memory debates that would later occupy a central place in negotiating the new situation of the political left.

An image, at its most simple and straightforward, is an iconic mental representation, but it is also the conditioning of that representation. The recording and interpretation of an image is determined by the filters of intelligibility that inform the image's reception. The mental image goes beyond the materiality of its visual, photographic, architectural, or spatial relations; what the mind receives and interprets is premised on the constructed nature of seeing and involves both voluntary and unconscious cognition as an active component.[8] In other words, the cognitive process of retaining an image in memory is conditioned by recognizable previous experiences, ordering schemes, or what Merleau-Ponty describes as "colourings" or "spectacles" of memory.[9] In reference to "the South," Solanas simultaneously means to signal visual representations of el sur as well as the constructed perception of that image, which expands the term's use.

This definition is particularly useful to audiovisual media, because their mediated images are generally designed to be momentary and fleeting. The experience of image reception demands that other cues—text, sounds, narrative, and signs—help the receiver decode what is being related. This inevita-

bly leads to greater ambiguity and variety of interpretation, which is in part the allure of this particular communication tool and also part of the task of making sense of its political interventions. As a medium, film complicates the question of image reception in that the material it presents in visual form is most often accompanied by cues from sound tracks, combining existing filters with audio suggestions for image interpretation. The reception of an image is premised on a set of basic constructs of historical context and subject positioning involving familiarity with political and cultural signage in order to make the presentation intelligible. The image of el sur in Solanas's films relies on such dialogue, music, and cinematographic techniques to trigger associations that rendered the ideographic construct meaningful within the setting of the cultural politics of the transition.

THE SOUTH, IMAGES, AND IMAGINARIES

The Uruguayan vanguard artist Torres García's inverted map of the Western Hemisphere was not the first incarnation of a political discourse of the South as an imaginary space of Southern Cone resistance and solidarity. During the nineteenth-century wars of independence, when European (largely Spanish) authority was finally thrown off in Latin America, creole elites across two continents defined new dimensions of authority to replace the colonial presumption of northern, Hispanic, and aristocratic superiority.[10] After a century of measuring progress by standards anticipated by the Industrial Revolution in northern Europe, separate vanguards of literary and cultural production turned to the "cannibal" South as a metamorphosing reaction to received messages of backwardness, underdevelopment, and lethargy. Displacement, disorientation, and abstraction rarified a concrete memory trace that would reposition the Southern Hemisphere as the home of independent and autonomous nations.

Throughout the early twentieth century, images of el sur argentino, the geographical Argentine South, with specific reference to both the country's southern region, called Patagonia, and to the southern neighborhoods of the city of Buenos Aires, were invoked to make private experiences public, rendering legible the realities of collective and individual conflicts that characterized the early Argentine state-building process. As it is in Sarmiento's *Facundo*, the South was conceived as a geographical allegory of civilization versus barbarism, with the Patagonian South home to the most authentic and native of Argentines.[11] Despite its status as a wild frontier, in early twentieth-century

literature this landscape became "assimiladas a 'tierra adentro,' 'desierto' y 'frontera interior,'" that is, assimilated as simultaneously the land inside, the desert, and the interior frontier.[12] In particular, images of el sur and *el sureño* (the southerner) were invoked to reveal tensions between the immigrant working classes and the nation-state, rural and urban political strongholds, and traditional and modern visions for the nation's future. Tangos and popular poetry added a layer of depth to these associations, such as the lyrics of the well-known left-leaning nationalist Homero Manzi's "Sur."

The image/imaginary of the South had such widespread currency that it was picked up even by elite cultural producers. Individuals in intellectual circles traded in symbols of the South, including prominent literary figures such as Victoria Ocampo, who founded a transnationalist literary magazine named *Sur*, and Jorge Luis Borges, whose short story "El Sur" would create a lasting image among bourgeois readers of a duel-laden southern frontier on the pampas and a South of the immigrant city of Buenos Aires, its inhabitants flashing their wild teeth at the crossing of Avenida Rivadavia. Even the popular literary genre of the gauchesque would turn to literary nuances to position the South as a place where struggles against the state could extend beyond marginalization, exoticizing, or othering to represent central tenets of national identity.[13]

The idea of the South as the frontier of political radicalism was later visited by national narratives of resistance and political repression. By the 1950s and 1960s, popular cultural imagination incorporated an idea of resistance associated with the South that Francine Masiello has attributed to a vogue of all things subaltern and outlaw.[14] The South of Argentina became a centerpiece in narratives of popular resistance and tales of internal exile as a stronghold of radical, antidictatorial, and nationalist ambitions.[15] In the period immediately prior to the 1976 dictatorship, the South came to represent specific narratives of militancy and of state repression, presaging what would soon follow. For example, Osvaldo Bayer celebrated the Patagonian South as a space of independence-minded heroism in his history of anarchist resistance to military rule, published in 1970; in 1974 Héctor Olivera adapted Bayer's book to make his *Patagonia in Rebellion,* which would later become a political film icon. The Patagonian South was also the site of a 1972 prison break, with twenty-five political dissidents escaping from the maximum-security facility in Rawson. Their initial imprisonment and the extreme nature of the military's response to their attempt to escape was a prelude to events under the military rule that followed in 1976.[16]

Historical imaging and imagining of a geopolitical concept of the "South" became a key referent in leftist cultural politics discourses following the dic-

tatorship. Writers, artists, media producers, and filmmakers imagined filmic accounts of the dictatorship and its aftermath by mobilizing the political symbols of the generation of youth and left-leaning activists that identified itself more broadly with the 1968 May demonstrations in Paris. Invocations of the anticolonial language that infused protests from Paris and Washington to Rio and Mexico City in 1968 likened the experience of the dictatorship to imperial regimes and the plight of subalterns struggling for emancipation in what would be conceptualized later as the "global South." This involved representing the activism of radical leftist groups, such as the PRT-ERP, the Revolutionary Armed Forces, and the Montoneros, as coupled with the fight for African independence in an account of global counterhegemonic solidarity, thus avoiding some inherently divisive questions about the radical left's involvement in violence prior to 1976.

In 1983, as Alfonsín's administration entered office, the idea of the South as a metaphor well suited to political confrontation with the recent past was obvious to Solanas and his contemporaries alike. The filmmaker Eliseo Subiela invoked the South in his film *Hombre mirando al sudeste* (*Man Facing Southeast*) by positing an image of the south as internal exile represented by insanity and amnesia. The director Miguel Pérez used images of underground resistance film spaces juxtaposed with clips from *The Battle of Algiers* in his pathbreaking *Lost Republic* documentary films to explain the ideological connections between communities of resistance that crossed national borders. Later, a number of documentaries would frame national politics within the pan-Americanist chronicle of leftist activity beginning with the Cuban Revolution in 1959, several of them noting the Rosario native Ernesto "Che" Guevara's famous voyage through Patagonia as the beginning of his political and spiritual enlightenment, giving leftist intellectuals and artists a space through which to reflect on the legacies of populist, left-wing, and radical politics. This rich set of symbolic associations made el sur an optimal choice at this particular moment not only for these directors but also for Solanas.

EL SUR DE SOLANAS

Solanas chose the metaphor of el sur to shape his own transition story of displacement, internal exile, resistance, and longing.[17] Drawing on this rich discursive field, Solanas made films that would be emblematic of and central to the constructive process, crafting a highly charged political notion of the South that would situate his own political agenda within the social imaginary

of the transition. Solanas's two fiction films *El exilio de Gardel: tangos* and *Sur* locate an imaginary universe of the South that came to stand in for resistance, otherness, and solidarity among oppressed people. His work re-presented images of a South that could evoke both a left-leaning political South and a South of the interior, or of the collective psyche. Solanas framed questions of forced flight, internal displacement, disappearance, survival, and resistance within a vocabulary of geographic and geopolitical "Souths." Folding images of a symbolic South into a cultural identification with victims of the dictatorship, Solanas created a collective association between the resistance of the late 1960s and early 1970s and the politics of the reemerging left.

Solanas began his career in the late 1960s, collaborating with Octavio Getino, with whom he would cofound the film collective Cine Liberación in 1968. Well-known for his activism and ties to Perón while the deposed ruler took refuge in Spain, Solanas and his contemporaries were a key point of reference in discussions of resistance filmmaking across Latin America, coining the term "Third Cinema" in an interview with *Cuban Cinema* in March 1969, and using it to designate films that fell neither within "first cinema," identified as industrial filmmaking, nor within "second cinema," or the cinema of the auteur.[18] Solanas's three-part epic film *La hora de los hornos* is perhaps the most widely recognized political film in Argentine cinema history. Although the controversial series was initially banned in Argentina, it was circulated in underground spaces and abroad, where its notoriety earned Solanas and his collective much praise among Peronist and leftist militant groups, such as the PRT-ERP and the Montoneros. In its defiance of censorship and its booming materialist interpretation of Argentine history, this early work, shown clandestinely to an estimated 100,000 spectators, fascinated many activists across the political spectrum, who saw this militant film as an example of cinema that could help spread revolutionary ideals.[19]

Solanas's work also fed blossoming transnational solidarities among social activists, who identified if not with the Argentine case specifically at any rate with resistance, nonalignment, counterhegemony, and subalternity. When *La hora de los hornos* first screened in June 1968 at the Pesaro Film Festival in Rome, student activists in attendance from the local universities publicly declared the film an expression of the kind of action that they hoped to foment through their own political activism. The film's content, reflected in its subtitle—*Notas y testimonios sobre el neocolonialismo, la violencia, y la liberación* (Notes and testimony concerning neocolonialism, violence, and liberation)—paralleled the ideology of postcolonial dissidence among the intellectuals and political figures whom these groups lionized.[20] Shortly after

the success of the film in Europe, Solanas and his codirector, Octavio Getino, wrote a manifesto entitled "Toward a Third Cinema"; riding the tide of this movement, the manifesto was widely embraced by aspiring radical filmmakers throughout Europe and Latin America and eventually Africa and Asia as well. Third Cinema as a movement identified its capital as Algiers and sought support from UNESCO, the Organization of American States, and even the Arab League. This group viewed technical progress as a liberating force, decolonizing imperialist modes of controlling economic and cultural forces. Despite an ideologically unified discursive frame, however, a radiographic examination of these film projects' political substructures would reveal a fragmented and disconnected set of political agendas.

The second part of the trilogy, a long essay-style notebook on the ten years of Perón's government, cast the regime as rule by the proletariat under the banner of a visionary politician. This film was made and released during the many years that Perón spent in Spain and even included an interview of him as a coda to the film's narrative. The film posits Peronism as the central axis of resistance and opposition to Onganía's military government and mirrors the politics of then-emerging guerrilla factions of radical Peronism. This message translated well to its first small underground audiences in Argentina, which were composed primarily of left-leaning university students and film aficionados.[21] It also set the stage for Solanas's depiction of Peronist leftist radicalism as a path to liberation,[22] casting Perón as a victim and as Argentina's legitimate representative of popular democracy. The early film thus gave a virtuous political mark both to radicalism in the service of popular ideology and to the politics of those forced to flee the country.[23]

For Solanas, the only truly political film was the militant, revolutionary film.[24] In the film magazine *Cine del Tercer Mundo,* which Solanas and Getino published under the auspices of the Grupo Cine Liberación, he authored articles condemning films such as *Martín Fierro* (1968), directed by Leopoldo Torre Nilsson, and *Don Segundo Sombra* (1969), made by Manuel Antín, accusing the two films of neglecting political principles to such a radical degree as to inadvertently support Onganía's military regime.[25] Solanas's answer to soft political filmmaking was the film *Los hijos de Fierro* (*Sons of Fierro* [1972]), which was intended to be an allegorical historical drama representing the exile of Perón via José Hernández's account of the subaltern outlaw gaucho Martín Fierro. Drawing on sources of "popular memory," Solanas hoped that the fiery, independent-spirited character would provoke and inspire resistance among its audiences in Argentina. The character of Fierro was meant to be a stand-in for Perón, but unlike the populist leader, with his

authoritarian image, this marginalized hero of popular resistance would evoke nationalist sympathies among viewers.[26] Solanas doubled his metaphor, pairing the idea of Perón out of power with the people out of power.

During the shooting, the actors and technicians were forced to work in secret. The actor who portrayed the older Fierro son, Julio Troxler, had been a militant Peronist and was assassinated by the Alianza Anticomunista Argentina during the film's production. The lives of Solanas and several other crew members, too, were threatened on a number of occasions. In 1976 Solanas chose to leave Argentina, seeking safety abroad, first in Madrid and then Paris, where he completed the postproduction of *Los hijos de Fierro.* Although released abroad in 1978, the film did not officially screen in Argentina until 1984.[27]

For Solanas the South was simultaneously an area of geopolitical ideology and a cultural aesthetic. He imitated the dispossession of the inhabitants of Third World nonaligned states by filming in a rough idiom, using what he called an "aesthetic of hunger." Activism was the only appropriate mode of filmmaking for Solanas, the camera a means of reproducing revolutionary ideology and speaking to a sympathetic international audience. Despite accusations of pamphleteering in his films, Solanas gained a great deal of respect within many circles of the radical and intellectual left in Argentina even before he himself was politically displaced.

THE EXPERIENTIAL SOUTH

His time outside Argentina proved to be productive for Solanas, whose geographical relocation drew attention to his work and improved his reputation as a serious political artist. In France Solanas found work teaching filmmaking in the Conservatoire National des Arts et Métiers, or National Conservatory of the Arts and Crafts, and secured financing for his subsequent film projects there. Solanas catered his next two films to a sympathetic European audience. Critics reviewed the films in such prestigious Continental publications as *Cahiers du Cinéma, Positif, Le Monde,* and *Libération.*[28] The acclaim he received from French critics granted him a degree of artistic freedom, and he gradually returned to political filmmaking for Argentine audiences and to describing Argentine experience to a broader international audience. Near the end of the dictatorship, Solanas started work on *El exilio de Gardel: tangos,* which he completed and released in 1985. Though filmed using French pro-

duction companies, *Tangos* was written for a national public, albeit one composed of Argentines on various continents. This film, about a group of expatriated artists and performers living in Paris, was a much more personal effort for Solanas.

Tangos confronts the daily aspects of a collective historical experience of dislocation. Heavily influenced by the French filmmaker Jean-Luc Godard and various Italian contemporaries, this film could be situated easily within the filmmaking tradition of the *nouvelle vague*, taking interiority, marginality, and forgetting as principal themes. Solanas took his narrative lead from the testimonial genre, telling his fictionalized story through a wide variety of different perspectives, and in so doing, he deliberately mirrored the work of truth commissions and human rights activists in collecting oral histories to reconstruct a memory of the dictatorship in Argentina. He used a large representative cast to relate the experiences of each of the refugees as part of an integrated narrative structure.

The film relates the group's production of a *tanguedia*, or a tango tragicomedy, the brainchild of the film's protagonist, a character called "Juan dos" (Juan number two). Juan dos receives tango music from a contact in Buenos Aires, "Juan uno," who sends his compositions to France clandestinely and who refuses to leave Argentina despite fear for his own personal safety. The community of actors, musicians, dancers, and the director experience a variety of reactions to the conditions of life as refugees, ranging from despair to fantasy and from alienation to acculturation. To some extent, however, they each struggle with the question of whether to return to their native land. The representative cast is held together by their involvement in the production of the tanguedia, a performance of resilience, recognition, and resistance that can be read as a commentary on the performative nature of transition politics.

The film uses iconic national images appearing haphazardly in the surreal landscape of an immigrant's Paris to suggest collective memories, meanings of dislocation, and relationships between the exiled and their homeland. In the studio of Juan dos, the walls are painted with an "anthology, mythology, cosmology" of famous Argentines, from Anibal Troilo to Roberto Arlt; a ceiling painting of Carlos Gardel looming large overhead becomes conscience and accomplice to the musician's artistic forays. Images and imaginary visits by two famous Argentines who fled to Paris—Carlos Gardel, the famous tango composer and singer who was killed in a 1935 airplane crash, and General San Martín, who helped liberate the country from the Spanish Crown—frame the two central motifs of Solanas's representation of the South

in this film. Images of liberation and resistance to the forces of colonialism are transposed over a storyline that recounts the characters' senses of powerlessness and inability to control their own destinies. The film takes three of the characters to visit the home where San Martín died, just after the words "la pampa es un espectaculo" ("the pampas is a spectacle") trail off from the prior scene. San Martín's absence and physical dislocation is likened to the irreconcilable feelings of loss the refugees experienced when loved ones were disappeared, his defiant spirit of resistance a model for the way the characters should interpret their own experience of displacement.

Images and evocations of Carlos Gardel occur throughout the film, sometimes in montage with photographs of street scenes of immigrant barrios of Buenos Aires from the early 1930s. Black-and-white still frames of the city's past—an empty street lit by the city's first electric lighting system or an image of the tram rails in front of a typical nineteenth-century *almacén*, or general store—are paired with tango lyrics of sentimental longing for return and a dialogue between the characters Juan dos and a French director about the "risk of existence." In communicating the story of the tanguedia, the musician wrestles with the incoherence of action without a sense of final purpose. This purpose is suggested by the ghost of Gardel, who plays the tango "Volver" on a gramophone, seconded by the ghost of San Martín, who suggests that those who do not return are not patriots. Through the intertextual image construct of Gardel and San Martín, in montage with footage of a female character who decides to take up the handkerchief and return to Argentina to find her missing loved ones, the director hints at a political solidarity with the Mothers and Grandmothers of the Plaza de Mayo. These groups are also symbolically suggested through newsreel footage of demonstrations of their counterparts in Paris, asylum-seeking South Americans and French sympathizers who began their search for justice and missing family members in parallel from Europe. In this way, dislocation is turned on itself to create an imagined space for collective political activism where transnational encounters and alliances can be fashioned and called into service. Indeed, many reviewers examined the film precisely on its merits as a testimony to the experience of forced flight.[29]

Tangos presents the South as an interior space, a national psyche hidden within the confines of a dislocated reality, but also as the Other to the experience of those who fled the country. The South stands in for South America; at the time many individuals from Brazil, Chile, Paraguay, and Uruguay communed in Paris's expatriate neighborhoods, sharing reflections and experiences that forced a reframing of the experience of dictatorship particular to

each individual country. The film repositions the Argentine experience within this pan-American historical continuum, allowing it to echo meanings associated with resistance to oppression and hegemony in other periods and contexts. In interiorizing this struggle to make meaning from their dislocation, Solanas uses the film to suggest natural solidarities and to essentialize the particularities of specific political experiences. Each character is forced to grapple with the question of returning to this South, a metaphor Solanas invokes to call attention to the interior landscape of denial, fear, complicity, and autoreflection.

LOS CAMINOS AL SUR: ROUTES SOUTH

Solanas followed *Tangos* with the film *Sur,* which similarly provoked a far-reaching public response to its representation of historical experiences and its implications for the cultural politics of the transition. In this film, Solanas again used tango music to represent a form of national conscience, an element of cultural identity and collective memory permeating the Argentine psyche.[30] *Sur* is the story of a young man, Floreal, who is released from jail in 1983 and returns to his home in a neighborhood referred to as being "in the south of the city of Buenos Aires." This barrio is Barracas al Sur, the same as that in Borges's "El Sur" and also used in Leopoldo Torre Nilsson's *Siete locos (Seven Madmen* [1972]), based on Roberto Arlt's novel of the same title. Solanas uses the setting of Barracas al Sur as a reference to all the older barrios of immigrants, tangos, and the nation's long history of political activism, as a dislocated utopian past. The scenes at the start of the film resonate with the still images used in *Tangos,* as if they have been brought to Technicolor life, displaced memories resuscitated and reinterpreted.

No one is aware that Floreal is to be released, and so he returns almost as a specter, at first observing his wife, Rosi, from outside his former home, vacillating as to whether to enter. During the five years that Floreal has spent imprisoned, his neighborhood, his family, his friends, and his country have changed significantly, and the film centers on the love story of the couple as a metaphor for the way these changes are confronted and experienced. The family of Rosi, tango musicians by trade, attempts to help her with her pleas for her husband's release during Floreal's imprisonment. In flashbacks and flashforwards, the film uses Floreal's memories to narrate and re-create the space-time of dislocation via the separation of the couple. Rosi has fallen in love with another man, leaving a space for Floreal to discover a new passion,

perhaps in the company of María, a young rock-and-roll fan whom he meets in his meanderings along a street called La Melancolía.

Solanas intended *Sur* to be the interior side of *Tangos,* "the other face of exile, that of absence."[31] Solanas called the film an attempt at the recovery of a lost space, of a lost nation, and of lost hope.[32] The film portrays victims of the dictatorship from a generation older and more mature than the ones emphasized in other films of similar subject matter. Solanas geared the film to the thirty-year-olds who had suffered the repression of the dictatorship and the older generations who understood resistance from a longer perspective, as well as a younger generation for whom the film would generate a collective memory of the repression they did not experience firsthand.[33] Floreal is a frame for the construction of images and interpretations of the past, a human face on which to order a set of received narrative encounters familiar yet unfamiliar to those of the next generation. In both *Tangos* and *Sur,* this question of displacement centers the films' argument, whether from one's own lived experiences or from the experiences of others.

The film employs the idea of memory as an integral part of recuperation, survival, and resistance. It also suggests that these memories maintain relationships between the disappeared and survivors, a tie made explicit in conversations between ghosts and the living throughout the film's narrative. Rosi's family members and their friends, who assemble at the "table of dreams," speak of historical memory and the realization of popular desire as a running commentary on the events of the film and the events external to the plot's action. In this way, the film's images, many of them hypertheatrical and abstract, are made more concrete through narrative development.

Images of el sur appear at every turn throughout the film's narrative. The film's most transparent evocations of the South come in images of the word itself, on the spine of the clandestine archival files of the "Proyecto Sur" or the name "Bar Sur" painted on the window of the café where many of the film's key dialogues take place. Solanas uses the film's narrative to infuse these textual signs with meaning, describing "los hombres del sur" as sons of the halcyon days of leftist organization against the military dictatorship of the 1930s—obreros, Marxistas, socialists, and part of a resistance to the hegemonic impulses of the neocolonial North. The "Projecto Sur," a secret library of political and otherwise "subversive" literature collected over decades by self-styled organic intellectuals from the barrio, is introduced as a hiding spot for Floreal when he is pursued by the military for his involvement in a work stoppage in protest of disappeared obreros. The archive reappears as the

subject of censorship later in the film, as military officials seize specific texts ranging from Foucault's *History of Sexuality* to Scalabrini Ortiz's political writings, pulling them off the shelves and discarding them in a heap on the floor, with a chorus chanting in the background, "Marxista . . . socialista . . . subersivo . . . Peronista . . . demagógico . . . pornográfico." When those responsible for the archive are questioned about its purpose, they respond by saying, "If one doesn't understand the South, it is because they are from the North," playing on the idea of the military's complicity with the neoliberal politics and economics of the United States.[34]

This second set of Souths includes two geographic locations, Barracas al Sur and Patagonia, that Solanas uses as background and as politicized zones of contestation. The neighborhood of Barracas al Sur provides the setting for encounters between the past and the present as Floreal reenters and reintegrates himself into his world after being released. The film frames his visions of the barrio through windowpanes, doorframes, ironwork, and architectural vignettes, drawing attention to the purposeful hand of place in constructing his memories of the past. As in *Tangos*, a breeze of loose papers drifts in and out of many scenes, like so many lost documents and pieces of information during the dictatorship. The image of a historical landscape with its past strewn like forgotten debris in the streets points to Solanas's argument for a "memoria popular" to reorder understandings of the collective past.

In flashbacks, the film relates Floreal's transfer to a detention center in Patagonia, where Rosi is allowed to visit him. Along the way, as the camera pans images of the Patagonian landscape seen through the car windshield, Rosi's travel companion speaks of his desire to escape to the South and of the work "sin papeles" that can be found there. He talks about the Patagonian South as a place where a different kind of life is possible, a place open to discovery and invention, where one can find new hope and new political centering. Gabriela Nouzeilles describes this common motif in literary treatments of Patagonia as the "iconography of desolation," figuring the place as a desert that refused colonization and resisted the traces of history. She argues that the invocation of the Patagonian terrain reminds Argentine audiences of the voyages of discovery undertaken by scientists such as Charles Darwin, whose well-known descriptions of Patagonia likened it to an inert mass and a sterile surplus of empty space and time.[35]

These physical Souths mirror the "Proyecto Sur," creating a dialectic between Floreal's individual experience and that of the characters who provide the protagonist temporary emotional refuge along his lonely path to a new

life and a new political consciousness. The moving images of both of these places serve to mediate the meaning of his persecution. In Patagonia his experience is read through the lens of the high-profile subversive Peronist resistance groups who were imprisoned there, and in Barracas al Sur, his experience is framed by the working class of the city's meatpacking and -freezing plants and the barrio's older generation of radicals. Despite Floreal's relatively apolitical past, the film asks its audience to read through his subject positioning the common cause uniting these groups, normalizing the radical left as a natural ally of more moderate labor activism.

Critics and other viewers invoked Solanas's choice in setting to call attention to the film's place in the historical narrative of the city of Buenos Aires. For critics, the barrio of Barracas, well known for its legendary *tanguero* bars and its historically significant architecture, exemplified modernity's indifferent push forward, a notion reflecting a critique of many of the social and economic politics of the military regime. The building of the highway from Buenos Aires to the city of La Plata caused the formerly vibrant neighborhood to decline, leaving thousands unemployed and searching for a new home. It also was responsible for concealing the remains of important detention centers, potentially sealing off any attempt to excavate those sites for information about the fates of their unfortunate inmates.[36] As it had with *Tangos,* media reception gave *Sur* a life outside the cinema hall that allowed it to speak to the public in ways that otherwise would have been unavailable. This leads to the question of what el sur came to mean within these debates of popular memory.

SURISMO AND THE GLOBAL SOUTH

From the turn of the nineteenth century, the question of memory has been linked to notions of a constructed ordering of the past. Certain scientific theories propose that the image might be used as a device to organize memory, presenting a physical place of memory, giving structures and similitudes that can trigger remembering.[37] Images, viewed in this context, are the raw data that can create mental relationships between fleeting events and ideas. As the mind undertakes the task of ordering memories, images can provide concrete parallels to reality in establishing causal relationships and historical agency. In the aftermath of military rule, the place of the visual and the image construct became a focal point in debates of collective memory politics.

In the case of transition Argentina, images and imagescapes gave shape to an only partially revealed past.

The hermeneutic uses of images in the transition spoke to a search for the "objective reality" of unknowable yet undeniable concealed truths. Underlining ephemeral disclosures in public messages, these images purported to reveal or fix details, in some cases enacting a false remembrance against the potential calamity of oblivion. A representational lexicon of images as signs reflected semiarticulated thoughts, suggestions, ruptures, and provocations in an open-ended conversation among the city's inhabitants and observers.[38] Among historians and media scholars, the purpose-laden construction and presentation of images initiated an autoreflexive dialogue about the discursive politics out of which these representations originated and the structures of power to which they responded. As an autocritical and reflexive public wrestled with the memory politics of the image, certain specific discourses emerged as dominant and authentic—those such as the CONADEP report, victims' testimonies during the juicio a las juntas, and the findings of human rights organizations—while others were discarded as divisive or even fraudulent (e.g., those provided by implicated government agencies or the Catholic Church and testimonies given by members of the military involved in detention).[39] In determining what could legitimately stand in for the absences —los desaparecidos, los exilados, los cuerpos—the image was often invoked as a placeholder that gave voice to the absence without necessarily defining a truth or an experiential reality in concrete terms.

Fixing a truth without specifying the facts created a frame for all the fragments of indecipherable information that the transition had to order, like the bits of paper flying around in Solanas's films. This deployment of the image in a highly creative and plurivocal project of reconstruction eventually moved from the hypersurreal presentation of "shocking" and "horrific" revelations to elements of highly structured narratives that would give voice to particular interpretations of events of the recent past. As Cecilia Lesgart has deftly articulated, the intellectual left after the dictatorship sought to distance itself from radical revolutionary politics and to reformulate an autocritical image based on a renewed orthodoxy and dialogue with the past that would prove productive for democracy. For leftist intellectuals and many of their counterparts in the political sphere, cementing this new alignment meant displaying the period of exile as an evolutionary stage, a time of maturation resulting in a new left that was easier to integrate into the mainstream politics of redemocratization.[40]

Conversant with the politics of the transition, left-of-center political figures and labor-based parties actively courted symbolic association with dislocation during the dictatorship, with the disappeared and the displaced, the marginalized workers and their families.[41] The narrative of displacement synthesized collective understandings of the political disfranchisement that many, particularly within the middle and working classes, had felt during the dictatorship and married this set of understandings to the representational politics of exile and disappearance as two of the major narrative themes of early transition sociocultural reckoning. This construct of displacement reflected the sense of the fugitive responsibilities of citizenship, incredulity at the political apparatus and its use of authority, and the "othering" of the self-conscious subject that took place during the dictatorship. Thus, the displaced subject became a central motif of ordering collective memories.[42]

The perceived authenticity of Solanas's filmmaking derived in large part from the correlation of his subject matter with his own personal political experience. As an activist threatened by the Triple A during the prelude to the dictatorship, a filmmaker adherent to the Third Cinema movement, and a political refugee after 1976, Solanas had a certain degree of credibility within the cultural politics of the transition. The experience of "double exile," mental and physical, related through his films *Tangos* and *Sur,* unquestionably belonged to Solanas's own past. As an artist, he was not merely someone sympathetic to his characters' fate but also a witness to, victim of, and participant in the histories his films detailed. Importantly, he returned home critical of the radicalism of his younger days but even more committed to his notion of solidarity with the Global South. He used the proscenium of his newfound public notoriety to articulate his vision for the role of cinema in catalyzing a new politics of activism, arguing that film should function as a vehicle for recovering popular agency. In interviews, he compared himself to earlier generations of politically minded public intellectuals, such as Jauretche and Scalibrini Ortiz, citing common cause with their struggles against injustice.[43] He even described the making of his films as "tantos años de lucha," so many years of struggle, as if they were part of a cultural resistance he had conducted from abroad.[44] In 1983 he responded to inquiries regarding his former adherence to militant Peronism by stating that he had evolved into being a supporter of democratic pluralism, where Peronists and non-Peronists could work in dialogue over serious issues confronting postdictatorship society.[45]

Even though only in the North was Solanas able to establish his reputation as a filmmaker, find financing for his films, and build his career, he claimed that his personal fiesta was to return to Buenos Aires, el sur, the underpin-

ning of his political identity.[46] In giving structure to the political narratives of the past, Solanas's work clearly identified the villains behind the dictatorship as complicit in the neoimperialist designs of South America's traditional abusers. By ordering the structure of his narratives of the dictatorship and its aftermath into his particular vision of class struggle and a chronology of independent and resisting national intellectual currents, Solanas's films provided a nuanced perspective on transition debates about the activity of militants, subversives, and workers in the lead-up to the military coup that were preoccupied with exposing the myth behind the national security doctrine, which depicted subversive threat as a justification for military intervention.[47] His films inscribed the disappeared and the exiled into the long history of social activism beginning in working-class and immigrant neighborhoods at the turn of the twentieth century and straight through to the anticolonialist protest movements of the late 1960s. Blurring the edges of what was meant by Peronism in the period immediately preceding the dictatorship and more sunny periods of broad-based Peronist sympathy, Solanas used the films to construct a memory narrative that dealt only suggestively with militant Peronism, erasing its significance within the nearly universally tangible experiences of resistance to the violent political hegemony of "el norte." Solanas used his films' powerful impact on the social imaginary to turn his public forum into a vehicle for repositioning the role of the left and reconstructing its postdictatorship identity.

OCTAVIO GETINO AND POSTCOLONIAL FILM POLITICS

The sense of displacement produced by flight abroad and the problem of reestablishing a political agenda in the postdictatorship period were issues that interested the filmmaker Octavio Getino as well. Solanas's codirector and colleague from Cine Liberación, Getino got involved with union activity as a young man and with militancy somewhat later as a unionized worker at a metallurgic plant. Eventually forced out of the industry because of his reputation as an extremist, Getino earned a place on several blacklists and eventually sought out Peronism as a means of identifying himself with a more ideologically friendly sector.[48] As a syndicalist organizer and radical filmmaker, Getino rose to important positions within Peronist organizations. The filmmaker's union, SICA, chose Getino to serve as its representative to the First Congress of Hispano-American Cinematographic Production, which took place in Buenos Aires in 1965, charging him with helping to design recommendations

for a new body of cinema legislation. And in 1973 he was asked to serve as the mediator of the Rating Entity by Juan Perón himself.[49]

Like many of his colleagues, Getino was forced to flee Argentina in 1976 as the campaign against both Peronists and leftists intensified. From 1976 to 1982, he lived in Peru, where he taught at the Universidad Católica and the Universidad de Lima.[50] The Argentine government attempted to extradite him, with penalties of prison and seizure of goods pending, but Fernando Balaúnde Terry, the president of Peru, intervened on his behalf.[51] His initial book, completed while still living in Lima in 1978, was one of the first Latin American works to address the theme of cinema from a social science perspective.[52] In 1982 Getino left Peru for Mexico, where he lived until 1988, working as a lecturer and assessor of production materials for communication media in the audiovisual education program at the Universidad Nacional Autónoma. During his time as a political refugee, Getino worked on several video projects documenting poverty and living conditions in the Third World, some for the United Nations, and between his academic and film work, he managed to establish himself as a leading expert on the conditions of communications media industries throughout Latin America.[53]

When Getino finally decided to return to Argentina in 1988, he was quick to market his reputation as a scholar and media intellectual to reposition himself within the politics of the film industry. In addition to becoming a regular contributor of editorial columns to the left-leaning newspaper *Página/12*, Getino wrote a number of books about the neoimperialism of international media markets and the impact of free-market capitalism on industries and workers in Latin America. He aligned himself with the labor sector of the industry advocating protectionism, state sponsorship, and support for the union.[54] The concerns that filled his editorials and public speeches on policy issues centered on reforming the market to better protect film producers, eliminating the domination of Hollywood cinema in national exhibition spaces, and building transnational ties among Latin American media producers.[55] His revival of the anti-imperialist, anticapitalist, and intraregional solidarity discourses of earlier generations of leftist intellectuals emphasized his experience of dislocation as a political refugee participating in a transnational community of activist scholars.

Getino's writing and public work influenced not only the curricula of cinema study but also the face of higher education in film. One of the first things Getino did was to open negotiations to reinstate the School of Cinema at the Universidad de La Plata and the Center for Audiovisual Production at the Universidad de Entre Ríos.[56] As a scholar, he committed himself to inves-

tigating the state of the national and Ibero-American media markets, giving them definition within a comparative context and establishing quantifiable data for determining the most efficient means to protect national cinema as "liberation" of Third World expression and expand its reach.[57] His critical engagement with the theoretical work of Frantz Fanon and various anticolonial liberation movements made his work relevant to later postcolonial theorists. For example, his early books *Cinema, cultura y descolonización* and *La tercera mirada,* both cowritten in 1973 with Fernando Solanas, became key texts in university film studies programs.[58] He followed this pathbreaking work by authoring a number of now analytical texts based on the same data. As Getino became the most prolific film scholar in Argentina by the 1990s, his Marxist analysis developed into an almost hegemonic discursive frame within the field of media studies.[59] Even scholars in other countries used the empirical data of Getino's study as a basis for their own investigations and critical readings of Latin American film and media industries.[60]

During Getino's early development as a film scholar, the politics of audiovisual space and leftist intellectuals' exile from that space under state repression became a flashpoint for a generation of cinema scholars. As such, it seemed to Getino that building up a knowledge base about communication media was a necessary part of organizing strategies of resistance to the forces of both imperialism and censorship. The final manuscript draft of *Cine y dependencia,* completed before Getino returned to Argentina, was mimeographed and circulated by his students as a form of subversive activism for several years before it was published in 1990.[61] His work, in which he categorized directors according to their political leanings and their audiences, illustrated the ideological crisis and displacement felt by many in his generation of political filmmakers. He referred to some directors in his study as intellectuals, distinguishing them from others, whom he called "film industrialists" or "film producers," drawing political and social distinctions that would be employed by subsequent generations of political filmmakers. As a key example, he credited the directors Leonardo Favio and Leopoldo Torre Nilsson with having made national films with "testimonial and cultural values,"[62] differentiating them from the capitalist forces of the industry itself.

Getino's work resonated with budding communities of cultural studies scholars in Buenos Aires. His use of the term "cultural industry," borrowed from Theodor Adorno and Max Horkheimer, of the Frankfurt school, invoked their application of critical analysis to the class dimensions of communication media. Getino modified his use of the term by making reference to the work of the French sociologist Edgar Morin, who analyzed communication

industries along traditional industrial economics logic, as simply another kind of business with the ends of maximizing consumption and profit. He entered into key Marxist debates of cultural studies, mirroring an international turn away from Marxist economic theory to its implications for ideas about class and identity, by weighing in with his own thoughtful theoretical advances, building on the work of the North American economist Fritz Machlup, who put forth the concept of knowledge industries, and the German theorist Hans Magnus Enzensberger, who discussed conscience and information industries. Inserting himself into these intellectual debates, Getino advanced a proposition about cultural production unique to the case of Argentina in the 1980s, one meant to dispel false notions of cultural independence. His objective was to demystify the relationship between the market economy and the political systems that traditionally supported the market.[63] Getino's work provided a foundational theoretical opening for a subsequent generation of filmmakers and a critical link between the political discontent of the 1960s and 1970s and the threatening impulses of neoliberalism and globalization in subsequent decades.

NEW DIRECTIONS FOR THE POLITICAL FILMMAKER AND THE LEFT

A year after the release of *Sur,* a neighborhood cultural association, the Ateneo Cultural de Barracas al Sur, proposed that the municipal government denominate the "Paseo del 900," the walkway of the 900 block, as a cultural center. The group argued that the neighborhood's artistic and cultural contributions to the city of Buenos Aires should be recognized, citing the film as part of the significance of the area's history.[64] Various proponents of the idea emphasized the connection between the neighborhood and the cultural notion of the "South," a South that stood in contrast to a neocolonial North: the Patagonian South of Argentina as a place of internal exile and historical resistance and the southern part of the city as the part with the longest history, dating back to the first immigrants and the first ambitious projects of creating a new republic in the Southern Cone.[65]

The vision of displacement upheld by Solanas and his contemporaries and the political discourses of the transition came together as an ordering narrative to give meaning to the memories of exile, particularly those of a fragmented political and intellectual left and of physical dislocation during

the military regime. Taken together, these modes by which the displaced and dispossessed South of Solanas intervened in transition cultural politics suggest an alternative to utopic correctives to the specific historical and political ills of a softened postdictatorship left. Mobilizing a reconstructed left in an imagined space where the Global South meets the southern territories of the interior psyche, Solanas's films became an important footnote to the representational politics of the transition. Following Borges's proposition about the historical realities of "El sur," Solanas's use of the image and image construct of el sur provides a useful symmetry and anachronism to structure the recuperation of agency and to give meaning to the new political identities that emerged during the transition. Using the drama of displacement and disappearance as modes of expressing the displacement many Argentines felt during the dictatorship and afterward, *el sur imaginario,* the imagined South of Solanas, created a set of common understandings that could hint at a new vision of the left's past, present, and future.

In 1989, when Carlos Menem became the president-elect, Solanas became a key cultural figure who drew attention to the ongoing democratic transition's failures in adequately dealing with the past. Solanas waged a popular campaign, alongside Julio Bárbaro, to turn the Galerías Pacífico, located in the center of Buenos Aires, into a cultural center. He proposed that this building, suspected to have been used as a clandestine detention center during the first years of the military regime, be renovated as a public site of memory and celebration of the arts.[66] Menem, however, ultimately gave the property development license to a close friend, Mario Falak, who turned the complex into a shopping center for tourists. Falak, who owned the luxurious Hotel Alvear, was not required to permit any kind of archaeological investigation into claims of the site's use in military detention. There is today an important cultural center situated in the Galerías, though not what had originally been envisioned by Solanas. Solanas subsequently gave an interview to *El Porteño* in March 1990 accusing Menem of corruption and treason.[67]

Solanas used his platform as defender of the absent and dispossessed to highlight the transition's failures to undo the neoliberal economic policies left in place by the military regime. In an interview with *Página/12,* he referred to Menem as uncultured, unintelligent, and corrupt, a traitor to his electorate, arguing that Menem's policies were a form of social and economic injustice on par with the dictatorship's most extreme excesses. He accused the voting public of having been seduced by the idea that Argentina was in a state of crisis and in need of a "strong man" to restore order and claimed that

nothing of Perón's legacy remained in the representatives of the party of Menem.[68] Solanas made similar remarks to the rebellious, tongue-in-cheek magazine *Humor* in January 1990.[69]

In May 1991 Solanas was attacked outside his home and shot six times in the leg in an incident that was immediately billed as a politically motivated assassination attempt. More than one hundred people demonstrated in the Plaza de Mayo, demanding the release of information concerning the perpetrators of the offense.[70] Menem attributed the attack to independent gangs that aimed to disrupt democracy through theft and other criminal activity, but police investigators quickly ruled out any possibility that the assault had been part of an attempted robbery.[71] Three former members of the national intelligence service (the Secretaría de Inteligencia del Estado, or SIDE), Norberto "Polaco" Cipolak, Aníbal Gordon, and Raúl Guglielmineti, eventually confessed to having committed the crime, and Solanas took the opportunity to relaunch his critiques of Menem and again draw attention to the case of the Galerías Pacífico.[72]

In May 1992 Solanas opened his speech announcing his candidacy for the Senate, under the aegis of the Frente del Sur (Southern Front), by remarking that when he started filmmaking, his films were called pamphlets and he was told that he would be better off in politics. He announced his candidacy as a breaking of silence, averring that he would no longer stand mute before the corruption of Menem's government. The Southern Front allied various opposition groups of different ideological perspectives, fielding candidates including Luis Brunati (Encuentro Popular), Jorge Seiser (Partido Socialista), Alejandro Mosquera (Partido Comunista), Néstor Vicente (Izquierda Popular Democratica), and Miguel Monserrat (Intransigencia Popular), as well as various representatives of traditional and splinter parties, such as factions of Justicialist and Política Obrero parties. Using the symbolic language that made his early reputation in filmmaking, Solanas's campaign focused on national autonomy, anticolonialism, and an end to conservative neoliberal financial politics. The Southern Front also took aim at factions within the left that it considered to have made the administration's abuses possible by a consistent policy of complacency and consent.[73]

In a flourish of symbolic performance, Solanas converted the public space of Avenida 9 de Julio, in the heart of Buenos Aires, into a site for fixing meanings to his political campaign. Immediately prior to the elections, 4,000 of Solanas's supporters marched from the Congreso to the Obelisco, the monument in the city center that commemorates the anniversary of the city's

founding. The crowd protested unresolved issues of social injustice and neo-liberal economics of the transition, targeting Menem in particular, and shouting slogans of "¡Viva Perón, viva Evita!" and "¡Viva el Che Guevara!" Some demonstrators raised fists suggesting leftist militancy, and several sang along to a version of the national anthem played especially for the march by the "*rockero*" Charly García.[74] The marchers carried a national flag 400 meters long.[75] A sympathetic public was asked to connect Solanas's platform with the legacies of working-class and nationalist ideology, a romanticized inclusionist Peronism, and a way forward through the social activism of the new generation.

Political analysts credited Solanas the politician as having helped redefine the left in national politics. According to official counts, Solanas received 130,000 votes in the 1992 election, constituting a little over 7 percent of the porteño body politic and winning his party four electoral college votes.[76] When Solanas successfully ran for the House of Representatives in 1993, *La Nación* and *Clarín* described his constituency as defectors from Peronist and communist sectors.[77] His coalition was hailed as a new possible future for the left, remaking a stable opposition to officialism and the two major parties.[78] From this campaign, Solanas announced that in 1995 he would run for the presidency.[79]

On a platform of combating corruption and the indulgences of the free market, the party won several regional offices and seats, even making a triumph over Raúl Alfonsín's Radical Party.[80] Solanas's presidential campaign centered on creating a future for unemployed youth, continuing popular resistance, and combating the "economic dictatorship" imposed by the International Monetary Fund.[81] Eventually, Solanas's coalition front fell apart, principally from divisions over what would become of privatizations and how to manage the economy, and Solanas ran as a representative of Alianza Sur (Southern Alliance), thus splitting the left-of-center vote.[82] In the presidential elections of May 1995, a disappointed Solanas received only 72,000 votes, a poor showing even among left-oriented candidates in the election.[83] Returning undaunted to his role as national diputado, Solanas reinforced his place in cultural politics of the transition by proposing a series of reforms that would affect the arts industries. He advocated bills for increased protection of the national audiovisual arts and communication market, arguing for the protection of cultural patrimony and the national ownership of the images that would constitute Argentina's "future memory."[84] In this way, he gave political voice to his vision of the place of cultural media in organizing

popular memory and ordering understandings of the past. Eventually his support waivered, however, and Solanas left public office, declaring the authenticity of making political films to be his preferred form of activism only to return again in 2009.[85]

In many ways, political displacement and dislocation became a homogenizing discourse among the reemerging left that would come to engulf a much wider variety of responses to the realities of the recent past and point them collectively toward a revisioned future of reclaimed political agency. The image construct of el sur created by Solanas thus became a site for thinking about and attempting to create an alternative left politics that would be able to reassert itself within the cultural imaginary of the transition. Solanas's South in this way became an organizing image that mediated between loss and the continuation of certain utopian and transformative visions created by the 1968 generation, after the traumatic break of the 1970s and early 1980s. From this position, Solanas then stepped into the imaginary space created by this image in an attempt to carry out this politics in the real world rather than on the screen.

Revisioning political identities and reworking public understandings of national film history, Argentine filmmakers claimed an important role in the history of knowledge production and meaning making during the transition to democracy. The authority they eventually cultivated derived from an identity that resonated within the historical imaginary of transition culture. As primarily fiction filmmakers, this set of directors asserted a mode of identifying, dealing with, and solving problems that set the groundwork for the testimonial documentary. It is clear that in determining the locus of agency during this period, this set of key cultural agents changed the status of national film and filmmakers. Their ideology and internal political organization was evidenced by their cultural production and the discourses surrounding that production, which directly informed their political activities. In instigating policies and modes of operation within intellectual and scholarly networks, these directors changed the place of national cinema in the representational politics of the early transition and the postdictatorship period. Nonetheless, their mode of filmmaking would soon be challenged by a new generation of political filmmakers.

PART THREE

The Mediated Subject

[Young filmmakers today] approach cinema with a strength and desire unknown to most of their elders . . . [producing] films neither the industry nor the public demanded, and that exist only because of the determination of their makers. . . .

. . . Rather than waiting to take their assigned places in a pre-existing market, they simply dove in and made their films—and in the process were often taken up by producers with an eye for talent. . . . Today even the most obtuse civil servant will speak of [Argentine] cinema as a cultural good with an export value that should be taken into account.

Edgardo Cozarinsky, "Letter from Buenos Aires"

The levels of poverty denounced in *La hora de los hornos* in the 1960s were barely a presage of the neoliberal genocide of the nineties.

Fernando "Pino" Solanas, *Memoria del saqueo*

5

DOCUMENTALISMO

Political Filmmaking and
Social Movements

IN 1999 A FILM collective calling itself the Insurgent Cinema Group produced the documentary *Diablo, familia y propiedad* (Devil, family, and property), a film about the exploitative working conditions of the Ledesma sugar mill in the northwestern Argentine province of Jujuy. Directed by Fernando Kirchmar, the film explores the local myth of a blood pact between the factory's owners and the devil, whereby the latter exacts the life of at least one millworker each year to guarantee the company's prosperity. The film traces the menacing connections between workers who were active in denouncing the factory's abusive working conditions and the "disappeared" victims of the devil's deal. Its narrative recounts Ledesma's high-profile collaboration with the military dictatorship of 1976–1983, during which mill owners and administrators provided vehicles, an airstrip, financing, and information to the regime. Contrasting interviews with workers, families of victims, and human rights activists against the accounts given by the mill owner himself, the film makes the argument that the company's complicity with the military during the dictatorship did not end in 1983 but continued afterward, evident in its commitment to neoliberal economic policies and the violent repression of labor.

Diablo, familia y propiedad sparked public interest when the film's director announced that its makers would boycott the international Mar del Plata

Film Festival shortly before the film's debut. In the weeks that led up to the film's release, Kirchmar and members of his crew gave interviews that pointedly assailed several prominent directors and figures of the film industry. The director accused major national cinema figures of having lost their vision of class conflict and abandoning the "question of combat."[1] The film collective's members reported to the media that they considered themselves the ideological heirs to Gleyzer, Birri, Solanas and the militant cinema of the 1960s and 1970s, ready to pick up the cause of revolutionary action through cinema. The Insurgent Cinema Group continued to make waves by organizing public debates and collective actions around screenings of the film in alternative film spaces across the city of Buenos Aires.

On one such occasion, the group was approached by HIJOS (Children for Identity and Justice against Forgetting and Silence), an organization of children of the disappeared. The group's leaders were aware of the film's reputation and asked Kirchmar and his colleagues to join them in an act of social activism. The HIJOS group invited the filmmakers to participate in an *escrache,* a public denunciation, of the Ledesma sugar mill's proprietors, the Blaquier family, as a part of the film's debut at the Cosmos Theater on August 12, 1999.[2] Following the screening, the group of filmmakers and activists in the audience marched from the theater to the home of Nélida de Blaquier, at the time serving as director of the National Museum of Fine Arts. When they reached her house, they made speeches, shouted revolutionary and accusatory refrains, and formally "marked" the home,[3] performing a sort of vandalism to increase public awareness, as is commonly done in escraches; the most common technique involves spattering red paint on the home of the accused to signify the targeted individual's relationship to the blood of the disappeared spilled by the dictatorship.[4]

Kirchmar's film represents the third generation of transition filmmaking, part of an explosion of Argentine political documentaries beginning after 1989. These primarily low-budget and grassroots films followed Alfonsín's presidency but, when they were made, spoke to an audience still much engaged in Argentina's incomplete and continuing transition toward being a just and democratic civil society. Critical of the failures of the first popularly elected civil government to undo the dictatorship's legacy of social and political ills, many directors made these subjects the driving themes of their projects. As Kirchmar noted to the popular on-line entertainment magazine *Miradas,* works such as *Diablo, familia y propiedad* demonstrated that filmmaking had become "an active intervention in concrete political debate, generating actions or impulses to action in its spectators."[5]

In the 1990s, Argentina, and particularly the city of Buenos Aires, became an international hub of film activity. The number of the nation's internally produced films and its film schools, workshops, and exhibition venues grew exponentially from the mid-1990s to the first decade of the new millennium. Rising numbers of skilled professionals coupled with lower commercial expenses made Argentina an ideal place for directors and commercial producers to come to film their projects. The increased circulation of capital and employment from abroad meant that filmmakers enjoyed more opportunities to develop and finance their own creative projects. The introduction of digital technology further extended the franchise of film production to a larger sector of the urban population and made the media market increasingly competitive. This surge in production led to the flourishing of something film critics began to call *nuevo-nuevo cine,* or the new new cinema, a term used to pull together the different approaches to filmmaking that emerged during this period. The documentary boom, partially explained by the genre's cost effectiveness, began to push the limits of national industry regulation as production grew from an average of 30 full-length films per year in the mid-1990s to almost 200 by 2004.[6]

The story of the third generation of transition film is the tale of grassroots documentary production since 1989 and its relationship to the reconstruction of a viable political left. The transition brought filmmakers and cinematic concepts into the fold of citywide intellectual activity in such a way as to privilege documentary filmmakers and their political messages. New forms of production and diffusion, coupled with advances in regulation and the contours of a new global marketplace, turned the act of filmmaking into a form of bottom-up political activism particularly well suited to projects of a political orientation that would again be called the "new left," that is, the rebuilding left that emerged after the military dictatorship. As such, left-leaning film activists and even leftist political parties began to use film to intervene in a range of appeals for social justice and reform to neoliberal economic policies. In addition, emerging political organizations on the left also began to use documentary film to colonize new public spaces for social activism. As a consequence, cinema became a fixture of critical inquiry in other politicized urban spaces.

INNOVATIONS OF TECHNOLOGY AND PLACE

On July 8, 1989, the Peronist candidate Carlos Menem assumed office as president of Argentina, having won the popular election on a campaign promise of restoring the country's former economic prosperity. Under the flag of

national unity, Menem's administration launched a number of economic reforms designed to bring Argentina out of the dire financial straits encountered during the late Alfonsín administration. To stop hyperinflation, the administration began a broad set of structural reforms. The Senate formally declared a "State of Economic Emergency," authorizing a 180-day suspension of state subsidies, industrial supports, and purchases by the national government. This law also modified legislation on foreign investment, opening opportunities considered beneficial to economic recovery. This belt-tightening and liberalization project preceded a highly controversial monetary reform, called convertibility, that Menem launched in April 1991. This convertibility policy, which pegged the Argentine peso to the U.S. dollar at a rate of one to one, was designed to stabilize the economy by maintaining the constant value of the currency so that it could be used as a common denominator in business transactions.[7]

Financial instability and the debt crisis shifted Argentina's political landscape across the board, and Menem's aggressive economic restructuring received little initial public resistance, even among the opposition, in part because of the traumatic effects of returning hyperinflation. As support for Alfonsín's Unión Civica Radical Party declined, the mainstream Peronist party, the Justicialist Party, had begun to rebuild itself, expanding its support base as early as 1986. From the early 1970s to the mid-1990s, Argentina's industrial sector shrank rapidly, and a loss of industrial jobs in the capital, Rosario, and Córdoba meant fewer working-class voters living in areas that had been strongholds of the labor movement. Two new groups of voters expanded to fill the void, the urban poor and the retail and service sector, the "new middle class." For this reason, support for labor-based parties steadily declined in this period, and even the Peronist party had begun to move away from its traditional populist, labor platform. Under Menem's leadership, the Justicialist Party apparatus divorced itself from the legacy of the 62 Organizations of the Cordobazo and entered a period of rapprochement with the country's conservative elite.

Under Menem, the intellectual and political left faced the challenge of finding a new role for civil society as it became clear that old models of Marxist class conflict had given way to apocalyptic visions of a postmodern neoliberal political economy.[8] Several traditional parties of the left began moving away from labor and toward European-styled social democracy models, while other "orthodox" labor-based parties began to make overtures to a broader support base, including displaced workers and the lower middle class.[9] Political parties of the traditional left did not make a strong comeback during

the initial democratic opening, and several began to build alliances around shared goals; for example, the Frente País Solidario (Front for a Country in Solidarity, or FREPASO) was an alliance front formed by several parties, including socialist parties and Christian democrats, to increase electoral showing. Problematically, as many social scientists have pointed out, the reemerging left now lacked a structuring economic model alternative to that of capitalism and tended to reflect the general disaffection of members who had lost faith in the socialist utopias of the Cuban Revolution and May '68.[10] At the same time, however, a proliferation of local initiatives began to institutionalize gains made by rights-based activism during the transition, and a dispersed left moved away from party structures and toward alternative modes of political participation.[11]

By the end of the transition, the intellectual left had made strong alliances with transnational organizations and institutions, a powerful means of resisting both the state and the internal problems of local political movements and parties. It had also found a powerful new source of strength within organizations of civil society, particularly human rights organizations, civic associations, and emerging social movements.[12] The transition's multiplication of public spheres within which critiques and demands could be expressed had given leftists new ways to confront state power, social and cultural forces that operated beyond the reach of political parties and institutions themselves. Whether this splintering of the left into discrete social movements, solidarities, and rights-based politics merely reinforced or was generated by dissatisfaction with Marxist materialism and class-based struggle, the Argentine intellectual left of the 1990s embraced a culturally articulated form of political activism, a politics of contention rather than one of direct political intervention. The Chilean cultural critic Nelly Richard describes this as the end of the Gramscian intellectual model, focused on competition with and opposition to hegemony, and the beginning of the Foucauldian intellectual model, whose critique could be launched from a position of cultural pluralism no longer tied to "the ethos of a culture of martyrdom."[13] No longer the excluded voice of the exterior, the intellectual had become a newly integrated participant in public debate.

Within this shifting political landscape, Menem's financial policies transformed the economic prospects of Argentina's growing middle class. Continued borrowing from international banks provided a reserve in the national treasury that stabilized and raised the value of the local currency, which translated into higher average standards of living. In addition, it became much cheaper to import goods from abroad. Inexpensive imports had the

dual effect of stunting national production while simultaneously facilitating the importation of capital goods. This economic resurgence resulted in higher spending power, especially among the upper half of the middle class, which manifested itself in increased conspicuous consumption both within the country and abroad, the citizen as global consumer, as Néstor García Canclini suggests.[14] The inflated economy of the early 1990s also enabled many young middle-class people to utilize their disproportional spending capacity to pursue nonremunerative creative work. It became increasingly possible for college-aged men and women to attend film school instead of following a more traditional or vocational educational path.[15]

In the 1990s filmmaking became newly accessible to a significant portion of the urban Argentine population. Even a few of the most economically disadvantaged sectors of Argentina, such as the Avellaneda barrio of Buenos Aires or the province of Entre Ríos, could boast of adequate facilities for training screenwriters, directors, cinematographers, and technicians. Largely as a result of state and municipal spending, film schools proliferated to meet the demands of an ever-growing quantity of aspiring filmmakers.[16] Although many schools lacked the funding to provide access to equipment for all their students, the digital revolution in cameras and computer editing did much to fill the gap. By the end of the 1990s, more than 7,000 students of cinema attended the thirty state and private film schools across the country.[17] In addition, upper-middle-class families could afford to own home filming equipment, ranging from fairly rudimentary Super-8 cameras and VHS recorders to sophisticated miniature digital cameras.[18] National film production benefited from this boom, and filmmakers across the spectrum benefited from increasingly cost-efficient access to editing studios, basic film crews, and rental equipment.

Technological advances in film production pushed gains already experienced in the film economy into high relief. First, videocassette recording made the inexpensive reproduction and circulation of films possible. Video allowed for an explosion of film clubs across Buenos Aires, many of which operated using pirated copies of films, avoiding the high cost of purchasing originals from distributors.[19] Eventually the informal market of pirated materials surpassed the formal market in delivering audiovisual media to private and public spaces. In 1980 the first national cable television network began transmission, doing so under the auspices of the Asociación Argentina de Circuitos Cerrados Comunitarios de Televisión. By 1987 cable providers had added film channels to their programming and were beginning to compete directly with video and film for viewership. The company Cable Visión and

its rivals capitalized on being able to cater to a large intraregional market, including North and South America, as well as Iberia, diversifying their interests so as reach the broadest audience possible with minimal resource investment.[20] All this translated into a crisis for large production companies, making it even more important to petition the government for subsidization, protection, and support.

Beginning in the mid-1990s, however, independent producers began to take advantage of the big studios' poor showings to introduce low-budget productions made on video and, later, digital media. When the technology to make homemade, or *casero,* films expanded during the course of the convertibility era, productions by students, amateurs, and grassroots filmmakers increased. By 2000, cable-based and other broadband Internet media had made it possible to completely drop intermediaries from distribution and exhibition.[21] The 1990s also witnessed a dramatic expansion of access to film exhibition in Buenos Aires. In addition to experiencing new cyberspaces, the public could view films at a variety of film series and festivals, impromptu public gatherings, cultural centers, museums, and university campuses, all outside the reach of commercial film markets. Filmmaking cooperatives in Argentina began to circumvent heavy industry legislation by producing films exclusively for alternative and informal markets. Paralleling a similar phenomenon in North American and European noncommercial cinema, these cooperative groups shared resources and personnel, bypassing unions and guilds.[22]

A number of nationally based cooperative organizations brought the global fight for grassroots agency in mass media to the city of Buenos Aires. Groups such as the Movimiento de Documentalistas (MD), ADOC/Argentina (Asociación de Cortometrajistas y Documentalistas Argentinos), Grupo de Cine Insurgente, and Kino Nuestra Lucha organized film projects as a form of social activism. These groups argued that grassroots film production participated in an international effort to open political and aesthetic debates to previously excluded groups, principally the middle and lower classes.[23] The films they produced concentrated on contemporary issues including economic inequality, political corruption, and workers' movements. Collectively these groups coordinated to open new spaces for the screening of commercial films and the production of grassroots video as an alternative to mainstream news media.[24] They often projected their films about current events at political party headquarters, student rallies, popular demonstrations, and student gatherings.

At the same time, independent film contests and festivals across the globe grew in number, providing a key forum for showcasing and supporting this

kind of work. Some of the more publicized international festivals, such as the Sundance, Rotterdam, and Toronto film festivals, began to offer substantial prizes for independently produced films, creating a small but significant source of funding available to grassroots and cooperative filmmaking.[25] In 1999 the municipal government of Buenos Aires hosted the first national Festival of Independent Cinema (BAFICI), following the Mexican initiative in 1998 to do the same. These new spaces created opportunities for encounter and exchange, allowing Argentine directors to gain wider exposure and to network with potential coproducers from abroad. Menem's opening of the Argentine economy further helped Argentine directors find financial and technical support through coproductions with groups outside South America.[26] Menem pushed the "blockbuster" model of film production and opened the market to foreign films from Hollywood, an appeal to the upwardly mobile middle class and the commercial interests of exhibitors.[27]

The explosion of filmmaking that resulted from low-budget technology revolutionized the way cinema participated in cultural life in Buenos Aires during the new millennium. Not only did these technological and market changes open the door for new groups of filmmakers and new forms of filmmaking, but they also specifically privileged the documentary as a mode of cultural expression and the social movement as a vehicle of political activism. Documentary filmmaking, as purveyor of denunciatory realism, acquired a new degree of authority in using the testimonial mode, one that was developed through use of images and audiovisual footage that could represent "documentary objectivity," an undeniable past experience captured in iconic fragments. Falling under the jurisdiction of journalism instead of entertainment law in Argentina, documentary filmmakers do not need to obtain any formal permission for the images they shoot and interviews they record. This difference from fiction film has allowed documentaries to stake a greater claim in the business of representing "objective truth."[28]

CULTURAL POLITICS AT A CROSSROADS

In the wake of advances for noncommercial cinema and foreign films under Menem, protest from the industry compelled the administration to initiate sweeping reforms.[29] This crisis came to a head when the established director Leonardo Favio asked that his film *Gatica, el mono* (*Gatica the Monkey* [1993]) be retired from preselection for the Oscars in the category of best foreign-language film, causing a huge public scandal. The film had been sup-

ported by the Argentine Cinematographic Directors association, the DAC, whose president, Luis Puenzo, released an official statement to the press; its withdrawal was meant to force the administration to reform cinema law.[30] Patricia Bullrich and other representatives of the Peronist Justicialists, the party most identified with filmmakers' unions, began pressuring legislative committees to find a rapid solution to the industry's problems so that Argentina could be represented that year at Hollywood's biggest award ceremony.[31] Filmmakers and industry representatives were concerned with the direction that national production would take. They were also increasingly conscious of the growing political interest in filmmaking at national levels and how this would affect their livelihoods. In November 1993 a consortium of organizations within the cinema industry came together to draft a petition to Congress that called for the reform of film legislation to face the challenges of the new technological era on the horizon.[32]

Beginning in 1994, changes in cinema legislation redefined national commitments to documentary and political filmmaking. As a largely symbolic gesture, the Senate renamed the film institute the Institute of Cinema and Audiovisual Arts (INCAA), recognizing the new modes of production and reproduction that had begun to revolutionize the market. Institutional legislation created a governing assembly that was directly responsible to the secretary of culture and included the participation of provincial undersecretaries of culture and their counterparts in the municipal Buenos Aires government. This assembly was charged with designing a new mission for the institute that would specifically encourage the production of films with cultural and social interest. The new legislation promoted institutional collaboration with and support of historical film projects, fine arts films, and films designed to combat social ills. It also addressed the question of cable and videocassette distribution, which had become significant threats to the commercial interests of film producers.[33] By legitimizing and giving support to generally low-budget political and social cinema projects, the Senate gave a nod to films seen as capable of competing within the new media environment.

During the process of legislation reform, filmmakers captured an important strategic advantage in the media market by leveraging the currency of their position via transition cultural politics. In 1994 the Justicialist Party formed a commission that proposed a number of reforms to cultural policy legislation. Led by figures strongly identified with the politics of the postdictatorship human rights movement, such as Bullrich and Irma Roy, this commission proposed taxes on radio and cable television to support national filmmaking. One of the most widely recognized transition filmmakers of the

second generation, Luis Puenzo, led a press conference in the San Martín Cultural Center to generate support for and publicize the needs of the cinema industry. Representatives of all elements of film production came together at this meeting to collectively petition for increased national support. Eventually the effort yielded proposed legislation that would require television and cable companies to provide publicity for national filmmaking and funds for eight new film projects a year.[34] The Senate presented this unanimously approved first step toward new legislation as a symbolic tribute to the contributions of filmmakers over the past decade, giving a standing ovation to the filmmakers, including Puenzo and Fernando Solanas, in attendance during the formal ratification.[35]

Despite these gains, many high-profile filmmakers continued to push for more far-reaching reforms. Several second-generation transition directors, including Puenzo, Adolfo Aristarain, Eliseo Subiela, and María Luisa Bemberg, launched a biting public campaign to put pressure on the institute.[36] Bemberg used the title of her film *De eso no se habla* (literally, "one does not speak of that") in several press conferences to signal a connection between public silences about the dictatorship and silences in the media industry. In this way, she compared the concessions that the Menem administration was making to television with the policies of the military government during the dictatorship.[37] The former INC head Manuel Antín and the director Eliseo Subiela spoke out against the "corruption" of the institute, making an appeal for honest management of funds.[38] Héctor Olivera also gave interviews during this time criticizing Menem's cultural administration and questioning the "behind closed doors" relationship of support among the party, the president, and the director of the film institute. His tone underlined the notion of high-level corruption and complicity, one that resonated with many transition period critiques of official complicity with the military and its interests.[39]

Several directors took to the streets to bring the politics of the film industry into important public spaces.[40] Organizing a demonstration in front of the congressional building, they demanded that the film institute director, Guido Parisier, step down because of corruption and proposed his replacement by Antonio Ottone, a pioneer of cooperative filmmaking and a well-respected figure within cinema industry organizations.[41] They also insisted on increased subsidies to film and a more transparent process for the collection and redistribution of film taxes.[42] On May 11, 1994, modifications to cinema law, Ley 17.741, were finally passed in both chambers of Congress. The revised law invested the new director of the institute, Ottone, with more authority to intervene in matters of exportation and external distribution of

films, giving him license to sign treaties on exchanges of films and coproduction agreements. It required the institute to introduce measures to formally study and assess other state organizations and their influence on both internal and external film markets. It also granted the assembly greater authority to protect and develop cultural spaces for film and audiovisual exhibition. The assembly was further authorized to generate treaties with universities and other educational institutions to promote education in audiovisual media.[43]

Under Ottone, the INCAA became an instrument for expanding Argentine film audiences abroad. The institute director signed a treaty with the customs workers union to allow Argentine film easier distribution outside its frontiers. He negotiated the showcasing of Argentine films at major film markets, such as the Cannes market, the Milan market (MIFED), and the American Film Market, and signed an accord with Phoenix Investments of Los Angeles for the distribution of Argentine films in North America. Ottone gave official financial support for filmmakers completing projects outside the country or directed toward foreign audiences. In this way, Ottone paved the way for Argentine filmmakers to extend transnational linkages and to expand their international audiences.[44] Ottone also negotiated an ambitious project in the Capital Federal district, renting a cinema along the central Avenue 9 de Julio, three blocks from the Obelisk, to show domestic and foreign films outside the typical commercial offerings from Hollywood companies. In doing so, he successfully arranged for reciprocity with other national cinemas, trading, for example, a week of French film in Buenos Aires for a week of Argentine film in Paris.

Throughout Carlos Menem's presidency, legislators made consistent efforts to centralize many of the offices of culture and force them to respond more strongly to the interests of the market.[45] At one point, Congress passed a law, supported by Senator Fernando Solanas, mandating the creation of a national *cinemateca* and film archive that would have ultimate authority over the way domestic films could be used in cultural projects designated by the national government. This law, Ley 25.119, would have provided the jurisdiction necessary to seize private collections. Based on the notion of protecting a diminished national patrimony of film resources, the project was supported by several directors, including Adolfo Aristarain, Leonardo Favio, Pablo Trapero, Luis Puenzo, Eliseo Subiela, Martín Rejtman, Marcelo Piñeyro, and a handful of others.[46] Drawing strong objections from industrial film sectors, this initiative drew attention to the relatively tentative legitimacy that film institutions had in maintaining authority, particularly in the face of potential commercial interests that might be attractive to the state.[47] President Menem

finally vetoed the law, however (by Decree 752/99), bowing to strong objections by lobbyists and the newly appointed INCAA director.[48]

By the late 1990s, the film industry recognized that legislative reforms and technology-driven market shifts had conferred permanent viability on noncommercial national cinema production. Well aware of their growing inability to influence or regulate the explosion of grassroots filmmaking, both the INCAA and the filmmakers' union (SICA) attempted to draw new groups of filmmakers into the industrial fold. In June 2000 the new INCAA director, José Miguel Onaindia, released a project statement of updated regulations for the implementation of cinema law 17.741 with support from the union. This set of reforms reinstituted screen quotas for national films at the discretion of the director of the film institute. It also extended subsidies and financial credit to coproductions, allowing Argentine filmmakers to apply for support for projects that might also be receiving funds from abroad. Subsidies were also expanded to include a broader set of functions, including project development, production, and publicity.[49] All these measures increased the potential for noncommercial filmmakers to work with the institute.

The film institute targeted grassroots documentary filmmakers as being likely to see merit in industrial protection. In 2001 the INCAA organized a conference of young documentalistas to promote the benefits of working through official channels of state and industry production. The institute's office of development made clear that its generosity would be restricted to films that followed strict codes of production. It stipulated that to receive credit, a film project would have to employ technicians and workers contracted through SICA. The office also urged the use of state-subsidized distribution, which would require doing all business through the INCAA as a single producer.[50] The film institute allocated funds to the municipality of Buenos Aires and provincial governments to develop documentary film projects of national interest, in the hopes that this would direct filmmakers to the state.[51] A highlight of the institute's initiatives during this period was the creation of a theater in the center of Buenos Aires named after the legendary tango and film star Tita Merello and devoted to the screening of domestically produced films. On the eve of the economic crisis of 2001, Onaindia, announced that the institute would continue to subsidize at least thirty-five to forty-five projects a year, despite a reduction in the national budget.

Maintaining the surge of national and foreign interest in Argentine cinema became a chief concern of the INCAA when confronting the financial limitations of the ensuing economic downturn. Citing young directors as the party primarily responsible for the success of Argentine films in international

festivals and markets, Onaindia announced that the institute would seriously negotiate with the Independent Cinema Project, an organization representing many of these young directors, while continuing to tailor the institute's support for grassroots filmmaking. Onaindia's administration created a number of new contests for independent filmmakers, with a variety of prizes and awards devoted to documentaries. Onaindia's successor, Jorge Coscia, continued these initiatives by extending financial credits to alternative film formats, including video-based and digital projects, and creating additional subsidies for documentary films. In 2002 the institute passed a measure requiring the release of at least 100 video or DVD copies of any film granted credits or subsidies; these copies were to be distributed to the cultural secretaries of each province, the municipal government of Buenos Aires, embassies, and the archive of the film institute.[52] This measure ensured wider dissemination of independent film projects and encouraged their use by government agencies. Although a significant downturn of the commercial film economy occurred during the period of the crisis, the film institute managed to turn this disadvantage into a means to bolster grassroots and noncommercial filmmaking.

RESISTANCE, DENUNCIALISMO, AND MARGINALIZED VOICES

Despite the economic gains of the middle class during the 1990s, leftist intellectuals grew increasingly concerned about widening class divides created by Menem's neoliberal reforms. Menem made significant cuts to social welfare programs while at the same time brokering under-the-table deals with big businesses to subsidize their growth through a variety of financial measures.[53] A group of Argentine social scientists working for the National Institute of Statistics and Censuses (INDEC) released an in-depth study of poverty just as Menem stepped into office. The document detailed the conditions of the urban poor, particularly in the greater Buenos Aires area. Diminishing wages followed by deindustrialization of key sectors resulted in a long-term unemployment rate of 16 percent that lasted throughout the 1990s.[54] The report categorized the structurally poor as those who lacked access to basic necessities, such as housing, food, and income. But it also identified a second class of the urban poor, which it described as the pauperized middle class, who regularly had access to basic necessities but who occasionally suffered in terms of meeting daily needs, whether in buying groceries and medications, paying

electricity or water bills, or finding adequate employment. The study found that because of Argentina's several decades of economic restructuring, the majority of those considered impoverished by the early 1990s were part of the second category, the "newly poor." The release of data from this study made major headline news. The political scientist Nancy Powers documented the INDEC release as the beginning of a new media phenomenon she called poverty as "news."[55]

With "news" of the impoverishment of the lower middle classes and the expansion of the structurally poor appearing on the front pages of major newspapers, such as *La Nación, Clarín,* and *Página/12,* new words of description became necessary to code the groups and distinguish one from another. It became an important political endeavor to differentiate the multiple groups of the urban poor and their diverse sets of needs, not only in terms of constructing a political agenda that would somehow include these groups, but also in terms of dealing with the increasing levels of public discontent over economic issues. For instance, among the new terms that began to circulate in the 1990s were *cartoneros,* which refers to individuals whose principal source of income comes from recycling; *piqueteros,* who are semiorganized demonstrators often associated with the unemployed; *desocupados,* or individuals involved with the movement of the unemployed; and *los sin tierra,* or the long-term homeless. During this period, the intellectual left began to develop theories centered on the reality of poverty, violence, and marginalization.[56] Although many of these categories overlapped in significant ways, separating the structurally poor from the newly poor also elicited new ideas about the political aspirations of each group.

Many political activists, disgruntled with the Peronist political machine that Menem had created, began to defect from traditional political parties by the mid-1990s or to participate in smaller social assistance activism from within factions of those parties. This period saw political organization flourish at the local level. At the end of Menem's presidency, the Argentine economy was still growing at a fairly steady rate, with exports and foreign capital inflows both on the rise, but heavy dependence on foreign loans and a large trade deficit left Argentina incredibly vulnerable to international ebbs and flows. Despite a rising GDP and stable financial reserves, nearly 29 percent of the population lived beneath the poverty level.[57] Social unrest was increasing, and even within Menem's Justicialist Party, new divisions emerged between "*menemistas*" and other factions, some of which sought a return to the working-class roots of Juan Perón's party, while others simply sought a new profile for the party that could help shelter it from increasingly hostile criti-

cism of Menem in the press. With the 1999 presidential elections approaching, debt defaults of "emerging markets" were provoking more difficult times for international lending and foreign investment, the two staples of Menem's economic policy. As unemployment reached 18 percent, voters expressed widespread disapproval of Menem and menemista policies.[58]

With financial crisis looming on the horizon, many groups within civil society had already formed around new identity categories of urban poverty, and political parties started to target these groups as potential allies. Some parties, such as the Justicialists, began to use a strategy of "problem-solving networks" to establish voter support within marginalized neighborhoods, providing soup kitchens, obtaining medical supplies, working with unions, organizing clubs for youth, and even working with senior citizens as alternative social welfare assistance. The group "Peronism for Everyone," for example, was led by a group of left-wing anti-Menemist Peronists, many of whom were former Montoneros, who used the organization to channel their critique of the state, to support strikes, and to conduct community outreach.[59] In the 1999 elections, Fernando de la Rúa, of the Alliance for Work, Justice, and Education, overcame the Justicialist Party's candidate, Eduardo Duhalde, the presumed successor to Menem. De la Rúa's running mate, Carlos "Chacho" Alvarez, had strong connections to the Frente Grande, which had evolved from the coalition Frente del Sur created by the first-generation transition filmmaker Fernando Solanas in the early 1990s.

The legacy of Menem's convertability policies made difficult work for de la Rúa and Alvarez. The domestic savings rate was down, imports were replacing nationally produced industrial products, and little internal investment was taking place. Not only did this result in increased unemployment, but the government had to continue to borrow a tremendous amount every year from international lenders, such as the International Monetary Fund and the World Bank, to keep up federal reserves and pay mounting international debts.

In early 2001 insecurity within the market and fear of a major currency devaluation led many Argentine citizens to draw on funds from the private sector, quickly depleting what remained of the federal reserves. On December 1, 2001, de la Rúa set limits on the amount of money that individuals could withdraw, preventing a run on banks. This policy, known as the *corralito,* or the "little corral," included a limit to weekly and monthly cash withdrawals and stipulated that all funds must be withdrawn in Argentine pesos and not U.S. dollars. This short-term measure only forestalled an eventual currency devaluation. Soon thereafter, de la Rúa ordered that all dollar-denominated savings

and loans be revalued in pesos, cutting the life savings of most middle-class urban residents by roughly three-fourths.[60] These measures evoked tremendous public outcry within both the lower and middle classes, including violent protests, clamorous marches on the presidential palace, and vandalism of foreign businesses and banks. De la Rúa resigned only three weeks after his financial policies were announced.[61]

The instability and institutional confusion caused by the 2001 financial crisis created conditions ripe for a surge in social mobilization and political critique. Several distinct social phenomena began to take shape within this environment, responding to the new economic realities of a devalued currency. Local neighborhood assemblies, called *asambleas barriales,* organized collective efforts to provide for those hardest hit by the crisis, such as the elderly, single mothers, and the homeless. Solidarity networks, often connected with neighborhood assemblies, began to construct exchange clubs whereby individuals could trade services and goods without having to resort to cash transactions. In one, for example, a psychologist traded sessions of trauma therapy for groceries and transportation. As many medium-sized manufacturing companies and businesses began to file for bankruptcy, a number of workers' cooperatives organized to occupy their constituents' former places of employment. Separate groups of unemployed workers, under the banner of the *movimiento de los desocupados,* or the movement of the unemployed, began to organize demonstrations and new political organizations. These groups began to cut off the major routes of transportation with picket lines in order to fight for increased employment opportunities and better unemployment benefits from the state.[62] The crisis underlined the failures of an uneven transition to neoliberal democracy in Argentina.

This set of political and economic circumstances also sparked renewed social activism within the film community and an outpouring of political documentary filmmaking. In the immediate wake of the crisis, the Argentine Actors Association (AAA) aired its political sympathies with the rising ranks of those pushed into poverty by the corralito and falling employment. Calling for a cessation of activities among the membership, the AAA reasserted itself politically for the first time since the early transition. It publicly rejected "the indiscriminate police repression" that resulted in the wounding and deaths of several participants during demonstrations, calling for better protection of the civil rights of workers and the Argentine people.[63] Given the poor financial prospects facing postcrisis film production, film students began organizing new labor-exchange collectives to continue producing low-budget films.[64] Several groups emerged from key film schools in Buenos Aires,

including Boedo Films, CINEFECTIVO, El Cuarto Patio, Grupo Primero de Mayo, and Proyecto ENERC, named after the film school of the institute. Many of the students who participated in these groups were familiar with a cinema studies pedagogy that privileged Argentina's history of social and radical filmmaking, and many cited militant precedents for the kind of activist filmmaking and nontraditional methods they chose to employ.[65]

The 2001 crisis gave documentary filmmakers the impetus to take up the banner of social justice and ally themselves with other groups of activists. Since 1996 a film cooperative called the Documentarians' Movement had been cooperating with the transnational independent documentary film movement. In 1997 this group organized its first film festival in the historically under-privileged barrio of Avellaneda, featuring films in video format and launching a film magazine called *Encuentro del Documentalista* (Documentarian's encounter). By the next year, its success had brought attention and support for publicity from the municipal government of Buenos Aires. After the corralito, however, the group broke away from official support and began to protest official corruption and economic injustice. The group's founders repositioned its mandate to turn the organization into a vehicle for activism. They began to use the terms "the movement" and "documentalismo" as synonyms for the group's collective identity. Soon after the postcrisis protests began, members of "the movement" took to the streets in several of the most radicalized spaces in Buenos Aires, aligning themselves with the movimiento de los desocupados, piqueteros, and other opponents of the corralito. Simultaneously taking part in and documenting public protest, they went on to produce films that exposed police repression and heightened awareness of victims of the economic disaster.[66]

The filmmakers in the Movimiento de Documentalistas, like those in other leftist groups, sought to reinforce their political identity by strengthening transnational networks connecting them to other activist documentary producers. The self-proclaimed leaders of documentalismo invited Mexican documentary filmmakers who shared their ideological sympathies to come and present their work; those extended an invitation included the director Fernando Buen Abad, who allied himself with the Zapatista cause in Chiapas. The founders of the Movimiento de Documentalistas met with other film cooperatives, such as the Insurgent Cinema Group and Grupo de Boedo. Realizing that they shared common objectives, these groups collaborated to host a national festival of cinema and documentary video that would end with a march on the Plaza de Mayo. The documentalistas created a web site to publish manifestos, post texts on documentary technique and theory, and address

political issues pertinent to the causes of the movement. This web site became instrumental in informing an increasing number of young filmmakers about events organized by the group and similar organizations around the world. The organization began to offer free filmmaking courses and, beginning in 2002, inagurated an international documentary film festival. The Festival of Three Continents invited African, Asian, and Latin American independent documentary filmmakers to present their work and compete for prizes in Buenos Aires. On May 25, 2005, the organization acquired a cable television channel and began showing documentary films from across Latin America. Official web-published manifestos of the Movimiento de Documentalistas announced the revolutionary ends of such filmmaking, citing its capacity to elevate organic intellectuals and their political concerns to an international level.[67]

Recognizing the tremendous reach of documentary filmmaking in the postcrisis period, several political organizations and state cultural apparatuses began to create their own organs of film production. An example of this kind of group is LuchArte,[68] the film forum of the Artists and Cultural Workers' branch of the Polo Obrero (Workers' Pole), a coalition of various political and social groups sympathetic to the impact of the crisis on workers. Representing asambleas barriales, unemployed worker's associations, the Partido Obrero (Workers Party), teachers guilds, factory-occupying workers, and organized demonstrators, Polo Obrero began hosting annual congresses in 2002.[69] LuchArte, as an arm of the Polo Obrero, organized cultural activities in support of these key constituencies. The documentary branch of the organization, Ojo Obrero, produced the internationally acclaimed documentary *Grissinopoli* (2004), a film about workers occupying a small breadstick-making factory. LuchArte campaigned for the election of legislators sympathetic to the causes of the organization and participated in a variety of assemblies and festivals hosted by other artists and cultural associations. Forming important alliances with these other groups, documentary filmmakers employed by political organizations became part of the complex mapping of film politics in the immediate postcrisis period.[70] At the same time, a number of international foundations encouraged the making of grassroots documentaries by offering support for films about economic and social justice. Spurred by the crisis, several foundations began to disperse funds for all aspects of production, distribution, and publicity of films loosely described as political cinema.[71]

A representative example of such collaborative efforts can be seen in the documentary productions of CINEFECTIVO, a collective formed by ENERC

and Fundación Universidad de Cine film school graduates. In 2002 CINE-FECTIVO's first project, *Los nadies* (*The Nobodies* [2002/2005]), won an INCAA-sponsored contest for best documentary screenplay for treating the subject of the financial crisis, and it was later produced for television, in 2005. The documentary addresses the impact of the crisis on street children and was filmed with just two cameras, one of which was used by the children themselves. The filmmakers gained international acclaim through the contest and went on to make their first commercial film in collaboration with another Argentine group, Terraplen, and the Spanish production company Aquelarre. This second project, *El tren blanco* (*The White Train* [2004]), documents the lives of indigent people who collect recyclable materials to make a living, the previously mentioned cartoneros. The film narrates the history of the creation of a special train, designated for their use, that daily transports the cartoneros and their oversized wheelbarrows to and from the more wealthy neighborhoods of Buenos Aires so that they do not disturb regular transit on the line. This documentary received much acclaim at the Fifty-fourth Festival of International Cinema in Berlin and eventually won INCAA funding for its amplification to 35mm film. It was used to spread information in the municipality of Buenos Aires about the identity of this group, to mitigate social misunderstanding.[72] This kind of militant cinema differs from the militant cinema of the 1960s and early 1970s fundamentally in that its makers are not necessarily trained professionals and usually have little experience working in audiovisual media; nonetheless, they are still able to circulate their productions.

CINE PIQUETERO AND PROJECTS OF URBAN SOLIDARITY

One of the more dynamic developments of this kind of filmmaking is the phenomenon of cine piquetero. In reference to documentary filmmaking, the label "cine piquetero" has come to refer to films made by and about the piqueteros and the variety of causes the piquetero movement advocates.[73] In some contexts, it has also been used to refer more generally to a style of radical documentary filmmaking focused on exposing the living conditions and political struggles of marginalized social groups.[74] The first example of this kind of filmmaking was the result of a meeting of the film collective Contraimagen in 1997 at the Universidad Nacional de La Plata, where participants decided to create Noticiero Obrero, an alternative news service, or *noticiero*,

that would chronicle the growing resistance movements to Menem's economic policies. During this initial meeting, participants in the collective decided to collaborate on a project filming the first roadblock demonstrations of the piquetero movement.[75] The term "cine piquetero" was first used in exhibition spaces in December 2001, in a film series that brought together a number of filmmakers working on similar projects.[76] The twenty films of the series were organized by the Insurgent Cinema Group to offer a testimony to the achievements of the piquetero movement.

By 2001, when cine piquetero was beginning to attract a larger public audience, filmmakers had already begun using the symbolic recognition of the piqueteros' projects to throw their weight behind the political interests of marginalized groups. One collective formed by former students of the Avellaneda film school even used a reference to historical cultural activism, calling itself the Grupo de Boedo after the porteño literary community of the 1920s that advocated social justice. In 1992 this group began critiquing the impact of Menem's economic policies on the urban poor, making short films such as *No crucen el portón* (They don't cross the threshold [1992]) and *Después de la siesta* (*After Nap* [1994]).[77] The group later organized with the collective Contraimagen to film *Control obrero de los trabajadores de Brukman* (Worker control Brukman [2002]), a documentary about workers occupying the Brukman factory. This project led the group to attend a congress of factory-occupying workers, the 2002 Second National Conference of Occupied Factories, where they joined forces with a larger collective, Kino Nuestra Lucha, to begin an information service they would call Noticiero Obrero/Kino Nuestra Lucha. This service specialized in presenting news of factory takeovers and the process of workers' "recuperation" of factories, focusing particularly on Brukman and Zanón, two of the most well-known cases. In 2003 Grupo de Boedo began to film a trilogy of documentary films on the Brukman experience, starting with *Control obrero* (Worker control [2003]) and *La fábrica es nuestra* (The factory is ours [2002]) and ending with *Obreros sin patrón* (Workers without a boss [2003]). Completely independently produced, these films went on to be selected for and were awarded prizes in over a dozen international film competitions, including the prestigious Trieste and Berlin festivals, and participated in over twenty transnational solidarity events.

A pivotal event that defined cine piquetero as a distinct movement within political documentary filmmaking in Argentina following the crisis was a film festival and debate hosted by the sociology department of the University of Buenos Aires in 2004. The event was organized by students at the univer-

sity to commemorate the second anniversary of the deaths of two piquetero protestors during a demonstration repressed by the police in July 2002 on Pueyrredón Bridge, in downtown Buenos Aires. The film series featured works by three prominent cine piquetero filmmakers' collectives: Grupo Alavío, Indymedia Video, and Grupo Ojo Obrero. The faculty screened three films, *Crónicas de libertad* (Chronicles of liberty [2002]), *Piquete Puente Pueyrredón* (Pueyrredón Bridge picket [2002]), and *Piqueteros carajo!* (Fucking piqueteros! [2002]), each depicting the events surrounding the Pueyrredón incident from the demonstrators' various viewpoints.

While each film presented a testament of the piqueteros' struggle against police repression and for social and political recognition, *Crónicas de libertad* provoked the most intense debate. A film composed entirety of interviews with masked and unidentified members of the piquetero movement, it raised an important issue about the filmmakers: to what extent did their films participate in the struggles they documented? The filmmakers claimed that the use of masks was essential to protecting the protesters from police attacks on their homes. One interviewee spoke about the necessity of self-defense among members of the movement during public demonstrations, describing his use of arms during protests. Several audience members re-garded the film as giving justification for a semiarmed movement.[78] These films collectively presented a public denunciation of a particular event in which two victims of police repression lost their lives, becoming martyrs of the movement. The audiovisual tracks and images of the films constituted a new source of documentation of one of the most divisive events of Argentine contemporary social reality.[79]

Cine piquetero's activism also became clear at this event in the way its films were created, distributed, and exhibited. Made on minimal budgets, using almost entirely voluntary labor, cine piquetero in its quintessential form became defined as using borrowed or shared equipment and basic personal computers for editing. Circulated via homemade videocassettes and DVD copies and screened in noncommercial settings, cine piquetero films cut out the industry entirely and circumvented any means of official regulation. The sociologists' forum and later proponents of cine piquetero championed such filmmaking as a form of political activism. Pablo Navarro Espejo, a director and the founder of Adoquín, argues that by circulating on video, his films have reached a larger audience in an informal market that responds well to this kind of timely material. He describes as a choice his decision to use cameras that produce rougher images but that are able to weather the conditions of filmmaking in the streets, so as to make the audience aware of the

fact that the filmmakers are also participants in the struggles they are documenting.[80] Several of these films took part in the Sixth Seoul International Labor Film and Video Festival in 2002, where pirated copies of the films were smuggled to workers in factories by a sympathetic local organization, Labor News Production.[81]

The kind of urban solidarities that emerged as filmmaking began to reassert its relative place within the reimagining of the new left reflected a set of new demands and objectives regarding the structure of Argentine civil society. The frame of neoliberal injustice gave filmmakers and the social actors with whom they aligned themselves a means of constructing a network of rights-based affiliations across the urban landscape of Buenos Aires and eventually a larger network that expanded to other cities and rural areas of the interior. The social grievances and formulation of urban life provided a base from which a collective identity could be constituted and performed. The fabric of an urban struggle of the marginalized against the protagonists of neoliberal advance was neatly knit from reformulations of the Third World solidarity discourses of filmmaking projects during the late 1960s and early 1970s; from early twentieth-century Marxist internationalism closely tied to concepts of the socialist state; and from a new thread, that of a transnational, cosmopolitan altruism buoyed by the human rights movement of the mid-1980s.

The specific critiques of the filmmakers speaking on behalf of the marginalized communities of urban Argentina centered on two streams of political logic: at the fore, the particular, and in the expansion of the argument, the universal. By singling out specific factories, neighborhoods, families, and demonstrators, the films embodied the particular dissatisfactions with the failures of the transition to democracy, translating universal strategies of social justice into a local vernacular. At the same time, the films rehearsed a familiar narrative of humanitarianism, one that would resonate within the broader structures of production, distribution, exhibition, and critique of the films and that would transcend the familiar borders of urban collective identity. In the late 1990s, James Petras argued that the Argentine left was suffering from a crisis of political credibility, a stagnation of the traditional left's political parties and a fragmentation of the organic left into impossibly varied factions and minor articulations of social movements.[82] In this atmosphere, it was necessary for the left to attach itself to the newly emergent political communities that were in the process of reimagining a unifying political critique within the frame of denouncing neoliberalism.

FILMMAKERS AND THE "NEW LEFT" OF THE TRANSITION

One of the latent but persistent characteristics of the filmmaking community's attempts to foster solidarity and its connection to social movements was a reinvigoration of a narrative about the labor movement of the late 1960s and early 1970s. Although filmmakers were certainly not alone in revisiting the political narrative of the Peronist left and the "62 Organizations" in the lead up to and during the dictatorship,[83] they were able to draw on the tools of audiovisual media to script a direct ideological liaison between the Montoneros, for instance, and the piqueteros, labor activism and the occupied factories movement. Reifying the Peronist and labor heritage of the urban protest movements, the urban clashes and workers' struggles of the late 1990s and early 2000s, these films constructed an intellectual continuity between the Peronist popular mobilization and the nuances of urban social activism as the continuation of the struggle between the people and the ambitions of a national elite compliant with the project of neoimperialism.

Revisiting the labor struggles of the past entailed a rapprochement between the filmmaking community and the institutions of industrial cinema. As strengthening transnational networks and increasing production opportunities presented themselves to filmmakers engaged in the political cinema of the new left, many returned to the film labor union and to calls for increased state sponsorship. Beginning in 2002, a small set of independent filmmakers began to acknowledge the problems of undercutting the national industry and the film institute. Influenced by the models of state-sponsored cinema in France, Spain, Canada, and elsewhere, this vocal set of independent producers began to mobilize for increased industry regulation and labor protection. They decided to "play by the rules" by paying the appropriate royalties for audiovisual materials they used, getting proper authorization for use of public space, obtaining union certificates for their laborers from SICA, and remitting the corresponding taxes on any profits their films might accrue.

Some began choosing to work on coproduction projects with the INCAA, allowing the state to keep a large portion of the film's ownership and box-office revenues in return for the subsidies offered by the institute. The most prominent example of this approach is shown by the founders of the independent production company Cine Ojo. Founded in 1986 by Marcelo Cespedes, formerly a member of the radical Cine Liberación movement in the

1970s, and the visual anthropologist Carmen Guarini, Cine Ojo produced eleven films and an equal number of coproductions between 1988 and 2004.[84] Its members made their films, such as *Jaime de Nevares: ultimo viaje* (Jaime de Nevares: last voyage [1994]) and *Tinta roja* (*Blood Ink* [1998]), in compliance with industry legislation, SICA, and the film institute;[85] in doing so, they gained a reputation that enabled them to work with national television channels, foreign coproducers, and even the veteran director Fernando Birri. By 2006 Cespedes and Guarini's company had become the most well-established producer of documentary films in the entire South American region.[86]

Many of these diverse filmmaking groups and producers share a set of thematic material and methodological approaches. These groups both reinvented the cine social genre and gave voice to a wide array of "new left" social movements. Their films most commonly concern historical events, particularly ones relating to the dictatorship and its antecedents, and contemporary social justice issues. Each year between 2002 and 2005 at least five major documentary films examined the subject of the children of the disappeared; these works include a film made by the Grandmothers of the Plaza de Mayo called *Nietos (identidad y memoria)* (*Grandchildren [Identity and Memory]* [2004]) and one made by Guarini called *H.I.J.O.S.: el alma en dos* (*H.I.J.O.S.: Split Soul* [2002]). An important film called *Inundaciones* (*Floods* [2003]) was made in the province of Santa Fe and deals with victims of the floods that devastated the area in 2003. *Inundaciones* was made by the collective Santa Fe Documenta and uses testimony from various survivors and rescue workers to create a narrative of the tragedy. Like many of the other films of this genre, it became a tool for political activism; *Inundacions* became a propaganda piece in the community-based campaign to seek reparations for flood victims from various branches of the national government.[87]

Many of the films utilize what has become a symbolic vocabulary, a lexicon of images and representations that serve as shorthand for important ideas within contemporary political culture. Because these filmmakers often use the same video, television, and film archives, several of the same clips appear in many films, as occurred with images of the Cordobazo in earlier documentaries. Within the narrative structures and montages of this body of documentaries, these audiovisual representations are repeated frequently, allowing directors to develop nuances and add layers of meaning as they are incorporated into the rest of the film. Among the most common of such representations in films that treat the period of the dictatorship are sequences showing the Mothers of the Plaza de Mayo, the Escuela Superior de Mecánica

de la Armada (ESMA), and photographs of the generals responsible for the military coup during the juicio a las juntas. A similar pattern of reuse of common images and footage appears in films that deal with the economic crisis. This group of recycled elements includes images and representations of violence and looting, police repression, the victims of the Pueyrredón incident, and de la Rúa's exiting helicopter. Directors use these common visual and audio elements to trigger memories, to fix historical references, and to participate in a conversation that attempts to contextualize contemporary and historical realities.[88]

Themes of historical revision, expressions of resistance, and denuncialismo predominate in the many films that emerged from the explosion of documentary production at the turn of the millennium. The majority use oral testimony, interspersed with news footage released during the transition to democracy, and relate stories of militancy, resistance, capture, detention, and reintegration into society. These films often revise the received narrative of the transition period, adding nuances and presenting new arguments about the past. Films such as *La escuela* (The school [2006]), *El proceso* (The process [2006]), and *El golpe militar* (The military coup [2006]) deal directly with the transition governments' failures to bring perpetrators of military repression to justice. Others focus on specific policies— for example, the policy of censorship and its execution as described in the personal testimony of those censored and even a former censor. One film, *El Nüremberg argentino* (*Nuremberg, Argentina* [2004]), simply presents a montage of the juicio de la junta, for the first time making the filmed testimonies from the proceedings public.

Many of these films revisit and reinterpret the militancy that preceded the military coup, reflecting on the ideology of participants and the early conflicts they had with authority. Films such as *Errepe* (*ERP* [2004]), *Paco Urondo* (2005), and *El tiempo y la sangre* (Time and blood [2004]) present the work and worldview of members of the different guerrilla movements in the late 1960s and early 1970s told from the viewpoint of surviving guerrillas. *Los perros* (The dogs [2004]), for example, relates the emergence of militancy in the early 1970s through the eyes of a former militant as he engages his past by revisiting his relatives, old friends, and former comrades in the armed struggle. Other films, such as *Prohibido dormir* (Sleep prohibited [2004]), *Rebelión* (*Rebellion* [2004]), and *Trelew* (2004), depict events leading up to the military coup, such as the Cordobazo and the escape of political prisoners in Trelew in 1972. The award-winning film *Flores de septiembre*

(*Flowers of September* [2003]) traces the political activism of students in the Pellegrini high school in the early and mid-1970s, incorporating images filmed by students at the school during the Argentine Anticommunist Alliance repression of student protests.

By far the most popular subjects of these documentary films are unresolved questions of the disappeared and children of the disappeared. A number of these films follow children of the disappeared as they search for information regarding their parents' fates. *Historias cotidianas (h)* (Daily histories [2001]), *Panzas (Bellies* [1999]), *Los rubios (The Blonds* [2003]), and *Botín de guerra (Spoils of War* [2000]) all focus on the children of disappeared victims of the repression, some of whom have been identified and connected to their biological families by the Grandmothers of the Plaza de Mayo. These films treat problems of collective memory, identity construction, and biogenetic family models in the wake of disappearances. The other major protagonists of these films are the human rights activists who work with families to uncover missing histories and identities. *Sol de noche* (A gleam in the dark [2003]) tells the story of the disappearance of thirty individuals in the northern province of Jujuy through the eyes of members of the Mothers and Grandmothers of the Plaza de Mayo, documenting their continuing struggle for justice and information.

After the 2001 economic crisis, a number of these films framed their subjects in relation to the ensuing economic devastation. Some films documented the *cacerolazos,* the mainly middle-class protests that followed the corralito, giving voice to the collective identities formed during the protests. Films such as *Memorias del saqueo (Social Genocide* [2004]) and *La mayor estafa del pueblo argentino (The Hoax* [2004]) framed and analyzed the political events surrounding the crisis. Films such as *Días de carton (Cardboard Days* [2003/2005]), *Vida en Falcon (Living in a Falcon* [2005]), and *The White Train* documented how marginalized groups responded to changing economic realities. Many of the filmmakers responsible for these films were trained at film schools founded by and staffed with faculty sympathetic to the political ideology of earlier kinds of resisting cinema, such as cine social and *cine militante.* Several publicly acknowledged the films of Raymundo Gleyzer, Fernando Solanas, and Fernando Birri as sources of inspiration, often doing so implicitly, too, by using clips from the earlier filmmakers' works as part of their films. Referencing their adherence to the motifs and central manifestos of the nuevo cine movement, most of these films aimed to raise consciousness and to use filmmaking as a tool for enacting political change.[89]

FOUCALDIAN FILMMAKERS AND
THE REINSCRIPTION OF CULTURAL AGENCY

The explosion of grassroots political documentary in third-generation transition filmmaking in the 1990s and early 2000s generated and facilitated social activism. It did this in part by facilitating the dissemination of information, with various parties using exhibition spaces to distribute literature and to organize strategic alliances by creating an archive of images and sounds documenting the past that would be open to public engagement. Filmmakers became Nelly Richard's Foucaldian intellectuals, who "*situate* their critique of power in the interior of the disperse multiplicity of its networks of enunciation and circulation, seeking to make them explode via oblique tactics of *local* resistance to the system's hierarchies."[90] This generation of transition cinema revealed how artists and intellectuals on the left began both to approach social realities and, in many cases, to strategically intervene in salient political debates through film.

Indicative of the impact and scope of this trend in political documentary filmmaking, even Pino Solanas decided to return to low-budget documentary filmmaking during this period. Making two documentary films in the new style being produced by contemporaries, Solanas reentered the realm of political filmmaking after a long absence. His documentary *Memorias del saqueo* capitalized on the momentum of the low-budget approach, which had benefited from considerable successes within international film markets and festivals. This film aimed to place the blame for the financial crisis squarely on the shoulders of the transition's economic policies. Receiving substantial acclaim for this film, Solanas went on to take on the case of marginalized groups of the urban poor. His film *La dignidad de los nadies (The Dignity of the Nobodies* [2005]), which won several international festival prizes, depicts indigent groups fighting to survive in the wake of neoliberal reforms, globalization, and the 2001 economic crisis. Simultaneously, Solanas was still considered the grandfather of the contemporary boom; clips from his film *The Hour of the Furnaces* are referenced in no fewer than thirty-five documentaries released since 1985.

The tremendous amount of documentary production that began in the mid-1990s and continued through the mid-2000s forced the question of documentary filmmaking into a much more prominent light in both cultural and political spaces. Not only the volume of films produced but the thematic nodes of production began to point to a "happeningness" that other citywide

cultural producers could not ignore. When established film directors, such as Solanas, began working in the genre, even the least interested national film critics were forced to take notice. The conversation taking place among filmmakers became increasingly clear to the public at large, who were not slow to pick up on the symbolic vocabulary being created and put to use in documentary film projects. Synergies created between documentalistas and other communities of activists, such as human rights advocates and worker's organizations, led to further exchange and collaboration. The extent of this interaction is a unique characteristic of contemporary political documentary film culture in Argentina.

In contrast, commercial filmmaking during the 1990s concentrated its advantage in producing new fiction cinema that, though it might attract international audiences, broke with the political fiction films of the 1980s. Whereas the second generation of transition filmmaking had used both political allegory and film as a means of exploring the postdictatorship national psyche, by the early 1990s this model seemed to have run aground. The fiction cinema of this period tended toward more ambiguity in its choice of subject and characters. The film scholar Gonzalo Aguilar notes that the fiction cinema of this period lacked an overarching political narrative and tended toward open endings rather than conclusions that might incite political action. In part, he attributes this cinema of indifference to a general depoliticization, "as though the backdrop of the political were unchanging, and as though there did not exist in these works a need to reformulate the terms themselves."[91] Political cinema and its cultural agency became the domain of the documentary and its sprawling ties to the phenomenon of documentalismo, while fiction film merely reflected the tide changes of the political.

6

POSTMODERN EXIGENCIES

New Media, Memory, and
Critical Spaces

FILM SCHOLARS INVESTIGATING the political cinema of Argentina are often struck by the paradoxical relationship between the objectives outlined by movements such as Cine Liberación or documentalismo and the particulars of the geopolitical economies of film circulation and First World discursive frames that bring these cinemas to the attention of the rest of the world. Even though some film scholars have begun to rethink the "mythical visions . . . of autonomous oppositional cinematic practice" of the past and complicate paradigms of the transnational flow of ideas of the "Other" on the big screen,[1] this inherent contradiction still positions the scholar and the filmmaker as reflections of each other's uneasy conscience. However, the autoreflexivity of Argentine political film culture offers an important set of digressions from the standard set of postcolonial anxieties about exchange and encounter. The history of Argentina's unique technology of place during the democratic transition and the critical juncture between the rebuilding left and activist filmmaking offer several thematic departures from this familiar vexation.

Coming to terms with the status of film in the Argentine political imaginary is a highly contentious project, despite the almost universal acknowledgment of its place in contemporary memory debates.[2] In contrast to the debates regarding the ethnographic film, which sparked divides over the problems of voice, authenticity, and exploitation among anthropologists in the 1970s,[3] this

debate among film scholars seems rather to center on the mode of reproduction, and in particular the relationship of the international coproduction model to the process of national identity construction and the aims of neoliberalism. In general, most recent scholarship on post-1989 Argentine cinema has been less concerned with challenging the legitimacy of a film's representational politics and more focused on the "message" of the medium. Even though these films typically attract between only 5,000 to 15,000 viewers domestically,[4] political cinema of the past two decades has been classified neither as bourgeois fare nor as "cinema for export," categories applied to intellectual cinema of earlier generations and political fiction films of the mid-1980s. Film scholars are instead interested in understanding the political subjectivities and the identity politics of these films, taking for granted that film possesses the authority to speak to these issues beyond the confines of popular culture.

The dialectical relationship between discursive engagement and the cultural politics of documentary filmmaking in the transition elevated the role of filmmakers to a new place of prominence in the national cultural imaginary. In a turn perhaps toward the surreal, major national newspapers reported that in September 2006, the national government had invited Enrique Piñeyro, who had directed a documentary on irregularities and corruption in national aviation regulation, to formally investigate the Ezeiza international airport and propose legislative reforms.[5] While this hyperbolic example may have caught the public's attention, a much more common occurrence involved filmmakers' collaborations with political groups and nongovernmental organizations. For instance, both the Mothers and the Grandmothers of the Plaza de Mayo began to get involved with filmmakers to promote their organizations' goals, the latter forming an audiovisual archive with a video collection open to the public. The organization of children of the disappeared, HIJOS, actively sought collaboration with documentary directors such as Fernando Kirchmar to add ranks to their public demonstrations and draw attention to their cause. Beyond moments like these, however, a handful of important films became objects of intense intellectual and critical scrutiny and, as such, illustrate how documentary filmmaking's role shifted as a result of the cultural politics of the transition.

FILM AS PROTAGONIST: *LOS RUBIOS* AND *RAYMUNDO*

Perhaps the most notable documentary of the past decade is Albertina Carri's 2003 film *Los rubios* (*The Blonds*). This documentary became the centrepiece of representation, memory, and identity debates across transnational

intellectual and academic communities. The title refers to Carri's parents, political activists in the 1960s and 1970s who disappeared under the military dictatorship in 1977, when Carri was only four years old. The film traces her search for information about their disappearance, using an actress, Analía Couceyro, to represent Carri in the film. Along with a small crew, the actress and the director visit the site of her parents' kidnapping, the police center where the Carris were thought to have been detained, and the homes of neighbors and friends of the family who might be able to offer insight into what happened. Like many of the films of this movement, *Los rubios* treats the subject of the dictatorship and its legacy, but the film stood out to film critics, and eventually also scholars, because of its focused attention on the constructed nature of collective history and personal memories. Responding to the postmodern exigency of memory debates regarding the subjective nature of our understandings of the past, the film deconstructs the relationships among testimony, truth, and history until even the identity of the survivor, in this case a daughter of disappeared parents, is jeopardized.

Calling into question the imperfect memories of witnesses, the film entered a controversial realm that challenged many of the central driving narratives tied to the struggle for justice during the transition. Carri uses the film to argue that even victims' and survivors' testimonies might be the product of flawed memory, aporias, or willful suppressions. It also examines both the victim and the casual observer as potentially complicit in distorting memories of the repression, making it difficult to establish evidence of what really happened. Unlike Lita Stantic, whose earlier film *Un muro de silencio* (*A Wall of Silence* [1993]) accused the middle class of tacit complicity with the regime, Carri turns her critical eye beyond possible connivance to examine the malfunction of memory itself as means of recording the past. Carri interviews a family neighbor who she believes might have witnessed her parents' kidnapping. The neighbor first denies any knowledge of the family and then recalls only that everyone in the Carri family was blond, either a mistaken memory or a deliberate misrepresentation, for they were in fact all dark-haired. Martin Kohan, writing in a special issue of *Punto de Vista* devoted to questions about modernity, proposed that the film offered a "supermarket memory model," memory as constructed within a dialectical relationship to forgetting, functioning as much by its own affirmation as its conscientious omissions and denials.[6] This film became an instant flashpoint for critical reflection. Gabriela Nouzeilles issued an immediate response to Kohan's reading of the film, arguing that *Los rubios* presents a model of postmodern collective memory construction much in line with social realism. She argued that Carri's film negates purely emotional reactions triggered by

typical survivors' testimonials and objectively deals with the negotiations and fractures within received representations of memory.[7]

As an object of intellectual inquiry, *Los rubios* connects the key concerns that made documentary filmmaking relevant in postmodern Buenos Aires political life to the cultural practices of making of this type of film. The film struck many outside the filmmaking community as appealing in part because it also mindfully documents the process of making a low-budget political documentary. *Los rubios* includes several scenes that merely present images and sounds of the filmmakers working at creating the film. At one point Carri's stand-in even reads aloud a letter from the INCAA announcing its refusal to grant the film subsidies because the director was not following a more traditional postdictatorship narrative. The film was eventually produced by Marcelo Cespedes and Carmen Guarini, of Cine Ojo, and did receive postproduction funding from the INCAA, though the scene remains in the film, creating a dynamic tension with the film's credits. Carri's work also moves into the territory of *cinéma d'auteur*, working through questions of aesthetics, artistic design, and the director's personal vision of the filmmaking process, making it a more likely candidate for consideration by scholars of film genre and cinema as art. Carri's presence as a director is never far removed from the film's drama. Her ruminations on the process of filmmaking and investigating the past are visible, like fingerprints across the film's frames and in its audio tracks. The montage is replete with autocritique, self-referentiality, and reflection on particular decisions made. *Los rubios* inspired a spate of academic articles around the globe, the majority of which concentrated on analyzing the film's argument within the context of contemporary memory debates and the questions raised by Argentina's ongoing pursuit of social justice for the disappeared.[8]

The film *Raymundo* (2002) shows another way in which activist filmmaking was incorparated into intellectual debates. As I mentioned at the beginning of this book, this film screened as part of a gesture of solidarity with workers occupying a factory on Avenida Jujuy in 2003. In contrast to *Los rubios,* this film shows how such documentary productions were disseminted in more popular settings. The film's directors, Ernesto Ardito and Virna Molina, made the film to memorialize the life and work of the Argentine activist filmmaker Raymundo Gleyzer as the founder of Cine de la Base and as a major symbol of the kind of political filmmaking in which they considered themselves to be involved. Inspired by Gleyzer's work to create social change through film, Ardito and Molina reconstruct in testimonial documentary fashion not only the personal story of an activist who disappeared during the last dictatorship but also a historical reading of his era's sociopolitical conditions.[9] Using tes-

timony from Gleyzer's wife and colleagues alongside footage from his films and home videos, Ardito and Molina reconstruct a vivid picture of the state of political militant cinema in Argentina in the 1960s and 1970s.

Raymundo's content reveals a constellation of concerns prevalent in the social activism of post-1989 grassroots documentary production. Gleyzer's son appears in early home movies and later in voice-over to help tell the story of his father, a strategy Ardito and Molina used to connect the political concerns of the 1960s and 1970s to those of the next generation, many of them children of the disappeared.[10] The directors also chose to include footage of the fateful Pueyrredón *piquetero* demonstration in 2002, combining their energies with those of cine piquetero activists. Their film singles out this demonstration as one of the many points of contact between the past and the present, a connectivity common to a great number of the films from the third generation of transition filmmaking. The film acts as a denunciation of historical events and of Argentina's contemporary reality, much as did the work of Gleyzer himself. Ardito and Molina's film is part of a set of interventions from filmmakers seeking to remake and reposition national film history and its heroes. Emulating Gleyzer's work and politics, the directors explain: "We felt the necessity of recuperating his ideas for new generations and to understand today, above all, what happened in 2001."[11] This focus on presenting a new vision of historical narratives, integrated with present political struggles, became a chief characteristic of the lion's share of political activist cinema beginning in 2001.

The film's production, too, is emblematic of the transnational nature of documentary filmmaking in Argentina from the mid-1990s. Ardito and Molina relied on the support of several different institutions to produce *Raymundo*. They received funds from the National Arts Fund and the INCAA early in the process; later, in editing and postproduction stages, they received funding from the Fondacion Alter-Ciné in Canada and the Jan Vrijman Foundation in the Netherlands. Initially, the film was not screened in commercial cinemas in Argentina because of industry regulations. Instead, it circulated in occupied factories, universities, neighborhood assemblies, and political rallies. By bringing their film to new locations, such as Brukman and other occupied factories, the filmmakers took part in the efforts of other social movements and opened dialogues about the way filmmaking could specifically address the goals of those movements. Prizes won for *Raymundo* in independent festivals around the world provided the funding for Ardito and Molina's next project, the fictionalized story of a factory takeover written in consultation with the participants in the actual event. In addition, the film was sent

to Italy, where, in a gesture of transnational unity, it circulated among workers occupying factories there.

Raymundo was a controversial film in many regards when it first was made, for it incorporated tactics from first-generation transition filmmaking. It included guerrilla-style footage of the piquetero demonstrations, skirted industrial and commercial regulations, and relied on circuits of grassroots political activism for exhibition. The film's popularity grew through noncommercial, politicized spaces, such as student rallies and political party events, and its reputation expanded primarily by word of mouth. Trained at the Escuela de Cine de Avellaneda, the husband-and-wife team of directors seemed to inspire great admiration in their colleagues, many of whom were quick to note that they had participated in Kino Nuestra Lucha, a film collective that Ardito and Molina had founded originally to create an alternative news source, producing *"noticiarios obreros"* (workers' newsreels) in cooperation with other independent film collectives, such as Contraimagen, Ojo Izquierdo, Boedo Films, and the international association of independent filmmakers and media producers Indymedia.

Ardito and Molina skillfully managed to evade legislation limiting exhibition by submitting the film to festivals and competitions as a noncommercial entry. By 2002 *Raymundo* had won its first significant award, a Special Jury Prize at the International Festival of Human Rights in Buenos Aires. This festival provided an important venue allowing the film to gain recognition among other film activists interested in the cause of human rights. The award increased local interest, but it also gave the film a useful tag line in its submission to film festivals abroad. The film would be selected by fifty film festivals around the globe, winning eleven awards in 2003 alone. In that same year, the film won Best Documentary Film on Memory at the Havana Festival in Cuba, the largest and most politically important Latin American film festival in the world. Argentina's major institutions of cinema would find it difficult to ignore a film with recognition at this important festival, and in 2004 SICA decided to include the film in a retrospective tribute to Raymundo Gleyzer's life, allowing its first showing in a commercial theater in Buenos Aires.[12] Eventually the INCAA and SICA would both contribute funds toward postproduction costs, which would ensure that the film could be legally screened in Argentina.

Los rubios and *Raymundo* both illustrate the politicized spaces and socialization of documentary film production in Buenos Aires at the turn of the millennium. Some of the most public activist groups have found a way to make their causes known through film and have gained ready audiences for their ideological politics among intellectual and cultural viewers. Today debates

about *Los rubios* and *Raymundo* can be found on the pages of any number of intellectual journals, film journals, newspaper reviews, and other critical spaces, not only in Argentina, but also in the United States and Europe. These debates illustrate the role that filmmakers have taken in addressing public concerns and political causes, but they also attest to some of the postmodern exigencies that political documentary film in Argentina has begun to address.

Since the practical objects of filmmaking and film reception are always related to structural elements and place-specific conditions, analyzing what happens to film in sociopolitical and technological spheres is vital to conceptualizing and assessing its historical meanings. The aim of such inquiry is to catch political cinema and its reception in the act of "flight from technical structure towards their secondary meanings, from the technological system towards a cultural system."[13] Understanding the anatomy of institutional, political, and social structures of filmmaking in Argentina illuminates the way filmmakers and film viewers, as agents, were able to consummate and consume the multiple meanings of film and thereby redefine and transform the practical ideology of the cultural system of film from the democratic transition. Reintegrating the empirical with the discursive frame responds to two central problems in contemporary Marxist cultural theory. The first of these is the saturation of social space with the culture of the image and the audiovisual, or the penetration of televisual forms of understanding the past and the present into the "secret folds and corners of the quotidian."[14] The temporal boundaries of historical consciousness, as Andreas Huyssen demonstrates in his work on memory of historical trauma, have weakened as a result of the modern modes of media communication, the speed of delivery and the scope of accessibility of images from the past advancing exponentially, apace with new media technologies.[15]

This proliferation of audiovisual media, particularly in the hypermediated spaces of global cities, such as Buenos Aires, has favored literary techniques of conceptualizing the past, doing so intertextually, discursively, and deconstructively and thus forging a postmodern historicity that is ever more prescient of the various subplots, factionalisms, and generational divides that complicate the construction of historical consciousness. The media's avid recycling of politicized images from Argentina's past normalized the process of continually revisiting and unfixing collective memories and historical interpretations in everyday life. Mediated knowledge of Argentine history, dealing in representations and captive impressions, generates a variable set of image constructs that substitute for absent proofs and missing data. While these images might minimize perceptual separation from the past, they presuppose "an

understanding of the structuring act by which plot is produced."[16] In other words, the naturalization of the symbolic order of political cinema has the power to turn discursive habits into the properties of the thing itself, the demands of the medium becoming more important than image content.[17] In Argentina transition politics discursively naturalized the interpretive lens of film and the vitality of the audiovisual, tying them to the political imaginary as a means of "seeing," of knowing and responding to signals and representations of the past. Of course, new historical interpretations germinated by audiovisual media may or may not act on the same set of registers as do the historical narratives they claim to be revising.

The voracious functional capacity of audiovisual media culture in Argentina certainly propels the subversive potential of its objects. It infuses the role of imagination, or the creative filtering and constructing of ideas, with a new distinction in the business of establishing the order of the past and historical sensibilities. As Zygmunt Bauman colorfully suggests, perhaps the meaning of postmodern cultural production, including cinema, is "to stimulate the process of meaning-making and guard it against the danger of ever grinding to a halt; to alert to the inherent polyphony of meaning and to the intricacy of all interpretation; to act as a sort of intellectual and emotional anti-freeze, which prevents solidification of any half-way finding into an icy canon arresting the flow of possibilities."[18] Does the prominence of audiovisual media ensure that history cannot break with narrative? Does the hyperreal present past of Argentine media spaces openly display the predicative relationship between agency and actions in receiving and comprehending the past?

This problematic gives birth to a separate theoretical quandary, the problem of agency and collective memory. In her landmark work *Regarding the Pain of Others*, Susan Sontag points out that images and sound serve as potent cognitive triggers not only to memory but also to structures of feeling. She argues, however, that manipulation can cause images and fragmentary evidence from the past to distort the reality they are meant to hold captive; with memories being anecdotal and always transcribed, any framing choice of the author is clearly an inherent exclusion.[19] Despite their often visceral resonance, aporias—absences or omissions within the imagescape of the past —become a structural feature of historical imagination, as do failures to solidify meaning or order. In recognizing incompleteness, instability, unreliability, disjointedness, and partiality of representations to and of memory, the productive imagination ostracizes the subject from a sense of knowing. This has the potential to turn memory politics, even in what could be described as the epidemic proportions of the transcendent political film of

postdictatorship Argentina, into a site of dispossession. The construction of cinematic historical subjectivities comprises an inherent ethical dimension that can easily be overlooked when celebrating the plurality of political articulations possible through film and the medium's efficacy in prompting subjective responses, threatening to divest historical subjects of not only past realities but also historical agency, as *Los rubios* powerfully attests.

The point at which these theoretical concerns converge, the driving force behind this research, is the revisionist challenge emerging from posttransition scholarly communities regarding who has the authority or right to speak truth to the past. The vocalization of the political filmmaker's concerns and the use of film to convey the perspectives and positions of the subaltern subject, as Ernesto Ardito and Virna Molina claim to realize in their films about a radical filmmaker and a factory takeover, reveal perhaps more about utopian fantasies of inclusion and political consciousness than about the real conditions of marginalization and modes of political resistance. The specific new cultural milieus brought into being by the transition point to a causal relationship between the construction of resonant historical subjectivities and a new lexicon of mimetic signs enabled via film. Activating this vocabulary and mobilizing it to revision the political left clearly required some degree of legitimization and even authorization by practitioners, markets, and the state, meaning that these two dimensions cannot be examined separately. Marrying analysis of the virtual life of ideas about cinema in Argentina to the social and material reproduction of those ideas clearly shows historical imaginary not merely as an object but in action, thus challenging Deleuze's conclusion that representation is merely a "site of transcendental illusion."[20]

TRANSNATIONAL SOLIDARITIES AND GLOBAL NETWORKS

Of course, interest in Argentine documentary filmmaking abroad did not arise organically within communities of intellectuals who came to know their subject independent of the activities of Argentine filmmakers, both in Buenos Aires and abroad. Prior to 2004, the political films being produced in Argentina rarely circulated through official channels outside the country. A handful of pirated VHS or DVD copies of films made it to Europe and North America in suitcases carried by friends of directors or film technicians, but typically these isolated copies were meant strictly for personal use. As the case of *Raymundo* exhibits, it has been difficult for grassroots Argentine

documentary filmmakers to legally distribute or exhibit their work in commercial spaces, much less negotiate any kind of distribution abroad. Even though they became quite skilled at using international film festivals as forums for bringing their work to a broader public, this strategic positioning cannot single-handedly account for the intellectual connections made between Argentine political filmmaking and its importance to national memory, identity, and political debates. If most knowledge production, as the historian Steven Shapin convincingly postulates, is based on such pragmatic matters as social practices, reputation building, and access to an intersubjectively knowable external world of data, then the central question of global interest in Argentine political cinema concerns how these films were socialized abroad and how their political subjectivities were communicated across national boundaries.[21]

During the late 1980s and early 1990s, artists and intellectuals everywhere widely embraced a range of evolving media technologies as potential vehicles for escaping state-based political narratives and creating a more democratic media environment within which civil society could assert a greater role in the production of knowledge. Optimism "grounded in the possibilities of the means of communication to serve as lightning rods for the rapid flow of new and empowering ideas, and for the sharing of collective interests, or what Raymond Williams calls 'resources of hope,'" cut a wide swath among media scholars and political activists who hoped that a global information society would put power into the hands of an idealized and humanitarian global civil society.[22] A far cry from the distance-issue solidarity movements of the late 1960s, the transnational framework into which these films were inserted was characterized by hegemonic discourses of rights-based unity and emergent post–cold war politics of global citizenship, an altruistic rather than a mutual solidarity envisioned within the context of cosmopolitan humanitarianism.[23]

To a certain extent, a receptive audience already lay in wait for the kind of counternarratives found in the political documentaries that Argentine cineastes were beginning to produce. Sontag's suggestion regarding reception, however, perhaps uncovers a more sinister undertone to audiences' prêt-à-porter receptiveness to new media from the "Global South" and the politics of representation. In creating the intimate encounters of cross-cultural engagement and communicating the "pain of others," testimonial images of suffering, exploitation, and repression can reinforce certain ideological distinctions, such as notions of non-European cultural inferiority or ideas about the naturalness of historical relations of power and privilege. Developing

interpretive tools to explore transnational cinema, like other arts or cultural practices, as Gayatri Spivak advocates, involves developing a "critical intimacy," a mode of comprehending the subject that is at once informed and fully engaged but also stands at a critical distance from the subject.[24] In the case of the ready audience for Argentine filmmaking in North American and European contexts, the nature of that critical remove for the most part reinforced characterizations of the "First World" as the humanitarian steward of its former colonies.

Critical intimacy developed between the external audiences and Argentine documentaries not only because of this receptiveness but also because of the intervention of filmmakers themselves in the physical and intellectual spaces of critical encounter. Filmmakers, well aware of the politics of reception abroad, utilized transnational networks to find resources for making their films, to access exhibition opportunities, and to promote the reputation of their film products. In different ways, the directors Andrés Di Tella and Fernando López Escriva illustrate the transnational political economy of Argentine independent documentary filmmaking and its intervention in critical discursive frames. Each represents important networks of solidarity that have been critical to the advance of filmmakers in intellectual spaces and in politics at home and abroad, in academic institutions, and within the human rights movement. These examples illustrate a filmmaking ethos that stands autonomous from traditional commercial film markets but that has managed to attain both critical appreciation and a nontrivial degree of influence in debates about human rights and the politics of memory. Although their films treat subjects vital to Argentine political interest, neither director's breakout films have been *primarily* financed by local political parties, nationally based nongovernmental organizations, or the Argentine state, and they fit closely with the model of independent filmmaking described in the previous chapter.

Di Tella, today the director of twelve feature-length films who enjoys a reputation as one of Argentina's most successful and acclaimed independent filmmakers, is an excellent example of a third-generation filmmaker, beginning his career in independent film at the tail end of the transition years of Alfonsín's administration. Di Tella's high-profile public image is certainly in part due to his family background and his social standing among the Buenos Aires intellectual elite. The Di Tella family, having made considerable fortunes manufacturing industrial machinery and home appliances, is one of the country's most important fixtures in promoting the arts and culture. In 1958 the family established the Torcuato Di Tella Institute, an educational and philanthropic society for the promotion of local artists that became the

cradle of the rebellious artistic vanguard of the 1960s.[25] In 1991 Andrés's uncle, Guido di Tella, former ambassador to the United States, together with Andrés's father founded the Universidad Torcuato Di Tella in Belgrano, one of the capital city's most exclusive barrios.[26] Di Tella's father, also named Torcuato Di Tella, established a reputation for himself as an academician, writing, among other things, about labor politics. Bearing the family name, Andrés Di Tella was quickly thrust into the national spotlight when he began making films in the late 1980s.

Clearly a member of Argentina's cultural and economic elite, Di Tella became a documentary filmmaker without great concern for the potential lucrativeness of his chosen profession. Having been educated in modern languages and literature at Oxford University and having traveled extensively with his family in his youth, he also came to filmmaking with a significant number of international experiences and contacts already under his belt. When he completed his second short documentary, the forty-five-minute *Desaparición forzada de personas* (Forced disappearance of people [1989]), it was one of the first of a handful of films examining the dictatorship and its violations of human rights that would constitute the third generation of transition filmmaking. The intellectual left showed measured interest in the film, which circulated in Buenos Aires in certain exclusive venues, such as university research groups and short film series at museums or cine clubs. In an article in *Punto de Vista* discussing Claude Lanzman's *Shoah* (1985), which had recently been screened within organizations of Buenos Aires's Jewish community, Beatriz Sarlo comparatively noted Di Tella's use of materials to depict the clandestine detention centers of the dictatorship.[27] The following year, Di Tella made a seven-minute short that he sent to various international film festival competitions, where it won a number of prestigious prizes, eventually becoming part of the permanent collection of New York's Museum of Modern Art. This positive reception, although limited to cultivated publics, did demonstrate that Di Tella's work had the potential to cross international divides and transcend the world of local filmmaking to take part in broader cultural contexts.

Over the next few years, Di Tella worked abroad, making films and publishing written pieces on cinema and filmmaking. He worked between 1991 and 1992 in Boston, producing documentaries for public television, and soon afterward spent time living in London, where he received a grant from the British Council and worked producing documentaries for the BBC and Channel 4.[28] He published *El guión cinematográfico* (The screenplay), a book about screenwriting, with a well-respected Argentine university press in Santa Fe.[29]

He wrote as a journalist and film critic for various newspapers, including *The Buenos Aires Herald, Tiempo Argentino, La Razón, Río Negro, and Radio Nacional de la Argentina,* and he continued to seek academic fellowships abroad to support his film projects. In 1994 Di Tella was able to capitalize on some of his academic preparation and contacts to become a Tribeca Film Institute Media Arts Fellow, and shortly afterward, in 1996, he won a Guggenheim Creative Arts Fellowship Award. To win this award, sponsored by the trustees of the Guggenheim Foundation, Di Tella had to draft a proposal that would appeal to the organization's mandate to "fully realize the goal of 'better international understanding'" and to promote a "commerce of the mind . . . [and] of spiritual values" that would parallel the economic international exchange with Latin America, from which the Guggenheim family financially benefited.[30]

While Di Tella was shuttling between the United States and Argentina, he returned to work on the history of the dictatorship, making two films dealing with different angles on the subject, *Montoneros, una historia (A History of Montoneros)* in 1995 and *Prohibido (Prohibited)* in 1997. The grants he was able to win abroad significantly contributed to his ability to finance and make his films, whose subjects fit nicely within the discursive politics of the international film festivals at which they were screened. In 1999 Di Tella helped to found the Buenos Aires International Festival of Independent Cinema (BAFICI) in collaboration with Buenos Aires's municipal ministry of culture, serving as its director for two years. In just a few years this event became one of the biggest independent film festivals in the world, drawing audiences of over 220,000 from all over the world, with strong sections of documentary films that treat the subject of politics of memory and human rights.[31]

Di Tella became the subject of serious scholarly and intellectual production when he began to further establish his work within academic circles abroad. He published transcriptions of some of the interviews used in his films to create a scholarly article for a volume on private life studies, transforming the audiovisual material into a variety of ethnographic fieldwork.[32] In 2002 Princeton University invited Di Tella to direct the Princeton Documentary Film Festival, a role he continues to this day, and in the spring of 2005 he was invited to serve as a visiting lecturer in the university's Latin American studies and modern languages programs by the Argentine novelist Ricardo Piglia, the author of *Artificial Respiration.* He was both author and the subject of the book *Andrés Di Tella: cine documental y archivo personal, conversación en Princeton* (Di Tella: documentary cinema and personal archive, conversation at Princeton), coedited by Paul Firbas and Pedro Meira

Monteiro and published in 2006 in Buenos Aires with partial funding from Princeton.[33] Providing another sign of his awareness that his documentary film work had moved into the realm of intellectual intervention, Di Tella made a personal entry into full-fledged subjecthood within the genre in his 2002 film *La televisión y yo* (*Television and Me*), a film essay on his own family's industrial past, and his 2007 film *Fotografías* (*Photographs*), which documents his search for family roots in Argentina, India, and England. Di Tella's international academic credentials in no small measure helped to position these films within critical intellectual spaces in Buenos Aires, and they were projected in spaces such as the Latin American Art Museum of Buenos Aires (MALBA) and the BAFICI festival alongside chats with the director and commentaries by important film scholars and critics. Much like Carri's film, *La televisión y yo* and *Fotografías* both explore the inscrutable personal past of the director's own family history. Unlike that of Carri's family, however, the Di Tella family's past has left a great deal of archival documentation, a subject on which Di Tella reflects in both films and his book, making reference to both Proust and Borges.[34] In an article Di Tella published in 2008, he compares his latest film with Carri's work; the accomplishments of both, he argues, consist in demonstrating the cineaste-investigator in action.[35]

In contrast to Di Tella, the director Fernando López Escriva was not already a member of the cultural elite when he began making political documentaries. Even after his film *Hotel Gondolín* had been selected for exhibition at the 2006 Mar del Plata Film Festival, he casually expressed his surprise that the film might amount to anything more than a "very pretty thought experiment."[36] The film was made primarily with the help of friends who volunteered their labor and used equipment and materials that came from a tight collective budget, supplemented by funds from the director's family. The film was set in a former flophouse that had been converted into a co-op for the organized transvestite and transsexual prostitutes who now work the red zone of the Parque Tres de Febrero every evening after dark. *Hotel Gondolín* (2005), which eventually won both the Human Rights Network Award and the Ibero-American Federation of Audio-Visual Schools Award for Best Young Latin-American Director in Mar del Plata, tells the story of Monica León, an HIV-positive sex worker and transgender rights activist. In the early 2000s León moved to the hotel and began trying to organize its denizens, the majority of whom were transsexual prostitutes. In her efforts to gain legal status both for the sex workers' occupancy of the hotel and for their labor rights, León had to fight uphill battles against drug addiction, violence against the sex workers, and the residents' resistance to collectivizing to pay for mainte-

nance of and taxes on the hotel. León's efforts included arranging for two local hospitals to provide monthly checkups for around forty *travestis,* so as to control tuberculosis and sexually transmissible diseases, and waging a campaign to distribute condoms and encourage their use on the job. Shortly after the filming, on December 18, 2004, the hotel was robbed, and a group of armed men, suspected to have been police officers, shot León eight times in the legs. She fled to Paris, seeking political asylum, but was unable to acquire the appropriate documentation for her legal status. Ultimately, López Escriva's film helped promote León's cause in the human rights circles that took interest in her plight in France.

The film highlights some of the critical features of the transnationalization of the Argentine political documentary filmmaking experience. First, the framing discourses of human rights and solidarity play a significant role, contextualizing this kind of film production for an international audience. *Hotel Gondolín* received critical attention following the Human Rights Network award it received at Mar del Plata. The jury for this prize consists of established directors and human rights activists well respected among national nongovernmental organizations.[37] The award then drew international attention to the film, which proceeded to circulate by invitation to film festivals sponsored by rights-based activist groups abroad. The film traveled to many countries and was screened at Outfest in Los Angeles, at the Barcelona International Gay and Lesbian Film Festival, and at similar activist-sponsored gay rights film festivals in Fresno and Calgary. The film's presence in the discursive frame of human rights activism surrounding the struggles of minority groups abroad gave additional weight to its credibility in representing its subjects and their political interests.

López Escriva's experience with this film is further relevant in the way it demonstrates reputation building in transnational communities of filmmakers and film producers. Seeking gainful employment using his skills as an image editor, the director migrated to Quebec, where he found work in Canadian television and film that supplemented his income while he developed ideas for his next documentary. His status as an Argentine filmmaker working on human rights material helped get him a job working as an image editor for the film *Dark Side of the White Lady* (2006), about torture on a Chilean sea vessel used as a floating prison after the Pinochet coup in 1973, and again for *Under the Hood, a Voyage into the World of Terror* (2008), about the history of terror in light of the attacks on New York's World Trade Center on September 11, 2001. Both films were directed by the Chilean filmmaker Patricio Henriquez, who had fled to Canada after Pinochet seized power in 1973. These

films were produced by the Canadian National Film Board and Macumba DOC, two typical meeting places for activist filmmakers in transit through Canada. Joining a community of Latin American, Canadian, and European filmmakers committed to using film for human rights activism, López Escriva was able to establish important connections with older, more experienced filmmakers and to learn the ins and outs of transnational film production.

In 2007 López Escriva was hired as an editor by Les Productions ISCA, an independent documentary production company making films about social injustices in Canada and abroad. He worked as a film editor for *Homo Toxicus*, directed by the French-Canadian Carole Poliquin, in which context he got to know the Turkish-Canadian director Isaac Isitan, Poliquin's partner at ISCA. With Isitan, López Escriva would begin working on a film called *Les femmes de la Brukman* (The women of Brukman [2008]), to be produced with funding from Radio-Canada Television, the Canadian Television Fund, the Quebec Council of the Arts and Letters, and SODEC Québec. This documentary, chosen as an official Canadian selection for the Sundance International Film Festival in 2008, concerns the women who helped take over the factory that became a symbol of anticapitalist social movements around the globe. Making it led López Escriva back to Argentina, where he not only intersected with a number of other filmmakers working on documentaries about factory takeovers but also began research for his own next feature-length film. This film, set in the impoverished Argentine Chaco, a region along the Paraguay-Argentine border, was shot from a boat, ethnographically documenting the plight of landless indigenous groups as the vessel wound its way along the banks of the Paraguay River. Because of his credentials and experience working on documentaries with Canadian production companies, López Escriva was able to find financing for the project through the Office Québec-Amériques pour la Jeunesse (Office for Quebec-American Youth).

Fernando López Escriva is the kind of organic film intellectual more representative of the third generation of transition filmmakers, while Di Tella represents the more traditional intellectual and cultural vanguard who made forays into political documentary filmmaking. López Escriva used social capital from the human rights activist movement to secure inroads among transnational film production networks, where Di Tella was able to build transnational academic networks cultivated over several generations. López Escriva continues to make a living working as a documentary filmmaker in Canada, using projects in Quebec to finance trips and film work in Argentina. At the same time, the work of Andrés Di Tella, one of the first of this generation of political filmmakers, was selected for exhibition in a 2008 retrospec-

tive in Spain sponsored by Archivos de la Filmoteca and in another sponsored by the Filmoteca de Catalyuna and Filmoteca Española de Madrid. An important continuity between the second and third generation of transition filmmakers is the set of discursive frames they used to enact their film politics agendas. The presence of veteran first- and second-generation transition filmmakers in newly emerging organizations of film sponsorship certainly helps account for this connection. Nonetheless, filmmakers' abilities to establish, manage, and maintain transnational networks of support and solidarity solidified this constancy by pairing film products with the demands and receptivity of international audiences. While Di Tella regularly accepts invitations to give scholarly talks at important universities in North America and Europe, speaking on film and the work of memory or human rights, López Escriva is frequently invited to participate in local human rights projects in Canada as a fellow sympathizer in universal causes. He has personally given DVD copies of his films to professors in North America in the hopes that they will be used in the classroom for educational purposes.

A NEW FILM INTELLECTUALISM:
ENTER THE CINEÓLOGOS

Filmmakers in contemporary Argentine society have benefited from a unique technology of place that has allowed them to circulate cultural products and ideas without having to rely on the vagaries of the film market. They have diversified the number of critical spaces, audiences, and means by which their projects can be experienced. Moving beyond cinema houses and television, their work has been screened in innumerable alternative film spaces. A number of key sponsorship and regulation interventions interacted with a particular political moment to promote the kind of activism that grassroots documentary filmmaking could best achieve. This new role was elaborated and reproduced through the work of film studies, film school pedagogy, municipal and national cultural policies, and a community of filmmakers dedicated to political intervention through cinema. What is unique about this development, or rather what sets Argentine filmmakers apart from other filmmakers in other equally politicized settings, is the scale of this phenomenon and its relationship to broader cultural politics mappings.

During Argentina's long transition to democracy, documentary film intervened critically at almost every level of political organization, from the international sphere to the community, and has become a critical means by

which certain marginalized and underrepresented groups make their political causes known. Whereas filmmakers were certainly politicized in other contemporaneous national cinemas, their projects often influencing public opinion and debate, nowhere else was the notion more popularized or more closely identified with specific communities of activists and intellectuals than in Buenos Aires. This came about because of the sheer scope of the reevaluation of film during the transition and the manner in which intellectual communities outside filmmaking responded to this shift. It resulted as well from a conscious remaking of public awareness of the history of Argentine cinema. During the transition, earlier film modes and movements were reappraised, reclassified historically, and assigned new meanings. Specific directors were singled out and redefined as models of the kind of activism that the third generation of transition filmmakers hoped to emulate. Filmmakers mobilized and were inspired to serve as protagonists in a number of public and intellectual debates.

Perhaps the most visible reflection of this shift was the creation and expansion of the discursive politics of film in central spaces of cultural exchange. In the mid-1990s institutions and cultural entities in Buenos Aires began to concentrate new energies on cinematic questions and assert national filmmaking as a primary cultural mode for examining larger artistic issues, both aesthetic and sociopolitical. A chief example of this phenomenon is the work of MALBA. From its inauguration in 1999, the museum's director, Eduardo Costantini Jr., and curator, Inés Katzenstein, have embarked on an ambitious cinema project, hiring the film historian Fernando Martín Peña to direct monthly activities including several film series, workshops, lectures, and advance screenings.[38] From 1999 to 2006 the museum printed a monthly guide to its film programming, open to the public, featuring detailed reappraisals and new readings of important national directors. Debates and film series were organized around new framings of national film history and specific sociopolitical or cultural themes, often engaging comparative contexts to underline the significance of this repositioning.

Similar programming strategies became particularly widespread after 1999 in other cultural venues. The pairing of national film retrospectives with talks given by literary or artistic luminaries placed film in broader national cultural narratives. For instance, in 2003 MALBA exhibited the work of Guillermo Kuitca. The museum director invited the well-known painter to select national and foreign films resonant with his work whose juxtaposition would structure a sort of debate on interconnectivity. The museum published an interview in which the artist addressed key questions of cinema as a relevant

forum for creative and critical deliberation. This project ran alongside a tribute to independent Argentine filmmaking in the 1960s and 1990s, pairing the work of Fernando Ayala, Jorge Cedrón, and Fernando Birri with up-and-coming Argentine directors such as Albertina Carri, Pablo Trapero, and Ricardo Becher. As an outgrowth of this project, the Eduardo F. Constantini Foundation, with the support of MALBA and the Torcuato Di Tella Institute, invited Martín Peña to edit a volume of critical readings of independent cinema from the 1960s and the 1990s. This project called on important film history scholars to examine links between these two generations of socially conscious filmmakers.[39] In this way, an important cultural space in Buenos Aires, one that often sets the tone for citywide intellectual conversations, privileged the film medium and Argentine filmmaking's place within the context of art history, criticism, and theory.[40]

Argentine documentary film and its discursive politics made inroads into a number of institutional and cultural settings that did not already incorporate cinema. Beginning in the late 1990s regular film series became the norm for the Ethnographic Museum, the Buenos Aires Museum of Modern Art (MAMBA), and the Ministry of Education. The Ministry of Education began bringing film series to primary schools across the country and sponsoring film events. In 2005 the ministry helped to host a documentary film retrospective on the human rights groups the Mothers and the Grandmothers of the Plaza de Mayo at the Cosmo Theater, with the program aimed at schoolchildren in Buenos Aires. In addition, cultural centers across Argentina programmed politically oriented film series. Having received by law copies of all INCAA-sponsored films, the cultural centers of the provinces and the municipal government of Buenos Aires, such as the Ricardo Rojas Cultural Center, in the heart of the theater district, drew on this material to begin regular national film series. The cultural center of the Communist Party co-op also began hosting activist films from across Latin America, along with presentations by directors and public debates. For example, in December 2006 the co-op reflected on the thirtieth anniversary of the military coup of 1976 by hosting a series of documentaries about the coup and its aftermath. The Goethe Institute, which officially promotes German culture abroad, also began to take part in 2004, hosting film contests and bringing Argentine filmmakers and academicians together with their European counterparts. Most of these institutions ran film series as a part of educational campaigns that equated transnational film experience with consciousness raising.

In the mid-1990s the "cine club" began to reemerge across the city, building on independent intellectual and cultural circles with an interest in film.

The Cine Club Buenos Ayres, Cine Club Núcleo, and Cine Club, for example, began screening both national and international films, often in themed series and minifestivals. These clubs also initiated a number of print and web-based publications, and some began to offer public access to their film collections.[41] Following suit, the Historical Institute of the City of Buenos Aires also offered public access to its audiovisual collection related to the city's history, including thousands of hours of recorded oral testimony collected in barrios from the 1970s onward. These efforts added to the growing body of audiovisual archives that documentary filmmakers could use and the public could examine. Several cinema clubs began programming intellectual debates; for example, Cine-Teatro IFT presented the seminar "Cinema and Marginality in Latin America: Subalternity, Dirty Realism, and Urban Violence," with the Ecuadorian sociologist Christian León as a keynote speaker.[42] In 2004 the Núcleo Audiovisual Buenos Aires hosted a public forum on truth in documentary cinema. These events drew filmmakers from around the world to participate in constructing discursive spaces across the city. Within a short time, Buenos Aires became a hub of film experience, filmmaking, and critical review. Virtually no aspect of cultural life went without expression in the medium, and almost all formal cultural institutions included film screenings as standard fare.

The intellectual reconsideration of filmmaking was sparked in part by the resurgence of the film revista as an influential outlet of cultural commentary and theoretical imagining of cinema. From 1983 Argentina's flourishing scholarly journals dedicated to filmmaking began to parallel their counterparts in Europe and North America. Traditional film studies journals, such as *Film, Kilómetro 111*, and *La Mirada Cautiva*, began to circulate abroad and receive wide scholarly and intellectual attention. *Film,* a film analysis journal that began publication in 1993, received submissions from important historians, journalists, critics, and filmmakers, including Fernando Martín Peña and Sergio Wolf. Borrowing its title from the signal Soffici film of cine social, the journal *Kilómetro 111* began its run in 2000 and is perhaps the most far-reaching of these interventions. Its articles concentrate on theoretical and aesthetic questions, with scholarly pieces running alongside in-depth interviews of major Argentine directors. *La Mirada Cautiva,* the film revista of the Museum of Cinema Pablo C. Ducrós Hicken, first published in 1998 and sponsored by the municipal government of Buenos Aires, was distributed widely without charge. It collaborated with the museum's mission of bringing to light and producing new knowledge about national cinema.

More popular reviews targeted a larger public and were available at local newspaper kiosks across major Argentine cities. The most notable of these

include *La Cosa* (The thing), *El Amante* (The lover), *Haciendo Cine* (Making cinema), and *Nosotros . . . los Cinéfilos* (We . . . the cinephiles). *La Cosa* began in 1995 and aims to familiarize the general public with unusual genres and the cinema of the fantastic. *Haciendo Cine,* published from 1995 to the present, is sponsored by the Center for Cinematographic Investigation, the University of Cinema, the Secretariat of Culture, and the INCAA, among others. This revista reports on film as both an artistic and a commercial product, presenting articles related to domestic and international filmmaking, with special editions printed during the largest national film festivals. This kind of cinema magazine aims to encourage the reading public to engage in debates on the political issues of filmmaking, film aesthetics, and the direction of national cinema. Digital media and the Internet began to further facilitate widespread public conversations regarding film. Argentine "neteros" began film web sites to post articles, film reviews, cinematographic notes, and debates in cyberspace. The most important of these include otrocampo.com, elamante.com, filmonline.com.ar, and cineismo.com, all of which were founded between 1999 and 2002.

University programming increased the porteño public's film literacy through increasing study tracks and student publications. The emergence of new programs related to the study of cinema, such as the combined arts degree at the University of Buenos Aires and the Center of Investigations in Cultural Studies, Education, and Communication of the Universidad Nacional del Litoral, combined with the rise in the number of private and public film schools to increase the visibility of film as an area of study. Subsequent increases in the number of film students also contributed to an expansion of the publication and pedagogical consideration of new film magazines. University-based periodicals such as *El Cinéfilo, Xanadú,* and *ConFUCión* allowed film students in Buenos Aires to participate in forming a conversation about national cinema and its industry. *El Cinéfilo* started in 1997 as a publication of a cinema workshop at the UBA. The Fundación Universidad del Cine, with Manuel Antín as its director, began publishing *ConFUCión* in 1992 when the school first opened its doors. These student periodicals gave a more informal treatment to film scholarship and generally combined critical analysis with discussion about technical aspects of filmmaking and screenwriting. In this sense, student revistas became one of the most accessible intersections of theory and practice in contemporary critical film writing.

Even major newspapers and industry periodicals began to devote more space to film news, critical debates, and festivals. The national dailies with the widest circulation, such as *Clarín* and *La Nación,* began regular magazine

supplements to cover film news. Both the Mar del Plata film festival and the Buenos Aires Independent Film Festival started to publish special newspapers specifically designed for each day of the festival, printed by these same major newspapers. Even the film union SICA began publishing its own magazine beginning in 1985. Initially designed as a review of labor politics in the film industry, in 1988 the SICA publication morphed into an ideological platform for the union's position on important debates of film activism and film content.[43] *DEISICA,* as the periodical came to be titled in 1991, ran under the motto "an unstudied reality is an unknown reality, and an unknown reality is a reality that cannot be transformed."[44] Taking on matters of conflict between the noncommercial cinema and the industry, several editions in the late 1990s began to address pirating, illegal exhibition, and the need for greater flexibility in film institute subsidies, calling on its membership to combat these industrial menaces.

Book publishing, the cultural medium slowest to respond to shifts in critical thinking, finally created a significant space for film by the late 1990s. Few books on Argentine film and directors had been published in Buenos Aires throughout the Alfonsín administration. By the end of Menem's presidency, however, the shelves of bookshops along Corrientes Avenue began to fill with major film histories; translations of volumes of film theory and technique; and extensive directories of national films, actors, and directors. Initial forays were primarily biographic works, describing the major accomplishments and life stories of the directors who had made waves during the transition and whom third-generation transition filmmakers were keen to make into symbols of the new mode of political documentary filmmaking. The Centro Editor de América Latina, together with the INCAA, published a series of works on individual directors, beginning with Adolfo Aristarain, Fernando Solanas, Héctor Olivera, Mario Soffici, Fernando Ayala, Fernando Birri, and Manuel Antín.[45] Similarly, Perfil Libros published a volume on Armando Bo, and Ediciones Culturales Argentinas released a book on the life and work of Hugo del Carril.[46] The INCAA assisted in publishing an edited volume of essays on Leopoldo Torre Nilsson.[47] The publishing company Corregidor published a dictionary of Argentine films,[48] and shortly afterward the publisher Legasa found ample market demand to periodically publish an updated edition.[49]

The rising public demand for film literature pushed publishers to consider extraordinary means to cater to its new market. The film union SICA combined forces with the city government of Buenos Aires to print a short-run journal on cultural enterprises entitled *Observatorio de industrias culturales* (Observation of cultural industries) and entirely devoted to the Argentine film

industry "between the limits of the market and state support."[50] The Argentine branch of the Spanish publisher Paidós began purchasing the rights to issue translations of classics of film theory and international film history, such as *European Cinema, European Societies, 1939–1990,* by Pierre Sorlin; *Cinema and Entertainment,* by Henry Giroux; and *Violence and Contemporary Cinema,* by Olivier Mongin.[51] Paidós also ran a series of books on the themes of memory and cinema, multimedia communication, and textual analysis, treating the works of important international directors including Alfred Hitchcock, Fritz Lang, Luis Buñuel, Sergei Eisenstein, and François Truffaut. Titles on technical issues and theory in translation included over forty different authors and ranged in subject from montage technique to sound arrangement and from guides for criticism to the spectator's gaze. Tellingly, an instructional work on film legislation was published in 2003 to inform and assist independent filmmakers; it was compiled by a former INCAA legal representative, Julio Raffo.[52] The legislative reform initiatives of the early and mid-1990s demonstrated to intellectual groups in Buenos Aires that the state was eager to participate in using film as a tool for political change. Even the director of the INCAA participated in the production of critical works, examining questions of politics in the light of the film institute's projects.[53]

In addition, the collusion of themes that appealed to both filmmakers and academic disciplines helped increase the scholarly attention given to Argentine film, particularly documentaries. Across the social sciences and the humanities, conversations beginning during the democratic opening of the early 1980s centered on questions of memory, testimony, identity, and social reintegration. Scholars working within traditional academic disciplines began widely rereading the past through film. Scholarly work on the dictatorship's repression began to consider documentary cinema and its use of oral testimony as chief new archives.[54] Both documentary and fiction film were quickly taken up as references by scholars of psychoanalytic theory, one of the most active intellectual communities in Buenos Aires. Confronting questions about repression of memories, working through trauma, and collective consciousness, many of these films served as starting points for discussions within scholarly writing, conferences, and popular editorial columns.

What seemed most to trigger the critical imagination in the mid-1990s were the aesthetics, political mappings, and discursive practices of recent documentary production.[55] High-profile leftist intellectual magazines, such as *Punto de Vista, Confines,* and *La Mujer de Mi Vida* (The woman of my life) began to incisively interrogate the subject of national grassroots filmmaking and the political documentary. In 2006 *Punto de Vista,* one of the most

significant cultural theory magazines to emerge from an underground status during the dictatorship, devoted two issues to new Argentine documentary filmmaking and its place within sociopolitical contexts. These editions featured the writings of key intellectual and academic figures, such as Beatriz Sarlo, Adrián Gorelik, Graciela Silvestri, Rafael Filippelli, and David Oubiña. Though they often wrote scathing critiques of individual films' aesthetics, these authors integrated the analytical perspectives and ideas presented in the films into broader questions of national memory and identity politics. In other words, they took grassroots documentary filmmakers' ideas seriously. By that point, many of these same writers had also begun to incorporate film as both historiographical footnote and as text into their own projects, which dealt with making sense of Argentine history and culture.[56] Their view of film as key to understanding modern life in Buenos Aires resonated with the shifting perceptions of documentary film in the wider context of their readership.

Although central Buenos Aires was certainly the locus of film activity and thought during this period, a similar, toned-down version of the phenomenon also occurred in the periphery of the city and in the interior provinces. Events in Córdoba, Rosario, Entre Rios, Tucumán, and elsewhere sparked intellectual and political responses across Argentina. In the town of Las Palmas, Chaco, the local representatives of the Documentalista Movement hosted a film screening in celebration of the 2004 "Day of the Documentalista." Participating political organizations included the Communitarian School of the Movement of Unemployed Workers of La Matanza (MTD), the cultural center of the occupied factory Gráfica Chilavert, and the Communitarian FM Radios of the Campesino Movement of Santiago del Estero. At the event, the group screened Solanas's film *Memoria del saqueo* and hosted talks by the film's cinematographer, Alejandro Fernández Moujan. It gave prizes to "social actors of the year," recognizing various documentary filmmakers for their contributions to activism in 2004. The event reflected on the work of Raymundo Gleyzer, to whose memory the Day of the Documentalista was dedicated.[57] In this way, the social activism and political organization of documentary filmmakers extended beyond the bounds of the city to incorporate like-minded groups across Argentina.

The Documentalista Movement was vital in extending the recognition of documentary filmmakers to the rest of the country. In addition to hosting workshops in various centers of the organization across Argentina, it also offered a set of virtual courses and web-based documentary photography exhibits on themes such as "women and social movements."[58] The organization, in conjunction with an organized branch of the unemployed workers' movement

in the greater Buenos Aires neighborhood of Matanza, inaugurated a grass-roots television network, Channel 21, or TV Libre, whose founders hailed it as the communitarian television of the people of La Matanza; the network was charged with "satisfy[ing] the communicational needs of the people of La Matanza and contributing to the resolution of their needs for health, education, nutrition, housing, culture, and dignity as workers and as an integral part of society."[59] It ran documentaries relevant to the neighborhood constituencies' attempts to gain greater access to public services, better protection of human rights, and improved working conditions. The network showed footage filmed by groups organized as grassroots documentary workshops who referred to themselves as "de la base" to reference their methodological and ideological influences from the Cine de la Base movement.[60]

These intellectual and cultural projects, from revistas to film school courses and from scholarly texts to public lectures, all helped elevate the cultural and political status of filmmaking. Elite communities of scholars and public figures—*cinéologos* of various stripes—inevitably had to recognize the impact of filmic meaning making and documentary knowledge production by the end of the 1990s and mid-2000s. The outpouring of cinema literature raised the critical importance of transition figures such as Solanas and Birri and heightened intellectual awareness of the protagonists of new waves of Argentine fiction and documentary film production, opening important discursive spaces to film. Communities of cultural producers responded to Argentine documentary filmmakers' assertions of their rightful place in critical and political debates. As a corollary, a new kind of intellectualism of film became important to major intellectual currents both inside and outside scholarly communities. While in other countries these two phenomena developed largely in isolation, in Argentina, film activism and film intellectualism were complementary.

LEY 17.741 FROM 1968 TO 2004

This book is bracketed by two important dates in Argentina's political history and its cinema history, 1968 and 2004. The former, aside from being a time of tremendous political upheaval and radical cinema activism, was also the year that Ley 17.741 was passed, the law that continues both to govern national cinema and to provide the most important set of structuring indicators for film markets. In 2004 Argentina's Congress made important modification of this cinema law: a new quota obliged exhibitors to screen at least one

national film per quarter. This year also saw the Espacio INCAA project, which created state-run theaters exclusively exhibiting Argentine films, expand beyond the national boundaries, opening theaters for the Argentine diaspora in Madrid, Rome, Paris, New York, Tel Aviv, and elsewhere.[61] In addition, at this time the film politics of Argentina began to show evidence of having substantially influenced other cinemas in the region. In November 2004 Argentina's neighbor Chile adopted new audiovisual arts legislation, Ley 19.981, announcing that the state would become more active in funding, protecting, and promoting the interests of its audiovisual industries, particularly cinema. Similar reforms were also already afoot in Colombia, Peru, and Mexico. Closely following the model of Argentina's cinema legislation, Latin American filmmakers across the globe celebrated Chile's law as confirmation of the major strides won by the success of independent documentary filmmaking in Buenos Aires.[62] Within Argentina, provinces and municipalities were also beginning to increase their cinematic activities, and by 2007, April 27 had been declared the annual "Day of Argentine Cinema" in the city of Buenos Aires (Decreto 1.711/007).

The year 2004 marks the end of the third generation of transition filmmaking in that the activity of making film to establish a voice and a political presence within civil society was well grounded at this point. By this date, filmmakers unquestionably had arrived. The modifications of film law that had gradually begun toward the end of the 1990s and culminated in reforms and new budgets by 2004 are proof that the state had started to acknowledge the significance of the growing community of independent filmmakers, specifically documentary activists, and instead of continuing to treat them as threats to the industry or to Argentina's reputation abroad, it began to support them.

In producing audiovisual archives of testimonies, documents, and interpretations, documentary filmmakers have undeniably contributed to Argentina's politics and collective memory work. Narrating politicized visions of the country's recent history of dictatorship and human rights repression, filmmakers were able to strategically operationalize the discursive framing of their films to clearly express their more specific social grievances and to consolidate access to both audience and financial support for their continued film production. Predominantly independent producers making political documentaries found ways around complex national industry law, obtaining funding from international foundations with commitments to broadly defined transnational solidarity in pursuit of global consciousness, or "Global Vision," as a festival in Edmonton was named (one of the first, moreover, to include a significant presence of third-generation Argentine documentaries).

The political scientist Thomas Olesen posits that transnational solidarity networks are largely processes of social construction within which a social movement or transnational phenomenon must frame common understandings if it is to have any collective agency.[63] One of the most prominent organizing discourses responsible for creating common understandings of documentary filmmakers' work since the beginning of the transition has been that of the universality of human rights, a discourse prominent in the reenactments of the dictatorship's tragic abuses that witnesses transmit to those who were absent or somehow removed from the events.[64] Despite the "critical intimacy" forged between destination audiences and filmmakers and their subjects, these constructions and framings have ended up reinforcing a politics of representation that privileges the organization of narratives of a barbaric Argentina and the great civilizing hope represented by its better integration into global legal forums and the international marketplace.

The development of distinct fields of intellectual work surrounding questions of cinema in Argentina did not happen by accident. The explosion of grassroots political documentary and the growing cultural agency of filmmakers were a large part of this development, phenomena fostered by documentary filmmaking's representation in intellectual journals, academic departments, and other citywide cultural spaces. The politicized spaces created by the explosion of third-generation transition filmmaking in the 1990s and 2000s generated and facilitated social activism. It did this in part by facilitating the dissemination of information, with various parties using exhibition spaces to distribute literature and organize strategic alliances through the creation of an archive of images and sounds documenting the past that would be open to public engagement.

Argentina's cinema history offers the study of culture a case in point showing how intellectual communities develop, how technology shapes cultural practices, and how urban synchronicities provide impetus for major social movements. The cultural politics of the transition colored national debates concerning collective memory, Argentine national identity, and the grounds conferring the right to relate the histories of the nation's inhabitants. From the vantage point of post-1989 Buenos Aires, one can begin to understand the development and political dynamics of film study and its emergence as a critical element of investigation across disciplines in Argentina. Although the case of Argentina sets it apart in many ways from other national political cinemas, its film history sheds light on the more universal role of legislation and activist politics in shaping leftist intellectual inquiry and cultural production.

CONCLUSION

THE INTELLECTUAL AND political dynamism of filmmaking that emerged in the city of Buenos Aires as a result of the ongoing transition to democracy suggests new ways of thinking about the role of audiovisual media in cultural history debates. The notion of film as a vibrant contribution to modes of intellectual inquiry and to projects of recording and historicizing the events of the nation's recent past was a political one constructed from the common experiences, expectations, desires, and necessities of an evolving Argentine society. It did not result from any one set of legislative reforms or any singular advance in technology. The idea of film as politics was not the product of a new wave of filmmaking or even a revitalization of previous waves; rather, it took shape over a broad expanse of time and a shifting political geography. Intimate encounters between film and politics permeated the fabric of daily life during the transition, both through conventional market means and by way of the direct agency of interested parties. The political film's timeliness and utility in sparking debate and intervening in national political life called filmmakers into action, and those facets will likely retire them when their collective visions fail to resonate with or reflect changing political realities. As film work in Argentina has had to adapt to changing political situations and socioeconomic conditions, it has taken on a number of different politicized personas,

from the Peronist film worker to the social activist turned organic intellectual. Argentine filmmaking can be understood as a political idea only in its dialogue with daily life, in multiple complicated and irreducible expressions. The idea of film as politics thus carries with it an ideographic genealogy that is both revealed and concealed as part of competing political agendas.

Film's political capacity developed in Argentina as an extended process of reflexivity among national institutions, transnational markets, individual agents, and local cultural practices. From its very invention in the nineteenth century, cinematic technology was designed with both scientific and popular uses in mind, a duality to which most film scholars tend to point. The acceptance of filmmaking as an instrument of historical knowledge transmission, however, did not derive from the period of early national cinema early in the twentieth century. During this early moment in cinema history, an Argentine "cinema of spectacle" was utilized to present nationalist visions of local history, creating a useful dialectic between cinema and spectator that would later be fashioned into an instrument of the nation-state. As the state launched educational and propagandist campaigns via cinema and support of the film industry, it became even clearer that reception did not necessarily mirror the aims of the state or the industry. In Argentina, filmmaking's contribution to popular culture and politics became a point of national pride, its competition with Hollywood a patriotic demonstration of cultural achievement. The box-office success of any one film may have reflected a timely common sentiment but more often revealed a constantly evolving set of identities within a heterogeneous topography of "structures of feeling."[1] This problematic took on even more pronounced dimensions as the nation vacillated between democratic and authoritarian governments or when film became suspect of collaborating with or resisting the state's authority, but it was rarely considered to be more than a momentary reflection or allegory of political tensions and never seen as the source of the tension itself. By the turn of the millennium, however, cinema had become a recognizable analytical component of intellectual life in the city of Buenos Aires, and this turning point has signaled a definitive shift away from the political filmmaking of the country's past.

The evolution of this relationship of filmmaking to politics in Argentina resulted from a specific moment in national political life. This shift evolved partially from the political and intellectual left's need to find a means for more directly accessing and discussing the perspectives and experiences of marginalized Argentines who did not have their own established vehicles of representation within the national media landscape. The role of the "new left" and the rise of social movements clearly gave a distinct liveliness to the political

identity of film and filmmakers during the long democratic transition. The medium of the political documentary allowed the political left to use news footage, interviews, and eye-witness testimonies to begin to craft a distinct set of grievances against the neoliberal politics of conservative and moderate parties, forging a powerful oppositional identity for itself.

The transition to democracy in the mid-1980s catalyzed the circulation of an idea of cinema as a useful tool for understanding historical experience, doing so in part by drawing on the film industry's unique political pasts and its key protagonists. Also during this time, film legacies from past decades were invoked by the filmmaking community to establish credibility and authority in speaking to matters of national significance. The constellation of problems that filmmakers addressed during the transition enabled them to enter into a local political dialogue that carried with it useful alliances to larger collective memory and to identity projects that concerned a wider public. The association of filmmaking with emergent leftist politics in particular gave cinema a stake in national political life that deftly avoided identification with some of the transition's failures to solidify a useful vision of the nation's political past. A handful of influential filmmakers used this strategic positioning to reshape not only film policy but also the collective notion of film's place in culture and politics.

The degree to which Argentina's political and cultural life is centralized in the city of Buenos Aires also accounts for the evolution of this particular set of ideas about political film. Filmmakers and their audiences assembled a mimetic vocabulary that allowed local cinema production and reception to become spaces for vibrant discursive political engagement. Repetitious audiovisual representations of the history of repression under the dictatorship proliferated throughout city spaces. Internalizations of transition political narratives of this history and memory debates became an integral part of the intersubjective identity filmmaking began to craft for itself. The postdictatorship political transformations in Argentina were also of a more urban nature than were those in Mexico and Brazil, where significant social movements transpired outside urban spaces—for example, within movements of indigenous peoples and peasant groups. The use of testimonial montage to frame collective memory permitted the management of a shared national trauma to be dominated largely by middle-class urbanites. Informed and cultivated audiences made the city of Buenos Aires a key location for cinema to assert its capacity for making meaning and producing knowledge.

The cultural machinery created by the democratic transition in the city of Buenos Aires generated a technology of place that brought filmmaking to

the fore in defining emergent memory and identity politics. Cultural policies enacted by the Alfonsín government framed producers of audiovisual media as playing a role vital to the success of a redemocratizing society. Images such as those from the juicio a las juntas, the *Nunca más* report, and the films of Cine Liberación formed a Proustian undercurrent to the political messages of documentary films. National and citywide projects that gave institutional support and recognition to grassroots initiatives further underlined the legitimacy of this vision for the representational politics of the postdictatorship period. Together with advances in the technology of filmmaking, the centralization of markets and political spaces, and the impulse of an emerging transnational market, these conditions favored the low-budget political documentary. Films that were made about political issues and national history were easily incorporated into state-sponsored cultural programs, such as those sponsored by the municipality of Buenos Aires and the Ministry of Education. The preferences of transnational funding institutions to award grants and prizes to political films were also critical in setting the tone for the kind of films that were likely to be made. A synergy between each of these developments created ideal conditions for political documentary filmmaking in particular to take on new significance within the cultural politics arena of the posttransition period.

The construction of a new ideography and experience of cinema in the city of Buenos Aires was also the consequence of the cultural agency of a handful of dedicated individual filmmakers in several distinct generations. Negotiating institutions, socioeconomic realities, and political structures across periods, these individuals used the cultural matrix of the transition to position themselves for greater political influence outside the artistic and commercial sphere. Solanas helped redraft film law in 2001, Bemberg and Stantic helped to promote women's filmmaking, and Di Tella helped create one of the most successful independent film festivals in the hemisphere. Solanas is still an active filmmaker and politician, remaining a key figure in cultural policy arenas and within a wide variety of communities of filmmakers. Film's intervention in politics, and later in intellectual discourse, resulted from the cultural agency of key directors whose vision for cinema and for the role of filmmakers extended beyond the bounds of cultural production. Individuals from the first and second generations of transition filmmakers demonstrated that cinema can transcend social and political barriers and create historical change, and through their continued efforts, they laid a foundation for filmmakers of the third generation to weigh in early and prominently when their time came. Filmmakers such as Albertina Carri, Ernesto Ardito, and Virna Molina, as

well as members of film cooperatives, began their professional activities cognizant of, and sometimes in direct communication with, their predecessors' interventions in the politics of the early transition. Third-generation transition filmmaking extended the early tentative pathways cut by those forebears' models to establish documentary cinema as a tool for reinforcing democratic civil society and promoting the representation of marginalized peoples. These filmmakers cemented new cinematic practices into everyday expectations.

The dynamism of both political cinema and its study in Argentina from the late 1960s to the present reflects transformative shifts not only in technology and access but also in the practice of cultural politics through film. In Argentina, increasing accessibility of both the medium and the critical universe surrounding film production has meant that notions of filmmaking are constantly subjected to new events and to the anecdotal particularities of each individual filmmaker's experience or scholar's analysis. The realizable potential of the political film as a medium of knowledge transmission, a filter of historical events, and an object of critical reflection reveals the impact of the exchange of ideas among communities of intellectuals, audiences, politics, and cineastes during the transition. The boom in documentary filmmaking in particular makes for a strong argument regarding the historical specificity and discreteness of film practice and the social life of cinema in the city of Buenos Aires. The promise of cinema as a mode of ideological reproduction appealed to influential sectors within the social landscape of the city's political and historical imaginary, favoring the political ambitions of transition filmmakers themselves.

During the transition to democracy in Argentina, documentalismo appealed to the sensibilities of a newly receptive audience, transforming quotidian political realities. Using coded encounters with audiovisual stimuli that would resonate with a carefully crafted subjective consciousness, the films of this genre confirmed the legacy of the cultural agendas and aspirations of Peronism to create a political identity for the filmmaker that extended beyond the sphere of the movie theater. National and eventually transnational audiences of these documentary films encountered a deliberate packaging of sensible experiences that they then were invited to examine through categories of understanding and intelligibility culturally constructed by these three generations of transition filmmakers and their intellectual and political interlocutors. The economic crisis of 2001 provided an opportunity for documentalistas to use discursive frames of the transition to foment social activism and to extend a new sense of ownership over cultural politics to previously marginalized groups. If early film culture in Argentina was intended to be "el

arma más fuerte" (strongest weapon) of the state, the transition, with its energetic and opportune positioning of film as politics, enabled the political film to become an armament of opposition politics and of a reimagined left. Transition filmmakers completed the mission of nuevo cine latinamericano by turning early notions of film's capacity in the service of politics into a means by which even dispossessed groups could speak to the "imponderables of the spirit" of an increasingly globalized viewing public.

A particular idea about filmmaking in post-1983 Buenos Aires situated individual cinematic encounters within an imagined relationship between the real conditions of film experience and its representational modes. The cultural politics of the transition provided the "social cement" that would fix this imaginary relationship to both formal and grassroots modes of production. As self-conscious subjects, film viewers and filmmakers alike had to recognize the new categories of knowledge and identity constitution that this process brought into being. The subjectivities that political documentary filmmaking conscientiously constructed would later act as a bridge between heterogeneous communities of film reception. And this perceptual shift would in turn naturalize the very roles that filmmakers had been enacting since the epoch of early cine social. The fact that documentary filmmaking became an autorepresentational strategy of even the most marginalized sectors of the city reflects the sweeping nature of this ideological shift.

As I have suggested throughout this work, the historical image constructs shaped by the advance of the audiovisual in public and political spaces have played an important part in forming understandings of Argentina's recent past. As Robert Rosenstone has evocatively suggested, filmmakers have come "to the rescue" in the postmodern crisis of history. Film work has fulfilled the notion that the kind of self-reflexive postmodernist history that theorists and skeptics have demanded is indeed possible and that this kind of history has ushered in a "new way of making meaning of the traces of the past."[2] Argentine postmodern historicities have filtered through the intertextual landscape of memory debates, allowing a sense of the past to exist in a way that recognizes the problematic nature of historical knowledge and received narratives of the past. The textualized events and individuals of the past can indeed be understood both empirically and discursively.[3] The continual revisiting of the past by filmmakers busy fixing and unfixing memories is not, however, an outright rejection of past registers of historical meaning making. These new histories of the audiovisual age do not take the view that knowledge of the past is impossible or dismissible. Rather, they invigorate the quest for truth and expand the terrain of memory and history.

Collective memory work through film does not hinge entirely on culturally constructed receptiveness, though this has been one of scholars' chief concerns in approaching conclusions about Argentine political cinema. While some continue to claim that transition films were merely performative acts or fantasies of resistance, examining the everyday life of Argentine political film in social and spatial encounters reveals these films to have exerted substantial agency both in constructing a place for film as historical narrative and for defining some of the key failures and absences of the knowability of a specific past. The key legacy of transition films in Argentina is the opening they have provided for observation of the historical imaginary in action, or in Arjun Appadurai's words, *the imagination as social practice*.[4] Looking at "transition culture" in Argentina along an expanded time horizon uncovers this social practice of actively constructing, reconstructing, and revising memory in the service of creating a usable present past.

When I moved to Buenos Aires in 2002, I quickly became aware of certain privileges of access granted me as a foreign researcher from a well-known academic institution. In the process of conducting my research, I was invited to a number of private film screenings, introduced to directors and actors, presented to cultural policy makers and senators, and even chatted up by film critics eager to share their opinions on various aspects of Argentine cinema. At film festivals, the great meeting place of local filmmakers, I might be asked to take part in critiquing new film projects, persuaded to tag along to watch a documentary crew filming interviews, or encouraged by film school professors to sit in on their courses. The lone cineólogo at a barbeque for visiting film archivists from around the world, I found myself drawn into conversations about the politics of film distribution and collection in North America. Hardly a week went by during the five years I remained a resident of the city that I was not able to participate in and observe some aspect of film culture in the making. The rather uncanny frequency of these encounters suggested to me a marked self-consciousness among filmmakers about intellectual reactions to their work. I would later discover that this enigmatic connection was the key to understanding the final phase of transition cinema.

An event that occurred in the first few months of my time in Buenos Aires stood out in my mind as having been particularly telling about the changing role of film in the cultural politics of the city, the social life of Argentine cinema that I had just begun to infiltrate. A colleague had invited me to sit in the broadcasting booth of La Tribu, an alternative media FM radio station, during its weekly hour-long show dedicated to discussing films and interviewing important local and visiting cineastes. That week, the program's presenter,

Luis Gusmán, had invited Juan José Campanella to the show to discuss his box-office hit *El hijo de la novia* (*The Son of the Bride* [2001]), a humorous family drama starring three of Argentina's most prominent actors of the 1980s, Norma Aleandro, Héctor Alterio, and Ricardo Darín. After the show, which mainly focused on the film's content and reception abroad—the film had been nominated for the Academy Award for Best Foreign-Language Film—the radio crew sat down for a drink with the director in the bar attached to the studio. Campanella seated himself beside me, curious to know about my research and my impressions of Argentine film but evidently disquieted by the idea that a young woman from the North might attempt to decipher the political economy of filmmaking during the transition period. His principal concern, he emphasized, as a veteran filmmaker enjoying a notable degree of success, was that I seemed to be paying too much attention to noncommercial cinema at the expense of understanding the classic studio feature film.

At first, I was surprised by the intensity of Campanella's invective against casting the critical gaze on the political cinema of independent filmmakers. His loyalties to the local industry did not seem to be a serious source of concern, as most of his income, he clarified, came from directing television abroad. From 2000 to 2007 he had worked on television series, including *Strangers with Candy, Law and Order: Special Victims Unit,* and *House M.D.,* and he would go on to direct an episode of the Emmy-winning sitcom *30 Rock* in 2006. Although many important directors supplemented their film production in Argentina with television gigs in North America and Europe, Campanella's profile in feature film production in Buenos Aires was relatively minimalist by industry standards, and the director confirmed that he planned to produce upcoming work in Hollywood studios. My next thought was that perhaps he feared that his fiction film *El mismo amor, la misma lluvia* (*Same Love, Same Rain* [1999]), which deals with relationships in the aftermath of the dictatorship's repression, might not be included in a more synoptic account of phases of political filmmaking. As we continued our conversation, my puzzlement only grew as Campanella continued to express concern about international perspectives on the politics of emerging trends in documentary filmmaking. As we got ready to say our goodbyes and head out of the bar, a member of the radio crew who had remained quiet up until then leaned over to me and asked if I could wait a minute before leaving.

I had not been properly introduced to the crewmember, a gentleman in his mid-sixties who had arrived late and had been quite occupied in the sound booth during the broadcast. When finally we sat alone together at the bar, he introduced himself as David Lipszyc, the director of a film called *La Rosales*

(1984), an allegorical fiction film about corruption based on a historic ship-wreck of the Argentine navy.[5] After inviting me to a *café cortado* and some empanadas, he took a long handwritten letter from his pocket and asked me if I could translate it into English so that he could speed it on to colleagues in Europe. From what I could understand from over his shoulder, the letter contained a description of the 2001 financial crisis that Argentina was then still suffering. I agreed to do the translation and promised to get it to him by the following week. When I took the letter home, I was surprised to find that it had nothing to do with cinema or even with the business of filmmaking. Instead, it was a statement of the author's political ideas, a commentary on current events from his personal vantage point. The letter included the film-maker's critical reflections on the political corruption and social inequalities that the crisis had exposed, a terse but biting diatribe against neoliberalism, and a set of abbreviated historical explanations for the current financial fiasco. I found out later that the letter I translated was to circulate as part of an intro-duction to a traveling series of documentary films about the crisis that would make the rounds of major cities in Western Europe, framing both the films and contemporary Argentine history for an international audience.

The persistence of this evening in my memory continued to challenge my thinking as I went about my fieldwork over the next few years. Campanella and Lipszyc, it seemed to me, were operating on two different planes of cin-ema politics, though both seemed to be critically sensitive to the transna-tional dimensions of Argentine film work and reception. Nonetheless, while Campanella's filmmaking spoke to transnational audiences in much the same way that Luis Puenzo's *La historia oficial* had done in the mid-1980s, Lipszyc represented a more direct route to framing debates and influencing opinion about Argentine politics and society abroad that had been staked out by the transnational documentalista. Campanella, who in 2010 would win an Oscar for yet another film reflecting on the legacy of the dictatorship, was appre-hensive about the external *mirada,* the foreigner's gaze, and its impact on the political understandings of film that would circulate in intellectual spaces; in contrast, Lipszyc saw the external interloper as a strategically placed ally and a means to an end for the greater circulation of ideas in intellectual conversa-tions that would transcend national boundaries. At the juncture of this di-vide, I realized, was evidence that the landscape of political filmmaking had begun to change in important ways and that by the time of the crisis, its modes and operating ideologies, along with the everyday practices of cinematic poli-tics, had also undergone a profound transformation.

NOTES

INTRODUCTION

1. *Corazón de fábrica* (2008) was produced with the support of the Jan Vrijman Foundation (the Netherlands) and the Alter-Ciné Foundation (Canada). For more about the factory takeovers in Argentina since the 2001 crisis, see Pablo Heller, *Fábricas ocupadas* (Buenos Aires: Rumbos, 2004); and Jorge Altamira, *El Argentinazo* (Buenos Aires: Rumbos, 2002).

2. Argentina has a long history of workers taking over factories, particularly in periods of high unemployment, a practice whose roots lie in early nineteenth-century industrial Europe, with important expressions during the Russian Revolution; in 1920s Italy, among anarchists; and in the Spanish Civil War—each of these comprising events of critical significance to Argentina's political life. The occupation of factories began rising in 1964, halting with the onset of a military dictatorship in 1966 and then resurging in periods of democratic opening in the 1970s and, prominently, the 2000s. See María Celia Cortarelo and Fabián Fernandez, "La toma de fábricas, Argentina 1964," working paper 4, Programa de Investigación sobre el Movimiento de la Sociedad Argentina, 1994.

3. Ernesto Ardito and Virna Molina, in discussion with the author and Noa Vaisman, Buenos Aires, Argentina, June 13, 2004. To see a complete list of films projected at Brukman on this date, see "Noticias," *Arte y Confección*, May 26, 2003.

4. Michael Chanan, *Cuban Cinema* (Minneapolis: University of Minnesota Press, 2004), xi.

5. See Marc Ferro, *Cinema and History*, trans. Naomi Greene (Detroit, Mich.: Wayne State University, 1988); and Michel Foucault, "Film and Popular Memory," in *Foucault Live: Interviews, 1961–1984*, ed. Sylvère Lotringer (New York: Seimotext(e), 1996), 89–106.

6. The cold war era saw the Argentine armed forces in power during 1955–58, 1966–73, and 1976–83.

7. A good introduction to political theory of democratization can be found in Jean Grugel's *Democratization: A Critical Introduction* (London: Palgrave Macmillan, 2002).

8. Davide G. Erro, *Resolving the Argentine Paradox, Politics, and Development, 1966–1992* (Boulder, Colo.: Lynne Rienner, 1993), 60. See also María Matilde Ollier, *El fenómino insurreccional y la cultura política (1969–1973)* (Buenos Aires: Centro Editor de América Latina, 1986); María José Moyano, *Argentina's Lost Patrol: Armed Struggle, 1969–1979* (New Haven, Conn.: Yale University Press, 1995); Javier Trímboli, ed., *La izquierda en la Argentina: conversaciones* (Buenos Aires: Manantial, 1998); and Nicolás Casullo, *Peronismo: militancia y crítica, 1973–2008* (Buenos Aires: Colihue, 2008).

9. Clara Kriger, *Cine y peronismo, el estado en escena* (Buenos Aires: Siglo XXI, 2009).

10. Although political filmmaking also occurred in the provinces, skilled laborers and technicians, along with their unions and professional organizations, were and continue to be demographically concentrated in the center of the city of Buenos Aires, as are the offices of distributors and exhibitors, production and editing studios, audiovisual media outlets, and institutions of state regulation and film sponsorship. Although key figures did work in other locations, such as Santa Fe, Córdoba, and Tucumán, most

filmmakers outside Buenos Aires were still closely connected to national-level institutions and organizations headquartered there and to international networks of production and exhibition that viewed them as Argentine, not regional, filmmakers.

11. This terminology was first suggested to me by Seth Fein, to whom I am grateful, who asked whether understanding the nature of "transition film" in the context of Latin America might shed light on the political cinema of countries in Europe going through similar processes of democratization at the end of the cold war. The Indian film scholar Priya Jaikumar deals with a similar idea about film in political transition in his work *Cinema at the End of Empire: A Politics of Transition in Britain and India* (Durham, N.C.: Duke University Press, 2006).

12. For a discussion of cultural transition, see Dilip Parameshwar Gaonkar, ed., *Cultures of Democracy,* special issue of *Public Culture* 19, no. 1 (Winter 2007). For approaches treating film as cultural text, see, e.g., Joanna Page, "Postmodernism, History, and Social Critique in Post-dictatorship Argentine Cinema: A Reading of Eliseo Subiela's 'El lado oscuro del corazón,'" *Modern Language Review* 96, no. 2 (Apr. 2001): 385–403; Kathleen Newman, "Cultural Redemocratization: Argentina, 1978–89," in *On Edge: The Crisis of Contemporary Latin American Culture,* ed. George Yúdice, Jean Franco, and Juan Flores (Social Text Collective) (Minneapolis: University of Minnesota Press, 1992), 161–85; Fernando Reati, "Argentine Political Violence and Artistic Representation in Films of the 1980's," *Latin American Literary Review* 17, no. 34 (July–Dec. 1989): 24–39; Currie K. Thompson, "Against All Odds: Argentine Cinema, 1976–1991," *Post Script* 11, no. 3 (Summer 1992): 32–45; Geoffrey Kantaris, "The Last Snapshots of Modernity: Argentine Cinema after the 'Process,'" *Bulletin of Hispanic Studies* 73, no. 2 (Apr. 1996): 219–44; Christian Gundermann, "The Stark Gaze of New Argentine Cinema," *Journal of Latin American Cultural Studies* 14, no. 3 (Dec. 2005): 241–61.

13. For some of the most important recent contributions to this literature, see Ana Amado, "Ficciones críticas de la memoria," *Pensamiento de los Confines* 13 (Dec. 2003): 54–63; Ana Amado, "Cine argentino: cuando todo es margen," *Pensamiento de los Confines* 11 (Sept. 2002): 87–95; Sergio Wolf, ed., *Cine argentino: la otra historia* (Buenos Aires: Letra Buena, 1992); Sergio Wolf, *Nuevo cine argentino* (Buenos Aires: Paidós, 2002); Raúl Beyceyro, *Cine y fotografía como intervención política,* ed. Susana Sel (Buenos Aires: Prometeo/Museo de Cine, 2007); Fernando G. Varea, *El cine argentino durante la dictadura militar 1976/1983* (Rosario, Argentina: Editorial Municipal de Rosario, 2006); Fernando Martín Peña, ed., *Generaciónes 60/90: cine argentino independiente* (Buenos Aires: Fundación Eduardo F. Costantini, 2003); Mónica Satarain, ed., *Plano secuencia: 20 películas argentinas para reafirmar la democracia* (Buenos Aires: La Crujía, 2004).

14. Francine Masiello, *The Art of Transition: Latin American Culture and Neoliberal Crisis* (Durham, N.C.: Duke University Press, 2001).

15. Dominick LaCapra, *History and Criticism* (Ithaca, N.Y.: Cornell University Press, 1987), 19–20.

16. David Forgacs, *Italian Culture in the Industrial Era, 1880–1980: Cultural Industries, Politics, and the Public* (Manchester, U.K.: Manchester University Press, 1990).

17. See Roger Chartier, "Intellectual History or Sociocultural History? The French Trajectories," in *Modern European Intellectual History: Reappraisals and New Perspectives,* ed. Dominick LaCapra and Stephen Kaplan (Ithaca, N.Y.: Cornell University Press, 1987), 16–17. For a more detailed discussion of this theme, see Elizabeth A. Clark, *History, Theory, Text: Historians and the Linguistic Turn* (Cambridge, Mass.: Harvard University Press, 2004); Dominick LaCapra, *History in Transit: Experience, Identity,*

Cultural Theory (Ithaca, N.Y.: Cornell University Press, 2004); and Willie Thompson, *Postmodernism and History* (New York: Palgrave Macmillan, 2004).

1. CAMERAS IN THE HANDS OF "ANGRY YOUNG MEN": FILMMAKING AND THE CORDOBAZO

1. Biographical information on Raymundo Gleyzer's life was diligently collected by Fernando Martín Peña and Carlos Vallina in the form of oral testimonies from Gleyzer's family, colleagues, and friends and published in *El cine quema: Raymundo Gleyzer* (Buenos Aires: Ediciones de la Flor, 2000). The Uruguayan Cinemateca houses an important collection of papers on Gleyzer's life, and several documents have been collected as part of a human rights case file by the National Commission on the Disappeared (CONADEP), which the following chapter discusses further. In addition to using these wonderful resources, I also relied extensively on the "Raymundo Gleyzer" and "Cine de la Base" folders in the archives of the Museo del Cine Pablo C. Dúcros Hickens. Secondary sources consulted include Maximiliano de la Puente and Pablo Russo, *El compañero que lleva la cámara—cine militante argentino contemporáneo* (master's thesis, ciencias de la comunicación, Facultad de Ciencias Sociales, Universidad de Buenos Aires, 2004); Ana Longoni and Mariano Mestman, *Del Di Tella a "Tucumán Arde": vanguardia artística y política en el '68 argentino* (Buenos Aires: El Cielo por Asalto, 2008); and Valeria Manzano, "Combates por la historia: interpretaciones de la historia del movimiento obrero en el cine militante argentino al principio de los 1970's," *Film and History* 32, no. 4 (2004): 46–57.

2. Pablo Piedras, "*Los traidores*, estilos y estragetias de actuación en el cine politico," *Revista Afuera* 3, no. 4 (May 2008), online journal, http://www.revistaafuera.com/NumAnteriores/pagina.php?seccion=Cine&page=04.Cine.Piedras.htm&idautor=83.

3. James P. Brennan and Marcelo Rougier, *The Politics of National Capitalism: Peronism and the Argentine Bourgeoisie, 1946–1976* (University Park: Pennsylvania State University Press, 2009).

4. Michael Chanan, *Cuban Cinema* (Minneapolis: University of Minnesota, 2004), 13, 196–200.

5. Federico Schuster, "Izquierda política y movimientos sociales en la Argentina contemporánea," in *La nueva izquierda en América Latina, sus orígenes y trayectoria futura*, ed. César A. Rodríguez Garavito, Patrick S. Barrett, and Daniel Chavez (Bogotá: Grupo Editorial Norma, 2004), 241. See also Horacio Tarcus, *Marx en la Argentina: sus primeros lectores obreros, intelectuales y científicos* (Buenos Aires: Siglo XXI, 2007); Roberto Pittaluga, *Catálogo de publicaciones políticas de las izquierdas argentinas, 1890–2000s* (Buenos Aires: CeDInCI, 2000).

6. Silvia Sigal, *Intelectuales y poder en Argentina: la década del sesenta* (Buenos Aires: Siglo XXI, 2002); María Matilde Ollier, *De la revolución a la democracia: cambios privados, públicos y políticos de la izquierda argentina* (Buenos Aires: Siglo XXI, 2009); and Claudia Gilman, *Entre la pluma y el fusil: debates y dilemas del escritor revolucionario en América Latina* (Buenos Aries: Siglo XXI, 2003). For an interesting comparison to the Brazilian case, see Marcelo Ridenti, "Artistas e intelectuais no Brasil pós-1960," *Tempo Social* 17, no. 1 (2005): 81–110. For Mexico and other countries, see Eric Zolov, "Expanding Our Conceptual Horizons: The Shift from an Old to a New Left in Latin America," *A Contracorriente* 5, no. 2 (2008): 47–73; Barry Carr, *Marxism and Communism in Twentieth-Century Mexico* (Lincoln: University of Nebraska Press,

1992); and Massimo Modonesi, *La crisis histórica de la izquierda socialista Mexicana* (Mexico City: Casa Juan Pablos, 2003). For Chile, see Katherine Hite, *When the Romance Ended: Leaders of the Chilean Left, 1968–1998* (New York: Columbia University Press, 2000); and for an overview of Central America, see Carlos Figueroa Ibarra, "Shipwreck and Survival: The Left in Central America," *Latin American Perspectives* 24 (1997): 114–29.

7. Jean Franco, *The Decline and Fall of the Lettered City: Latin America in the Cold War* (Cambridge, Mass.: Harvard University Press, 2002). See also Pablo Ponza, "Comprometidos, orgánicos y expertos: intelectuales, marxismo y ciencias sociales en Argentina (1955–1973)," *A Contracorriente* 5, no. 2 (2008): 74–98.

8. Diana Sorensen, *A Turbulent Decade Remembered: Scenes from the Latin American Sixties* (Stanford, Calif.: Stanford University Press, 2007). For a broad overview of the international 1960s, see Jeremi Suri, *Power and Protest: Global Revolution and the Rise of Détente* (Cambridge, Mass.: Harvard University Press, 2003); Mark Kurlansky, *1968: The Year that Rocked the World* (New York: Ballantine, 2004); Kristin Ross, *May '68 and Its Afterlives* (Chicago: University of Chicago Press, 2002); and Jorge Castañeda, *Utopia Unarmed: The Latin American Left after the Cold War* (New York: Vintage, 1994).

9. Brennan and Rougier, *Politics of National Capitalism,* 10–11.

10. The dictatorship of Onganía, which began in 1966, was only the most recent in a string of modern military subversions of democratic politics that began in 1930 and continued to punctuate the Argentine political landscape at fairly regular intervals thereafter. The industrial working class, which had found a strange bedfellow under the rule of General Juan Perón by the 1950s, had become a strong ally of the populist's program of economic nationalism at the expense of autonomous or left-leaning unions. The Cordobazo pushed Peronist industrial unions, which dominated labor politics from Buenos Aires well after Perón fled to Spain, to their breaking point.

11. Ernesto Salas, *Uturuncos: el origen de la guerrilla peronista* (Buenos Aires: Biblos, 2003).

12. Raúl Burgos, *Los gramscianos argentinos: cultura y política en la experiencia de "Pasado y Presente"* (Buenos Aires: Siglo XXI, 2004).

13. Oscar Anzorena, *Tiempo de violencia y de utopia (1966–1976)* (Buenos Aires: Contrapunto, 1988), 19–26.

14. James Brennan, *The Labor Wars in Córdoba, 1955–1976* (Cambridge, Mass.: Harvard University Press, 1994), 103. See also Juan Carlos de Pablo, *Política antiinflacionaria en la Argentina, 1967–1970* (Buenos Aires: Amorrortu, 1990), 32–33.

15. Davide G. Erro, *Resolving the Argentine Paradox: Politics and Development, 1966–1992* (Boulder, Colo.: Lynne Rienner, 1993), 53–55.

16. Guillermo O'Donnell, *Bureaucratic Authoritarianism: Argentina, 1966–1973, in Comparative Perspective,* trans. James McGuire (Berkeley: University of California Press, 1988), 179.

17. For more on la noche de los bastones largos, see Sergio Morero, Ariel Eidelman, and Guido Lichtman, *La noche de los bastones largos,* 2d ed. (Buenos Aires: Latinoamericana, 2002); Eduardo Anguita, *La voluntad: una historia de la militancia revolucionaria en la Argentina, 1973–1976,* 2d ed. (Buenos Aires: Grupo Editorial Norma, 1998); and Oscar Terán, "La década del 70: la violencia de las ideas," *Revista Lucha Armada* 2, no. 5 (2006): 24–38.

18. *Arte y política en los '60* (Buenos Aires: Fundación Banco Ciudad, 2002), an eponymous catalog for an exhibition in the Palais de Glace, curated by Alberto Giudici, that ran from September 20 through October 27, 2002.

19. Longoni and Mestman, *Del Di Tella,* 87–92.

20. Ibid.

21. For more detailed discussion of these events, see Brennan, *Labor Wars*; Ana Julia Ramírez, "Tucumán 1965–1969: movimiento azucarero y radicalización política," *Nuevo Mundo/Mundos Nuevos* (July 12, 2008), available at http://nuevomundo.revues.org/index38892.html; Elipdio Torres, *El Cordobazo organizado, la historia sin mitos* (Buenos Aires: Catálogos, 1999); Juan Carlos Cena, ed., *El Cordobazo, una rebelión popular* (Buenos Aires: La Rosa Blindada, 2000); Beba C. Balvé and Beatriz S. Balvé, *El '69: huelga política de masas—rosariazo, cordobazo, rosariazo* (Buenos Aires: Razón y Revolución/CISCO, 2005); María Matilde Ollier, *La creencia y la pasión: privado, público y político en la izquierda revolucionaria* (Buenos Aires: Ariel, 1998); Daniel James, *Resistance and Integration: Peronism and the Argentine Working Class, 1946–1976* (New York: Cambridge University Press, 1988); Ruth Werner and Facundo Aguirre, *Insurgencia obrera en la Argentina, 1969–1976* (Buenos Aires: Ediciones Instituto del Pensamiento Socialista Karl Marx, 2007); Christian Petralito and Alberto Alderete, *De agosto a diciembre de 1972: Trelew, historia de una masacre y la organización popular como respuesta* (Buenos Aires: Nuestra America, 2007); Pablo Pozzi and Alejandro Schneider, *Los setentistas: izquierda y clase obrera: 1969–1976* (Buenos Aires: Eudeba, 2000).

22. Oscar Terán, *Nuestros anos sesenta* (Buenos Aires: El Cielo por Asalto, 1993), 97.

23. Jorge Canelles, "Muere la dictadura: la lucha continua," in *El Cordobazo*, ed. Cena, 75.

24. Ibid.

25. Cachulín Alvarez, "Simplemente, acaté el paro active," in *El Cordobazo*, ed. Cena, 123.

26. Brennan, *Labor Wars*, 152.

27. James P. Brennan and Monica Gordillo, "Working Class Protests, Popular Revolt, and Urban Insurrection in Argentina: The 1969 Cordobazo," *Journal of Social History* 27, no. 3 (Spring): 477–98.

28. Maurice Halbwachs, *On Collective Memory*, trans. Lewis A. Coser (Chicago: University of Chicago Press, 1992), 40, 182.

29. Valeria Manzano, "Combates por la historia: interpretaciones de la historia del movimiento obrero en el cine militante argentine al principio de los 1970s," *Film and History* 34, no. 2 (2004): 46–57.

30. Michael Goebel, "A Movement from Right to Left in Argentine Nationalism? The Alianza Libertadora Nacionalista and Tacuara as Stages of Militancy," *Bulletin of Latin American Research* 26, no. 3 (2007): 366.

31. Mirta Varela, "Media History in a 'Peripheric Modernity': Television in Argentina 1951–1969," *Westminster Papers in Communication and Culture* 4, no. 4 (2007): 96, 100.

32. The first film that was later attributed to this genre was Claudio Martínez Payva's work *Ya tiene comisario el pueblo* (The people already have a commissary), released in 1936. The label "cine social" as that of a genre, however, came only after recognition of a veritable film movement, by mid-1938 (Domingo di Núbila, *Historia del cine argentino*, 2 vols. [Buenos Aires: J. Héctor Matera, 1959–60], 1:194).

33. Ibid.

34. "El tema social en el cine Argentino," *Dinamis*, December 1969, pp. 40–47.

35. Gustavo Cabrera, *Hugo del Carril: un hombre de nuestro cine* (Buenos Aires: Ediciones Culturales Argentinas, 1989), 31.

36. In 1956, in the wake of the Revolución Libertadora, the first explicitly anti-Peronist films were produced. The first, *Después del silencio* (*After the Silence*), by veteran director Lucas Demare, was written by Sixto Pondal Ríos and denounced the

most notorious of abuses of power conducted under Perón's presidency. The subject of the film is the detention of a worker, his subsequent torture, his eventual exile, and the persecution of his family. In a semidocumentary style, the film recounts the most criminal offenses of the regime without mentioning the proper names of any of the perpetrators and without insulting the general himself. According to the film historian Domingo di Núbila, the film "participated in a moment of public vehemence and outcry, within which it contributed to a common currency of ideas and language" (di Núbila, *Historia del cine argentino*, 2:211).

37. Cabrera, *Hugo del Carril*, 186.

38. The Italian film genre of *neorealismo* emerged during World War II. Its primary characteristic is the representation of the daily lives of ordinary people. Directors working in the genre often employed nonprofessional actors, following individuals during their quotidian activities to reveal the miserable conditions of the lower classes.

39. Tzvi Tal, *Pantallas y revolución: una visión comparativa del Cine de Liberación y el Cinema Novo* (Buenos Aires: Lumière, 2005), 62.

40. Fernando Birri, "Manifesto," in *Twenty-five Years of the New Latin American Cinema,* ed. Michael Chanan (London: British Film Institute, 1983), 24–36.

41. Emilio Bernini, "Politics and the Documentary Film in Argentina during the 1960s," *Journal of Gender Studies* 13, no. 2 (2004): 155.

42. For an example of this anticolonialism and the language associated with it, see Frantz Fanon, *The Wretched of the Earth,* trans. Richard Philcox (New York: Grove, 2004).

43. Fernando Solanas and Octavio Getino, "Towards a Third Cinema: Notes and Experiences for the Development of a Cinema of Liberation in the Third World," in *New Latin American Cinema,* vol. 1, ed. Michael Martin (Detroit, Mich.: Wayne State University Press, 1997), 33–58; and Glauber Rocha, "An Esthetic of Hunger," in ibid., 71–85.

44. Glauber Rocha, "History of Cinema Novo," in *New Latin American Cinema,* vol. 1, ed. Michael Martin (Detroit, Mich.: Wayne State University Press, 1997), 272–94.

45. "Editorial," *Cine al Día* (Caracas), December 6, 1968, p. 2.

46. Octavio Getino, "Some Notes on the Concept of a Third Cinema," in *New Latin American Cinema,* vol. 1, ed. Michael Martin (Detroit, Mich.: Wayne State University: 1997), 99–107.

47. Cecily Marcus, "The Molecular Intellectual: Cultural Magazines and Clandestine Life under Argentina's Last Dictatorship" (PhD diss., University of Minnesota, 2005).

48. Di Núbila, *Historia del cine argentino,* 1:174.

49. See Lee Grieveson and Haidee Wasson, eds., *Inventing Film Studies* (Durham, N.C.: Duke University Press, 2008).

50. Paula Félix-Didier, "La crítica de cine en los 60," in *Generaciones 60/90: cine independiente argentino,* ed. Fernando Martín Peña (Buenos Aires: Fundación Eduardo F. Constantini, 2003), 328–35.

51. Mariano Mestman, "From Algiers to Buenos Aires: The Third World Cinema Committee (1974–1974)," *New Cinemas: Journal of Contemporary Film* 1, no. 1 (2002): 40–53.

52. "Third World Cinématèque" folder, Museo del Cine Pablo C. Dúcros Hickens.

53. This group was highly critical of more traditional branches of Peronism, claiming that they had become corrupt and had failed to advance underclass interests. In the Revolutionary Workers Party, Gleyzer came into contact with other political filmmakers who helped him advance his career, including fellow sympathizer Jorge Cedrón.

54. Tal, *Pantallas y revolución*, 80–81.

55. "Definidas pautas para romper dependencias culturales en un proyecto de ley fílmica," *La Opinión*, May 27, 1973, p. 17.

56. "Cine Liberación: revertir la tendencia," *Primera Plana*, April 18, 1968, pp. 44–45.

57. Fernando Martín Peña, *El cine quema: Jorge Cedrón* (Buenos Aries: Altamira, 2003), 90.

58. Juan Perón to Grupo Cine Liberación, March 10, 1971, "Cine Liberación" folder, Museo del Cine Pablo C. Dúcros Hickens. See also "Solanas y Perón, Cine Liberación," *Primera Plana*, July 27, 1971, pp. 13–14.

59. *Argentina, mayo de 1969* was a collaborative effort by Solanas, Getino, Jorge Cedrón, and Eliseo Subiela. Other films made in this style include *Informes y testimonios: la tortura política en la Argentina, 1966–1972*, directed by an associated film collective formed at the Escuela de Cine de La Plata, and *Alianza para el progreso*, by Julio Ludueña.

60. "El grupo Cine y Liberación quiere abolir el desencuentro entre pueblo y cultura," *Clarín*, January 18, 1973, sect. "Espectaculos," p. 6; "El Grupo Cine Liberación pasa de la clandestinidad a la exhibición pública," *La Opinión*, January 24, 1973, sect. "Cultura y espectáculos."

61. It was thought that all copies of this film were destroyed during the period of the military dictatorship of 1976–83, but recently, it was discovered that the ICAIC, the Cuban film institute, preserved a copy. Fernando Kirchmar, a member of the Grupo Cine Insurgente, brought back a copy of the film to Argentina in 2007 and exhibited it in the MALBA to a sold-out audience. See Ana Bianco, "La militáncia en imagenes," *Página/12*, August 25, 2007, sect. "Cultura y espectáculos," p. 1.

62. Stuart Hall, "Cultural Identity and Cinematic Representation," *Framework 36* (1989): 68–82.

2. FILMMAKERS INTO FILM WORKERS: PERONISM, DICTATORSHIP, AND THE FILM INDUSTRY

1. Marcos Novaro and Vicente Palermo, *La dictadura militar* (Buenos Aires: Paidós, 2003), 73.

2. Cecily Marcus, "The Molecular Intellectual: Cultural Magazines and Clandestine Life under Argentina's Last Dictatorship" (PhD diss., University of Minnesota, 2005), 205.

3. The series of events from 1976 to 1983 is certainly framed by the mention of national security doctrine; the intercontinental struggle against the evils of communism; the example of other military regimes in Brazil, Uruguay, and Chile; and the context of the cold war. Nevertheless, these frames are debatably not the pretext for what was to occur specifically in the case of Argentina. And despite later repudiation, there was a large consensus that the military took this initiative in good faith.

4. Comisión Argentina por los Derechos Humanos, *Argentina: proceso al genocidio* (Madrid: Elias Querejeta, 1977).

5. Marguerite Feitlowitz, *Lexicon of Terror: Argentina and the Legacies of Torture* (London: Oxford University Press, 1998), 12.

6. CELS Centro de Documentación, *The Pattern of Detentions and Disappearances, 1971–1983* (Buenos Aires: Centro de Estudios Legales y Sociales, 1985).

7. Maximiliano Ignacio de la Puente and Pablo Mariano Russo, "El compañero que lleva la cámara—cine militante argentino contemporáneo" (thesis, Universidad de Buenos Aires, 2004).

8. Guillermo O'Donnell, *Bureaucratic Authoritarianism: Argentina, 1966–1973*, in *Comparative Perspective,* trans. James McGuire (Berkeley: University of California Press, 1988), 32.

9. Marta Castiglione, *La militarización del estado en la Argentina (1976/1981)* (Buenos Aires: Centro Editor de América Latina, 1992), 14.

10. For additional discussion of U.S. foreign policy in the 1960s and early 1970s, see Gerard T. Rice, *The Bold Experiment: JFK's Peace Corps* (Notre Dame, Ind.: University of Notre Dame Press, 1985); Elizabeth Cobbs Hoffman, *All You Need Is Love: The Peace Corps and the Spirit of the 1960s* (Cambridge, Mass.: Harvard University Press, 1998); Michael E. Latham, *Modernization as Ideology: American Social Science and "Nation Building" in the Kennedy Era* (Chapel Hill: University of North Carolina Press, 2000); Stephen G. Rabe, *The Most Dangerous Area in the World: John F. Kennedy Confronts Communist Revolution in Latin America* (Chapel Hill: University of North Carolina Press, 1999); Daniela Spencer and Gilbert M. Joseph, eds., *In from the Cold: Latin America's New Encounter with the Cold War* (Durham, N.C: Duke University Press, 2007); and Greg Grandin, *The Last Colonial Massacre: Latin America in the Cold War* (Chicago: University of Chicago Press, 2004).

11. Sebastián Barros, *Orden, democracia y estabilidad* (Córdoba, Argentina: Alción, 2002), 38.

12. Castiglione, *La militarización del estado,* 21–23. See also David Pion-Berlin, "The National Security Doctrine, Military Threat Perception, and the 'Dirty War' in Argentina," *Comparative Political Studies* 21, no. 3 (1988): 382–407.

13. Feitlowitz, *Lexicon of Terror,* 31.

14. John Beasley-Murray, "Peronism and the Secret History of Cultural Studies: Populism and the Substitution of Culture for State," *Cultural Critique* 39 (Spring 1998): 196; Matthew B. Karush, "The Melodramatic Nation: Integration and Polarization in the Argentine Cinema of the 1930s," *Hispanic American Historical Review* 87, no. 2 (May 2007): 293–326. The German philosopher G. W. F. Hegel was among the first to introduce the idea of the Other as a constituent in self-consciousness. His ideas were further developed by, among many others, Jacques Lacan, Michel Foucault, Jacques Derrida, Simone de Beauvoir, Jean-Paul Sartre, and Edward Said. For a discussion of Peronist emergent identities, see John Beasley-Murray, "Peronism and the Secret History of Cultural Studies: Populism and the Substitution of Culture for State," *Cultural Critique* 39 (Spring 1998): 189–217; Matthew B. Karush, "The Melodramatic Nation: Integration and Polarization in the Argentine Cinema of the 1930s," *Hispanic American Historical Review* 87, no. 2 (May 2007): 293–326.

15. An excellent introduction to the legacy of Peronism and its relationship to the military can be found in Tomás Eloy Martínez's historically based novel *Santa Evita* (New York: Vintage, 1997).

16. Alfredo Mason, *Sindicalismo y dictadura: una historia poco contada, 1976–1983* (Buenos Aires: Biblos, 2007), 21–39.

17. For more information on political upheaval during period, see Liliana de Riz, *La política en suspenso, 1966–1976* (Buenos Aires: Paidós, 2000); Luis E. Duhalde, *El estado terrorista argentino: quince años después, una mirada crítica* (Buenos Aires: Eudeba 1999); María Laura Lenci, "Cámpora al gobierno, Perón al poder: la tendencia revolucionaria del peronismo antes de las elecciones del 11 de marzo de 1973," in *La*

primacía de la política, ed. Alfredo Pucciarelli (Buenos Aires: Eudeba 1999), 167–201; Silvia Sigal and Eliseo Verón, *Perón o muerte: los fundamentos discursivos del fenómeno peronista* (Buenos Aires: Legasa, 1986); Horacio Verbitsky, *Ezeiza* (Barcelona: Debolsillo, 2007); and Hugo Vezzetti, *Pasado y presente: guerra, dictadura y sociedad en Argentina* (Buenos Aires: Siglo XXI, 2002).

18. The question of armed struggle was particularly divisive for the left in Argentina after Perón's exile in the 1970s. For a more in-depth description of the variety of factions within militant and radical Peronism, see Juan Eugenio Corradi, "Argentina and Peronism," *Latin American Perspectives* 1, no. 3 (1974): 3–20. See also María José Moyano, *Argentina's Lost Patrol: Armed Struggle, 1969–1979* (New Haven, Conn.: Yale University Press, 1995).

19. Raúl Burgos, *Los gramscianos argentinos: cultura y política en la experiencia de "Pasado y presente"* (Buenos Aires: Siglo XXI, 2004), 169–83.

20. Verbitsky, *Ezeiza*.

21. Ruth Werner and Facundo Aguirre, *Insurgencia obrera en la Argentina, 1969–1976* (Buenos Aires: Ediciones Instituto del Pensamiento Socialista Karl Marx, 2007), 147–65.

22. Ibid.

23. Maria Seoane and Vicente Muleiro, *El dictador: la historia secreta y publica de Jorge Rafael Videla* (Buenos Aires: Sudamericana, 2001), 223.

24. Amnesty International, *Report of an Amnesty Mission to Argentina: 6–15 November 1976* (London: Amnesty International, 1977).

25. César Maranghello, *Breve historia del cine argentino* (Barcelona: Laertes, 2005), 111–16.

26. For one of the best works on the development of Perón's interventionist politics, see David Rock, *Authoritarian Argentina* (Berkeley: University of California Press, 2005).

27. Maranghello, *Breve historia*, 113.

28. Ibid., 62.

29. Apold's handling of the relationship of the film industry and the state was in large part to blame for increasingly deleterious production conditions. In March 1949 Apold was named the secretary of the press and broadcasting, in which office he was able to pass various reforms to the initial cinema legislation from 1944, Ley 12.999, creating Ley 13.651. These new laws added additional layers of centralization by legislating how funds would be collected and redirected to support national film.

30. Domingo di Núbila, *Historia del cine argentino*, 2 vols. (Buenos Aires: J. Héctor Matera, 1959–60), 2:144–45. Original text: "Pareciera que la protección oficial sólo estimuló el aumento en número de películas, pero no en calidad. . . . Los quebrantos que [nuestros productores] han sufrido o sufren algunas empresas son debidos a mala organización, frondosos presupuestos administrativos, mala comercialización de las películas y mala calidad de las mismas. . . . Los mercados exteriores se conquistan y se mantienen a base de competencia, de calidad en las películas, de espíritu comercial y de propaganda, y nuestros productores han descuidado últimamente todos esos factores."

31. Ibid., 2:161.

32. Maranghello, *Breve historia*, 116.

33. Anahí Ballent, *En las huellas de la política: vivienda, ciudad, y peronismo en Buenos Aires, 1943–1955* (Quilmes, Argentina: Editorial de la Universidad Nacional de Quilmes, 2005), 33.

34. Sindicato de la Industria Cinematográfica Argentina (SICA), *40 aniversario* (Buenos Aires: SICA, September 1998), 3.

35. Mario Lopez Barreiro, secretary general of SICA, in discussion with the author, June 2004.

36. SICA, *40 aniversario*, 4.

37. The term *compañero/a*, which means "companion" or "colleague," was frequently used by members of leftist political organizations in Argentina. Much like the term *comrade* as used by English-speaking leftists, it indicated equality of status and participation in a common cause, often as a means of negating the typical boundaries between members from radically different socioeconomic backgrounds. Eva Duarte had been attacked by the AGICA for her conduct as an actress on the set, and speculation remains that this offense partially stimulated the creation of a new union. See "Una actitud inadmisible," *AGICA,* October 1945, p. 3.

38. The CGT was responsible for convening the marches on the Plaza de Mayo, first to demand Perón's release from prison in 1945 and then to demand that he be allowed to return from abroad after the military's so-called Revolución Libertadora in 1955.

39. SICA, *40 aniversario*, 9.

40. Mario Lopez Barreiro, in discussion with the author, June 2004; SICA, *40 aniversario*, 13.

41. Mar del Plata, Argentina, *Boletín municipal*, 1954, p. 112. See also Elisa Pastoriza and Juan Carlos Torre, "Mar del Plata, un sueño de los argentinos," in *Historia de la vida privada en la Argentina,* 3 vols., ed. Fernando Devoto and Marta Madero (Buenos Aires: Taurus, 1999), 3:67–68.

42. In fact, the town's facilities already had begun to be remarketed for working-class consumption. Perón's speech alluded to the many resort facilities that unions and Catholic organizations had built to serve the leisure demands of their constituencies in the previous decade, largely as a result of the economic prosperity of the postwar industrial climate. By 1954 the Fundación Eva Perón had also begun to administer vacation centers in the city that rented out rooms, acting as pensions and hotels for the summer season. The slogan of the governor of the province of Buenos Aires was, "You pay the passage, and the province pays the lodging." See Pastoriza and Torre, "Mar del Plata," 69.

43. Perón's inauguration of the festival in Mar del Plata at first negated the fact that for almost twenty years the same festival had taken place in Buenos Aires. This reflects a representative case of Peronist rewriting of history, erasing the festival's past to claim more symbolic territory as an accomplishment of the regime.

44. Graciela Zuppa, "Plazas: lecturas de huellas y registros," in *Mar del Plata: ciudad e historia de Buenos Aires,* ed. Fernando Cacopardo (Mar del Plata, Argentina: Alianza, 1997). See also Clara Kriger, *Cine y peronismo: el estado en escena* (Buenos Aires: Siglo XXI, 2009), 203–39.

45. See material in the folder labeled "Solicitadas," at the Museo de Cine Pablo C. Ducrós Hicken.

46. "Una demora de senadores y el cine argentino," *Correo de la Tarde,* February 16, 1960.

47. "El gremio cinematográfico respondió con UN SI," *La Nación,* July 11, 1957.

48. Valeria Manzano, "Trabajadores en celuloide: representaciones de los trabajadores urbanos en el cine argentino, 1933–1999" (thesis, Universidad de Buenos Aires, October 2002).

49. SICA, *40 aniversario*, 29. The riotous demonstration, according to the union's report, demanded that *La bestia humana* (The human beast [1957]) and *La casa del angél* (The house of the angel [1959]), films by Daniel Tinyare and Leopoldo Torre Nilsson, respectively, be treated fairly under the terms stipulated by the new cinema law, Ley 62/57.

50. Anibal di Salvo, "Interview," *SICA*, September 1998, pp. 29.

51. The city of Buenos Aires already had a long history of radical activism associated with labor movements, expanding from strikes and demonstrations to include violence, vandalism, and sometimes occupations. Important proponents of leftist ideology were well rooted in the early twentieth century in the city, including important organizations of anarcho-syndicalists, communists, socialists, and many republicans who fled to Argentina during the Spanish Civil War. For an excellent overview of the political history of the left during the first half of the century, see José Luis Romero, *Las ideas políticas en Argentina* (Buenos Aires: Fondo de Cultura Económica, 2005); Tulio Halperín Donghi, *La Argentina y la tormenta del mundo: ideas e ideologías entre 1930 y 1945* (Buenos Aires: Siglo XXI, 2003); Juan Suriano, *Anarquistas: cultura y política libertaria en Buenos Aires* (Buenos Aires: Manantial, 2001); Raanan Rein and Rosalie Sitman, eds., *El primer peronismo: de regreso a los comienzos* (Buenos Aires: Lumière, 2005); and Daniel James, *Resistance and Integration: Peronism and the Argentine Working Class* (London: Cambridge University Press, 1994). For a collection of primary documents from 1943 to 1973, see Carlos Altamirano, *Bajo el signo de las masas* (Buenos Aires: Ariel, 2001).

52. Emilio Bernini, "Politics and the Documentary Film in Argentina during the 1960s," *Journal of Latin American Cultural Studies* 13, no. 2 (2004): 155–70.

53. María Elena de las Carreras de Kuntz, "El cine político durante el Proceso," *Foro Político* 22 (Apr. 1998): 29–51.

54. "Ahora nuestro país puede afrontar la producción de películas, dice el Instituto Nacional del Cine," *El Mundo*, November 26, 1958, p. 19; "Cometido del Instituto de la Cinematografía," *La Nación*, November 25, 1958, p. 15.

55. César Maranghello, "Del proyecto conservador a la difusión peronista," in *Cine argentino: industria y clasicismo, 1933–1956*, vol. 2, ed. Claudio España (Buenos Aires: Fondo Nacional de las Artes, 2000), 156–59.

56. See "Problemas del cine argentino y el Instituto Nacional del Cine," *La Prensa*, February 11, 1961; "Fue intervenido el Instituo Nacional de Cinematografía," *La Razón*, September 20, 1963; "Se ratificó el acuerdo del cine nacional," *La Nación*, August 28, 1963; "Formula declaraciones el presidente del Instituto del Cine," *La Prensa*, August 27, 1963; "El interventor en el Instituto del Cine asumió ayer su cargo," *La Prensa*, September 24, 1963; "Recurso por la intervención a un organismo," *La Nación*, September 29, 1963; "Entregáronse los premios del cine nacional," *La Nación*, December 30, 1963; "Recurso de amparo del presidente del Instituto de Cinematografía," *La Prensa*, August 31, 1963; "Variase intervenido el Instituto de Cine," *La Prensa*, September 18, 1963; "Algunos problemas del cine argentino fueron analizados," *La Nación*, November 18, 1965.

57. "Informó sobre su labor el Instituto Nacional de Cinematografía," *La Prensa*, November 25, 1958.

58. "La nueva ley de cine protegerá a todo tipo de films que no dé la espalda al público, afirmó el nuevo administrador del Instituto de Cinematografía," *La Razón*, January 10, 1967. See also "Es inminente la aprobación de una nueva ley para el cine," *La Nación*, August 5, 1967.

59. "La racionalización de radios, TV, cinematografía y turismo," *La Nación*, August 1, 1967.

60. "Espectáculos: el incendio y sus vísperas," *Confirmado*, August 10, 1967, pp. 60–63.

61. "Hay verdadera conmoción en el ámbito cinematográfico," *La Razón*, December 27, 1968.

62. The stipulations of the Rating Entity were outlined in article 2 of Ley 18.019, which stated that scenes and films would be prohibited if they promoted adultery; opposed the institutions of marriage or the family; presented lascivious or morally repugnant scenes; apologized for crimes or misdemeanors; justified abortion, prostitution, or sexual perversity; affected national security; or were simply unpatriotic. See "Se dio a conocer la nueva ley del cine," *La Razón,* December 27, 1968.

63. "Espectáculos: el incendio y sus vísperas."

64. Ibid.

65. "Instituto de Cinematografía," *Clarín,* January 27, 1972.

66. "Quinto ordenamiento jurídico en 30 años que coincide con la decadencia, agonía y muerte del cine nacional," *La Opinión,* October 22, 1971, p. 19.

67. Ricardo García Oliveri, "Ojos vendados," *Clarín,* March 24, 2001, sect. "Espectáculos," pp. 11–12.

68. "Apoyo oficial para la industria del cine," *La Razón,* May 20 1981, p. 12.

69. Juan Eugenio Corradi, "Argentina and Peronism," *Latin American Perspectives* 1, no. 3 (1974): 3–20. See also Moyano, *Argentina's Lost Patrol.*

70. Fernando Martín Peña, *El cine quema: Jorge Cedrón* (Buenos Aires: Altamira, 2003), 122–25.

71. "Optimas recaudaciones obtiene la producción local," *La Opinión,* September 5, 1970.

72. See folders labeled "SICA" and "Censura," Museo del Cine Pablo C. Dúcros Hickens, Buenos Aires. These claims are further supported by interviews that Fernando Martín Peña and Carlos Vallina conducted with former film students and participants in these movements, some of which are reprinted in their compilation *El cine quema: Raymundo Gleyzer* (Buenos Aires: Ediciones de la Flor, 2000).

73. Tim Barnard, *Argentine Cinema* (Toronto: Nightwood, 1986), 159.

74. García Oliveri, "Ojos vendados," 11–12.

75. CONADEP, *Nunca más* (1985; repr., Buenos Aires: Eudeba, 2006). Correspondence and documents of the Gleyzer family were also made available to the Cinemateca Uruguaya for the compilation of a book entitled *Raymundo Gleyzer* (Montevideo: Cinemateca Uruguaya, 1985). Some of this material is also available in photocopy in the "Raymundo Gleyzer" folder at the Museo del Cine Pablo C. Dúcros Hickens, Buenos Aires.

76. SICA, *40 aniversario,* 44.

77. Open letter from Héctor Taldi on behalf of the Comité Permanente en Defensa y Promoción del Cine Argentino, November 8, 1979, in the folder labeled "Producción" at the Museo del Cine Pablo C. Dúcros Hickens, Buenos Aires.

78. "La Situación por la cual está atravesando el cine argentino fue expuesta por el Comité de Defensa y Promoción ante el Secretario de Información," *La Razón,* November 14, 1979. See also "Cine nacional: una audiencia," *Clarín,* November 14, 1979, sect. "Espectáculos," p. 8.

79. SICA, *40 aniversario,* 43.

80. "Cine argentino: el rechazo a un proyecto," *Clarín,* September 30, 1980.

81. "Inquieta al medio cinematográfico la supresión del impuesto a las entradas," *Convicción,* September 30, 1980.

82. "Por el mañana del cine nacional," *Clarín,* December 17, 1980.

83. "Cine abierto," *La Nación,* December 13, 1981.

84. *Redacción,* suplemento cultural, May 1981, pp. xv–xiii.

85. "Demandan al Instituto de Cine 2 alumnos expulsados," *Clarín,* August 19, 1982.
86. "Córtenla con la censura," *Revista la semana,* July 29, 1982.
87. "Contra la censura," *Diario Popular,* August 4, 1982.

3. THE SCENE AND THE CITY: CODED LANDSCAPES AND COLLECTIVE MEMORY IN TRANSITION

1. Davide G. Erro, *Resolving the Argentine Paradox: Politics and Development, 1966–1992* (Boulder, Colo.: Lynne Rienner, 1993), 126–29.
2. Claudia Feld describes this phenomenon as a memory "boom." She chronicles the explosion of monumentalizing projects, extensive media coverage, and the unprecedented commercial success of "survivor" testimonies of the dictatorship beginning in 1995 in *Del estrado a la pantalla: las imágenes del juicio a los ex comandantes en Argentina* (Madrid: Siglo XXI/Social Science Research Council, 2002).
3. Susan Koshy, "From Cold War to Trade War: Neocolonialism and Human Rights," *Social Text* 58 (Spring 1999): 1–32.
4. Alfonsín's moderate Radical Party, the Unión Cívica Radical, had been elected partially because of a perceived failure of Peronism, giving Alfonsín an edge over the Peronist Justicialist Party's candidates. This meant that Alfonsín's was the party of default, not one elected solely on the merits of its campaign platform. That being the case, the Justicialist Party still retained a large number of seats in Congress and frequently presented obstacles to the Radical agenda for the transition. Generally, all parties asserted a certain set of structural and institutional reforms to implement the return to civilian rule, but Alfonsín's presidency also needed to establish his party's credibility to enable its longevity in office.
5. Martin Heidegger, *Vorträge und Aufsätze* (Pfullingen, Germany: Günter Neske, 1954). For an excellent French translation, see Heidegger, *Essais et conferences: Vorträge und Aufsätze,* trans. André Préau (Paris: Gallimard, 1958).
6. Martin Heidegger, "The Question of Technology," in *The Question Concerning Technology and Other Essays,* trans. William Lovitt (New York: Harper and Row, 1977), 3–35.
7. Leopoldo Bravo, "El motín de Pascuas y la reconciliación nacional," *La Nación,* May 8, 1987.
8. The Radical Party, typically supported by a self-defined middle class and the traditional opposition to Peronism, usually campaigned on platforms of economic liberalism and social democracy, neither of which were particularly in favor in the postdictatorship political climate. The election of Alfonsín as a Radical Party candidate did not mark a lack of large-scale support for the Peronist Justicialist Party. During the concurrent provincial elections, twelve of the twenty-two national provinces elected members of the Justicialist Party to governorships. Of the remaining, eight provinces elected Radical candidates. Of the twelve provinces favoring the Justicialist Party locally, half of them elected Radical Party candidates to the House of Representatives. This meant that the House of Representatives had a Radical majority, but only by a slim margin of 129 to 111. Thus, despite the profound divides between the two parties on ideological lines, they often competed for and represented the same constituencies. See Maria Laura San Martino de Dormí, *Argentina contemporáneo: de Perón a Menem* (Buenos Aires: Ciudad Argentina, 1996), 1028–29.

9. Roberto Ortiz de Zárate, *Raúl Alfonsín* (Barcelona: Fundación CIDOB, 2006), report available at http://www.cidos.org/es/documentacio/biografias_lideres_politicos/america_del_sur/argentina/raul_alfonsin (accessed Oct. 12, 2011).

10. This internal party movement was called the Movement for Intransigence and Renovation. For a more detailed analysis of the political climate of this transition period, see David Pion-Berlin, "To Prosecute or to Pardon? Human Rights Decisions in the Latin American Southern Cone," *Human Rights Quarterly* 15 (1993): 105–30; Pion-Berlin, "Between Confrontation and Accommodation: Military and Government Policy in Democratic Argentina," *Journal of Latin American Studies* 23, no. 3 (1991): 543–71; Colin Lewis and Nissa Torrents, eds., *Argentina in the Crisis Years, 1983–1990: From Alfonsín to Menem* (London: Institute of Latin American Studies, 1991); Elizabeth Jelin, "The Politics of Memory: The Human Rights Movement and the Construction of Democracy in Argentina," *Latin American Perspectives* 21, no. 81 (1994): 38–58; Jelin, *Los trabajos de la memoria* (Madrid: Siglo XXI/Social Science Research Council, 2002); Alison Brysk, *The Politics of Human Rights in Argentina: Protest, Change and Democratization* (Stanford, Calif.: Stanford University Press, 1994); Carlos Acuña et al., *Juicio castigos y memorias: derechos humanos y justicia en la política* (Buenos Aires: Edhasa, 1995); Lindsay Dubois, "Torture and Construction of an Enemy: The Example of Argentina 1976–1983," *Dialectical Anthropology* 15, no. 4 (1990): 317–28.

11. In the brief return to democracy in 1958, he returned to politics and was elected provincial *diputado*, or representative; in 1963, while serving in that office, he was elected to Congress. When General Onganía assumed office in 1966 following a military coup, Alfonsín retired from Congress and returned to practicing law. From 1963 to 1973, he served as the party's president, and he ran for the presidency for the first time in 1973, after Onganía's military successors stepped down. When he ran again in 1983, it was crucial for his presidency's success that his public image be one of confrontation and not collaboration with the military officials leaving office. During the 1970s, Alfonsín was responsible for promoting social democratic policies within the party and formed a movement within the party to distance it from Peronism.

12. Brysk, *Politics of Human Rights,* 75–80.

13. Ortiz de Zárate, *Raúl Alfonsín.*

14. The Pact of San José was passed into law as Ley 23.054. This pact had not been signed by Onganía at the time of its writing and was ignored by subsequent administrations. The United Nations decree was passed into law as Ley 23.338.

15. In addition, the House of Representatives selected three representatives, the Ministry of the Interior provided logistical support, and the judiciary provided clerical staff. These members worked for the commission *ad honorem* and were assisted by no fewer than 100 representatives of NGOs who volunteered their services. The Teatro General San Martín, located in one of the most important municipal cultural centers in the heart of the theater district of Buenos Aires, was the locus of the commission's organization and activity.

16. Eduardo Rabossi, "La comisión nacional sobre la desaparición de personas: una experiencia argentina," public report by member of CONADEP (Buenos Aires, 1989), later published in *Actas del XV Congreso Interamericano de Flilosofía* (Lima: Pontificia Universidad Católica de Perú, 2004). See also Emilio Crenzel, "Las fotografías del *Nunca más*: verdad y prueba jurídica de las desapariciones," in *El pasado que miramos: memoria e imagen ante la historia reciente,* ed. Claudia Feld and Jessica Stites Mor (Buenos Aires: Paidós, 2009), 281–314.

17. Eventually, because the scope of abuses being investigated was vast, CONADEP set up additional offices in the cities of Córdoba, Mar del Plata, Rosario, and Bahía Blanca. See San Martino de Dromi, *Argentina contemporanea*, 1067–72, 1169–74.

18. Crenzel, "Fotografías del *Nunca más*," 281–314.

19. Marcelo Roniger and Leandro Kierszenbaum, "Los intelectuales y los discursos de derechos humanos en el Cono Sur," *Estudios Interdisciplinarios de America Latina y el Caribe* 16, no. 2 (June–Dec. 2005): 5–26, available at http://www.tau.ac.il/eial/current/roniger.html. See also Beatriz Sarlo, "El campo intelectual: un espacio doblemente fracturado," in *Represión y reconstrucción de una cultura: el caso argentino,* ed. Saúl Sosnowski (Buenos Aires: Eudeba, 1999), 96–108; and María Matilde Ollier, *De la revolución a la democracia: cambios privados, públicos y políticos de la izquierda argentina* (Buenos Aires: Siglo XXI, 2009).

20. Sebastián Barros, *Orden, democracia y estabilidad: discurso y política en la Argentina entre 1976 y 1991* (Córdoba, Argentina: Alción Editora, 2002), 80–81.

21. Feld, *Del estrado.*

22. For notable examples of discussion of these subjects, see Francine Masiello, *The Art of Transition: Latin American Culture and Neoliberal Crisis* (Durham, N.C.: Duke University Press, 2001); Diane Taylor, *Disappearing Acts: Spectacles of Gender and Nationalism in Argentina's "Dirty War"* (Durham, N.C.: Duke University Press, 1997); Marguerite Feitlowitz, *Lexicon of Terror: Argentina and the Legacies of Torture* (London: Oxford University Press, 1998); Dot Tuer, "Cartographies of Memory: Tracing the Representational Legacy of Argentina's Dirty War in the Work of Guillermo Kuitca," *Parachute* 83 (July 1996): 24–29; Kerry Bystrom, "Orphans and Origins: Family, Memory and Nation in Argentina and South Africa" (PhD diss., Princeton University, 2007); and Claudia Feld and Jessica Stites Mor, eds., *El pasado que miramos: memoria e imagen ante la historia reciente* (Buenos Aires: Paidós, 2009).

23. Amy K. Kaminsky, *Argentina: Stories for a Nation* (Minneapolis: University of Minnesota Press, 2008), 158–82.

24. Manuel Puig, *Kiss of the Spider Woman,* trans. T. Colchie (New York: Vingage, 2006).

25. Ricardo Piglia, *Artificial Respiration,* trans. Daniel Balderston (Durham, N.C.: Duke University Press, 1998); Jacobo Timerman, *Prisoner without a Name, Cell without a Number,* trans. Toby Talbot (New York: Knopf, 1981).

26. Masiello, *The Art of Transition,* 1–18.

27. For more on this event, see the articles, testimonies, essays, and other material collected in Ana Longoni and Bruzzone Gustavo, comps., *El siluetazo* (Buenos Aires: Adriana Hidalgo, 2008).

28. Feitlowitz, *Lexicon of Terror.*

29. Taylor, *Disappearing Acts, 164.*

30. Brysk, *Politics of Human Rights,* 127–29.

31. Cecily Marcus, "The Molecular Intellectual: Cultural Magazines and Clandestine Life under Argentina's Last Dictatorship" (PhD diss., University of Minnesota, 2005), 25.

32. The new radio channels went to the cities of Santa Fe, Rosario, and Resistencia and the provinces of La Rioja, Jujuy, and Neuquén; see Decreto 1.839, *Boletín Oficial,* August 24, 1985; Decreto 1.708, *Boletín Oficial,* August 8, 1985; Decreto 3.285, *Boletín Oficial,* October 10, 1985; Decreto 2.528, *Boletín Oficial,* August 21, 1984; Decreto 2.529, *Boletín Oficial,* August 21, 1984; Decreto 2.195, *Boletín Oficial,* November 8, 1985. The

institutions receiving broadcasting rights were the national universities at Luján, San Juan, San Luis, Tucumán, and Mar del Plata; see Decreto 482/89, *Boletín Oficial,* April 14, 1989; Decreto 985/89, *Boletín Oficial,* July 11, 1989.

33. See, e.g., Anexo 1, *Boletín Oficial,* December 2, 1983.

34. Officially, it was placed under the jurisdiction of the Ministry of Education and Justice, to be overseen by the secretary of culture. This was a distinction related to funding and had no impact on administration decisions. See Anexo 1, *Boletín Oficial,* September 4, 1984, p. 2.

35. San Martino de Dromi, *Argentina contemporanea.*

36. Raúl Alfonsín, *Anexo a Mensaje presidencial* (Buenos Aires: Congreso de la Nación, May 1, 1989).

37. Liliana Barela, "Diez años de historial oral en el Instituto Histórico: la legitimación de una propuesta (1985–1995)," *Nuevas Perspectivas del Patrimonio Histórico Cultural* 1 (2000): 91–112.

38. Pablo Buchbinder, *Historia de las universidades argentinas* (Buenos Aires: Sudamericana, 2006), 219–34.

39. Roberto Russell, "Sistema de creencias y política exterior Argentina: 1976–1989," in *Relaciones Internacionales,* Documentos e Informes de Investigación, no. 204 (Buenos Aires: FLACSO, 1996).

40. During Alfonsín's presidency, the United States took several measures to actively support the consolidation of the new democratic regime. Aside from issuing numerous official declarations, such as those against new threats from the military or in favor of new economic stability plans, the United States also made inroads in the United Nations, international lending institutions, and other international forums to the same effect. The United States also supported the new Radical government by assisting in debt restructuring and direct economic assistance. President Reagan interceded on behalf of Argentina with the World Bank and the International Monetary Fund. And in March 1984, the first rescue aid package was approved, amounting to $500 million, principally designed so that the Alfonsín government would not default on its loans to international and private North American banks. In the wake of the 1985 Mexican peso crisis, and the fall of the former Soviet Union, the United States was increasingly interested in helping to keep Third World economies afloat through international lending. Again in 1987, the United States negotiated a loan to Argentina for another $500 million, this time from a coalition of twelve countries' central banks. This was followed closely by a credit of $500 million from the U.S. Department of the Treasury in 1988, earmarked for assisting Alfonsín's administration in its financial crisis. As a consequence, however, the Alfonsín administration was responsible for the highest international debt in the region and one of the highest rates of funds transferred abroad in service of debt per capita in the world. See Carlos Escudé and Marisa González de Oleaga, "La política exterior de Alfonsín: lecciones de una sobredosis de confrontaciones," Working Paper no. 31 (Buenos Aires: Universidad Torcuato di Tella, 1993), booklet archived at the university's library.

41. Francisco Corigliano, "El impacto de Estados Unidos y de España en el proceso de democratización en Argentina," *Nueva Sociedad* 135 (Jan.–Feb. 1995): 235–59.

42. "La censura y el cine argentino en el programa de los candidatos," *La Nación,* October 27, 1983, sect. 2, pp. 1, 4.

43. "Intervienen el Ente y proyectan crear una comisión calificadora," *La Nación,* January 20, 1984.

44. "Manuel Antín: apelar a la esperanza," *La Nación,* November 30, 1983, sect. 2, p. 1.

45. Manuel Antín, president, Fundación Universidad de Cine, in discussion with the author, December 2001.

46. "Lo que debe desaparecer del país es la palabra prohibir," *El Tribuno,* December 24, 1984.

47. "Antín y Wullicher dirigirán el Instituto de Cinematografía," *La Nación,* November 19, 1983, sect. 2, p. 1; Centro de Participación Política, Unión Civica Radical Movimiento de Renovación y Cambio, "Problemas y soluciones del cine argentino," petition signed by Manuel Antín, Ricardo Wullicher, Javier Torre, Martín Schor, Bernardo Boranholtz, Carlos Olguín, and Osvaldo Tarolli, Buenos Aires, 1983, archived in folder labeled "INCAA," Museo del Cine Pablo C. Ducrós Hicken.

48. "Antín frente a la censura en el cine," *La Voz,* November 19, 1983, sect. "Artes y espectáculos"; "Libre expresión y federalismo," *Clarín,* November 13, 1983, sect. "Espectáculos," p. 3.

49. Manuel Antín, in discussion with the author, December 2001.

50. "Semana de cine argentino en USSR," *Heraldo de Cine,* November 22, 1985, p. 832.

51. "Antín y Wullicher dirigirán el Instituto," 1.

52. "Antín analiza nuestro cine," *Diario del Interior,* August 1, 1984, p. 1.

53. "Proyecto para restituir al cine nacional su fondo de fomento," *La Nación,* December 7, 1984, sect. 2, p. 1; "Tiene media sanción la Ley de Fomento Cinematográfico," *Clarín,* December 28, 1984, sect. "Espectáculos," p. 1; "Promulgaron la ley de fomento al cine," *La Nación,* March 7, 1985, sect. 2, p. 1.

54. Manuel Antín, in discussion with the author, December 2001.

55. "Nuevo régimen para la calificación de filmes," *La Nación,* March 20, 1984, sect. 2, p. 1.

56. This commission would be formalized under presidential decrees 828/84 and 3899/84. Members would be chosen by the INC; the secretary of the Ministry of Education and Justice; the secretary of the Ministry of Human Development and Family; the Episcopal Team, organized by the Catholic Church to oversee social communication and the media; a member of the educated Jewish community; a non-Catholic member of the Christian community; a licensed psychologist; and a lawyer named by the Ministry of the Interior.

57. Lita Stantic and Julio Raffo, "Falsas opciones," *Página/12,* August 29, 1989.

58. "Se agrupan productores independientes de cine," *La Voz,* July 16, 1983, sect. "Artes y espectáculos," p. 1.

59. "Cine argentino: crean otra asociación de productores," *Clarín,* July 13, 1983, sect. "Espectáculos," p. 1.

60. "Una nueva asociación, ¿una futura revolución?" *Clarín,* July 31, 1983, sect. "Espectáculos," p. 2.

61. The Unión de Cineastas Argentinos, Cooperativa de Trabajo, was officially authorized via Expediente 40844/85 in the National Register of Cooperatives by the secretary of cooperative action, serving under the Ministry of the Economy at the beginning of 1986. See Resolution 014, Ministry of the Economy, January 13, 1986, signed by Héctor T. Polino.

62. "Cine argentino en cooperativa," *Clarín,* November 24, 1987, sect. "Espectáculos," p. 2.

63. "Cooperación para no morir," *Heraldo de Cine,* November 20, 1987, p. 14. See also Darío Berchones, "El cine argentino busca variantes para afrontar la crisis," *Los Hechos,* April 27, 1988.

64. "Desarrollo cooperativo y cine argentino," *Heraldo de Cine,* November 20, 1987, pp. 11–12.

65. Ibid.

66. Agrupación 17 de Octubre, *Nosotros* and *El Compañero,* pamphlets (March 1983; April 1983).

67. Sindicato de la Industria Cinematográfica Argentina, *40 aniversario* (Buenos Aires: Sindicato de la Industria Cinematográfica Argentina, September 1988).

68. "Cuando el cine viene marchando," *Cine Libre* 1, nos. 3–4 (1983): 43–45. See also various front page articles of *Clarín,* September 8–12, 1983; *La Nación,* September 8–10, 1983; *La Voz,* September 8, 1983; *La Prensa,* September 8 and 10, 1983; and *La Voz del Interior,* September 8–9, 1983.

69. "Mamá, ¿qué vas a hacer en la paz?" *Humor,* August 1982.

70. "Niños sequestrados-desaparecidos desde 1976," *Clarín,* January 5, 1983, sect. "Noticias," p. 12.

71. "Padre Múgica: una vida para el pueblo," *Clarín,* May 11, 1984, sect. "Internacionales," p. 21.

72. "Cultura y democracia," *Tiempo Argentina,* April 26, 1985, p. 1; "Democracia, liberación y justicia social," *Tiempo,* April 26, 1985, p. 5.

73. "Directores Cinematográficos Argentinos reclama la vigencia de la Constitución," *Convicción,* July 10, 1982; "Una declaración de los directores de cine," *La Nación,* July 9, 1982, sect. 2, p. 4; "Directores de cine defienden la cultura," *Crónica,* morning edition, June 10, 1982, p. 22; "Piden cese de censura," *La Voz,* September 19, 1982, sect. "Artes y espectáculos," p. 1; "Declaración de los directores de cine," *La Nación,* June 10, 1982.

74. "Alerta en cuatro sindicatos cinematográficos," *Tiempo Argentino,* December 12, 1982, p. 5.

75. Clara Kriger, ed., *Páginas de cine* (Buenos Aires: Archivo General de la Nacíon, 2003).

76. Municipalidad de Buenos Aires, "La hora de los hornos," pamphlet (Buenos Aires: Municipality of Buenos Aires: 1983).

77. Fernando Birri, "Cinema and Underdevelopment," in *New Latin American Cinema,* vol. 1, *Theory, Practices, and Transcontinental Articulations,* ed. Michael Martin (Detroit: Wayne State University Press, 1997), 86–94.

78. Tim Barnard, *Argentine Cinema* (Toronto: Nightwood, 1986), 161.

79. Ruby Rich, "An/Other View of New Latin American Cinema," *Iris: Revue de Théorie de l'Image et du Son* 13 (1991): 10.

80. Fernando Ferreira, *Luz, camara . . . memoria: una historia social del cine argentino* (Buenos Aires: Corregidor, 1995).

81. For an additional plot summary, see David William Foster, *Contemporary Argentine Cinema* (Columbia: University of Missouri Press, 1992), 38–53.

82. Ibid., 47.

83. Aída Bortnik and Luiz Puenzo, *La historia oficial* (Buenos Aires: Ediciones de la Urraca, 1985).

84. Instituto Nacional de Cinematografía y Artes Audiovisuales, *The Official Story,* press book (Buenos Aires: Editorial del *Heraldo,* 1985).

85. "La historia oficial-repercusiones," *Télam,* television program, Télam network, March 25, 1986.

86. Foster, *Contemporary Argentine Cinema*, 35.

87. Ibid., 31.

88. Other important films of this second generation included Miguel Pereira, *La deuda interna* (1987); Eliseo Subeila, *Últimas imágenes del naufragio* (1989); Héctor Oliveira, *Buenos Aires Rock* (1983); Alejandro Agresti, *Boda secreta* (1988) and *El amor es una mujer gorda* (1987); Lautaro Murúa, *Cuarteles de invierno* (1984); Luis Brunati, *DNI* (1989); Rafael Filippelli, *El ausente* (1987); Fernando Solanas, *Sur* (1987) and *El exilio de Gardel* (1985); Emilio Vieyra, *El poder de la censura* (1983); Gerardo Vallejo, *El rigor del destino* (1985); Osvaldo Andéchaga, *La ciudad oculta* (1989); Jorge Zuhair Jury, *La mayoría silenciada* (1986); Héctor Olivera, *La noche de los lápices* (1986); Alberto Fischerman, *Los días de junio* (1985); and Juan José Jusid, *Made in Argentina* (1987). This second generation of transition films also included allegorical films, such as David Lipscyz's *La rosales* and Juan José Jusid's *Asesinato en el senado de la nación,* and documentaries, such as Carlos Echeverría's *Juan, como si nada hubiera sucedido* (1987) and *Cuarentena* (1983) and Marcelo Céspedes's *A los compañeros la libertad* (1987).

89. Clara Kriger, "La narración del pasado en el cine argentino," in *Cine argentino en democracia: 1983–1993,* ed. Claudio España (Buenos Aires: Fondo Nacional de las Artes, 1994), 54–67; and David Oubiña, "Exilios y regresos," in *Cine Argentino,* ed. España, 68–81.

90. Manuel Antín, in discussion with the author, December 2001. The former director must have felt a special attachment to this phrase, because he also used it in an interview that he gave to Andrea Schettini in 1988, which is cited by Tamara Falicov in *The Cinematic Tango: Contemporary Argentine Film* (London: Wallflower, 2007), 48.

91. See 1985–1986 editions of *Heraldo de Cine* and *Gaceta.*

92. "Un llamado a la consciencia de los argentinos," *Familia Cristiana,* January 1987, p. 19.

93. "Finalmente se vio 'La historia oficial' en Chile," *Heraldo de Cine,* January 9, 1987, p. 19.

94. Carlos Ares, "Diez años después, no todo está perdido . . . ," *La Razón,* March 24, 1986, sect. "Arte y espectáculos," p. 29.

95. See, for example, "El cine argentino, de moda en Italia," *La Nación,* February 19, 1987, sect. 2, p. 1; "Aplauden en Italia a 'La historia oficial,'" *La Nación,* February 7, 1987, sect. 2, p. 4.

96. Diego Curubeto, "Pedro Almodóvar y su opinión sobre el nuevo cine argentino," *Ambito Financiero,* July 25, 1987, p. 3.

97. See, for instance, "'La historia oficial' y las razones del Oscar," *La Vanguardia,* April 3, 1986, p. 5.

98. César Magrini "Este premio," *Gente,* April 3, 1986, pp. 14–15; Luis Puenzo, "Mi película es política, el premio no," *Gente,* April 3, 1986, pp. 14–15.

99. Mona Moncalvillo, "Luis Puenzo," *Humor,* 1986, pp. 49–57.

100. "Homenaje en diputados al cine argentino," *La Nación,* April 19, 1986, sect. 2, p. 1.

101. "Blitzkrieg en la tierra de nadie," *A Fondo,* February 1984, pp. 27–30.

102. "El amor es más profundo en una pantalla grande," *La Voz del Interior,* 7 November 1988, sect. 4, p. 1.

103. "Manuel Antín: 'En pocos países la TV compite tanto con el cine como aquí,'" *Ambito financiero,* October 7, 1988, sect. 2, p. 1.

104. Alfonsín, *Mensaje presidencial,* May 1, 1989.

4. EXPERIENCE, REPRESENTATION, AND REPRODUCTION: DISPLACEMENT AND *EL SUR DE SOLANAS*

1. Marina Franco, "Between Urgency and Strategy: Argentine Exiles in Paris, 1976–1983," *Latin American Perspectives* 34, no. 4 (July 2007): 50–67.

2. Silvina Jensen, "Suspendidos de la historia/exiliados de la memoria: el caso de los argentinos desterrados en Cataluña (1976 . . .)" (PhD diss., Universitat Autònoma de Barcelona, 2004), 106.

3. Beatriz Sarlo, "Argentina 1984: la cultura en el proceso democrático," *Nueva Sociedad* 73 (1984): 78–84.

4. Franco, "Between Urgency and Strategy."

5. For more on transforming political identities, particularly as seen through narratives of the "dirty war," see Amy Kaminsky, *After Exile: Writing the Latin American Diaspora* (Minneapolis: University of Minnesota Press, 1999). See also Francine Masiello, *The Art of the Transition: Latin American Culture and Neoliberal Crisis* (Durham, N.C.: Duke University Press, 2001); and Kathleen Newman, "National Cinema after Globalization: Fernando Solanas's *Sur* and the Exiled Nation," in *Mediating Two Worlds: Cinematic Encounters in the Americas,* ed. John King, Ana M. López, and Manuel Alvarado (London: British Film Institute, 1993), 242–57.

6. Klaus Friedrich Veigel, *Dictatorship, Democracy, and Globalization: Argentina and the Cost of Paralysis, 1973–2001* (University Park: Pennsylvania State University Press, 2009), 127.

7. Marcos Novaro, *Historia de Argentina contemporánea: de Perón a Kirchner* (Buenos Aires: Edhasa, 2006), 162–63.

8. Paul Ricoeur, *Memory, History, Forgetting,* trans. Kathleen Blamey and David Pellauer (Chicago: University of Chicago Press, 2004), 41.

9. Maurice Merleau-Ponty, *Phenomenology of Perception,* trans. Colin Smith (New York: Routledge, 1958), 22–23.

10. Mark Thurner, "After Spanish Rule: Writing Another After," in *After Spanish Rule: Postcolonial Predicaments of the Americas,* ed. Mark Thurner and Andres Guerrero (Durham, N.C.: Duke University Press, 2003), 2–57. See also Marzena Grzegorczyk, *Private Topographies: Space, Subjectivity, and Political Change in Modern Latin America* (New York: Palgrave Macmillan, 2005).

11. Eva-Lynn Alicia Jagoe, *The End of the World as They Knew It: Writing Experiences of the Argentine South* (Lewisburg, Pa.: Bucknell University Press, 2008), 16.

12. Graciela Facchinetti, Silvina Jensen, and Teresita Zaffrani, *Patagonia: historia, discurso e imaginario social* (Temuco, Chile: Universidad de la Frontera, 1997), 125.

13. Josephina Ludmer, *The Gaucho Genre: A Treatise on the Motherland* (Durham, N.C.: Duke University Press, 2002), xii.

14. Masiello, *Art of the Transition,* 28–29.

15. Laura Mombello, "Neuquén es memoria y memoria es Neuquén," *Revista de Historia* (Neuquén, Argentina) 9 (2001): 113. See also Jagoe, *End of the World.*

16. Political prisoners identified at Trelew were members of the PRT-ERP, the Fuerzas Armadas Revolucionarias, and the Montoneros. Six of these (Roberto Santucho, Marcos Osatinsky, Fernando Vaca Narvaja, Roberto Quieto, Domingo Menna, and Enrique Gorriarán Merlo) successfully escaped and fled by plane to Salvador Allende's Chile. The other nineteen were captured in the airport and three days later were *fusilados,* shot execution style, on the naval base Almirante Zar. Only three of these nineteen survived.

17. "Fernando Solanas, el largo peregrinaje de los hijos de Fierro," *La Voz,* suppl. "Semana cultural," October 17–23, 1982.

18. Fernando Solanas and Octavio Getino, *Cine, cultura, y descolonización* (Buenos Aires: Siglo XXI, 1973).

19. César Maranghello, *Breve historia del cine argentino* (Buenos Aires: Laertes, 2005), 191.

20. "Fernando Solanas, el largo peregrinaje."

21. Fernando Martín Peña, *El cine quema: Jorge Cedrón* (Buenos Aires: Altamira, 2003).

22. Octavio Getino and Susana Velleggia, *El cine de las historias de la revolución: aproximación a las teorías y prácticas del cine político en América Latina, 1967–1977* (Buenos Aires: Altamira, 2002), 47–48.

23. Tzvi Tal, *Pantallas y revolución: una visión comparativa del cine de liberación y el cinema novo* (Buenos Aires: Lumière, 2005), 118.

24. Fernando Solanas and Octavio Getino, "Towards a Third Cinema: Notes and Experiences for the Development of a Cinema of Liberation in the Third World," in *New Latin American Cinema*, vol. 1, *Theory, Practices, and Transcontinental Articulations*, ed. Michael T. Martin (Detroit, Mich.: Wayne State University Press, 1997), 33–58.

25. Luciano Monteagudo, *Fernando Solanas* (Buenos Aires: Centro Editor de América Latina, 1993), 29.

26. "Fernando Solanas, el largo peregrinaje," 5.

27. Carlos Morelli, "Del éxito a la victoria," *Clarín*, May 24, 1988, sect. "Espectáculos," p. 3.

28. Monteagudo, *Fernando Solanas*, 34; "Cannes 80: Perspectives," *Cahiers du Cinéma*, August 1980, p. 35; "Interview with Solanas," *Cahiers du Cinéma*, March 1969, p. 64; Vincent Ostria, «Le tutoiement du rêve,» *Cahiers du Cinéma*, November 1985, p. 50; Paulo Antonio Paranagua, «Entretien avec Fernando E. Solanas,» *Positif*, November 1985, p. 25; "Interview with Solanas," *Cinéthique*, 1969, pp. 37–43.

29. Osvaldo Pepe, "El permanente exilio de los argentinos," *La Razón*, March 21, 1986, p. 14.

30. "Interview with Solanas."

31. This was part of his own early description of the project in preproduction records for the film submitted to the National Registry. See Cinesur *Sur* (Buenos Aires: Cinesur, 1983), archived in folder labeled "Solanas, Fernando," Museo del Cine Pablo C. Ducrós Hicken.

32. "'Sur': para recuperar el país perdido," *La Nación*, May 14, 1988, sect. "Artes y espectáculos," p. 3.

33. Shirley Pfaffen, "'Mi muerto es el reapercido,'" *Fin de siglo*, May 1988, pp. 40–43.

34. For an interesting discussion of the idea of the geopolitical in deconstructionist reading of *Sur*, see Elia Geoffrey Kantaris, "Last Snapshopts of Modernity: Argentine Cinema after the 'Process,'" *Bulletin of Hispanic Studies* 73, no. 2 (Apr. 1996): 219–44.

35. Gabriela Nouzeilles, "The Iconography of Desolation: Patagonia and the Ruins of Nature," *Review: Literature and Arts of the Americas* 40, no. 2 (2007): 257.

36. "*Sur*, utopia y después," *La Nación*, June 25, 1988, sect. 2, p. 8.

37. For an excellent discussion of shifting historical scientific theories of memory, see Frances A. Yates, *The Art of Memory* (Chicago: University of Chicago Press, 1966).

38. Marguerite Feitlowitz, *A Lexicon of Terror: Argentina and the Legacies of Terror* (New York: Oxford University Press, 1998), 154, 168, 186–89.

39. Ibid., 194–95. See also Mark J. Osiel, "Constructing Subversion in Argentina's Dirty War," *Representations* 75 (2001): 119–58.

40. Cecilia Lesgart, *Usos de la transición a la democracia: ensayo, ciencia y política en la década del '80* (Rosario, Argentina: Homo Sapiens, 2003), 152–53.

41. Julio Godio, *Historia del movimiento obrero argentino: 1870–2000* (Buenos Aires: Corregidor, 2000), 1135–40.

42. Valeria Manzano has compellingly argued that during the 1980s and 1990s, when the Peronist left was excluded from newly opened political spaces, Solanas and others worked to find a "political-cultural space" for it to occupy, using myth to renovate its image. See Manzano, "Betrayal, Loyalty, the Peronist People, and the Forgotten Archives: Miguel Bonasso's Narrative and the Peronist Left's Political Culture, 1984–2003," *Journal of Latin American Cultural Studies* 16, no. 2 (2007): 183–99.

43. "Y Gardel volvió del exilio," *Nuevo País,* April 17, 1986, p. 32.

44. "Solanas de regreso: 'Fue el triunfo de un equipo,'" *Clarín,* May 27, 1988, sect. "Espectáculos," p. 3.

45. "Solanas y Gardel: después del exilio," *Clarín,* October 9, 1983, sect. "Espectáculos," pp. 1–2.

46. Néstor Tirri, "Sobre la identidad y la colonización" and "Transgredir los modelos impuestos," *Clarín,* July 12, 1986, sect. "Espectáculos," pp. 2–3.

47. Osiel, "Constructing Subversion," 119–58.

48. Mona Moncalvillo, "Octavio Getino," *Humor,* August 9, 1988, pp. 38–42.

49. "Getino adhiere a la política del gobierno en material cinematográfica y de difusión," *La Opinión,* December 21, 1975.

50. At the Universidad Católica, Getino was in charge of the Center for Tele-Educative Production. At the Universidad de Lima, he served as a lecturer and researcher in the Department of Communication Sciences. In Peru, Getino also spent time working in the northern Andean Sierra, where he assisted in a rural development project, administering a communication service on topics of education, health, and agriculture.

51. Moncalvillo, "Octavio Getino," 40.

52. Only the work of Domingo di Núbila, Agustín Mahieu, and Jorge Abel Martín could be counted as predecessors to Getino's publication on Argentine cinema.

53. Francisco Acri, "Octavio Getino," *Sin Cortes,* July 1989, pp. 16–17; Aníbal M. Vinelli, "Octavio Getino: aquel censor sin censura," *Clarín,* November 15, 1984, sect. "Espectáculos," pp. 1, 6.

54. Octavio Getino, "Propuesta para un cine nacional," *El Cronista,* December 1973, p. 189.

55. Octavio Getino, "El cine argentino y el mercado iberoamericano, realidad y desafío," *Clarín,* January 26, 1984, sect. "Cultura y nación," pp. 1–3.

56. "Una formula radical-peronista para salvar al cine argentino," *La Voz del Interior,* November 21, 1988.

57. "Getino: 'No puede debatirse el cine como hecho aislado,'" *Ambito Financiero,* November 21, 1988, sect. "Arte-ocio espectáculos," p. 21.

58. Solanas and Getino, *Cine, cultura y descolonización.* For the work's prevalence in curricula, see syllabi from various film courses, including "Cine y política," taught by Sergio Wolf at the Universidad de Buenos Aires, 2002–2006; "Antropología de lo visual," taught by Silvia María Hirsch, Facultad Latinoamericana de Ciencias Sociales, 2007; "Análisis de los lenguajes: el cine y las formas de lo popular," taught by Gonzalo Aguilar, Universidad de Buenos Aires, 2005–2007; "El cine y la memoria del pasado reciente," Docentes, Comisión Provincial por la Memoria, 2005; "Política, legislación y planeamiento en comunicación," taught by Gustavo López, Fundación Universidad de Cine, 2005–2007; and "De la radicalización política a la radicalización del discurso fílmico," taught by Ana Laura Lusnich, Universidad de Buenos Aires, 2005.

59. Getino's major publications include *Cine y dependencia: el cine en la Argentina* (Buenos Aires: Puntosur Editores, 1990 [1979/1983]), *Cultura, comunicación y desar-*

rollo en América Latina (Buenos Aires: Edimedias, 1984), *Cine latinoamericano: economía y nuevas tecnologías audiovisuales* (Buenos Aires: Legasa, 1987 [1985]), *Las industrias culturales en la Argentina: dimensión económica y políticas públicas* (Buenos Aires: Colihue, 1994), *La tercera mirada: panorama del audiovisual latinoamericano* (Barcelona: Paidós Ibérica, 1996), and *Cine y televisión en América latina: producción y mercados* (Santiago: LOM, 1998).

60. Guy Hennebelle and Alfonso Gumucio-Dagrón, *Les cinémas de l'Amérique latine* (Paris: Nouvelle Editions Pierre Lherminier, 1981). Some parts of the work were also published in Mexico, Spain, Bolivia, and later Venezuela. The volume was finally published in Argentina in its entirety in 1983, just after the transition had begun.

61. "Getino mira hacia el 90," *Clarín*, December 30, 1989.

62. Getino, *Cine y dependencia*, 68–69.

63. Getino, *Las industrias culturales.*

64. "Propician crear en el barrio de Barracas el 'Paseo del 900,'" *La Nación*, July 24, 1989, sect. 1, p. 5.

65. Fernando López, "'*Sur*': el mundo poético de solanas en imágenes emotivas y deslumbrantes," *La Nación,* May 6, 1988, sect. 2; "Ese sur que es un paisaje interior," *Clarín,* June 2, 1988, sect. "Espectáculos," p. 12.

66. Gerardo Yomal, "'Acuso a Menem de corrupción y traición,'" *El Porteño*, March 1990, pp. 6–9. See also Feitlowitz, *Lexicon of Terror,* 89.

67. Yomal, "'Acuso a Menem,'" 6–9.

68. Javier Díaz, "Para Solanas, el menemismo es el enemigo número uno," *La Nación,* 19 June 19, 1992, sect. "Policía/tribunales," p. 1.

69. Moncalvillo, "Fernando Solanas," 28–33.

70. This delegation was headed by leading figures in the film community, including Manuel Antín, María Luisa Bemberg, Luis Puenzo, Aída Bortnik, Jorge Polaco, Juan J. Jusid, Eliseo Subiela, and Octavio Getino. See Rafael Granado, "Con la memoria de la gente," *Clarín*, September 22, 1991, sect. "Espectáculos," p. 3; "Petitorio al Gobierno para que se esclarezca el atentado a Solanas," *La Nación,* May 25, 1991, sect. 2, p. 1.

71. "Respuesta unánime al atentado contra cineasta Solanas," *Clarín,* May 24, 1991. sect. "Política," p. 5.

72. "Respuesta unánime al atentado," 5 (confession); "'Menem es la comadreja de los llanos,'" *Pagina/12*, November 3, 1991, sect. "*Cultura,*" p. 24 (relaunched critiques). For statements on the Galerías, see "Detrás del atentado a Solanas se esconden siniestros interrogantes," *Seminario,* May 28, 1991, p. 2; "Pino Solanas en Tribunales: 'Quiero probar lo que dije,'" *Página/12,* May 22, 1991; "El mundo pido por 'Pino,'" *Flash,* July 12, 1991, p. 19.

73. "Un candidate de película," *Página/12*, May 6, 1992, p. 7.

74. Atilio Bleta, "Solanas apuntó contra el ajuste," *Clarín,* June 25, 1992, sect. "Política," p. 6.

75. "Con críticas cerró Solanas su campaña," *La Nación,* June 25, 1992, sect. "Política," p. 1.

76. Javier Días, "El Frente del Sur encara un futuro ambicioso como tercera fuerza," *La Nación,* June 30, 1992.

77. Atilio Bleta, "El Frente, radiografía de una sorpresa," *Clarín,* 17 April 17, 1994, sect. "Política," p. 9.

78. "La izquierda posible," *Clarín,* April 17, 1994, sect. 2, pp. 2–3.

79. Javier Díaz, "El Frente Grande improvisa su campaña en Buenos Aires," *La Nación,* July 5, 1993, p. 11.

80. "Solanas: 'Hay que regar la semilla,'" *Clarín,* April 17, 1994, sect. "Política," p. 9.

81. "Alianza Sur entra en escena," *Propuesta*, March 30, 1995, p. 5.

82. Pablo Calvo, "Pino Solanas, candidato a Presidente de la Alianza Sur, 'Buscamos el cambio,'" *Clarín*, April 24, 1995, sect. *"Política,"* p. 10 (privatization); "Chacho Alvarez y Pino Solanas se pelean por la economía," *Página/12*, September 22, 1994, p. 6 (economy); Atilio Bleta, "Alvarez y Solanas discrepan por el plan económico del Frente Grande," *Clarín*, September 21, 1994, sect. *"Política,"* pp. 4–5 (split vote).

83. Roberto Durán, "La izquierda culpa ahora a Solanas por el fracaso electoral," *Ambito Financiero*, May 22, 1995, p. 19.

84. Fernando "Pino" Solanas, "Necesitamos una gran industria audiovisual argentina," *Clarín*, 19 June 19, 1997, sect. "Opinión," p. 21.

85. In June 2009 Fernando Solanas made a successful bid for diputado in Congress, using the campaign slogan "Proyecto Sur" to promote an idea of his political vision. Bearing a light green background, posters announced his candidacy and that of those affiliated with his coalition. Although his campaign rhetoric left some mystery with regard to important issues on the table in the election, Solanas's major platform addressed political corruption, combating urban violence, resource politics, and working out a more efficient public transit scheme. To a slight extent, the coalition identified with "green" parties of other countries as a way of expressing Solanas's ideological alliance with "third" parties, oppositional parties, and the spectrum of the left that best fit with his own ideas about protecting the environment and sustainable urban growth. The future senator made a series of videos in which he addresses the public via the camera, at times sipping maté, announcing his platform. These videos, which had a wide circulation on the Internet, particularly via the YouTube site, focused on the four chief objectives of his campaign, "coherency, ethics, unity, and a common goal [*proyecto*]," the last term referring to a political movement of those who share his vision of Argentina's future, still a very Marxist one of Argentine citizens as coproprietors of the nation's land, industry, and resources.

5. *DOCUMENTALISMO:* POLITICAL FILMMAKING AND SOCIAL MOVEMENTS

1. Cristian Vitale, "Dios y el diablo en el Ingenio Ledesma," *Página/12*, July 21, 1999, p. 26.

2. Lorena Cancela, "Una realidad distinta de la que se suele mostrar," *Otrocampo*, August 2001.

3. Fernando Kirchmar, "Grupo de cine insurgente," Miradas, no. 6. 2004, available at http://www.miradas.eictv.co.cu/content_otro_cine.php?id_articulo=6.

4. Susana Kaiser, "The Struggle for Urban Territories: Human Rights Activists in Buenos Aires," in *Ordinary Places, Extraordinary Events: Citizenship, Democracy, and Public Space in Latin America*, ed. Clara Irazábal (New York: Routledge, 2008), 170–97.

5. Kirchmar, "Grupo de cine insurgente" (my translation; the original reads, "Uno de los aspectos más interesantes de la experiencia de *Diablo, Familia y Propiedad* fue su intervención activa en un debate concreto en el campo político, generando acciones o impulsos a la acción en algunos de sus espectadores").

6. Statistics compiled in consultation with the Instituto Nacional de Cine y Artes Audiovisuales; the Núcleo Audiovisual Buenos Aires; and the Centro Cultural San Martín, Gobierno de la Ciudad de Buenos Aires.

7. María Laura San Martino de Dromi, *Argentina contemporánea de Perón a Menem* (Buenos Aires: Ciudad Argentina, 1996), 1325–42.

8. Beatriz Sarlo, "Educación: el estado de las cosas," *Punto de Vista* 22, no. 63 (1999): 17–21.

9. Steven Levitsky, *Transforming Labor-based Parties in Latin America: Argentine Peronism in Comparative Perspective* (New York: Cambridge University Press, 2003).

10. Kenneth Roberts, Leslie Bethell, and René Antonio Mayorga, "Conceptual and Historical Perspectives," in *The "New Left" and Democratic Governance in Latin America*, ed. Cynthia J. Arnson and José Raúl Perales (Washington, D.C.: Woodrow Wilson International Center for Scholars, 2006), 10–23.

11. Richard Stahler-Sholk, Harry E. Vanden, and Glen David Kuecker, "Globalizing Resistance: The New Politics of Social Movements in Latin America," *Latin American Perspectives* 34, no. 5 (2007): 5–16. See also Claudio Lomnitz, "Foundations of the Latin American Left," *Public Culture* 19, no. 1 (2007): 23–27; and Maxwell Cameron, "Latin America's Left Turns: Beyond Good and Bad," *Third World Quarterly* 30, no. 2 (2009): 331–48.

12. Gabriela Nouzeilles, "Apocalyptic Visions: National Tales and Cultural Analysis in a Global Argentina," *Journal of Latin American Cultural Studies* 10, no. 3 (2001): 291–301.

13. Nelly Richard, *Insubordination of Signs: Political Change, Cultural Transformation, and Poetics of Crisis*, trans. Alice A. Nelson and Silvia R. Tandeciarz (Durham, N.C.: Duke University Press, 2004), 43.

14. Néstor García Canclini, *Consumers and Citizens: Globalization and Multicultural Conflicts*, trans. George Yúdice (Minneapolis: University of Minnesota Press, 2001).

15. Lorena García, "Egresados con sueños de película," *La Nación*, February 8, 1997, sect. 4, p. 2.

16. Edgardo Cozarinsky, "Letter from Buenos Aires," *New Left Review* 26 (Mar.–Apr. 2004), available at http://www.newleftreview.org/A2501 (accessed Nov. 8, 2011).

17. García, "Egresados con sueños de película," 2. See also Victoria Tatti, "Hay en el país 7 mil estudiantes de cine," *Clarín*, July 9, 2000.

18. For more on increased consumer spending, see Ana Wortman's edited collection *Imágenes publicitarias/nuevos burgueses* (Buenos Aires: Prometeo, 2004).

19. Juán Landaburru, assessor, INCAA, in discussion with the author, December 2005.

20. Ibid.

21. Tamara Falicov, "The Contemporary Argentine Film Industry, 1983–1998: State Cultural Policy within a Global Market" (PhD diss., University of California, San Diego, 1999).

22. Geoffrey Nowell-Smith, *The Oxford History of World Cinema* (Oxford: Oxford University Press, 1999), 547.

23. Kirchmar, "Grupo de cine insurgente."

24. Ernesto Ardito and Virna Molina, codirectors and producers of *Raymundo*, in discussion with the author and Noa Vaisman, June 2004.

25. Ibid.

26. Luis Gusmán, director of Cinema Radio program *El Tribu*, in discussion with the author, November 6, 2001.

27. Tamara Falicov, *The Cinematic Tango: Contemporary Argentine Film* (London: Wallflower, 2007), 106–7.

28. Jorge Oubiña, lecture, "Legislación y cine" class, University of Cinema, Buenos Aires, Jan. 15, 2003.

29. Diego Lerer, "El 63% de las películas estrenadas en 1993 fueron norteamericanas," *La Maga*, February 2, 1994, sect. "Temas," pp. 4–5.

30. "El Parlamento demora el tratamiento de la Ley de Cine," *La Maga*, February 9, 1994, sect. "Cine," pp. 44.

31. Sergio Levit, "Vaivenes de un proyecto del Instituto Nacional de Cinematografía," *La Nación*, February 5, 1994.

32. Asociación Argentina de Actores, Sindicato de la Industria Cinematográfica Argentina, Confederación Sindical de Trabajadores de Medos de Comunicación Social, Cámara Argentina de la Industria Cinematográfica, Asociación General de Productores Cinematográficos, Federación Argentina de Cooperativas, and Directores Argentinos Cinematográficos, "Cine en video y televisión, sin evasión por el inmediato tratamiento de proyecto de ley," petition to the Congreso Nacional, Buenos Aires, November 11, 1993, folder labeled "SICA," Museo del Cine Pablo C. Ducrós Hicken.

33. "La ley de fomento de cine," *La Nación*, August 11, 1994, sect. "Espectáculos," p. 1.

34. Laura Ubfal, "Con ley, promete la TV ocho films al año," *Ambito Financiero*, July 17, 1994, sect. "Arte-ocio espectáculos," p. 1.

35. "Senado aprobó la Ley de Cine," *Ámbito Fianciero*, September 29, 1994, sect. "Arte-ocio espectáculos," p. 1.

36. "Luis Puenzo," *Sin Cortes* 84, no. 15 (July 1994): 30–34.

37. "La industria confía en que hoy sancionarán Ley de cine," *Ambito Financiero*, April 27, 1994, sect. "Arte-ocio espectáculos," p. 1.

38. "Muy duro Antín con la inminente Ley de Cine," *Ambito Financiero*, August 11, 1994, sect. 2, pp. 1, 3.

39. Héctor Olivera, "Puenzo ha sido inoportuno," *Página/12*, February 22, 1994.

40. "Reclaman nueva Ley de Cine," *La Razón*, April 23, 1994, sect. "Espectáculos," p. 5. See also "Cine Argentino," *Clarín*, July 10, 1994, sect. "Espectáculos, artes y estilos," pp. 2–3.

41. "Diputados aprobó la ley de cine," *Página/12*, May 12, 1994.

42. "Cine Argentino," *Clarín*, July 10, 1994.

43. Alberto R. Pierri, "Proyecto de ley en revisión modificando la Ley Número 17.741—Fomento de la cinematografía nacional," *Boletín Oficial* (May 11, 1994): 349–54.

44. Pablo O. Scholz, "¿Y ahora, que?" *Clarín*, January 16, 1995, sect. "Espectáculos, artes y estilos," pp. 4–5.

45. "Actores, contra el veto de la legislación," *La Nación*, March 10, 1999, sect. "Espectáculos," p. 2.

46. "Cinemateca: es ley a creación de la Cinemateca y el Archivo de la Imagen," *Télam*, July 15, 1999.

47. "Jurado: 'Es una locura esta ley que aprobaron'" and "Miller: 'Atacan por ignorancia,'" *Ambito Financiero*, July 20, 1999, sect. "Arte-ocio espectáculos," pp. 1, 3.

48. Comisión de Cultura del H. Senado de la Nación, "Hoja de cultura," año 2, no. 12, Buenos Aires, July 26, 1999.

49. INCAA Subdirector Nacional, "Proyecto de Reglamentación para la Ley 17.741 T. O. 2000," Buenos Aires, June 26, 2000, INCAA archives.

50. Kirchmar, "Grupo de cine insurgente."

51. Verónica Pagés, "Cuentas claras piden las entidades de cine," *La Nación*, November 24, 1996.

52. José Coscia, INCAA Resolution no. 658/2004, Buenos Aires, March 4, 2004, INCAA archives.

53. Paul H. Lewis, *The Agony of Argentine Capitalism: From Menem to the Kirchners* (Santa Barbara, Calif.: ABC-CLIO, 2009), 35–36, 46, 52–55.

54. Sebastián Galiani and Hugo A. Hopenhayn, "Duration and Risk of Unemployment in Argentina," working paper for the Center for International and Development Economics Research at the University of California, Berkeley, 2001.

55. Nancy Powers, "The Politics of Poverty in Argentina in the 1990s," *Journal of Interamerican Studies and World Affairs* 37, no. 4 (Winter 1995): 89–137.

56. For examples of such theories, see Claudio Lomnitz, "Foundations of the Latin American Left," *Public Culture* 19, no. 1 (2007): 23–27. See also Beatriz Jaguaribe, "The Shock of the Real: Realist Aesthetics in the Media and the Urban Experience," *Space and Culture* 8 (2005): 66–83.

57. Lewis, *Agony of Argentine Capitalism*, 112.

58. Ibid., 116.

59. Levitsky, *Transforming Labor-based Parties*.

60. Guillermo Mondino, national minister of finance, in discussion with the author, October 2002.

61. The ensuing succession of short-lived presidencies included those of Federico Ramón Puerta, Adolfo Rodríguez Saá, Eduardo Camaño, and finally Eduardo Duhalde, all from the Peronist Justicialist Party. See Luis Alberto Romero, *A History of Argentina in the Twentieth Century* (Buenos Aires: Fondo de Cultura Económica, 2006).

62. Ana Dinerstein, "The Battle of Buenos Aires: Crisis, Insurrection and the Reinvention of Politics in Argentina," *Historical Materialism* 10, no. 1 (2002): 7.

63. "Hoy no trabajan los actores," *Crónica*, December 21, 2001; "Comunicado," *Página/12*, December 23, 2001; "Actors: Show Must Go On," *Buenos Aires Herald*, December 22, 2001; "Los actors levantan el cese de actividades," *Diario Popular*, December 22, 2001.

64. Ana Bianco, "El cine 'piquetero,' o como dar cuenta de la resistencia popular," *Página/12*, December 6, 2001.

65. Ardito and Molina, discussion with author and Vaisman, June 2004.

66. Jorge Falcone, "Movimiento de Documentalistas," May 27, 2002, available at the Movimiento de Documentalistas web site, http://www.documentalistas.org.ar/presentacion.shtml.

67. Ibid.

68. The stated political aims of LuchArte are to divest national culture industries of the power to arbitrarily favor specific commercial interest groups, to improve and protect cultural workers' working conditions and job security, to wrest control of the media from the corporate sector, and to defend the accessibility of cultural and artistic education.

69. LuchArte, *Ciclo cine piquetero* (Buenos Aires: LuchArte, 2004).

70. Kirchmar, "Grupo de cine insurgente."

71. The largest donors came from Western Europe, such as Spain's Instituto de Fomento Industrial (I.F.I.), Bancoldex, and Fondo Ibermedia; the Netherlands' Hubert Bals Foundation and Jan Vrijman Foundation; Sweden's Göteborg Film Festival Fund; and Italy's Fondazione Montecinemaverità. European and North American festivals also expanded financial opportunities for new political documentary directors. International foundations used festivals to award prizes with cash value to Third World filmmakers, such as the award for Best Latin American Film given by the John D. and Catherine T. MacArthur Foundation at the Sundance Festival. Production fellowships and development support also began to be offered by the Ford Foundation, the Rockefeller Foundation, the Center for Alternative Media and Culture, ITVS–International Media Development Fund, and the Soros Documentary Fund. Some grants became available for coproductions, such as those disbursed by Fonds Sud for French–Latin

American coproductions, the Berlin-based World Cinema Fund, and private organizations such as the Quebecois Alter-Ciné Foundation and Vision Sud Est. The trend of external support for documentaries also extended to include Spanish and French television channels and a number of NGOs, such as OXFAM, UNICEF, Amnesty International, and Mama Cash.

72. See the films' official web sites, www.eltrenblanco.com.ar and www.losnadies.com.ar.

73. The majority of the cine piquetero films that would be produced in the following years were products of similar film collectives, such as Cine Urgente, Ojo Izquerido, Grupo de Boedo, Grupo Primero de Mayo, and Ojo Obrero.

74. Michel Silva, "Um novo cinema militante," *O olho da história* 12, no. 9 (Dec. 2006), available at http://www.ojoobrero.org/textos_cine_latino.html.

75. Kirchmar, "Grupo de cine insurgente."

76. *Clarín*, August 22, 2002, sect. "Espectáculos," p. 8.

77. In 1997, the group achieved national recognition by winning support from the National Fund of the Arts. Grupo de Boedo produced a film entitled *Jorge Gianonni, NN ese soy yo (Jorge Giannoni Anonymous, That's Me)* that documented the life of a filmmaker who worked with Raymundo Gleyzer on radical projects in the 1960s and who also disappeared under the military regime. This is just one example of the common occurrence of film collectives getting an economic start by producing a film about the dictatorship.

78. Other works that are representative of this kind of filmmaking include the documentaries *Matanza, La crisis causó 2 neuvas muertes, Polo obrero, Acampe piquetero, Un fantasma recorre la Argentina—los piqueteros,* and *Agua de fuego* (each of which traces the development of the piquetero movement) and *Contra el poder—un nuevo poder—las Asambleas populares, Agentinazo . . . la revolución comienza, Sasetru obrera,* and *Grissinopoli,* which narrate the experiences of workers in occupied factories and the creation of popular assemblies.

79. Anton Kaes, "History and Film: Public Memory in the Age of Electronic Dissemination," *History and Memory: Studies in Representation* 2, no. 1 (Fall 1990): 112–13.

80. Bianco, "El cine 'piquetero,'" 30.

81. Hernán Vasco, "Cine piquetero: una imagen recorre el mundo," *Prensa Obrero,* February 20, 2003, sect. "Sociedad," p. 14, available at http://archivo.po.org.ar/po/po790/cine.htm (accessed Nov. 8, 2011).

82. James Petras, "Latin America: The Resurgence of the Left," *New Left Review* 1, no. 223 (May–June 1997): 17–47.

83. Valeria Manzano makes a similar argument about the testimonial writings of Miguel Bonasso in her article "Betrayal, Loyalty, the Peronist People and the Forgotten Archives: Miguel Bonasso's Narrative and the Peronist Left's Political Culture, 1984–2003," *Journal of Latin American Cultural Studies* 16, no. 2 (2007): 183–99.

84. Marcelo Cespedes, director and producer, Cine Ojo, in discussion with the author and Noa Vaisman, June 2004.

85. Carmen Guarini, director and producer, Cine Ojo, in discussion with the author and Noa Vaisman, June 2004.

86. David Oubiña, in discussion with the author and Noa Vaisman, May 2004.

87. Lidia Acuña, director, Centro de Investigaciones en Estudios Culturales, Educacionales y Comunicacionales (CIECEC), Universidad Nacional del Litoral, Santa Fe, Entre Ríos, in discussion with the author, May 2005.

88. Ibid.

89. Cespedes, in discussion with the author and Vaisman, June 2004.

90. Richard, *Insubordination of Signs,* 70.

91. Gonzalo Aguilar, *Other Worlds: New Argentine Film,* trans. Sarah Ann Wells (New York: Palgrave Macmillan, 2008), 118.

6. POSTMODERN EXIGENCIES: NEW MEDIA, MEMORY, AND CRITICAL SPACES

1. Annette Kuhn and Catherine Grant, "Screening World Cinema," in *Screening World Cinema,* ed. Catherine Grant and Annette Kuhn (New York: Routledge, 2006), 3; Ella Shohat and Robert Stam, eds., *Unthinking Eurocentrism: Multiculturalism and the Media* (New York: Routledge, 1994).

2. During 2009–11, several important contributions to the study of recent film in Argentina signaled film's "active participation in the political decisions in the cultural field and intervention in contemporary debates" (Gonzalo Aguilar, *Other Worlds: New Argentine Film* [New York: Palgrave Macmillan, 2008], 207). See. e.g., Tamara Falicov, *The Cinematic Tango* (London: Wallflower, 2007); David Oubiña, "Construcción sobre los márgenes: itinerarios del nuevo cine independiente en América Latina," in *Hacer cine: producción audiovisual en América Latina,* ed. Eduardo Russo (Buenos Aires: Paidós, 2008), 31–42; and Joanna Page, *Crisis and Capitalism* (Durham, N.C.: Duke University Press, 2009).

3. Alison Griffiths, *Wondrous Difference: Cinema, Anthropology, and the Turn of the Century Visual Culture* (New York: Columbia University Press, 2002).

4. Jorge La Ferla, "El cine argentino, un estado de situación," in *Hacer cine: producción audiovisual en América Latina,* ed. Eduardo Russo (Buenos Aires: Paidós, 2008), 231.

5. Natasha Niebieskikwiat, "Por una película, pasan el control aéreo a civiles," *Diario Clarín,* September 2, 2006. The documentary in question was *Fuerza Aérea S.A.,* a follow-up to the director's international and box-office success *Whisky, Romeo, Zulu.*

6. Martín Kohan, "La apariencia celebrada," *Punto de Vista* 78 (Apr. 2004): 24–30.

7. Gabriela Nouzeilles, "Postmemory Cinema and the Future of the Past in Albertina Carri's *Los rubios," Journal of Latin American Cultural Studies* 14, no. 3 (2005): 263–78.

8. For something of a sampling, see Betina Kaplan, "Los rubios," *Chasqui* 33 (2004): 169–79; Verónica Garibotto and Antonio Gómez, "Más allá del 'formato memoria': la repostulación del imaginario postdictatorial en *Los rubios* de Albertina Carri," *A Contracorriente* 3, no. 2 (Winter 2006): 107–26; Gabriel Gatti, "Las narrativas del detenido-desaparecido (o de los problemas de la representación ante las catástrofes sociales)," *Confines* 2, no. 4 (2006): 27–38; Joanna Page, "Memory and Mediation in *Los Rubios:* A Contemporary Perspective on the Argentine Dictatorship," *New Cinemas* 3, no. 1 (Apr. 2005): 29–40; and María Laura Caneda, "Sobre los recuerdos y el futuro del cine nacional," *Criterio* 80, no. 2326 (May 2007), online journal, http://www.revistacriterio.com.ar/cultura/sobre-los-recuerdos-y-el-futuro-del-cine-nacional/.

9. Ana Bianco, "Tratamos de entender cómo era un militante," *Pagina/12,* June 10, 2004, p. 24.

10. Ernesto Ardito and Virna Molina, in discussion with the author and Noa Vaisman, June 2004.

11. Cristain Vitale, "Tenemos que recuperar sus ideas para nuevas generaciones," *Pagina/12,* August 4, 2003, p. 20. Author's translation.

12. In conversation with SICA director Mario López Barreiro, June 2004, Buenos Aires.

13. Jean Baudrillard, *The System of Objects,* trans. James Benedict (New York: Verso, 1996), 8.

14. Fredric Jameson, *The Cultural Turn: Selected Writings on the Postmodern, 1983–1998* (New York: Verso, 1998), 111.

15. Andreas Huyssen, *Present Pasts: Urban Palimpsests and the Politics of Memory* (Stanford, Calif.: Stanford University Press, 2003), 1.

16. Paul Ricoeur, *From Text to Action: Essays in Hermeneutics,* vol. 2, trans. Kathleen Blamey and John B. Thompson (Evanston, Ill.: Northwestern University Press, 2007), 10.

17. Roland Barthes, *Mythologies,* trans. Annette Lavers (London: Paladin, 1979).

18. Zygmunt Bauman, *Postmodernity and Its Discontents* (New York: New York University Press, 1997), 107.

19. Susan Sontag, *Regarding the Pain of Others* (New York: Farrar, Straus and Giroux, 2003), 6–46.

20. Gilles Deleuze, *Difference and Repetition,* trans. Paul Patton (New York: Columbia University Press, 1994), 265.

21. Steven Shapin, *A Social History of Truth: Civility and Science in Seventeenth-Century England* (Chicago: University of Chicago Press, 2004), 31–33.

22. Andrew Calabrese, "The Promise of Civil Society: A Global Movement for Communication Rights," *Continuum* 18, no. 3 (2004): 321.

23. In her book *The Claims of Culture: Equality and Diversity in the Global Era* (Princeton, N.J.: Princeton University Press, 2002), Seyla Benhabib claims an inherent ethnocentricity to the ideological underpinnings of the variety of universalism that guides these trends.

24. Gayatri Spivak, *A Critique of Postcolonial Reason: Toward a History of the Vanishing Present* (Cambridge, Mass.: Harvard University Press, 1999), ix–x.

25. See Ana Longoni and Mariano Mestman, *Del Di Tella a "Tucumán Arde," vanguardia artística y política en el '68 argentino* (Buenos Aires: El Cielo por Asalto, 2008).

26. An excellent history of the Instituto Di Tella is available in Longoni and Mestman's *Del Di Tella* and Andrea Giunta's *Vanguardia, internacionalismo, y politica* (Buenos Aires: Paidós, 2001).

27. Beatriz Sarlo, "El historia contra el olvido," *Punto de Vista* 11, no. 36 (1989): 11–14.

28. Andrés Di Tella, *Andrés Di Tella: cine documental y archivo personal, conversación en Princeton* (Buenos Aires: Siglo XXI, 2006), 8.

29. Andrés Di Tella, *Guión cinematográfico* (Santa Fe, Argentina: Universidad Nacional del Litoral, 1990).

30. Taken from the web site of the competition for Guggenheim Fellows at http://www.gf.org/applicants/the-latin-american-caribbean-competition/.

31. BAFICI web site, http://www.bafici.gov.ar/home/web/es/index.html.

32. "La vida privada en los campos de concentración," in *Historia de la vida privada en la Argentina,* vol. 3, ed. Fernando Devoto and Marta Madero (Buenos Aries: Taurus, 1999), 78–105.

33. Di Tella, *Andrés Di Tella.*

34. Ibid., 85–86.

35. Andrés Di Tella, "Recuerdos del nuevo cine argentino," in *Hacer cine: producción audiovisual en América Latina,* ed. Eduardo Russo (Buenos Aires: Paidós, 2008), 248.

36. In conversation with author, July 2009, Buenos Aires.

37. The year that López Escriva won, the award was juried by Ana Cacopardo, a journalist and audiovisual director; Horacio Javier Ríos, an audiovisual director; and Soledad García Muñoz, an expert on human and women's rights.

38. These activities were sponsored by a number of collaborators, including the INCAA; the Filmoteca de Buenos Aires; the General Directorship of Museums of Buenos Aires; the municipal government of the city; the French government; the Goethe Institute; and commercial interests such as Kodak, Cinecolor, the supermarket chain Carrefour, the high-tech audio company Bang and Olufsen, the auto manufacturer BMW, and the cable movie network I-Sat.

39. Fernando Martín Peña, ed., *60/90 Generaciones* (Buenos Aires: Fundación Eduardo F. Constantini, 2003).

40. See the MALBA publication *malba.cine*, 2002–6.

41. These film collections include Fundación Cineteca Vida, the Cine-Teatro IFT, the Videoteca of Buenos Aires, the Centro de Estudios de Cine, and the Biblioteca de Cine.

42. Centro de Estudios Cineteca Vida, "Seminario Cine y marginalidad en América Latina Subalternidad, realismo sucio y violencia urbana," November 3, 2006.

43. For detailed information on these and other titles, see Clara Kriger, ed., *Páginas de cine* (Buenos Aires: Archivo General de la Nación, 2003).

44. Taken from the cover of SICA's publication *DEISICA* 1 (Jan.–June 1991).

45. See, for example, Luciano Monteagudo, *Fernando Solanas* (Buenos Aires: Centro Editor de América Latina, 1993); Carlos Landini, *Héctor Olivera* (Buenos Aires: Centro Editor de América Latina, 1993); Fernando Brenner, *Adolfo Aristarain* (Buenos Aires: Centro Editor de América Latina, 1993); and David Oubiña, *Manuel Antín* (Buenos Aires: Centro Editor de América Latina, 1993).

46. Rodrigo Fernández and Denise Nagy, *La gran aventura de Armando Bo* (Buenos Aires: Libros Perfil, 1999); Gustavo Cabrera, *Hugo del Carril, un hombre de nuestro cine* (Buenos Aires: Ediciones Culturales Argentinas, 1989).

47. María del Carmen Vieites, ed., *Leopoldo Torre Nilsson: una estética de la decadencia* (Buenos Aires: Grupo Editor Altamira, 2002).

48. Raúl Manrupe and María Alejandra Portela, *Un diccionario de films argentinos (1930–1995)* (Buenos Aires: Corregidor, 2001).

49. Daniel López, *Catálogo del nuevo cine argentino 1989/1991* (Buenos Aires: Legasa, 1993).

50. Pablo Perelman and Paulina Seivach, *La industria cinematográfica en la Argentina: entre los límites del mercado y el fomento estatal,* special issue, *Observatorio de Industrias Culturales* 1 (Jan. 2004).

51. Pierre Sorlin, *Cine europeo, sociedades europeos, 1939–1990* (Buenos Aires: Paidós, 1996); Henry A. Giroux, *Cine y entretenimiento* (Buenos Aires: Paidós, 2004); Olivier Mongin, *Violencia en cine contemporáneo* (Buenos Aires: Paidós, 1999).

52. Julio Raffo, *Ley de fomento y regulación de la actividad cinematográfica* (Buenos Aires: Lumière, 2003).

53. Jorge Coscia, *Del estallido a la esperanza: reflexiones sobre cine, cultura y peronismo* (Buenos Aires: Corregidor, 2001).

54. Carmen Guarini, in discussion with the author and Noa Vaisman, June 2004.

55. Julia Bermúdez, Carolina González Centeno, Celeste Egea, Anastasia Macagni, Pablo Piedras, Silvana Spadaccini and Romina Spinsanti, "Revistas de cine en Argentina," paper presented at V Jornadas de Estudios e Investigaciones, Instituto de Teoría e Historia del Arte Julio E. Payró, Buenos Aires, October 16–18, 2002.

56. See, for example, Beatriz Sarlo, *Una modernidad periférica* (Buenos Aires: Nueva Visión, 1988); Adrián Gorelik, *La grilla y el parque* (Buenos Aires: Universidad

Nacional de Quilmes, 2004); and Graciela Silvestri, *El color del rio* (Buenos Aires: Universidad Nacional de Quilmes, 2003).

57. Later that year, the organization cohosted a congress on the use of language called the Jornada de Lenguas y Lenguajes, which took place on June 19 at the worker-occupied Hotel Bauen in Rosario. This event was cohosted by the organizations IMPA-La Fábrica Ciudad Cultural, Centro Cultural Chilavert, and Serpaj Pueblos Originarios and was additionally sponsored by MTD de La Matanza Centro de Formación y Capacitación Comunitaria, Movimiento Nacional de Empresas Recuperadas, Foro de la Tierra y la Alimentación, Biblioteca Popular José Murillo, Asamblea Popular de San Andrés, and Teatro por la Identidad. The Movimiento de Documentalistas also sponsored film series in several cities, including cinema from Africa, Asia, and Latin America in the Arte Selecta del Centro Cultural del Pasaje Dardo Rocha in La Plata and the Biblioteca Popular de Bella Vista-Fundación Pedro Milesi, in Córdoba.

58. Movimiento de Documentalistas, *Boletín,* May 2004.

59. TV Libre, *Manifesto,* pamphlet dated May 22, 2004.

60. Fernando Buen Abad Domínguez, *Praxis de TV Libre,* pamphlet dated May 2005.

61. Tamara Falicov concedes the importance of this event in *The Cinematic Tango,* 138.

62. "Nuevo projecto de cine," roundtable discussion, Havana, New Latin American Film Festival, December 2004.

63. Thomas Olesen, *International Zapatismo: The Construction of Solidarity in the Age of Globalization* (London: Zed, 2005), 20.

64. A similar point is made by Luis Roniger and Leandro Kierszenbaum in "Los intelectuales y los discursos de derechos humanos: la experiencia del Cono Sur," Estudios Interdisciplinarios de América Latina y el Caribe 16, no. 2 (2005): 5–36.

CONCLUSION

1. Matthew B. Karush, "The Melodramatic Nation: Integration and Polarization in the Argentine Cinema of the 1930s," *Hispanic American Historical Review* 87, no. 2 (2007): 293–326. The phrase "structures of feeling" comes from Raymond Williams, *Marxism and Literature* (Oxford: Oxford University Press, 1977), 132.

2. Robert Rosenstone, "The Future of the Past," in *The Persistence of History: Cinema, Television and the Modern Event,* ed. Vivian Sobchack (London: Routledge, 1996), 205, 202.

3. Ibid., 206.

4. Arjun Appadurai, "Disjuncture and Difference in the Global Cultural Economy," *Public Culture* 2, no. 2 (1990): 1–24.

5. Tzvi Tal, "La Rosales: Historia, intertextualidad y alegoría en una película de la transición a la Democracia en Argentina," in *Història i cinema—25 aniversari del centre d'investigacions film-història,* ed. J. M. Caparrós Lera (Barcelona: Edicions Universitat de Barcelona, 2009).

GLOSSARY

Note: all terms are Argentine Spanish.

asamblea barrial · A neighborhood assembly used in Argentina following the financial crisis to organize collective social welfare strategies, such as exchange clubs and solidarity networks.

barrio · A neighborhood district.

cacerolazo · Public demonstrations using the clattering of pots and pans to peacefully protest, a common phenomenon in Argentina following the 2001 financial crisis.

cartonero · Someone who collects recyclables as a source of income.

cinemateca · A film library or archive.

compañero/a · A comrade, companion, colleague.

corralito · Fernando de la Rúa's economic policy to end a run on banks following the 2001 crisis in Argentina.

denuncia · A popular denunciation, usually of public acts or figures.

desocupado · An unemployed person.

diputado · A representative to the lower chamber of Argentina's Congress.

documentalista · A documentary filmmaker who identifies with the aims of political cinema.

escrache · A public denunciation that sometimes uses street demonstrations and vandalism to raise awareness about some issue.

fábrica ocupada · A factory occupied or operated by its workers; a factory that workers have taken over.

golpe de estado · A coup d'état.

juicio a las juntas · Public trials, ordered by Raúl Alfonsín's administration, of the military generals responsible for the 1976 coup d'état beginning on April 22, 1985.

movimiento de los desocupados · An organized movement of the unemployed.

noticiario · A newsreel film, often in the form of a short documentary.

noticiero · A news report.

nueva izquierda · The "new left," a term applied at various times and in various contexts of transformation and historical change to leftists in Argentina and other parts of Latin America.

obrero/a(s) · Worker(s); this term was used widely by labor organizations to describe their memberships.

piquetero · An unemployed semiprofessionalized demonstrator.

porteño · A native of Buenos Aires.

revista · A magazine or journal.

rock nacional · Argentine music styled after North American and British rock and roll.

rockero · A fan of Argentine rock nacional.

los sin tierra · The homeless, or literally landless; the term is used to describe both urban and rural poor in Argentina.

solicitada · An announcement, denunciation, or declaration made in periodicals.

tanguedia · A tragic musical comedy with tango as a central element.

villa de emergencia · An urban shantytown or slum, also referred to as a villa miseria or villa precaria.

FILMOGRAPHY

A los compañeros, la libertad (To the comrades, liberty). Directed by Marcelo Céspedes and Carmen Guarini. Produced by Cine Ojo. 1987.

Acampe piquetero (Camp piqueteros). 25 min. Directed and produced by Grupo Cine y Foto Ojo Obrero. 2002.

Agua de fuego (Water from fire). Directed by Candela Galantini and Sandra Godoy. Produced by Grupo de Boedo Films. 2001.

Las aguas bajan turbias (Dark River or *River of Blood).* Directed by Hugo del Carril. Produced by Lina C. de Machinandiarena. 1952.

Alianza para el progreso (Alliance by a Progress). Directed and produced by Julio César Ludueña. 1971.

El amor es una mujer gorda (Love is a Fat Woman). Directed by Alejandro Agresti. Produced by César Maidana. 1987.

Argentina mayo de 1969, los caminos de la liberación (Argentina, May 1969: the paths of liberation). Directed and produced by Octavio Getino, Nemesio Juárez, Rodolfo Kuhn, Humberto Ríos, Rubén Salguero, Mauricio Berú, Pablo Szir, Jorge Martín, and Eliseo Subiela. 1969.

Argentinazo . . . comienza la revolución (Argentinazo . . . the revolution begins). 19 min. Directed and produced by Grupo Cine y Foto Ojo Obrero. 2002.

Asesinato en el senado de la nación (Murder in the Senate). Directed by Juan José Jusid. Produced by Horacio Casares Producciones and Alberto Trigo. 1984.

El ausente (The Absentee). Directed and produced by Rafael Filipelli and Unión de Cineastas Argentinos Cooperativa de Trabajo. 1987.

La battaglia di Algeri (The Battle of Algiers). Directed by Gillo Pontecorvo. Produced by Igor Film (Italy) and Cabash Film (Algeria). 1965.

Barrio gris (Grey barrio). Directed by Mario Soffici. Produced by Cinematográfica Cinco. 1954.

La bestia humana (The human beast). Directed by Daniel Tinyare. Produced by Cinematográfica Cinco. 1957.

Boda secreta (Secret Wedding). Directed by Alejandro Agresti. Produced by All Arts Enterprises (the Netherlands), Cogurccio Films (Italy), and Cinephile (Canada). 1988.

Botín de guerra (Spoils of War). Directed by David Blaustein. Produced by Zafra Difusión. 2000.

Buenos Aires rock. Directed by Héctor Oliveira. Produced by Fernando Ayala and Luis Osvaldo Repetto for Aries Cinematográfica Argentina. 1983.

Camila. Directed by María Luisa Bemberg. Produced by Lita Stantic for GEA Producciones and Impala Films (Spain). 1984.

La cifra impar (Odd Number). Directed by Manuel Antín. Produced by Axel Harding. 1962.

La ciudad oculta (The hidden city). Directed by Osvaldo Andéchaga. Produced by Isabel Lettner and Orsai Cine. 1989.

Contar hasta diez (Count to Ten). Directed by Oscar Barney Finn. Produced by Oscar Barney Finn Producciones. 1985.

Control obrero (Worker control). 25 min. Directed by Sandra Godoy, Lucas Martelli, Claudio Remedi, Oriana Tizziani, and Carlos Broun. Produced by Grupo Boedo Films and Contraimagen. 2003.

Control obrero de los trabajadores de Brukman (Worker control Brukman). 26 min. Directed by Sandra Godoy. Produced by Grupo de Boedo Films and Contraimagen. 2002.

Contra el poder, un nuevo poder . . . las asambleas populares (Against power, a new power . . . popular assemblies). 25 min. Directed and produced by Grupo Cine y Foto Ojo Obrero. 2002.

Corazón de fábrica (Heart of the Factory). Directed by Ernesto Ardito and Virna Molina. Produced by Ernesto Ardito, Virna Molina, the Jan Vrijman Foundation (the Netherlands), Alter-Ciné Foundation (Canada), and others. 2008.

La crisis causó 2 neuvas muertes (The crisis caused two new deaths). Directed by Patricio Escobar and Damián Finvarb. Produced by Foco Producciones, Patricio Escobar, and Marcel Gonnet Wainmayer. 2007.

Crónicas de libertad (Chronicles of liberty). 47 min. Directed and produced by Grupo Alavio. 2002.

Cuarentena (Forty). Directed by Carlos Echeverría. Produced by Renate Stegmuller. 1983. Not commercially released.

Cuarteles de invierno (Winter quarters). Directed by Lautaro Murúa. Produced by Guillermo Smith. 1984.

De eso no se habla (I Don't Want to Talk about It). Directed by María Luisa Bemberg. Produced by Aura Film, Mojame, and Oscar Kramer. 1993.

Death and the Maiden. Directed by Roman Polanski. Produced by Canal Plus (France), Capitol Films (U.S.A.), Channel Four Films (U.K.), Fine Line Features (U.S.A.), Flash Film Works (U.S.A.), and TF1 Films Productions (France). 1994.

Después de la siesta (After Nap). 33 min. Directed by Claudio Remedi and Eugenia Rojas. Produced by Claudio Remedi and Grupo de Boedo Films. 1994.

Después del silencio (After the silence). Directed by Lucas Demare. Produced by Artistas Argentinos Asociados. 1956.

La deuda interna (Veronico Cruz). Directed by Miguel Pereira. Produced by Channel Four Films (U.K.), British Film Institute, Mainframe Entertainment (Canada), and Yacoraite Film Cooperative de Trabajo. 1987.

Diablo, familia y propiedad (Devil, family, and property). Directed by Fernando Kirchmar. Produced by Grupo de Cine Insurgente. 1999.

Días de cartón (Cardboard Days). 51 min. Directed and produced by Verónica Souto. 2003.

Los días de junio (Days in June). Directed by Alberto Fischerman. Produced by Alberto Fischerman and Santos Productores Asociados de Cine y TV. 1985.

La dignidad de los nadies (Dignity of the Nobodies). Directed by Fernando Solanas. Produced by Fernando Solanas, Sara Silveira (Brazil), and Pierre Alain Meier (Switzerland). 2005.

DNI: La otra historia (DNI: the other history). Directed by Luis Brunati. Produced by Grupo Cine Argentino. 1989.

Don Segundo Sombra. Directed by Manuel Antín. Produced by Producciones Manuel Antín. 1969.

Errepé (ERP). Directed by Gabriel Corvi and Gustavo de Jesús. Produced by Gabriel Corvi and Gustavo de Jesús. 2004.

La escuela (The school). Directed by Eduardo Yedlin. Produced by Centro de Estudios y Producción Audiovisual, Bin Cine, INCAA, and Universidad Nacional Lomas de Zamora. 2006.

El exilio de Gardel: tangos (Tangos, The Exile of Gardel). Directed by Fernando Solanas. Produced by Argentina Sono Film. 1985.

La fábrica es nuestra (The factory is ours). 25 min. Directed by Carlos Broun, Claudio Remedi, Nicolas Pousthomis, Gabriela Jaime, Sandra Godoy, and the Workers of the Brukman Factory. Produced by Grupo de Boedo Films and Contraimagen. 2002.

Un fantasma recorre la Argentina—los piqueteros (A ghost in Argentina—the piqueteros). 40 min. Directed and produced by Grupo Cine y Foto Ojo Obrero. 2001.

El Fausto criollo (Criollo Faust). Directed by Luis Saslavsky. Produced by Valentino Cinematográfica. 1979.

Flores de septiembre (Flowers of September). Directed by Pablo Osores, Roberto Testa, and Nicolás Wainzelbaum. Produced by Nicolás Wainzelbaum. 2003.

Fotographías (Photographs). Directed by Andrés Di Tella. Produced by Cine Ojo. 2007.

Fuerza Aérea Sociedad Anónima (Air Force Anonymous Society). Directed by Enrique Piñeyro. Produced by Aquafilms. 2006.

Gatica, el mono (Gatica, the Monkey). Directed by Leonardo Favio. Produced by Choila. 1993.

El golpe militar, also known as *El golpe, memoria del horror* (The military coup; The coup, memory of horror). Directed by Jorge Manzur. Produced by Telefé. 2006.

Grissinopoli. Directed by Darío Doría. Produced by A4 Films, COSUDE, INCAA, and the Secretaría de Cultura de la Nación, Argentina. 2004.

El hijo de la novia (The Son of the Bride). Directed by Juan José Campanella. Produced by Pol-ka Producciones, Jempsa Entertainment, Patagonik Film Group, and Tornasol Films. 2001.

Los hijos de Fierro (Sons of Fierro). Directed by Fernando Solanas. Produced by Tercine, Little Bear (France), Telepool (Germany), and Westdeutscher Rundfunk (Germany). 1972. Commercially released in Argentina in 1984.

H.I.J.O.S.: el alma en dos (H.I.J.O.S: Split Soul). Directed by Marcelo Céspedes and Carmen Guarini. Produced by Cine Ojo, the Jan Vrijman Foundation (the Netherlands), Soros Documentary Fund (U.S.A.), and Centre National de la Cinématographie (France). 2002.

La historia oficial (The Official Story). Directed by Luis Puenzo. Produced by Cinemanía Sociedad Anónima and Historias Cinematográficas Sociedad Anónima. 1985.

Historias cotidianas (h) (Daily histories). Directed by Andrés Habegger. Written by Luis Puenzo. Produced by La Mano Producciones Audiovisuales and Zafra Difusión Sociedad Anónima. 2001.

Hombre mirando al sudeste (Man Facing Southeast). Directed by Eliseo Subiela. Produced by Cine Quanon. 1987.

La hora de los hornos (The Hour of the Furnaces). Directed by Fernando Solanas. Produced by Anglemi, Fernando Solanas, and Edgardo Pallero. 1966–68. First commercially released in 1973.

Hotel Gondolín. Directed and produced by Fernando López Escriva. 2005.

Informes y testimonios: La tortura política en la Argentina, 1966–1972 (Reports and testimonies—the political torture in Argentina, 1966–1972). Directed and produced by Film Collective Escuela de Cine de La Plata. 1973.

Inundaciones (Floods). Directed and produced by Colectivo de Video Santa Fe Documenta. 2003.

Los inundados (Flooded Out). Directed by Fernando Birri. Produced by Productora América Nuestra. 1962.

Jaime de Nevares: ultimo viaje (Jaime de Nevares: last voyage). Directed by Carmen Guarini and Marcelo Céspedes. Produced by Cine Ojo. 1995.

El jefe (The boss). Directed by Fernando Ayala. Produced by Aries Cinematográfica. 1958.

Jorge Giannoni, NN ese soy yo (Jorge Giannoni anonymous, that's me). Directed by Gabriela Jaime. Produced by Grupo de Boedo Films. 2000.

Juan: como si nada hubiera sucedido (*Juan, As If Nothing Ever Happened*). Directed by Carlos Echeverría. Produced by Evangelisches Zentrum für Entwicklungsbezogene, Mathias Film, Hochschule für Fernsehen und Film, INC, and Westdeutscher Rundfunk. 1987.

Kilómetro 111 (*Kilometer 111*). Directed by Mario Soffici. Produced by Argentina Sono Film. 1938.

Made in Argentina. Directed by Juan José Jusid. Produced by José Jusid Cine Sociedad Anónima and Progress Communications. 1987.

Malayunta (*Bad Connection*). Directed by José Santiso. Produced by Santiso Cine. 1986.

Martín Fierro. Directed by Leopoldo Torre Nilsson. Produced by Leopoldo Torre Nilsson and André Du Rona. 1968.

Matanza. Directed and produced by Grupo Documental Primero de Mayo. 2002.

La mayor estafa del pueblo argentino (The hoax). Directed by Diego Musiak. Produced by Buenaventura Producciones. 2004.

La mayoría silenciada (*The Silenced Majority*). Directed by Jorge Zuhair Jury. Produced by Miguel Angel de Velasco. 1986.

Me matan si no trabajo, y si trabajo me matan (They kill me if I don't work and if I work they kill me). Directed by Raymundo Gleyzer. Produced by Cine de la Base. 1974.

Memorias del saqueo (*Social Genocide*). Directed by Fernando Solanas. Produced by ADR Productions (France), Centre National de la Cinématographie (France), Cinesur, Ciné Cinémas (France), INCAA, TVI (Portugal), Thelma Film AG (Chile), Trigon Film (Germany), Télévision Suisse-Romande (Switzerland), and Yleisradio (Finland). 2004.

Memorias y olvidos (Memories and forgetting). Directed by Simón Feldman. Produced by Gerardo Arazi Producciones. 1987.

Missing. Directed by Costa-Gavras. Produced by PolyGram Filmed Entertainment (U.K.) and Universal Pictures (U.S.A.). 1982.

Montoneros, una historia (*A History of Montoneros*). Directed by Andrés Di Tella. Produced by Cine Ojo. 1998.

Un muro de silencio (*A Wall of Silence*). Directed by Lita Stantic. Produced by Aleph Producciones, Channel 4 Television Productions, and Instituto Mexicano de Cinematographía. 1993.

Los nadies (*The Nobodies*). Directed by Sheila Pérez Giménez and Ramiro García. Produced by Cecilia Diez. 2002/2005.

Nietos (identidad y memoria) (Grandchildren [identity and memory]). Directed by Benjamín Avila. Produced by Daniel Cabezas. 2004.

Ni olvido ni perdón: 1972, la masacre de Trelew (Neither forgetting nor forgiveness: 1972, the Trelew Massacre). Directed by Raymundo Gleyzer. Produced by Cine de la Base. 1972.

No crucen el portón (No trespassing). 18 min. Directed by Claudio Remedi. Produced by Grupo de Boedo Films and Claudio Remedi. 1992.

No habrá más penas ni olvido (*Funny Dirty Little War*). Directed by Hécor Olivera. Produced by Aries Cinematográfica Argentina. 1983.

La noche de los lápices (*Night of the Pencils*). Directed by Héctor Olivera. Produced by Aires Cinematográfica Argentina. 1986.

La noche eterna (Eternal night). Directed by Marcelo Cespedes and Carmen Guarini. Produced by Cine Ojo. 1991.

Noticiero obrero—kino nuestra lucha. Directed and produced by Grupo Noticiero Obrero Kino Nuestra Lucha. 2002.

El Nüremberg argentino (Nuremberg, Argentina). Directed by Miguel Rodríguez Arias. Produced by Damián Schujman. 2004.

Obreros sin patrón (Workers without a boss). 20 min. Directed by Kino Nuestra Lucha Colectivo. Produced by Grupo de Boedo Films, Contraimagen, and Kino Nuestra Lucha. 2003.

Operación masacre (Operation massacre). Directed by Jorge Cedrón. Produced by Cinetel. 1973.

Paco Urondo, la palabra justa (Paco Urondo). Directed by Daniel Desaloms. Produced by Diana Frey. 2005.

Palestina, otro Vietnam (Palestine, another Vietnam). Directed by Jorge Giannoni. Produced by San Diego Cinematográfia. 1971.

Panzas (Bellies). 45 min. Directed and produced by Laura Bondarevsky. 1999.

La parte del león (The Lion's Share). Directed by Adolfo Aristarain. Produced by Aries Cinematográfica Argentina. 1978.

Patagonia rebelde (Patagonia in Rebellion). Directed by Héctor Olivera. Produced by Aries Cinematográfica Argentina. 1974.

Perón: actualización política y doctrinaria para la toma del poder (Perón: political and doctrinal actualization for the assumption of power). Directed by Fernando Solanas and Octavio Getino. Produced by Cine Liberación. Not released commercially.

Los perros (The Dogs). Directed by Adrián Jaime. Produced by Cine Ojo. 2004.

Piquete Puente Pueyrredón (Pueyrredón Bridge picket). 35 min. Directed and produced by Indymedia Video. 2002.

Piqueteros carajo! (Fucking piqueteros!). 17 min. Directed and produced by Grupo Cine y Foto Ojo Obrero. 2002.

Plata quemada (Burnt Money). Directed by Marcelo Piñeyro. Produced by Oscar Kramer, Cuatro Cabezas, Estudios Darwin, Romikin, Patricio Tobal, Editorial Capayán, Fundación Octubre, Ibermedia European Community Program (Spain), INCAA, Mandarin Films, Punto BSRL, Taxi Films (Uruguay), Tornasol Films (Spain), and Vía Digital (Spain). 2000.

El poder de la censura (The Power of censorship). Directed by Emilio Vieyra. Produced by Total Cinematográfica. 1983.

Polo obrero. 15 min. Directed and produced by Grupo Cine y Foto Ojo Obrero. 2001.

Prisioneros de la tierra (Prisoners of the Earth). Directed by Mario Soffici. Produced by Pampa Film. 1939.

El proceso (The process). Directed by Aureliano Barros. Produced by Alejandra Ferreyra Ortiz. 2006.

Prohibido dormir (Sleep prohibited). Directed by Paula Bassi and Diego Paulí. Produced by Cine Ojo. 2004.

Raymundo. Directed by Ernesto Ardito and Virna Molina. Produced by Ernesto Ardito and Virna Molina with the Alter-Ciné Foundation (Canada), Jan Vrijman Fund (the Netherlands), and Fondo Nacional de las Artes. 2002.

Rebelión (Rebellion). Directed by Federico Urioste. Produced by Federico Urioste and Marcelo Altmark. 2004.

La república perdida (The Lost Republic), parts 1 and 2. Directed by Miguel Pérez. Produced by Enrique Vanoli for Norán. 1983, 1985.

Revelación (Revelation). 8 min. Directed and produced by Rolado Enrique Santos. 1986.

El rigor del destino (*The Rigor of Destiny*). Directed by Gerardo Vallejo. Produced by Aguatus Films. 1985.

La Rosales. Directed by David Lipscyz. Produced by LDG Films. 1984.

Los rubios (*The Blonds*). Directed by Albertina Carri. Produced by Cine Ojo. 2003.

Sasetru obrera (*Worker Sasetru*). Directed and produced by Grupo de Cine y Foto Ojo Obrero. 2003.

Los siete locos (*The Seven Madmen*). Directed by Leopoldo Torre Nilsson. Produced by Leopoldo Torre Nilsson and José Slavin for Producciones Cinematográficas Litoral. 1973.

Siluetas (*Silhouettes*). Directed by Víctor Alejandro González. 1982. Not completed.

Sol de noche (A gleam in the dark). Directed by Norberto Ludin and Pablo Milstein. Produced by La Azotea. 2003.

Sur (*South*). Directed by Fernando Solanas. Produced by Cinesur and Pacific Production (France). 1988.

Swift. Directed by Raymundo Gleyzer. Produced by Cine de la Base. 1971.

La televisión y yo (*Television and Me*). Directed by Andres Di Tella. Produced by Cine Ojo. 2001.

Tiempo de revancha (*Time for Revenge*). Directed by Adolfo Aristarain. Produced by Aries Cinematográfica Argentina. 1981.

El tiempo y la sangre (Time and blood). Directed by Alejandra Almirón. Produced by Cine Ojo. 2004.

La tierra quema (The burning earth). 12 min. Directed by Raymundo Gleyzer. Produced by Rodolfo Goldschwartz. 1964.

Tinta roja (*Blood Ink*). Directed by Carmen Guarini and Marcelo Céspedes. Produced by Cine Ojo and Inger Servolin (France). 1998.

Tire díe (*Toss Me a Dime*). Directed by Fernando Birri. Produced by Edgardo Pallero. 1956.

Los traidores (The traitors). Directed by Raymundo Gleyzer. Produced by Cine de la Base and William Susman. 1972. Not commercially screened.

Trelew. Directed by Mariana Arruti. Produced by Fundación Alumbrar. 2004.

El tren blanco (*The White Train*). Directed by Nahuel García, Ramiro García, and Sheila Pérez Giménez. Produced by Aquelarre Servicios Cinematograficos. 2004.

Ultimas días de la víctima (*Last Days of the Victim*). Directed by Adolfo Aristarain. Produced by Aries Cinematográfica Argentina. 1982.

Ultimas imágenes del naufragio (*Last Images of the Shipwreck*). Directed by Eliseo Subiela. Produced by Cinequanon Argentina and TVE (Spain). 1989.

Los venerables todos (*The Venerable Ones*). Directed by Manuel Antín. Produced by José Alberto Garber. 1962.

El viaje (*The Voyage*). Directed by Fernando Solanas. Produce by Cinesur, Films A2, Instituto Mexicano de Cinematografía (IMCINE), and Les Films du Sud. 1992.

Vida en Falcón (*Living in a Falcon*). Directed by Jorge Gaggero. Produced by Libido Cine. 2005.

Whisky, Romeo, Zulu. Directed by Enrique Piñeyro. Produced by Aquafilms. 2004.

The Women of Brukman. Directed by Isaac Isitan. Produced by Radio-Canada Television and RDI. 2008.

Ya es tiempo de violencia (Now is the time for violence). Directed by Enrique Juárez. Produced by Armando Bresky. 1969.

Ya tiene comisario el pueblo (The people already have a commissary). Directed by Claudio Martínez Payva. Produced by Río de la Plata. 1936.

SELECTED BIBLIOGRAPHY

ARCHIVAL SOURCES

Academia Nacional de la Historia de la República Argentina
Archivo del Ministerio de Cultura y Educación de la Nación Argentina
Archivo del Ministerio del Interior de la Nación, Argentina
Archivo General de la Nación, Argentina
Archivo Histórico de la Ciudad de Buenos Aires, Municipalidad de la Ciudad de Buenos Aires
Archivo Histórico del Sindicato de la Industria Cinematográfica Argentina
Archivo Instituto Artes del Espectáculo, Universidad de Buenos Aires
Biblioteca del Congreso de la Nación, Argentina
Biblioteca Escuela Nacional de Experimentación y Realización Cinematográfica
Biblioteca Nacional de la República, Argentina
Fundación Cinemateca Argentina
Fundación Universidad del Cine, Buenos Aires
Instituto Nacional de Cine y Artes Audiovisuales
Museo de Arte Latinoamericano de Buenos Aires
Museo de la Ciudad de Buenos Aires
Museo del Cine Pablo C. Ducrós Hicken
Núcleo Audiovisual Buenos Aires, Centro Cultural San Martín, Gobierno de la Ciudad de Buenos Aires

ARGENTINE NEWSPAPERS AND NONFILM PERIODICALS

A Fondo (1984)
Ahora (1995)
Ambito Financiero (1985–2002)
Los Andes (1982)
Arte y Confección (2003)
Así en Crónica (1990)
Boletín Municipal (Mar del Plata) (1954)
Buenos Aires Herald (2001)
La Capital (1946)
Clarín (1972–2001)
Claudia (1982)
Confirmado (1967)
Convicción (1980–82)
Correo de la Tarde (1960)
Crónica (1982–2001)
El Cronista (1973)
El Diario (1896, 1983)
Diario del Interior (1984)
Diario Popular (1982–83, 2001)
Dinamis (1969)

Familia Cristiana (1987)
Fin de siglo (1988)
Flash (1991)
Gente (1986)
Humor (1981–92)
Jornada (1987)
Línea (1982)
El Litoral (1983, 1987)
La Maga (1994)
La Mujer de Mi Vida (2003–2007)
El Mundo (1958)
La Nación (1957–2004)
El Nacional (1981)
La Nueva Provincia (1988)
Nuevo País (1986)
La Opinión (1970–75)
La Opinión Cultural (1977)
Página/12 (1988–2001)
El Porteño (1990)
La Prensa (1958–66)
Los Principios (1979–81)
Propuesta (1995)
Punto de Vista (1978–2007)
La Razón (1963–2004)
Redacción (1981)
Revista la Semana (1982–83)
Salimos (1981)
Semanario (1991)
Somos (1983)
Sur (1989)
Télam (1999)
Tiempo (1982–85)
Tiempo Argentina (1982–85)
El Tribuno (1983–84)
La Vanguardia (1986)
La Voz (1982–2004)
La Voz del Interior (Córdoba, 1985–88)

ARGENTINE FILM MAGAZINES AND FILM INDUSTRY PUBLICATIONS

AGICA (1945)
El Amante (1991–2004)
Antena (1939–66, 1968–71, 1973–79, 1983–87)
Boletín Mensual de Cine del Cine Club Argentino (1941–43)
Cine (1943–46)
Cine '64 (1964)
Cine Argentino (1938–42)

Cinecrítica (1960–62)
Cine del Tercer Mundo (1969–70)
El Cinéfilo (1997–2004)
Cinegraf (1932–37)
Cine Libre (1983)
Cinema Nuovo (1964–65)
Cine Mínimo (1948)
Cine Prensa (1939–40, 1943–47)
Cine Productor (1944–45)
Cine Técnica (1944)
Cine y Liberación (1969)
ConFUCión (1992–2004)
La Cosa (1995–2002)
Cuadernos de Cine (1969)
DESICA (1991–92)
Encuentro del Documentalista (1997–2004)
Film (Augusto Alvarez, 1942–47)
Film (Marienbad SRL, 1993–2004)
Flashback (1960)
Gaceta (1966–78, 1984–85)
Gente de Cine (1951–54)
Guión (1939–1941)
Heraldo del Cinematografista (1931–88)
Luminarias (1943)
Magazine Cinematográfico (1930)
Malba.cine (1999–2006)
Maravillas Films (1930)
Micrófono Estrellas (1943)
La Mirada Cautiva (1998–2004)
Nosotros . . . los Cinéfilos (1998)
Otrocampo (2001)
Película (1983)
La Película (1919–34, 1937–48)
Plantea (1959–62)
Primera Plana (1968–71)
Radiolandia (1947–67)
Set (1946–1953)
SICA (1985–88, 2004)
Sin Cortes (1980–2001)
Sintonía (1933–56)
"Sobre" Cine Argentino (1989–1991)
Tiempo de Cine (1968)
Xanadú (1997–2005)

NON-ARGENTINE PERIODICALS

Cahiers du Cinéma (1969, 1980, 1985, 1990)
Cinéthique (1969, 1985)

Liberation (1985)
Le Monde (1985)
Positif (1985)

SECONDARY SOURCES

Acuña, Carlos H., Inés González Bombal, Elizabeth Jelin, Oscar Landi, Luis Alberto Quevedo, Catalina Smulovitz, and Adriana Vacchieri. *Juicio castigos y memorias: derechos humanos y justicia en la política.* Edhasa: Buenos Aires, 1995.

Aguilar, Gonzalo. *Other Worlds: New Argentine Film.* New York: Palgrave Macmillan, 2008.

Altamira, Jorge. *El Argentinazo.* Buenos Aires: Rumbos, 2002.

Altamirano, Carlos. *Bajo el signo de las masas.* Buenos Aires: Ariel, 2001.

Amado, Ana. "Cine argentino: cuando todo es margen." *Pensamiento de los Confines* 11 (Sept. 2002): 87–95.

———. "Ficciones críticas de la memoria." *Pensamiento de los Confines* 13 (Dec. 2003): 54–63.

Anguita, Eduardo. *La voluntad: una historia de la militancia revolucionaria en la Argentina, 1973–1976.* 2d ed. Buenos Aires: Grupo Editorial Norma, 1998.

Anzorena, Oscar. *Tiempo de violencia y de utopía (1966–1976).* Buenos Aires: Contrapunto, 1988.

Appadurai, Arjun. "Disjuncture and Difference in the Global Cultural Economy." *Public Culture* 2, no. 2 (1990): 1–24.

Arte y política en los '60. Exhibition catalog. Buenos Aires: Fundación Banco Ciudad, 2002.

Ballent, Anahí. *En las huellas de la política: vivienda, ciudad, y peronismo en Buenos Aires, 1943–1955.* Quilmes, Argentina: Editorial de la Universidad Nacional de Quilmes, 2005.

Balvé, Beba C., and Beatriz S. Balvé. *El '69: huelga política de masas—rosariazo, cordobazo, rosariazo.* Buenos Aires: Razón y Revolución and CISCO, 2005.

Barela, Liliana. "Diez años de historia oral en el Instituto Histórico: la legitimación de una propuesta (1985–1995)." *Nuevas Perspectivas del Patrimonio Histórico Cultural* 1 (2000): 91–112.

Barnard, Tim. *Argentine Cinema.* Toronto: Nightwood, 1986.

Barros, Sebastián. *Orden, democracia y estabilidad: discurso y política en la Argentina entre 1976 y 1991.* Córdoba, Argentina: Alción, 2002.

Barthes, Roland. *Mythologies.* Translated by Annette Lavers. London: Paladin, 1979.

Baudrillard, Jean. *The System of Objects.* Translated by James Benedict. New York: Verso, 1996.

Bauman, Zygmunt. *Postmodernity and Its Discontents.* New York: New York University Press, 1997.

Beasley-Murray, John. "Peronism and the Secret History of Cultural Studies: Populism and the Substitution of Culture for State." *Cultural Critique* 39 (Spring 1998): 189–217.

Beceyro, Raúl. *Cine y fotografía como intervención política.* Edited by Susana Sel. Buenos Aires: Prometeo, 2007.

Benhabib, Seyla. *The Claims of Culture: Equality and Diversity in the Global Era.* Princeton, N.J.: Princeton University Press, 2002.

Bermúdez, Julia, Carolina González Centeno, Celeste Egea, Anastasia Macagni, Pablo Piedras, Silvana Spadaccini, and Romina Spinsanti. "Revistas de cine en Argentina." Paper presented at V Jornadas de Estudios e Investigaciones, Instituto de Teoría e Historia del Arte Julio E. Payró, Buenos Aires, October 16–18, 2002.

Bernini, Emilio. "Politics and the Documentary Film in Argentina during the 1960s." *Journal of Gender Studies* 13, no. 2 (2004): 155–70.

Birri, Fernando. "Cinema and Underdevelopment." In *New Latin American Cinema,* vol. 1, *Theory, Practices, and Transcontinental Articulations,* edited by Michael Martin, 86–94. Detroit, Mich.: Wayne State University Press, 1997.

———. "Manifesto." In *Twenty-five Years of the New Latin American Cinema,* edited by Michael Chanan, 24–36. London: British Film Institute, 1983.

Bortnik, Aída, and Luiz Puenzo. *La historia oficial.* Buenos Aires: Ediciones de la Urraca, 1985.

Brennan, James. *The Labor Wars in Córdoba, 1955–1976.* Cambridge, Mass.: Harvard University Press, 1994.

Brennan, James, and Marcelo Rougier. *The Politics of National Capitalism: Peronism and the Argentine Bourgeoisie, 1946–1976.* University Park: Pennsylvania State University Press, 2009.

Brennan, James P., and Monica Gordillo. "Working Class Protests, Popular Revolt, and Urban Insurrection in Argentina: the 1969 Cordobazo." *Journal of Social History* 27, no. 3 (Spring): 477–98.

Brenner, Fernando. *Adolfo Aristarain.* Buenos Aires: Centro Editor de América Latina, 1993.

Brysk, Alison. *The Politics of Human Rights in Argentina: Protest, Change and Democratization.* Stanford, Calif.: Stanford University Press, 1994.

Buchbinder, Pablo. *Historia de las universidades argentinas.* Buenos Aires: Sudamericana, 2006.

Burgos, Raúl. *Los gramscianos argentinos: cultura y política en la experiencia de "Pasado y Presente."* Buenos Aires: Siglo XXI, 2004.

Burton-Carvajal, Julianne. "Marginal Cinemas and Mainstream Critical Theory." In *Screening World Cinema,* edited by Catherine Grant and Annette Kuhn, 17–35. New York: Routledge, 2006.

Bystrom, Kerry. "Orphans and Origins: Family, Memory and Nation in Argentina and South Africa." PhD diss., Princeton University, 2007.

Cabrera, Gustavo. *Hugo del Carril, un hombre de nuestro cine.* Buenos Aires: Ediciones Culturales Argentinas, 1989.

Calabrese, Andrew. "The Promise of Civil Society: A Global Movement for Communication Rights." *Continuum* 18, no. 3 (2004): 317–29.

Cameron, Maxwell. "Latin America's Left Turns: Beyond Good and Bad." *Third World Quarterly* 30, no. 2 (2009): 331–48.

Canclini, Néstor García. *Consumers and Citizens: Globalization and Multicultural Conflicts.* Translated by George Yúdice. Minneapolis: University of Minnesota Press, 2001.

Carr, Barry. *Marxism and Communism in Twentieth-Century Mexico.* Lincoln: University of Nebraska Press, 1992.

Castañeda, Jorge. *Utopia Unarmed: The Latin American Left after the Cold War.* New York: Vintage, 1994.

Castiglione, Marta. *La militarización del estado en la Argentina (1976/1981).* Buenos Aires: Centro Editor de América Latina, 1992.

Casullo, Nicolás. *Peronismo: militancia y crítica, 1973–2008*. Buenos Aires: Colihue, 2008.

Cena, Juan Carlos, ed. *El Cordobazo, una rebelión popular.* Buenos Aires: La Rosa Blindada, 2000.

Chanan, Michael. *Cuban Cinema*. Minneapolis: University of Minnesota Press, 2004.

Chartier, Roger. "Intellectual History or Sociocultural History? The French Trajectories." In *Modern European Intellectual History: Reappraisals and New Perspectives,* edited by Dominick LaCapra and Stephen Kaplan, 13–36. Ithaca, N.Y.: Cornell University Press, 1987.

Clark, Elizabeth A. *History, Theory, Text: Historians and the Linguistic Turn*. Cambridge, Mass.: Harvard University Press, 2004.

Cobbs Hoffman, Elizabeth. *All You Need Is Love: The Peace Corps and the Spirit of the 1960s*. Cambridge, Mass.: Harvard University Press, 1998.

Corigliano, Francisco. "El impacto de Estados Unidos y de España en el proceso de democratización en Argentina." *Nueva Sociedad* 135 (Jan.–Feb. 1995): 235–59.

Corradi, Juan Eugenio. "Argentina and Peronism." *Latin American Perspectives* 1, no. 3 (1974): 3–20.

Cortarelo, María Celia, and Fabián Fernandez. "La toma de fábricas, Argentina 1964." Working paper 4, Programa de Investigación sobre el Movimiento de la Sociedad Argentina, 1994.

Coscia, Jorge. *Del estallido a la esperanza: reflexiones sobre cine, cultura y peronismo.* Buenos Aires: Corregidor, 2001.

De la Punte, Maximiliano, and Pablo Russo. *El compañero que lleva la cámara—cine militante argentino contemporáneo.* Master's thesis, ciencias de la comunicación, Facultad de Ciencias Sociales, Universidad de Buenos Aires, 2004.

De las Carreras de Kuntz, María Elena. "El cine político durante el Proceso." *Foro Político* 22 (Apr. 1998): 29–51.

Deleuze, Gilles. *Difference and Repetition*. Translated by Paul Patton. New York: Columbia University Press, 1994.

de Pablo, Juan Carlos. *Politica antiinflacionaria en la Argentina, 1967–1970*. Buenos Aires: Amorrortu, 1990.

De Riz, Liliana. *La política en suspenso 1966–1976*. Buenos Aires: Paidós, 2000.

Devoto, Fernando. *Estudios de historiografía Argentina*. Vol 2. Buenos Aires: Biblos, 1999.

Devoto, Fernando, and Marta Madero, eds. *Historia de la vida privada en la Argentina*. 3 vols. Buenos Aries: Taurus, 1999.

Dinerstein, Ana. "The Battle of Buenos Aires: Crisis, Insurrection and the Reinvention of Politics in Argentina." *Historical Materialism* 10, no. 1 (2002): 5–38.

di Núbila, Domingo. *Historia del cine argentino*. 2 vols. Buenos Aires: J. Héctor Matera, 1959–60.

Di Tella, Andrés. *Andrés Di Tella: cine documental y archivo personal, conversación en Princeton*. Edited by Paul Firbas and Pedro Meira Monteiro. Buenos Aires: Siglo XXI, 2006.

———. *Guión cinematográfico*. Santa Fe, Argentina: Universidad Nacional del Litoral, 1990.

———. "Recuerdos del nuevo cine argentino." In *Hacer cine: producción audiovisual en América Latina,* edited by Eduardo Russo, 243–55. Buenos Aires: Paidós, 2008.

Donghi, Túlio Halperín. *La Argentina y la tormenta del mundo: ideas e ideologías entre 1930 y 1945*. Buenos Aires: Siglo XXI, 2003.

Dubois, Lindsay. "Torture and Construction of an Enemy: The Example of Argentina 1976–1983." *Dialectical Anthropology* 15, no. 4 (1990): 317–28.

Duhalde, Luis E. *El estado terrorista argentino: quince años después, una mirada crítica.* Buenos Aires: Eudeba, 1999.

Eloy Martínez, Tomás. *Santa Evita.* New York: Vintage, 1997.

Erro, Davide G. *Resolving the Argentine Paradox: Politics and Development, 1966–1992.* Boulder, Colo.: Lynne Rienner, 1993.

Escudé, Carlos, and Marisa González de Oleaga. "La política exterior de Alfonsín: lecciones de una sobredosis de confrontaciones." Working paper 31, Universidad Torcuato di Tella, Dept. of Political Science and Government. Buenos Aires: Universidad Torcuato di Tella, 1993.

Facchinetti, Graciela, Silvina Jensen, and Teresita Zaffrani. *Patagonia: historia, discurso e imaginario social.* Temuco, Chile: Universidad de la Frontera, 1997.

Falicov, Tamara L. *The Cinematic Tango: Contemporary Argentine Film.* London: Wallflower, 2007.

———. "The Contemporary Argentine Film Industry, 1983–1998: State Cultural Policy within a Global Market." PhD diss., University of California, San Diego, 1999.

Fanon, Frantz. *The Wretched of the Earth.* Translated by Richard Philcox. New York: Grove, 2004.

Feitlowitz, Marguerite. *Lexicon of Terror: Argentina and the Legacies of Torture.* London: Oxford University Press, 1998.

Feld, Claudia. *Del estrado a la pantalla: las imágenes del juicio a los ex comandantes en Argentina.* Buenos Aires: Siglo XXI, 2002.

Feld, Claudia, and Jessica Stites Mor, eds. *El pasado que miramos: memoria e imagen ante la historia reciente.* Buenos Aires: Paidós, 2009.

Félix-Didier, Paula. "La crítica de cine en los 60." In *Generaciones 60/90: cine independiente argentino,* edited by Fernando Martín Peña, 328–35. Buenos Aires: Fundación Eduardo F. Constantini, 2003.

Fernández, Rodrigo, and Denise Nagy. *La gran aventura de Armando Bo.* Buenos Aires: Libros Perfil, 1999.

Ferreira, Fernando. *Luz, cámara . . . memoria: una historia social del cine argentino.* Buenos Aires: Corregidor, 1995.

Ferro, Marc. *Cinema and History.* Translated by Naomi Greene. Detroit, Mich.: Wayne State University Press, 1988.

Figueroa Ibarra, Carlos. "Shipwreck and Survival: The Left in Central America." *Latin American Perspectives* 24 (1997): 114–29.

Fiorucci, Flavia. "Intelectuales peronistas y anti-peronistas." Paper presented at the Instituto de Desarrollo Económico y Social, Buenos Aires, September 14, 2006.

Forgacs, David. *Italian Culture in the Industrial Era, 1880–1980: Cultural Industries, Politics, and the Public.* Manchester, U.K.: Manchester University Press, 1990.

Foster, David William. *Contemporary Argentine Cinema.* Columbia: University of Missouri Press, 1992.

Foucault, Michel. "Film and Popular Memory." In *Foucault Live: Interviews, 1961–1984,* edited by Sylvère Lotringer, 89–106. New York: Seimotext(e), 1996.

Franco, Jean. *The Decline and Fall of the Lettered City: Latin America in the Cold War.* Cambridge, Mass.: Harvard University Press, 2002.

Franco, Marina. "Between Urgency and Strategy: Argentine Exiles in Paris, 1976–1983." *Latin American Perspectives* 34, no. 4 (July 2007): 50–67.

Galiani, Sebastián, and Hugo A. Hopenhayn. "Duration and Risk of Unemployment in Argentina." Working paper Coo<p'>117. The Center for International and Development Economics Research, University of California at Berkeley, 2001.

Gaonkar, Dilip Parameshwar, ed. *Cultures of Democracy*. Special edition. *Public Culture* 19, no. 1 (Winter 2007).

Garibotto, Verónica, and Antonio Gómez. "Más allá del 'formato memoria': la repostulación del imaginario postdictatorial en *Los rubios* de Albertina Carri." *A Contracorriente* 3, no. 2 (Winter 2006): 107–26.

Gatti, Gabriel. "Las narrativas del detenido-desaparecido (o de los problemas de la representación ante las catástrofes sociales)." *Confines* 2, no. 4 (2006): 27–38.

Getino, Octavio. *Cine argentino: entre lo posible y lo deseable*. Buenos Aires: Ciccus, 1998.

———. *Cine latinoamericano: economía y nuevas tecnologías audiovisuales*. Buenos Aires: Legasa, 1987.

———. *Cine y dependencia: el cine en la Argentina*. Buenos Aires: Puntosur Editores, 1990.

———. *Cine y televisión en América latina: producción y mercados*. Santiago: LOM, 1998.

———. *Cultura, comunicación y desarrollo en América Latina*. Buenos Aires: Edimedias, 1984.

———. *Las industrias culturales en la Argentina: Dimensión económica y políticas públicas*. Buenos Aires: Colihue, 1994.

———. *La tercera mirada: panorama del audiovisual latinoamericano*. Barcelona: Paidós Ibérica, 1996.

Getino, Octavio, and Susana Velleggia. *El cine de las historias de la revolución: aproximación a las teorías y prácticas del cine político en América Latina (1967–1977)*. Buenos Aires: Altamira, 2002.

Gilman, Claudia. *Entre la pluma y el fusil: debates y dilemas del escritor revolucionario en América Latina*. Buenos Aries: Siglo XXI, 2003.

Giroux, Henry A. *Cine y entretenimiento*. Buenos Aires: Paidós, 2004.

Giunta, Andrea. *Vanguardia, internacionalismo, y politica*. Buenos Aires: Paidós, 2001.

Godio, Julio. *Historia del movimiento obrero argentino: 1870–2000*. Buenos Aires: Corregidor, 2000.

Goebel, Michael. "A Movement from Right to Left in Argentine Nationalism? The Alianza Libertadora Nacionalista and Tacuara as Stages of Militancy." *Bulletin of Latin American Research* 26, no. 3 (2007): 356–77.

Gorelik, Adrián. *La grilla y el parque*. Buenos Aires: Universidad Nacional de Quilmes, 2004.

Grandin, Greg. *The Last Colonial Massacre: Latin America in the Cold War*. Chicago: University of Chicago Press, 2004.

Grieveson, Lee, and Haidee Wasson, eds. *Inventing Film Studies*. Durham, N.C.: Duke University Press, 2008.

Griffiths, Alison. *Wondrous Difference: Cinema, Anthropology, and the Turn of the Century Visual Culture*. New York: Columbia University Press, 2002.

Grugel, Jean. *Democratization: A Critical Introduction*. London: Palgrave Macmillan, 2002.

Grzegorczyk, Marzena. *Private Topographies: Space, Subjectivity, and Political Change in Modern Latin America*. New York: Palgrave Macmillan, 2005.

Guinta, Andrea. *Vanguardia, internacionalismo, y política*. Buenos Aires: Paidós, 2001.

Gundermann, Christian. "The Stark Gaze of New Argentine Cinema." *Journal of Latin American Cultural Studies* 14, no. 3 (Dec. 2005): 241–61.

Hall, Stuart. "Who Needs Identity?" In *Questions of Cultural Identity*, edited by Stuart Hall, 1–17. Thousand Oaks, Calif.: Sage, 1996.

Heidegger, Martin. *Essais et conferences: Vorträge und Aufsätze*. Translated by André Préau. Paris: Gallimard, 1958.

———. "The Question of Technology." In *The Question Concerning Technology and Other Essays*, translated by William Lovitt, 3–35. New York: Harper and Row, 1977.

Heller, Pablo. *Fábricas ocupadas*. Buenos Aires: Rumbos, 2004.

Hennebelle, Guy, and Alfonso Gumucio-Dagrón. *Les cinémas de l'Amérique latine*. Paris: Nouvelle Editions Pierre Lherminier, 1981.

Hite, Katherine. *When the Romance Ended: Leaders of the Chilean Left, 1968–1998*. New York: Columbia University Press, 2000.

Hobsbawm, Eric. *The Age of Extremes*. New York: Time Warner Abacus, 2002.

Huyssen, Andreas. *Present Pasts: Urban Palimpsests and the Politics of Memory*. Stanford, Calif.: Stanford University Press, 2003.

Jagoe, Eva-Lynn Alicia. *The End of the World as They Knew It: Writing Experiences of the Argentine South*. Lewisburg, Pa.: Bucknell University Press, 2008.

Jaguaribe, Beatriz. "The Shock of the Real: Realist Aesthetics in the Media and the Urban Experience." *Space and Culture* 8 (2005): 66–83.

Jaikumar, Priya. *Cinema at the End of Empire: A Politics of Transition in Britain and India*. Durham, N.C.: Duke University Press, 2006.

James, Daniel. *Resistance and Integration: Peronism and the Argentine Working Class*. London: Cambridge University Press, 1994.

Jameson, Fredric. *The Cultural Turn: Selected Writings on the Postmodern, 1983–1998*. New York: Verso, 1998.

Jelin, Elizabeth. "The Politics of Memory: The Human Rights Movement and the Construction of Democracy in Argentina." *Latin American Perspectives* 21, no. 81 (1994): 38–58.

———. *Los trabajos de la memoria*. Madrid: Siglo XXI/Social Science Research Council, 2002.

Jensen, Silvina. "Suspendidos d la historia/exiliados de la memoria: el caso de los argentinos desterrados en Cataluña (1976 . . .)." PhD diss., Universitat Autònoma de Barcelona, 2004.

Kaes, Anton. "History and Film: Public Memory in the Age of Electronic Dissemination." *History and Memory: Studies in Representation* 2, no. 1 (1990): 112–49.

Kaiser, Susana. "The Struggle for Urban Territories: Human Rights Activists in Buenos Aires." In *Ordinary Places, Extraordinary Events: Citizenship, Democracy, and Public Space in Latin America*, edited by Clara Irazábal, 170–97. New York: Routledge, 2008.

Kaminsky, Amy K. *After Exile: Writing the Latin American Diaspora*. Minneapolis: University of Minnesota Press, 1999.

———. *Argentina: Stories for a Nation*. Minneapolis: University of Minnesota Press, 2008.

Kantaris, Geoffrey. "The Last Snapshots of Modernity: Argentine Cinema after the 'Process.'" *Bulletin of Hispanic Studies* 73, no. 2 (Apr. 1996): 219–44.

Kaplan, Betina. "*Los rubios*." *Chasqui* 33 (2004): 169–79.

Karush, Matthew B. "The Melodramatic Nation: Integration and Polarization in the Argentine Cinema of the 1930s." *Hispanic American Historical Review* 87, no. 2 (May 2007): 293–326.

Koshy, Susan. "From Cold War to Trade War: Neocolonialism and Human Rights." *Social Text* 58 (Spring 1999): 1–32.

Kriger, Clara. *Cine y peronismo: el estado en escena.* Buenos Aires: Siglo XXI, 2009.

———. "La narración del pasado en el cine argentino." In *Cine argentino en democracia: 1983–1993,* edited by Claudio España, 54–67. Buenos Aires: Fondo Nacional de las Artes, 1994.

———, ed. *Páginas de cine.* Buenos Aires: Archivo General de la Nación, 2003.

Kurlansky, Mark. *1968: The Year That Rocked the World.* New York: Ballantine, 2004.

LaCapra, Dominick. *History and Criticism.* Ithaca, N.Y.: Cornell University Press, 1987.

———. *History in Transit: Experience, Identity, Cultural Theory.* Ithaca, N.Y.: Cornell University Press, 2004.

La Ferla, Jorge. "El cine argentino, un estado de situación." In *Hacer cine: producción audiovisual en América Latina,* edited by Eduardo Russo, 215–42. Buenos Aires: Paidós, 2008.

Landini, Carlos. *Héctor Olivera.* Buenos Aires: Centro Editor de América Latina, 1993.

Latham, Michael. *Modernization as Ideology: American Social Science and "Nation Building" in the Kennedy Era.* Chapel Hill: University of North Carolina Press, 2000.

Lenci, María Laura. "Cámpora al gobierno, Perón al poder: la tendencia revolucionaria del peronismo antes de las elecciones del 11 de marzo de 1973." In *La primacía de la política,* edited by Alfredo Pucciarelli, 167–201. Buenos Aires: Eudeba, 1999.

Lesgart, Cecilia. *Usos de la transición a la democracia: ensayo, ciencia y política en la década del '80.* Rosario, Argentina: Homo Sapiens, 2003.

Levitsky, Steven. *Transforming Labor-based Parties in Latin America: Argentine Peronism in Comparative Perspective.* New York: Cambridge University Press, 2003.

Lewis, Colin, and Nissa Torrents, eds. *Argentina in the Crisis Years, 1983–1990: From Alfonsín to Menem.* London: Institute of Latin American Studies, 1991.

Lewis, Paul H. *The Agony of Argentine Capitalism: From Menem to the Kirchners.* Santa Barbara, Calif.: ABC-CLIO, 2009.

Lipszyc, Cecilia. "Los feminismos en la Argentina (1983–2004)." In *Perfiles del feminismo iberoamericano,* vol. 2, edited by María Luisa Femenías, 83–120. Buenos Aires: Catálogos, 2005.

Lomnitz, Claudio. "Foundations of the Latin American Left." *Public Culture* 19, no. 1 (2007): 23–27.

Longoni, Ana, and Bruzzone Gustavo, comps. *El Siluetazo.* Buenos Aires: Adriana Hidalgo, 2008.

Longoni, Ana, and Mariano Mestman. *Del Di Tella a "Tucumán Arde": vanguardia artística y política en el '68 argentino.* Buenos Aires: El Cielo por Asalto, 2008.

López, Daniel. *Catálogo del nuevo cine argentino 1989/1991.* Buenos Aires: Legasa, 1993.

Ludmer, Josephina. *The Gaucho Genre: A Treatise on the Motherland.* Durham, N.C.: Duke University Press, 2002.

Manrupe, Raúl, and María Alejandra Portela. *Un diccionario de films argentinos (1930–1995).* Buenos Aires: Corregidor, 2001.

Manzano, Valeria. "Betrayal, Loyalty, the Peronist People, and the Forgotten Archives: Miguel Bonasso's Narrative and the Peronist Left's Political Culture, 1984–2003." *Journal of Latin American Cultural Studies* 16, no. 2 (2007): 183–99.

———. "Combates por la historia: interpretaciones de la historia del movimiento obrero en el cine militante argentino al principio de los 1970s." *Film and History* 32, no. 4 (2004): 46–57.

———. "Trabajadores en celuloide: representaciones de los trabajadores urbanos en el cine argentino, 1933–1999." Thesis, licenciatura in history, Universidad de Buenos Aires, October 2002.

Maranghello, César. *Breve historia del cine argentino*. Buenos Aires: Laertes, 2005.

———. "Del proyecto conservador a la difusión peronista." In *Cine argentino: industria y clasicismo, 1933–1956,* vol. 2, edited by Claudio España, 24–159. Buenos Aires: Fondo Nacional de las Artes, 2000.

Marcus, Cecily. "The Molecular Intellectual: Cultural Magazines and Clandestine Life under Argentina's Last Dictatorship." PhD diss., University of Minnesota, 2005.

Martín Peña, Fernando. *El cine quema: Jorge Cedrón*. Buenos Aires: Altamira, 2003.

———, ed. *Generaciones 60/90: cine argentino independiente*. Buenos Aires: Fundación Eduardo F. Costantini, 2003.

———. Martín Peña, Fernando, and Carlos Vallina, eds. *El cine quema: Raymundo Gleyzer*. Buenos Aires: Ediciones de la Flor, 2000.

Masiello, Francine. *The Art of Transition: Latin American Culture and Neoliberal Crisis*. Durham, N.C.: Duke University Press, 2001.

Mason, Alfredo. *Sindicalismo y dictadura: una historia poco contada, 1976–1983*. Buenos Aires: Biblos, 2007.

Merleau-Ponty, Maurice. *Phenomenology of Perception*. Translated by Colin Smith. New York: Routledge, 1958.

Mestman, Mariano. "From Algiers to Buenos Aires: The Third World Cinema Committee (1973–1974)." *New Cinemas: Journal of Contemporary Film* 1, no. 1 (2002): 40–53.

Modonesi, Massimo. *La crisis histórica de la izquierda socialista Mexicana*. Mexico City: Casa Juan Pablos, 2003.

Mombello, Laura. "Neuquén es memoria y memoria es Neuquén." *Revista de historia* (Neuquén) 9 (2001): 113–23.

Mongin, Olivier. *Violencia en cine contemporáneo*. Buenos Aires: Paidós, 1999.

Monteagudo, Luciano. *Fernando Solanas*. Buenos Aires: Centro Editor de América Latina, 1993.

Morero, Sergio, Ariel Eidelman, and Guido Lichtman. *La noche de los bastones largos*. 2d ed. Buenos Aires: Latinoamericana, 2002.

Moyano, María José. *Argentina's Lost Patrol: Armed Struggle, 1969–1979*. New Haven, Conn.: Yale University, 1995.

Newman, Kathleen. "Cultural Redemocratization: Argentina, 1978–89." In *On Edge: The Crisis of Contemporary Latin American Culture*, edited by George Yúdice, Jean Franco, and Juan Flores, 161–85. Minneapolis: University of Minnesota Press, 1992.

———. "National Cinema after Globalization: Fernando Solanas' *Sur* and the Exiled Nation." In *Mediating Two Worlds: Cinematic Encounters in the Americas,* edited by John King, Ana M. López, and Manuel Alvarado, 242–57. London: British Film Institute, 1993.

Nouzeilles, Gabriela. "Apocalyptic Visions: National Tales and Cultural Analysis in a Global Argentina." *Journal of Latin American Cultural Studies* 10, no. 3 (2001): 291–301.

———. "The Iconography of Desolation: Patagonia and the Ruins of Nature." *Review: Literature and Arts of the Americas* 40, no. 2 (2007): 252–62.

————. "Postmemory Cinema and the Future of the Past in Albertina Carri's *Los rubios.*" *Journal of Latin American Cultural Studies* 14, no. 3 (2005): 263–78.

Novaro, Marcos. *Historia de Argentina contemporánea: de Perón a Kirchner.* Buenos Aires: Edhasa, 2006.

Novaro, Marcos, and Vicente Palermo. *La dictadura militar.* Buenos Aires: Paidós, 2003.

Nowell-Smith, Geoffrey. *The Oxford History of World Cinema.* Oxford: Oxford University Press, 1999.

O'Donnell, Guillermo. *Bureaucratic Authoritarianism: Argentina, 1966–1973, in Comparative Perspective.* Translated by James McGuire. Berkeley: University of California Press, 1988.

Olesen, Thomas. *International Zapatismo: The Construction of Solidarity in the Age of Globalization.* London: Zed, 2005.

Ollier, María Matilde. *La creencia y la pasión: privado, público y político en la izquierda revolucionaria.* Buenos Aires: Ariel, 1998.

————. *De la revolución a la democracia: cambios privados, públicos y políticos de la izquierda argentina.* Buenos Aires: Siglo XXI, 2009.

————. *El fenómino insurreccional y la cultura política (1969–1973).* Buenos Aires: Centro Editor de América Latina, 1986.

Ortiz de Zárate, Roberto. *Raúl Alfonsín.* Barcelona: Fundación CIDOB, 2006.

Osiel, Mark. "Constructing Subversion in Argentina's Dirty War." *Representations* 75 (2001): 119–58.

Oubiña, David. "Construcción sobre los márgenes: itinerarios del nuevo cine independiente en América Latina." In *Hacer cine: producción audiovisual en América Latina,* edited by Eduardo Russo, 31–42. Buenos Aires: Paidós, 2008.

————. "Exilios y regresos." In *Cine argentino en democracia: 1983–1993,* edited by Claudio España, 68–81. Buenos Aires: Fondo Nacional de las Artes, 1994.

————. *Manuel Antín.* Buenos Aires: Centro Editor de América Latina, 1993.

Page, Joanna. *Crisis and Capitalism.* Durham, N.C.: Duke University Press, 2009.

————. "Memory and Mediation in *Los rubios*: A Contemporary Perspective on the Argentine Dictatorship." *New Cinemas* 3, no. 1 (Apr. 2005): 29–40.

————. "Postmodernism, History and Social Critique in Post-dictatorship Argentine Cinema: A Reading of Eliseo Subiela's 'El lado oscuro del corazón.'" *Modern Language Review* 96, no. 2 (Apr. 2001): 385–403.

Paranagua, Paulo Antonio. "Entretien avec Fernando E. Solanas." *Positif* 297 (Nov. 1985): 21–30.

Pastoriza, Elisa, and Juan Carlos Torre. "Mar del Plata, un sueño de los argentinos." In *Historia de la vida privada en la Argentina,* edited by Fernando Devoto and Marta Madero, 3:67–68. Buenos Aires: Taurus, 1999.

Petralito, Christian, and Alberto Alderete. *De agosto a diciembre de 1972: Trelew, historia de una masacre y la organización popular como respuesta.* Buenos Aires: Nuestra América, 2007.

Petras, James. "Latin America: The Resurgence of the Left." *New Left Review* 1, no. 223 (May–June 1997): 17–47.

Piglia, Ricardo. *Artificial Respiration.* Translated by Daniel Balderston. Durham, N.C.: Duke University Press, 1998.

Pion-Berlin, David. "Between Confrontation and Accommodation: Military and Government Policy in Democratic Argentina." *Journal of Latin American Studies* 23, no. 3 (1991): 543–71.

————. "To Prosecute or to Pardon? Human Rights Decisions in the Latin American Southern Cone." *Human Rights Quarterly* 15 (1993): 105–30.

Pittaluga, Roberto. *Catálogo de publicaciones políticas de las izqueirdas argentinas, 1890–2000s.* Buenos Aires: CeDInCI, 2000.

Ponza, Pablo. "Comprometidos, orgánicos y expertos: intelectuales, marxismo y ciencias sociales en Argentina (1955–1973)." *A Contracorriente* 5, no. 2 (2008): 74–98.

Powers, Nancy. "The Politics of Poverty in Argentina in the 1990s." *Journal of InterAmerican Studies and World Affairs* 37, no. 4 (Winter 1995): 89–137.

Pozzi, Pablo, and Alejandro Schneider. *Los setentistas: izqueirda y clase obrera: 1969–1976.* Buenos Aires: Eudeba, 2000.

Puig, Manuel. *Kiss of the Spider Woman.* Translated by Thomas Colchie. New York: Vintage, 2006.

Rabe, Stephen G. *The Most Dangerous Area in the World: John F. Kennedy Confronts Communist Revolution in Latin America.* Chapel Hill: University of North Carolina Press, 1999.

Raffo, Julio. *Ley de fomento y regulación de la actividad cinematográfica.* Buenos Aires: Lumière, 2003.

Reati, Fernando. "Argentine Political Violence and Artistic Representation in Films of the 1980s." *Latin American Literary Review* 17, no. 34 (July–Dec. 1989): 24–39.

Rein, Raanan, and Rosalie Sitman, eds. *El primer peronismo: de regreso a los comienzos.* Buenos Aires: Lumière, 2005.

Rice, Gerard T. *The Bold Experiment: JFK's Peace Corps.* Notre Dame, Ind.: University of Notre Dame Press, 1985.

Rich, Ruby. "An/Other View of New Latin American Cinema." *Iris: Revue de Théorie de l'Image et du Son* 13 (1991): 5–28.

Richard, Nelly. *Insubordination of Signs: Political Change, Cultural Transformation, and Poetics of Crisis.* Translated by Alice A. Nelson and Silvia R. Tandeciarz. Durham, N.C.: Duke University Press, 2004.

Ricoeur, Paul. *From Text to Action: Essays in Hermeneutics.* Vol. 2. Translated by Kathleen Blamey and John B. Thompson. Evanston, Ill.: Northwestern University Press, 2007.

————. *Memory, History, Forgetting.* Translated by Kathleen Blamey and David Pellauer. Chicago: University of Chicago Press, 2004.

Ridenti, Marcelo. "Artistas e intelectuais no Brasil pós-1960." *Tempo Social* 17, no. 1 (2005): 81–110.

Roberts, Kenneth, Leslie Bethell, and René Antonio Mayorga. "Conceptual and Historical Perspectives." In *The "New Left" and Democratic Governance in Latin America,* edited by Cynthia J. Arnson and José Raúl Perales, 10–23. Washington, D.C.: Woodrow Wilson International Center for Scholars, 2006.

Rocha, Glauber. "An Esthetic of Hunger." In *New Latin American Cinema,* vol. 1, *Theory, Practices, and Transcontinental Articulations,* edited by Michael Martin, 71–85. Detroit, Mich.: Wayne State University Press, 1997.

Rock, David. *Authoritarian Argentina.* Berkeley: University of California Press, 2005.

Romero, José Luis. *Las ideas políticas en Argentina.* Buenos Aires: Fondo de Cultura Económica, 2005.

Romero, Luis Alberto. *A History of Argentina in the Twentieth Century.* Buenos Aires: Fondo de Cultura Económica, 2006.

Roniger, Luis, and Leandro Kierzsenbaum. "Los intelectuales y los discursos de derechos humanos en el Cono Sur." *Estudios Interdisciplinarios de América Latina y el Caribe* 16, no. 2 (2005): 5–26.

Rosenstone, Robert. "The Future of the Past." In *The Persistence of History: Cinema, Television and the Modern Event,* edited by Vivian Sobchack, 210–18. London: Routledge, 1996.

Ross, Kristin. *May '68 and Its Afterlives.* Chicago: University of Chicago Press, 2002.

Russell, Roberto. "Sistema de creencias y política exterior Argentina: 1976–1989." *Relaciones Internacionales.* Documentos e informes de investigación, no. 204. Buenos Aires: FLACSO, 1996.

Russo, Eduardo, ed. *Hacer cine: producción audiovisual en América Latina.* Buenos Aires: Paidós, 2008.

Salas, Ernesto. *Uturuncos: El origen de la guerrilla peronista.* Buenos Aires: Biblos, 2003.

San Martino de Dormí, Maria Laura. *Argentina contemporáneo: de Perón a Menem.* Buenos Aires: Ciudad Argentina, 1996.

Sarlo, Beatriz. "Argentina 1984: La cultura en el proceso democrático." *Nueva Sociedad* 73 (1984): 78–84.

———. "El campo intelectual: un espacio doblemente fracturado." In *Represión y reconstrucción de una cultura: el caso argentino,* edited by Saúl Sosnowski, 96–108. Buenos Aires: Eudeba, 1999.

———. "Educación: el estado de las cosas." *Punto de Vista* 22, no. 63 (1999): 17–21.

———. "El historia contra el olvido." *Punto de Vista* 11, no. 36 (1989): 11–14.

———. *Una modernidad periférica.* Buenos Aires: Nueva Visión, 1988.

Satarain, Mónica, ed. *Plano secuencia: 20 películas argentinas para reafirmar la democracia.* Buenos Aires: La Crujía, 2004.

Schuster, Federico. "Izquierda política y movimientos sociales en la Argentina contemporánea." In *La nueva izquierda en América Latina, sus orígenes y trayectoria futura,* edited by César A. Rodríguez Garavito, Patrick S. Barrett, and Daniel Chavez, 239–82. Bogotá: Grupo Editorial Norma, 2004.

Seoane, Maria, and Vicente Muleiro. *El dictador: la historia secreta y publica de Jorge Rafael Videla.* Buenos Aires: Sudamericana, 2001.

Shapin, Steven. *A Social History of Truth: Civility and Science in Seventeenth-Century England.* Chicago: University of Chicago Press, 2004.

Shohat, Ella, and Robert Stam, eds. *Unthinking Eurocentrism: Multiculturalism and the Media.* New York: Routledge, 1994.

Sigal, Silvia. *Intelectuales y poder en Argentina: la década del sesenta.* Buenos Aires: Siglo XXI, 2002.

Sigal, Silvia, and Eliseo Verón. *Perón o muerte: los fundamentos discursivos del fenómeno peronista.* Buenos Aires: Legasa, 1986.

Silva, Michel. "Um novo cinema militante." *O Olho da História* 12, no. 9 (Dec. 2006): 1–12.

Silvestri, Graciela. *El color del río.* Buenos Aires: Universidad Nacional de Quilmes, 2003.

Solanas, Fernando, and Octavio Getino. *Cine, cultura y descolonización.* Buenos Aires: Siglo XXI, 1973.

———. "Towards a Third Cinema: Notes and Experiences for the Development of a Cinema of Liberation in the Third World." In *New Latin American Cinema,* vol. 1, *Theory, Practices, and Transcontinental Articulations,* edited by Michael Martin, 33–58. Detroit, Mich.: Wayne State University Press, 1997.

Sontag, Susan. *Regarding the Pain of Others*. New York: Farrar, Straus and Giroux, 2003.

Sorensen, Diana. *A Turbulent Decade Remembered: Scenes from the Latin American Sixties*. Stanford, Calif.: Stanford University Press, 2007.

Sorlin, Pierre. *Cine europeo, sociedades europeos, 1939–1990*. Buenos Aires: Paidós, 1996.

Spencer, Daniela, and Gilbert M. Joseph, eds. *In from the Cold: Latin America's New Encounter with the Cold War*. Durham, N.C.: Duke University Press, 2007.

Spivak, Gayatri. *A Critique of Postcolonial Reason: Toward a History of the Vanishing Present*. Cambridge, Mass.: Harvard University Press, 1999.

Stahler-Sholk, Richard, Harry E. Vanden, and Glen David Kuecker. "Globalizing Resistance: The New Politics of Social Movements in Latin America." *Latin American Perspectives* 34, no. 5 (2007): 5–16.

Stites Mor, Jessica, and Noa Vaisman. "Memory, Political Space, and Activism: Mapping the New Documentary Film Movement in Argentina." Paper delivered at the Latin American Studies Association Conference, San Juan, Puerto Rico, March 17, 2006.

Suri, Jeremi. *Power and Protest: Global Revolution and the Rise of Détente*. Cambridge, Mass.: Harvard University Press, 2003.

Suriano, Juan. *Anarquistas: cultura y política libertaria en Buenos Aires*. Buenos Aires: Manantial, 2001.

Tal, Tzvi. *Pantallas y revolución: una visión comparativa del Cine de Liberación y el Cinema Novo*. Buenos Aires: Lumière, 2005.

———. "*La Rosales*: historia, intertextualidad y alegoría en una película de la transición a la democracia en Argentina." In *Història i cinema—25 aniversari del Centre d'Investigacions Film-Història*, edited by J. M. Caparrós Lera, 243–62. Barcelona: Edicions Universitat de Barcelona, 2009.

Tarcus, Horacio. *Marx en la Argentina: sus primeros lectores obreros, intelectuales y científicos*. Buenos Aires: Siglo XXI, 2007.

Taylor, Diane. *Disappearing Acts: Spectacles of Gender and Nationalism in Argentina's "Dirty War."* Durham, N.C.: Duke University Press, 1997.

Terán, Oscar. "La década del 70: la violencia de las ideas." *Revista Lucha Armada* 2, no. 5 (2006): 24–38.

———. *Nuestros años sesenta*. Buenos Aires: El Cielo por Asalto, 1993.

Thompson, Currie K. "Against All Odds: Argentine Cinema, 1976–1991." *Post Script* 11, no. 3 (Summer 1992): 32–45.

Thompson, Willie. *Postmodernism and History*. New York: Palgrave Macmillan, 2004.

Thurner, Mark. "After Spanish Rule: Writing Another After." In *After Spanish Rule: Postcolonial Predicaments of the Americas*, edited by Mark Thurner and Andrés Guerrero, 2–57. Durham, N.C.: Duke University Press, 2003.

Timerman, Jacobo. *Prisoner without a Name, Cell without a Number*. Translated by Toby Talbot. New York: Knopf, 1981.

Torres, Elipido. *El Cordobazo organizado: la historia sin mitos*. Buenos Aires: Catálogos, 1999.

Trímboli, Javier, ed. *La izquierda en la Argentina: conversaciones*. Buenos Aires: Manantial, 1998.

Tuer, Dot. "Cartographies of Memory: Tracing the Representational Legacy of Argentina's Dirty War in the Work of Guillermo Kuitca." *Parachute* 83 (July 1996): 24–29.

Varea, Fernando G. *El cine argentino durante la dictadura militar 1976/1983*. Rosario, Argentina: Editorial Municipal de Rosario, 2006.

Varela, Mirta. "Media History in a 'Peripheric Modernity': Television in Argentina 1951–1969." *Westminster Papers in Communication and Culture* 4, no. 4 (2007): 84–102.

Veigel, Klaus Friedrich. *Dictatorship, Democracy, and Globalization: Argentina and the Cost of Paralysis, 1973–2001*. University Park: Pennsylvania State University Press, 2009.

Verbitsky, Horacio. *Ezeiza*. Barcelona: Debosillo, 2007.

Vezzetti, Hugo. *Pasado y presente: guerra, dictadura y sociedad en Argentina*. Buenos Aires: Siglo XXI, 2002.

Vieites, María del Carmen, ed. *Leopoldo Torre Nilsson: una estética de la decadencia*. Buenos Aires: Grupo Editor Altamira, 2002.

Waisbord, Silvio. *El gran desfile: campañas electorales y medios de comunicación en Argentina*. Buenos Aires: Sudamericana, 1995.

Werner, Ruth, and Facundo Aguirre. *Insurgencia obrera en la Argentina, 1969–1976*. Buenos Aires: Instituto del Pensamiento Socialista Karl Marx, 2007.

Williams, Raymond. *Marxism and Literature*. Oxford: Oxford University Press, 1977.

Wolf, Sergio, ed. *Cine argentino: la otra historia*. Buenos Aires: Letra Buena, 1992.

———. *Nuevo cine argentino*. Buenos Aires: Paidós, 2002.

Wortman, Ana, ed. *Imágenes publicitarias/nuevos burgueses*. Buenos Aires: Prometeo, 2004.

Yates, Frances A. *The Art of Memory*. Chicago: University of Chicago Press, 1966.

Zolov, Eric. "Expanding our Conceptual Horizons: The Shift from an Old to a New Left in Latin America." *A Contracorriente* 5, no. 2 (2008): 47–73.

Zuppa, Graciela. "Plazas: lecturas de huellas y registros." In *Mar del Plata: ciudad e historia de Buenos Aires,* edited by Fernando Cacopardo, 203–39. Mar del Plata, Argentina: Alianza, 1997.

INDEX

Academia de Artes y Ciencias Cinematográficas de la Argentina, 29

Academy Awards. *See* Oscars

Africa, 20, 148, 226n57; and nuevo cine, 34–35; and Third Cinema, 32, 110–11; and Third World solidarity, 35, 39, 109

AGICA (Union Association of the Argentine Cinematographic Industry), 54–55, 204n37

Aguas bajan turbias, Las (Dark River or *River of Blood)*, 29–30

Aguinis, Marcos, 82, 102

Alfonsín, Raúl: administration of, 9, 10, 94, 103, 109, 132, 169; cultural policy of, 86–89, 91–92, 101–3, 189; economic policy of, 93, 133–34; and the film industry, 89–90, 91–92, 96, 98, 99–100; and human rights, 80–81, 82, 98, 106; political career of, 208n11; and publishing, 180; and the Radical Party, 127, 134, 207n4, 207n8; and the transition to democracy, 76–78, 79–81, 98; and the United States, 210n40

Algeria, 21, 32, 35–36, 40, 47, 111

Alianza Anticomunista Argentina (Triple A), 43, 66, 112, 120

Allende, Salvador, 26, 48, 214n16

Alliance for Progress, 45

Alvarez, Carlos "Chacho," 145

Alvarez, Santiago, 20, 33

Amnesty International, 50, 68, 222n71

anticolonialism, 32, 34, 36, 109, 121, 123, 126

Antín, Manuel, 100, 111, 180, 217n70; as director of the Fundación Universidad del Cine, 179; as head of INC, 89–91, 102–03; and international promotion of Argentine film, 90–91; and the Menem regime, 140

Apold, Raúl Alejandro, 52–54, 203n29

Aramburu, Pedro Eugenio, 44, 61

archives, 13, 36, 65, 154, 178, 181, 184

Ardito, Ernesto, 1, 2–3, 4, 162–64, 167, 189–90

Argentina Sono Film, 28, 53, 54, 61

Argentine Actors Association (AAA), 93, 146

Argentine Association of Independent Cinematographers, 91–92

Argentine Cinematographic Directors (DAC), 71, 93–94, 139

ARGENTORES, 90, 93–94

Aristarain, Adolfo, 94, 140, 141, 180

Arlt, Roberto, 113, 115

art: under Alfonsín, 87; in Castro's Cuba, 19–20; and cinema, 176–77, 179; and cultural imperialism, 35; as criticism of the state, 63; and historical narrative, 11–12; labor and, 25, 71–72; and the military regime, 24–25, 70, 84; and political activism, 84, 94, 148; and state repression, 24–25, 43; and el sur, 107, 109; and technology, 168

Artificial Respiration, 84, 171. *See also* Ricardo Piglia

asambleas barriales, 2, 146, 148, 163

Asia, 148, 226n57; and nuevo cine, 34–35; and the promotion of Argentine cinema, 80; and Third Cinema, 32, 110–11; and Third World solidarity, 35, 39

audiovisual media, 127, 171; archives, 160, 178, 184; in Chile, 184; and cultural policy, 86–87, 140–41, 188–89; and historical narrative, 85–86, 138, 151, 153, 154, 165–66, 191; and militant cinema, 149; and political culture, 88; politics of, 1, 123; and radicalism, 44; reception of, 106–7, 165, 190; role of, 186, 188–89, 190, 191; and stock footage, 28; and technology, 136–37, 165

Avellaneda, 136, 147

Ayala, Fernando, 63, 70, 97, 177, 180

BAFICI (Festival of Independent Cinema), 138, 171, 172

Barracas al Sur, 115, 117–18

Batista, Fulgencio, 19, 26

Battaglia di Algeri, La (The Battle of Algiers), 40, 109

Bayer, Osvaldo, 108

10; human rights and, 5, 12, 105, 135; identity and, 82, 106, 128, 188; images of, 106–7; intellectual, 3, 62, 119, 134–35, 143–44; Latin America and, 20, 21–22, 28, 76; and the transition, 4–5; memory and, 106; under Menem, 134–35, 144–45; militancy of, 22; under Perón, 51–53, 54–58; Peronism and, 72; Perón's legacy and, 46–47, 62–63; poverty and, 144; Raymundo Gleyzer and, 36–37; Revolutionary Armed Forces and, 64, 109; repression of, 49, 65–68, 68–69; Third Cine and, 38–39; transnationalism and, 21–25. *See also* New Left; Revolutionary Army of the People; Revolutionary Workers Party

legislation, 6, 20, 35, 57, 69–70, 71, 92, 94, 122, 134, 137, 139–40, 164, 181, 184, 203n29; Decreto 1.711/007, 184; Decreto 157/83, 81; Decreto 158/83, 82; Decreto 752/99, 142; Executive Decree 21.264, 49; Ley 12.999, 203n29; Ley 13.651, 203n29; Ley 17.741, 61, 140–41, 142, 183–84; Ley 18.019, 61, 206n62; Ley 22.942, 80; Ley 23.042, 80; Ley 23.049, 80; Ley 23.052, 91; Ley 23.077, 80; Ley 23.170, 90; Ley 23.521, 83; Ley 25.119, 141; Ley del Sábado Inglés, 26; Security Act 20.840, 49; University Reforms of 1918, 24

León, Christian, 178

León, Monica, 172–73

Les Productions ISCA, 174

Levingston, General Roberto, 47

Lipszic, David, 193–94

literature of transition: *Artificial Respiration,* 84; Benedetti, Mario, 84; *Kiss of the Spider Woman,* 84; Partnoy, Alicia, 84; Piglia, Ricardo, 84; *Prisoner without a Name, Cell without a Number,* 84; Puig, Manuel, 84; Timerman, Jacobo, 84; Valenzuela, Luisa, 84

López Escriva, Fernando, 169, 172–75

López Rega, José, 48–49

LuchArte, 148, 221n68

Madrid, 33, 38, 91, 112, 184

magazines. *See* film periodicals

MALBA (Latin American Art Museum of Buenos Aires), 172, 176–77

Mar del Plata Film Festival, 56–57, 61, 91, 131–32, 172–73, 180, 204n43

Martín Peña, Fernando, 176, 177, 178, 197

Marxism: and contemporary cultural theory, 165; and film magazines, 33–34; under Menem, 134–135; in the work of Octavio Getino, 123–24; in *Pasado y Presente,* 23; and the return to democracy, 105; and Third World solidarity, 152

Me matan si no trabajo, y si trabajo me matan (They kill me if I don't work, and if I work they kill me), 36–37

Memorias del saqueo (*Social Genocide*), 156, 157, 182

memory: agency and, 166–67; art and, 83–84; cultural policy and, 188–89; debates over, 11–12, 118–19, 159–60, 166–67, 185, 191; detention centers and, 76, 81, 83, 106, 125; disappeared persons and, 4, 43–44, 76, 80, 83, 84, 116; displacement and, 104–5, 120, 124–25; el sur and, 105–7, 107–8, 124–25, 128; fiction cinema and, 181; film and, 4–5, 10–11, 96–97, 111–12, 113, 115–18; film intellectualism and, 104–5, 159–60, 161–62, 166–67, 181–82, 187, 192; Grandmothers of the Plaza de Mayo and, 97, 156, 160; human rights and, 76, 83–86, 94, 96, 105, 113, 156, 169; identity and, 115, 185; image and, 119, 154–55; the media and, 165; Peronism and, 106, 120, 127; portrayed on film, 160–67; preservation of, 42–43, 87–88, 127–28; reconstruction of, 121, 191, 192; sites of, 125; social class and, 188; technology and, 165

Menem, Carlos, 180; cultural policy of, 138–43; economic policy of, 133–34, 135–36, 143–45; and Fernando Solanas, 125–27; and the film industry, 138–43; and the left, 134–35; opposition to, 125–27, 149–50; as successor to Alfonsín, 103

Mexico, 22, 59, 67, 122, 184, 188. *See also* Mexico City

Mexico City, 22, 34, 109. *See also* Mexico

middle class: and collective memory, 188; in the Cordobazo, 26–27; and historical narrative, 98; under Menem, 134, 135–36, 143–44; under Onganía, 24; and the 2001 financial crisis, 2, 145–46, 156

transnationalism: and the Argentine left, 21–25; and cultural politics, 6; and the documentary film movement, 32, 147–48; and dissemination of Argentine film, 141, 163–64, 168–69, 177, 190–91, 194; and the elite, 45; and the film market, 35, 187, 189; and film production, 35, 163, 173–75; and *Hotel Gondolín*, 172–73; and human rights, 152, 173; and Latin American literature, 22; and nuevo cine, 30, 32, 34; and the political economy of film, 169; and political thought, 22; and scholarship, 122, 159, 160–61; solidarity, 20, 110–11, 135, 150, 163–64, 167–68, 184–85; and state sponsorship of film, 153
Trapero, Pablo, 141, 177
Tucumán, 20, 25, 182

Unión Cívica Radical. *See* Radical Party
unions: AGICA (Union Association of the Argentine Cinematographic Industry), 54–55, 204n37; Cinematographic Operators, 95; 62 Organizations, 26, 44, 134, 153; Union of Employees of Cinematographic Distributors, 95; Union of Public Spectacle Workers, 95. *See also* General Confederation of Labor; labor; SICA
United Nations, 80, 84, 122, 210n40
United States, 68, 171; and cold war anticommunism, 24, 45, 47; and cultural geopolitics, 101; distribution of Argentine films in, 141, 167; economic policies

of, 55, 117; on film, 20; and film intellectualism, 33–34, 164–65; and the Non-Aligned Movement, 34; as a place of exile, 67; and support for Alfonsín, 80, 88, 210n40; and Vietnam, 21, 26, 32, 37, 40, 47
Universities: Universidad de Buenos Aires, 24, 36, 79, 88, 150–51, 179; Universidad Católica (Peru), 122; Universidad de Córdoba, 19; Universidad de Entre Ríos, 122; Universidad de Lima, 122; Universidad Nacional Autónoma de México, 122; Universidad Nacional del Litoral, 30, 179; Universidad de la Plata, 122; Universidad Torcuato Di Tella, 170
Uruguay, 35, 50, 114–15, 201n3

Venezuela, 32, 66
Videla, Jorge Rafael, 49, 50, 69
Vietnam War, 21, 26, 32, 37, 40, 47
viewer, 4, 10–11, 41, 44, 97, 164–65, 191
violence. *See* state repression
Vivas, Horacio Ramiro, 67–68

Walsh, Rodolfo, 63–64
Western Hemisphere Institute for Security Coordination. *See* School of the Americas
Worker's Party (Partido Obrero), 2, 93, 148
World Bank, 145, 210n40
World War II, 18, 53–54, 55

Ya es tiempo de violencia (Now is the time for violence), 39